Harry N. Abrams, Inc., Publishers | The Richard Avedon Foundation

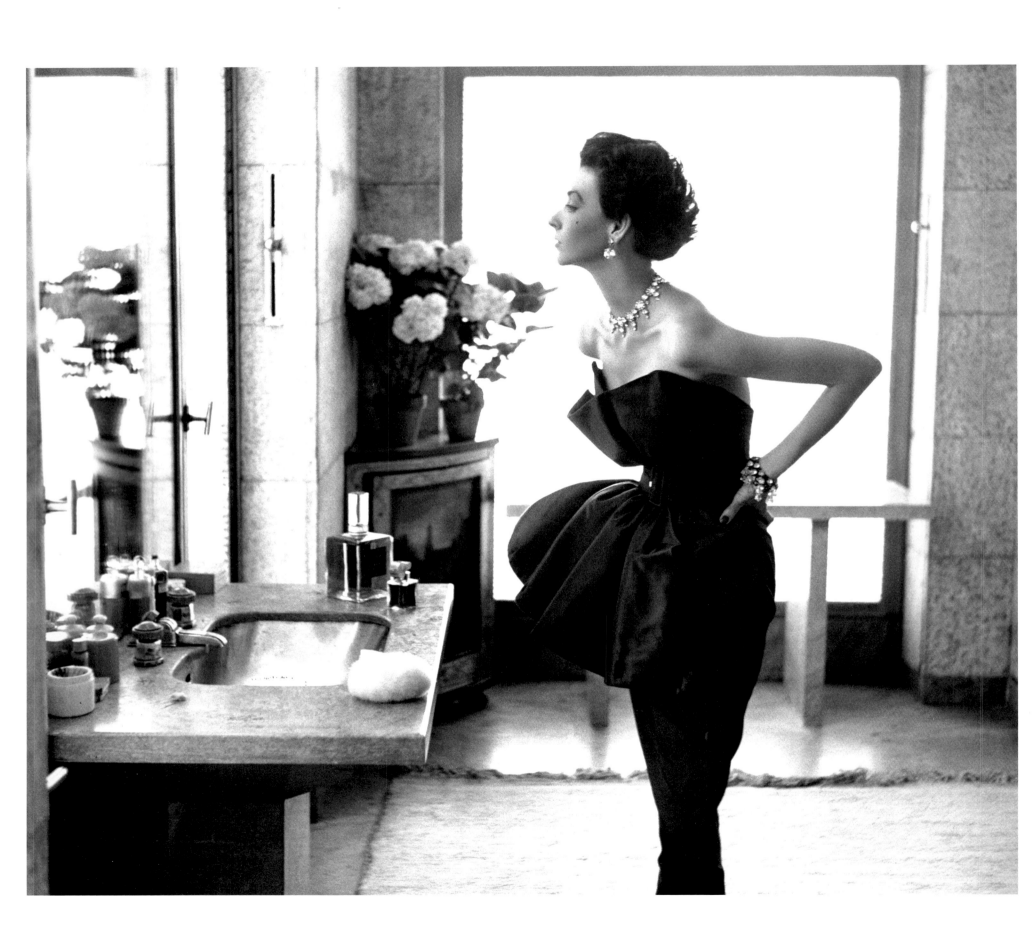

Woman in the Mirror
Richard Avedon

Essay by Anne Hollander | Designed by Mary Shanahan

"You can only get beyond the surface by working with the surface.
I have great faith in surfaces. A good one is full of clues."

RICHARD AVEDON, 1970

It was Richard Avedon's idea to create a book about one of his favorite subjects—women.

He began this project in 2002 by editing his sittings of the last sixty years. Poring over thousands of contact sheets he discovered a wealth of forgotten photographs—some published, some not. Of the images he selected, the first was taken in 1946; the last, a half-century later in 2004.

A year ago, while having dinner with his friends Martha Parker and Adam Gopnik, he spoke about the book and the question of what the title might be. Adam suggested *Woman in the Mirror*. The title goes to the heart of what, I believe, intrigued Dick about photography—its ambiguity. Who is reflected in the mirror: the seer, the seen, or the unseen?

The reader of these pages is a voyeur, invited to participate in the intimate triangle of subject, photographer, and viewer that is an Avedon photograph.

While on assignment for *The New Yorker*, Richard Avedon was considering going to Iraq and gave me, his constant colleague and friend for two decades, clear instructions to have *Woman in the Mirror* published, whether he was alive or not.

Richard Avedon died suddenly on October 1, 2004, in San Antonio, Texas, and this is his book.

NORMA STEVENS
Executive Director
The Richard Avedon Foundation

Anna Magnani, actress. New York, April 1953

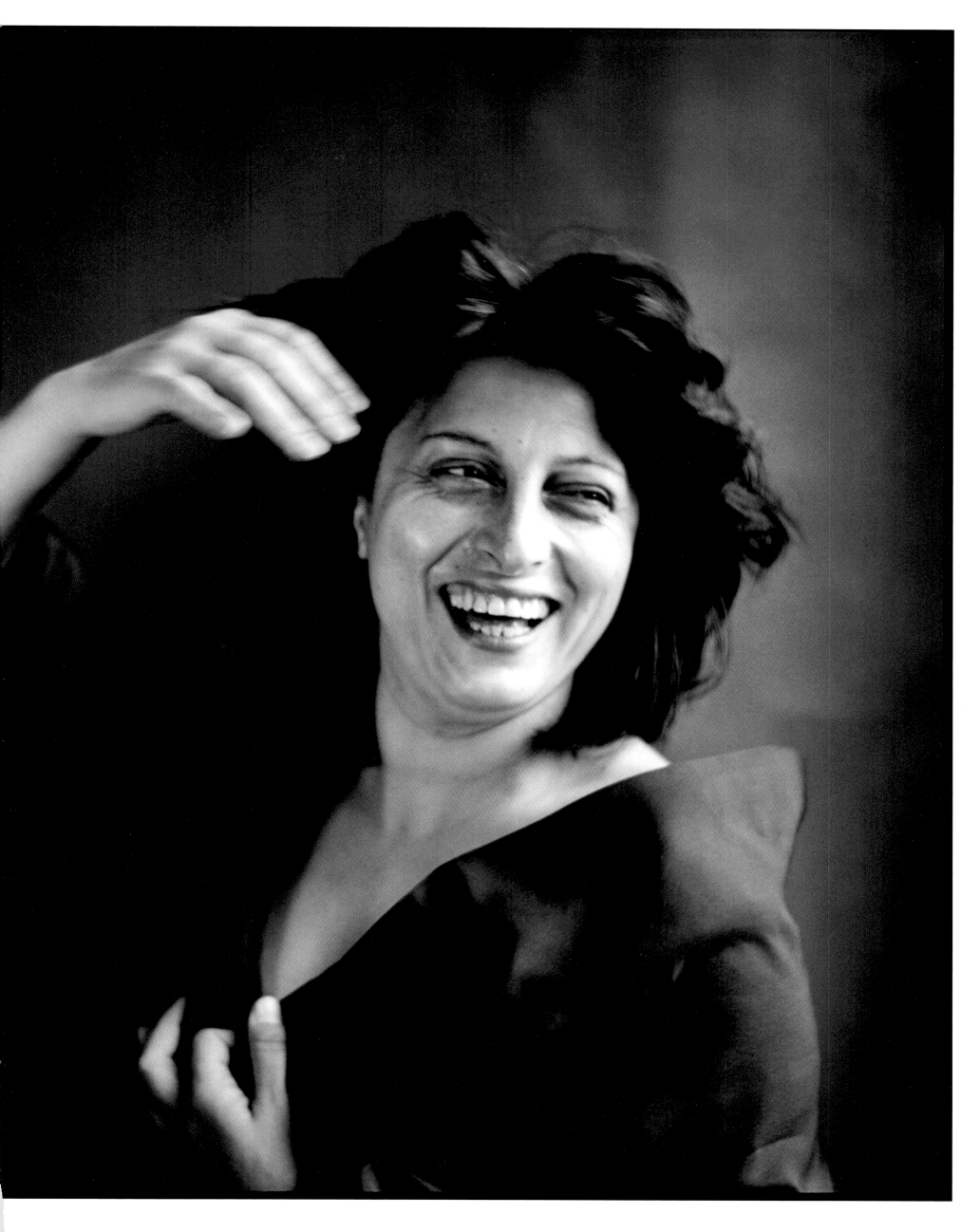

Dorian Leigh, model, with bicycle racer. Dress by Dior. Champs-Élysées, Paris, 1949

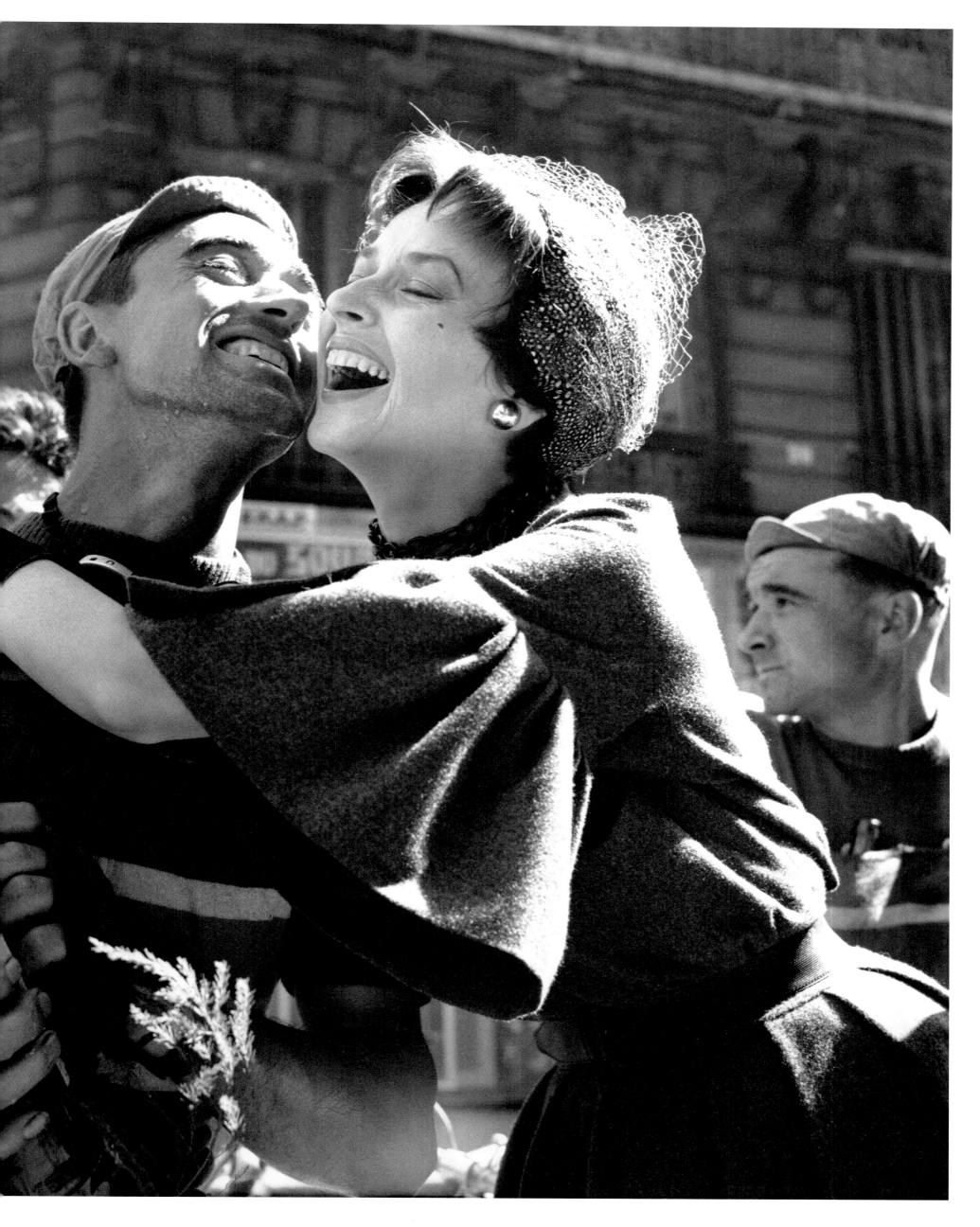

Zazi, street performer. Piazza Navona, Rome, July 1946

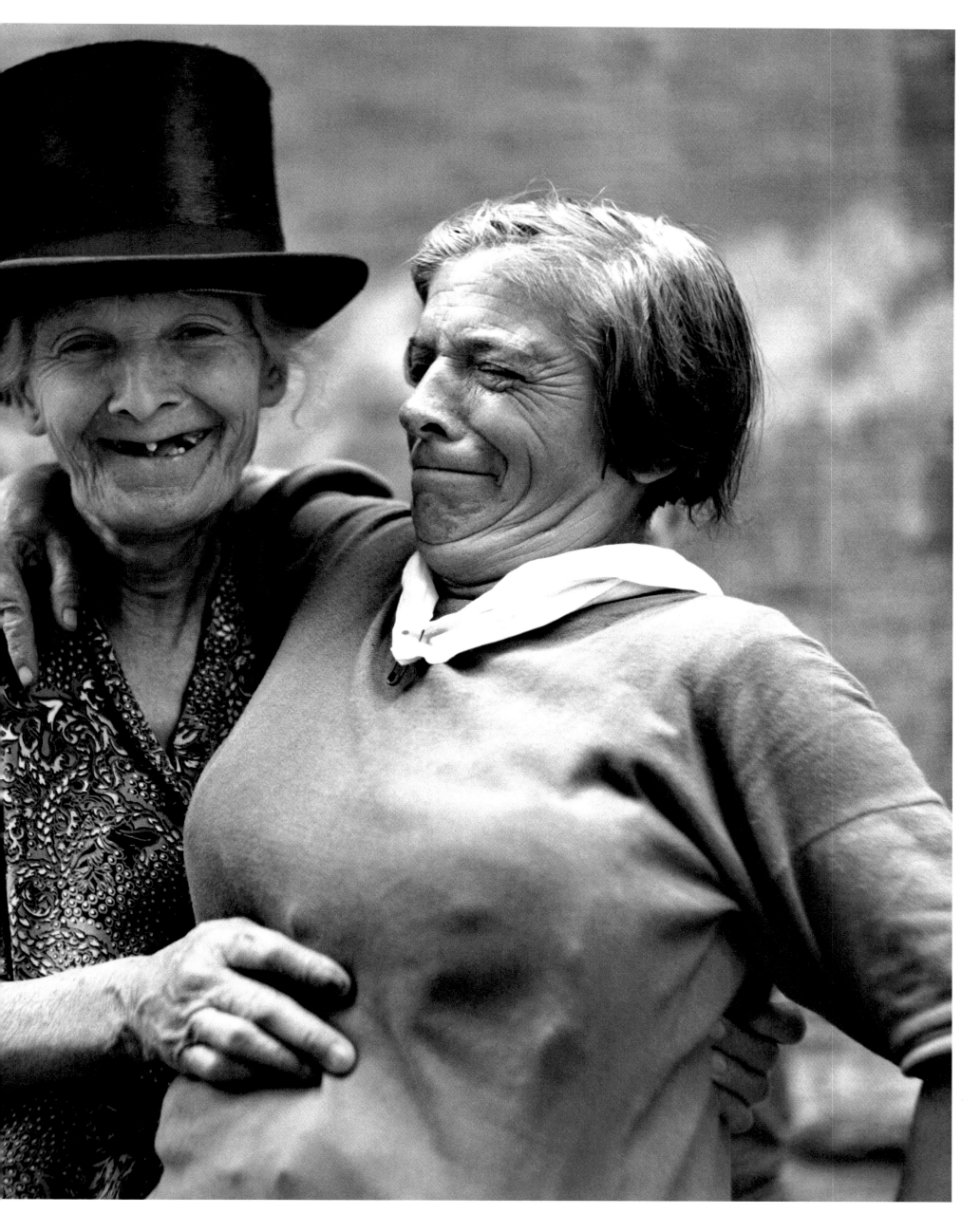

Zazi, street performer. Piazza Navona, Rome, July 1946

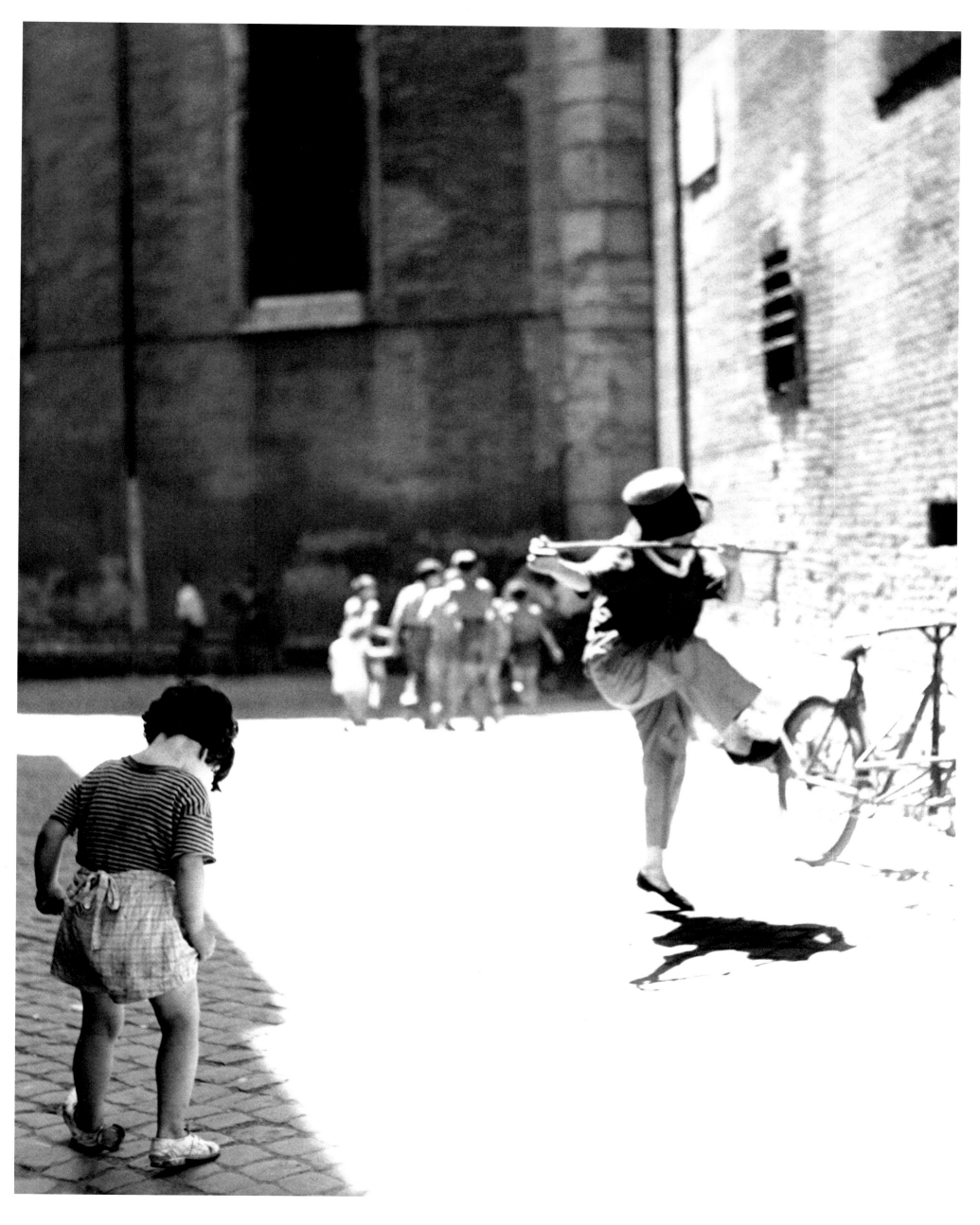

Dorian Leigh, model. Coat by Dior. Avenue Montaigne, Paris, August 1949

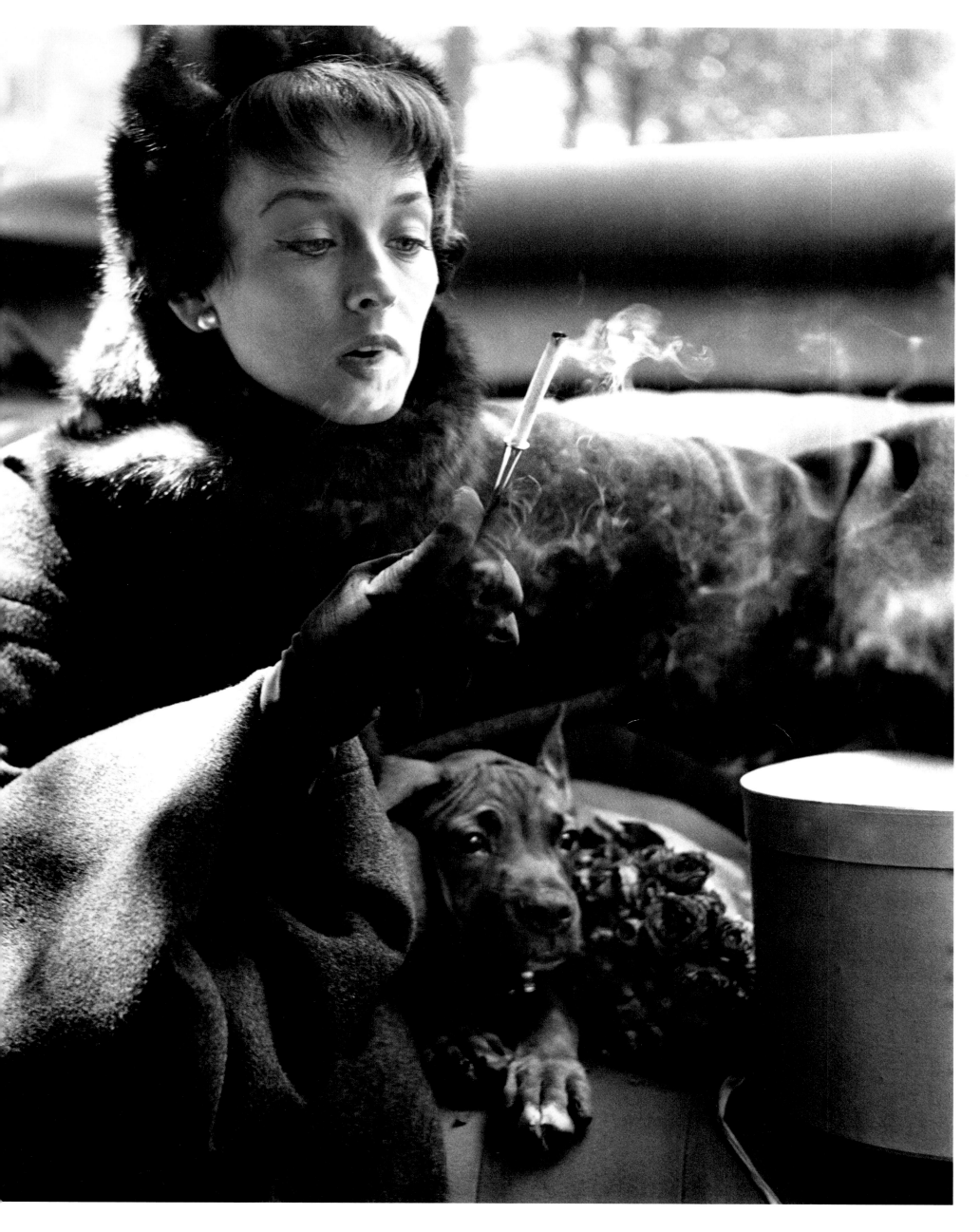

Elise Daniels and Monique, models. Hats by Schiaparelli. Café de Flore, Paris, August 1948

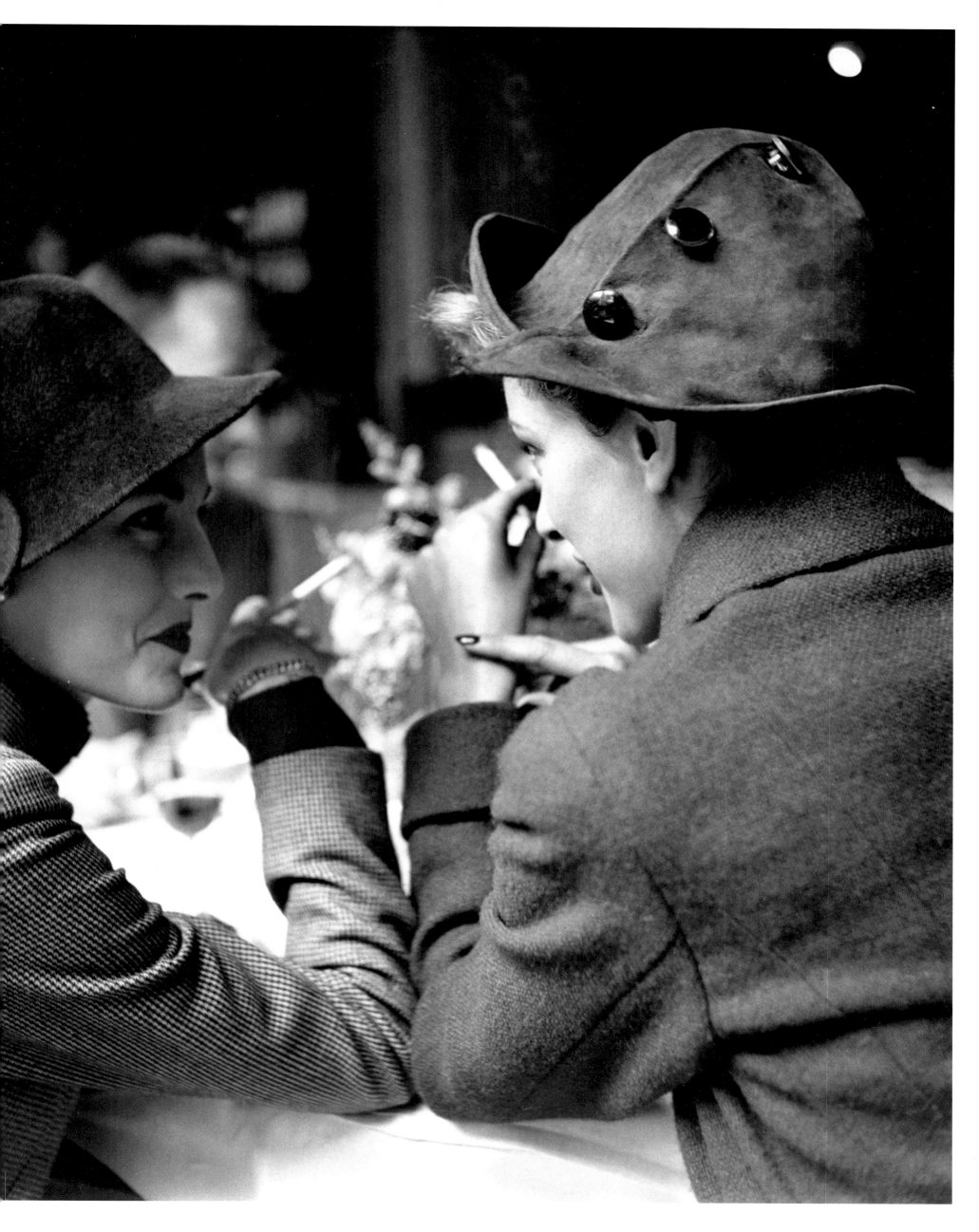

Dorian Leigh, model. Schiaparelli rhinestones.
Pré-Catelan, Paris, August 1949

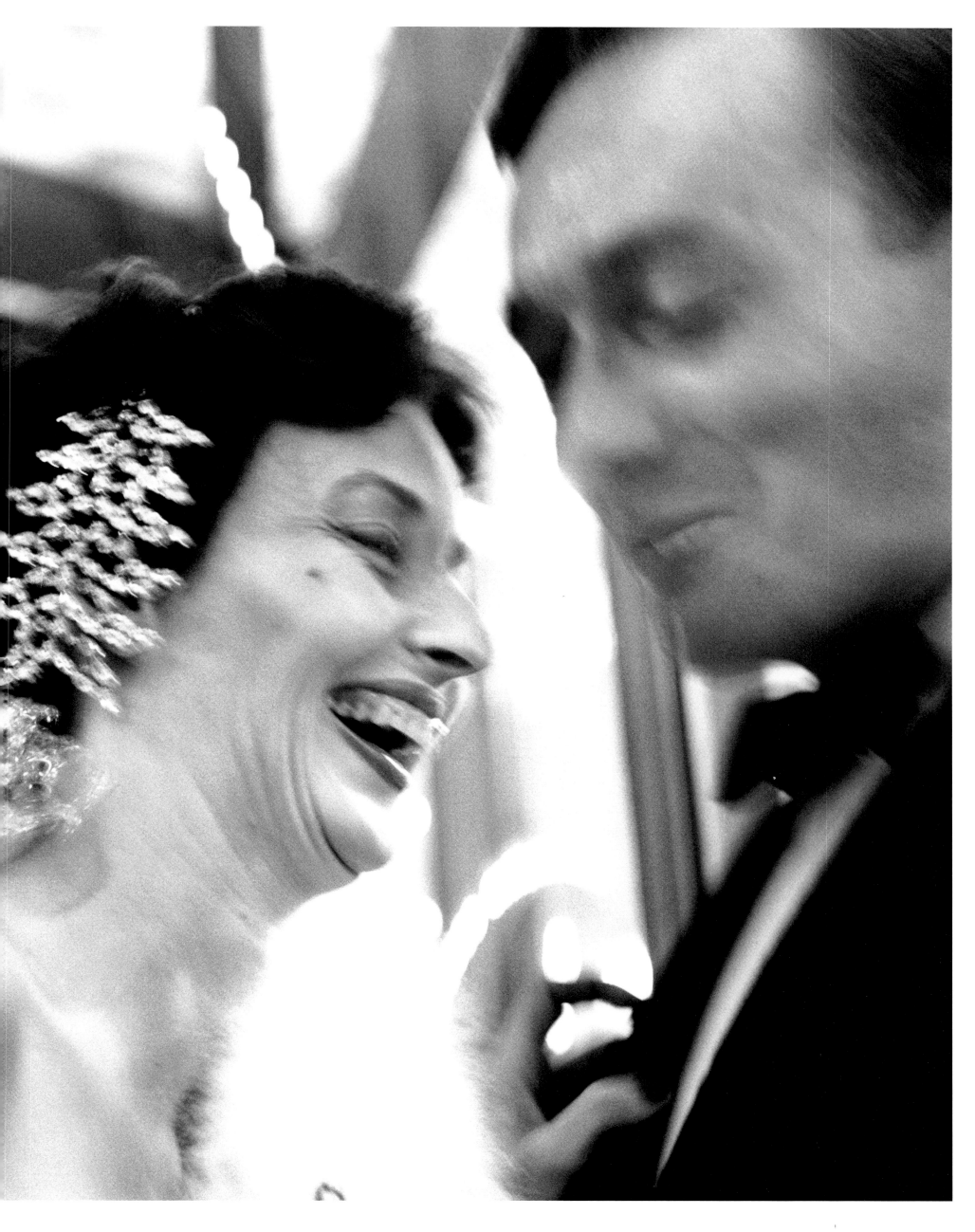

Anonymous woman. Harlem, New York, September 1949

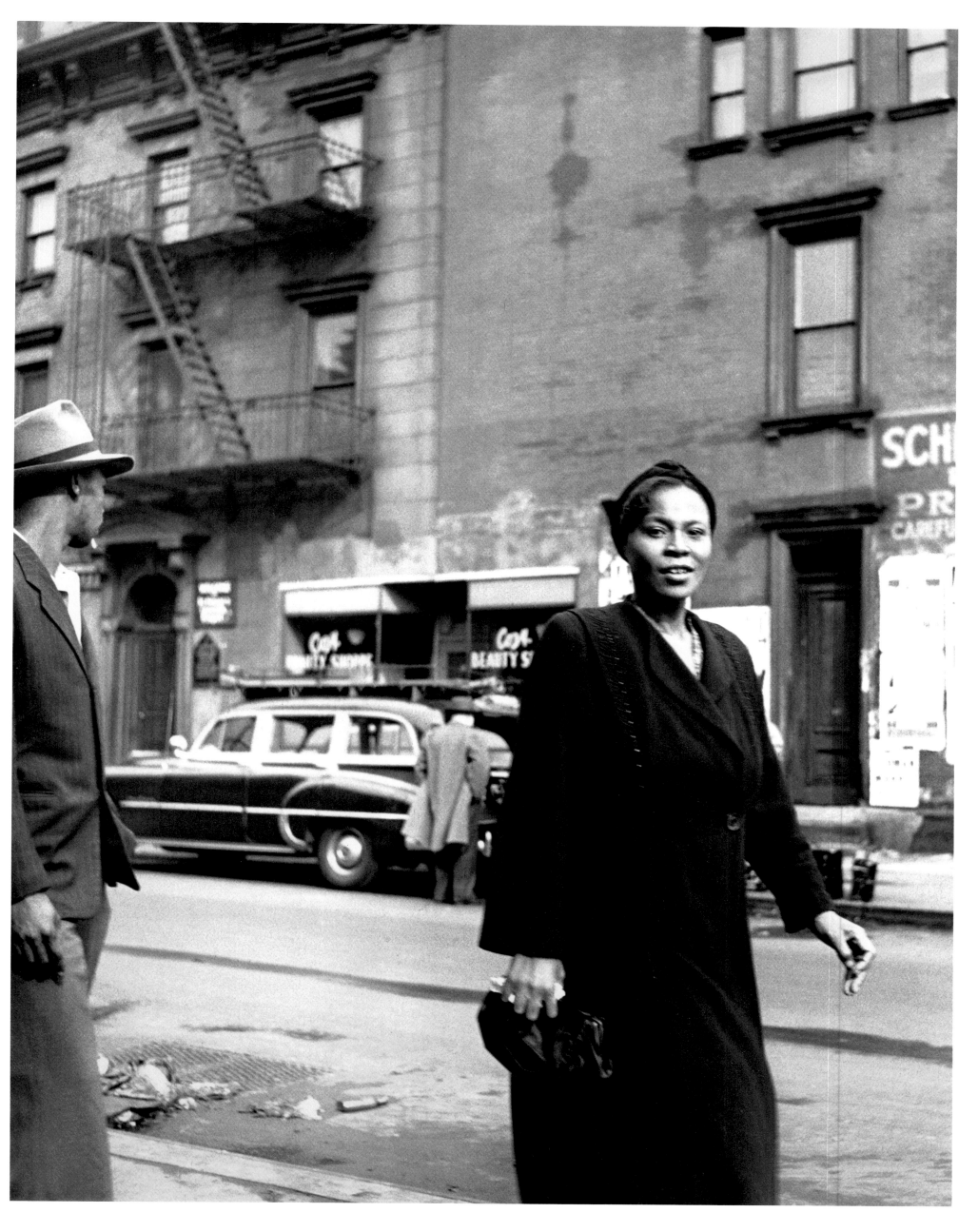

Dovima, model. Hat by Balenciaga. Paris, August 1955

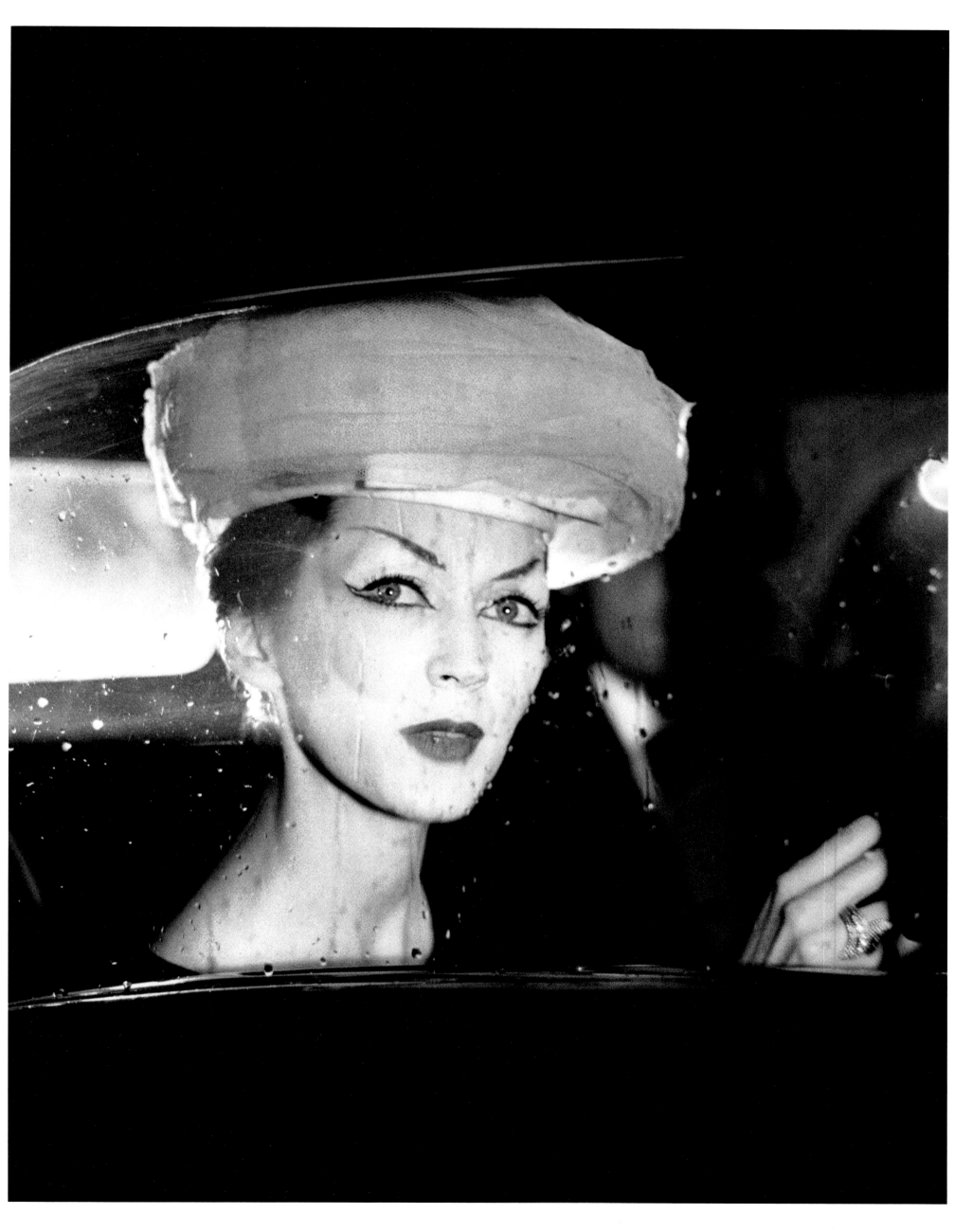

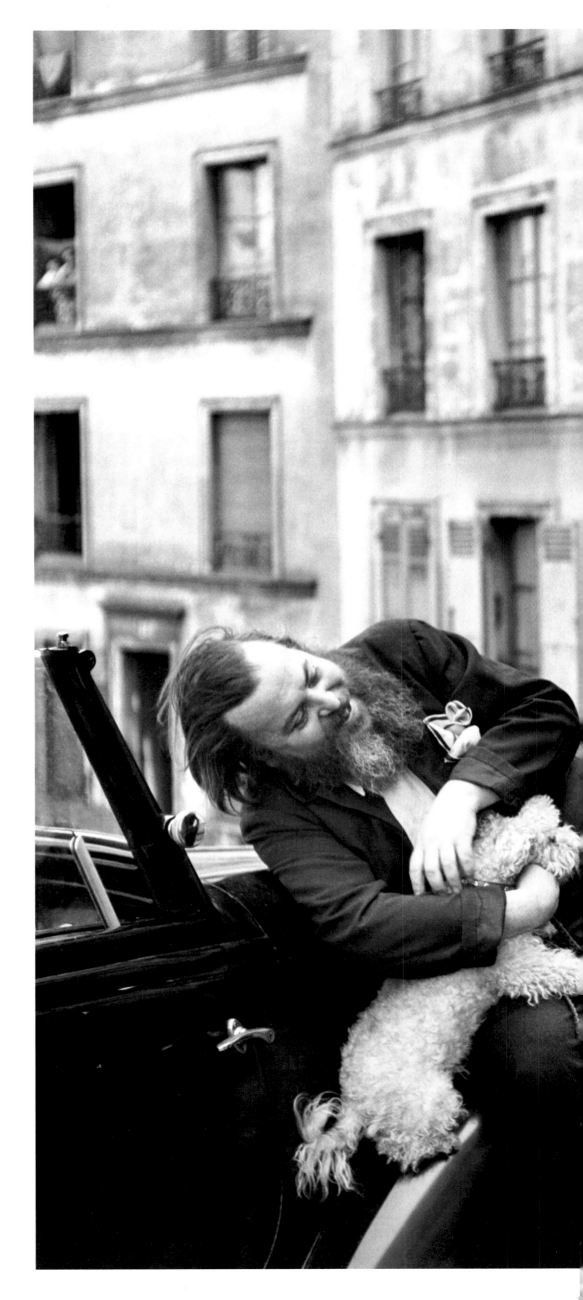

Christian Bérard and Renée, artist and model. Suit by Dior.
Le Marais, Paris, August 1947

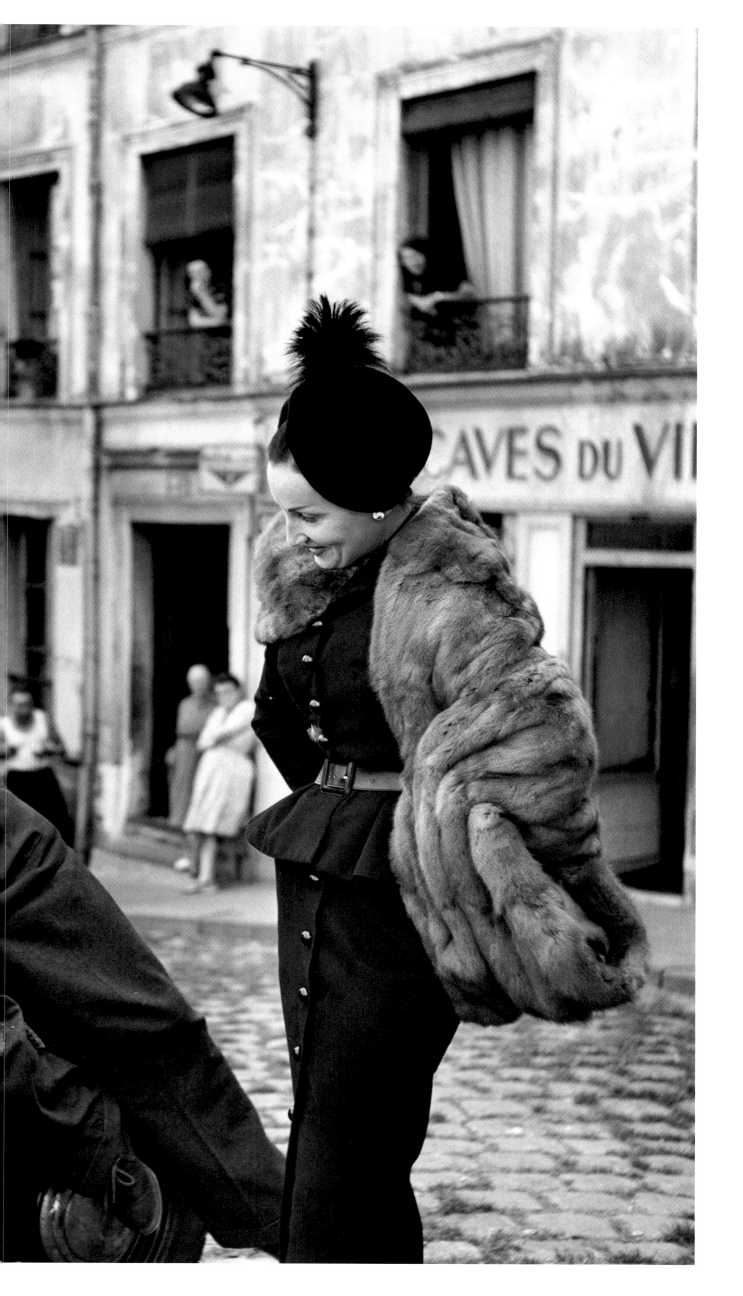

Trastevere, Rome. July 1946

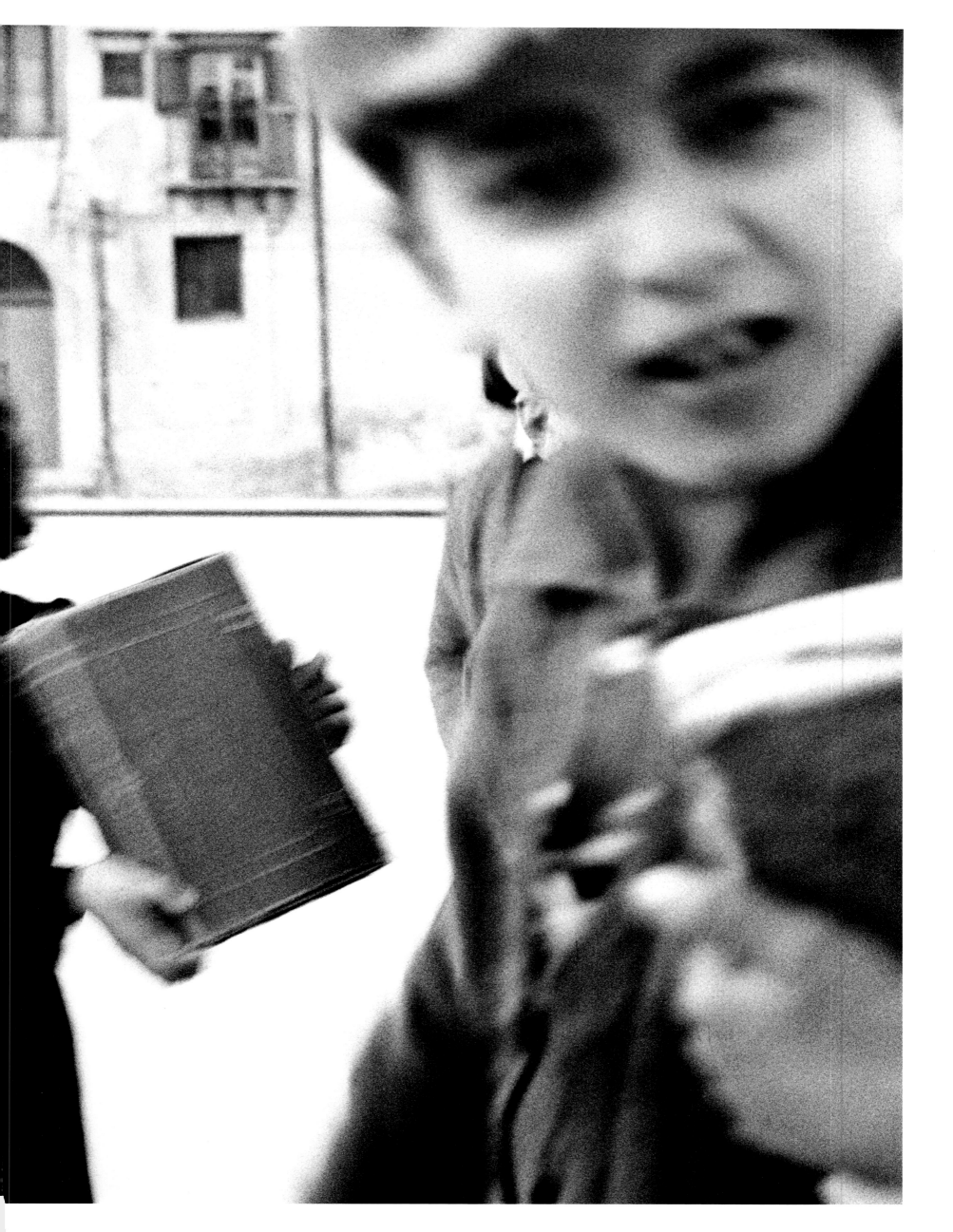

Elise Daniels, model. Turban by Paulette. Rue François 1ᵉʳ, Paris, August 1948

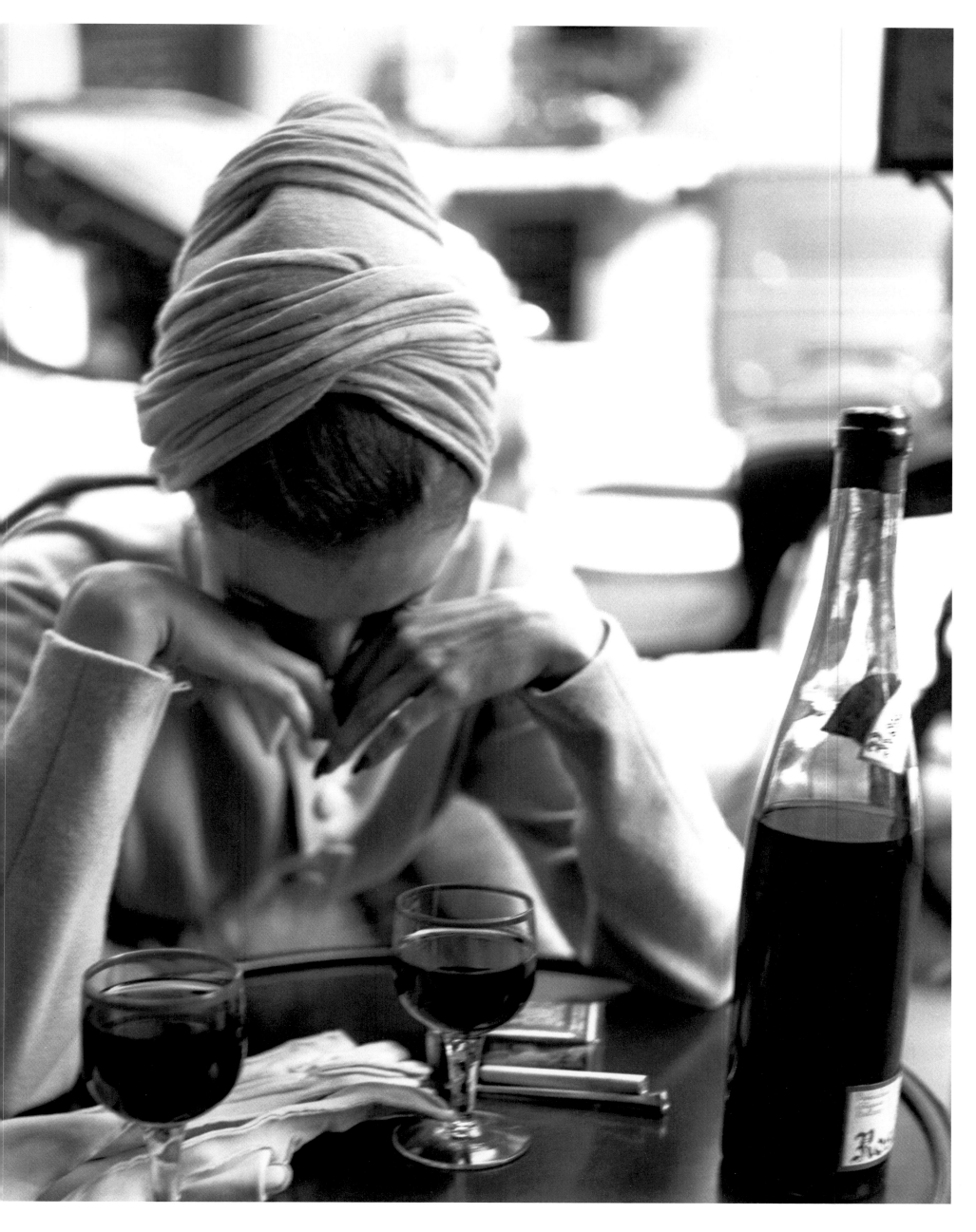

Dorian Leigh, model. Dress by Piguet. Helena Rubinstein's apartment,
Île Saint-Louis, Paris, August 1949

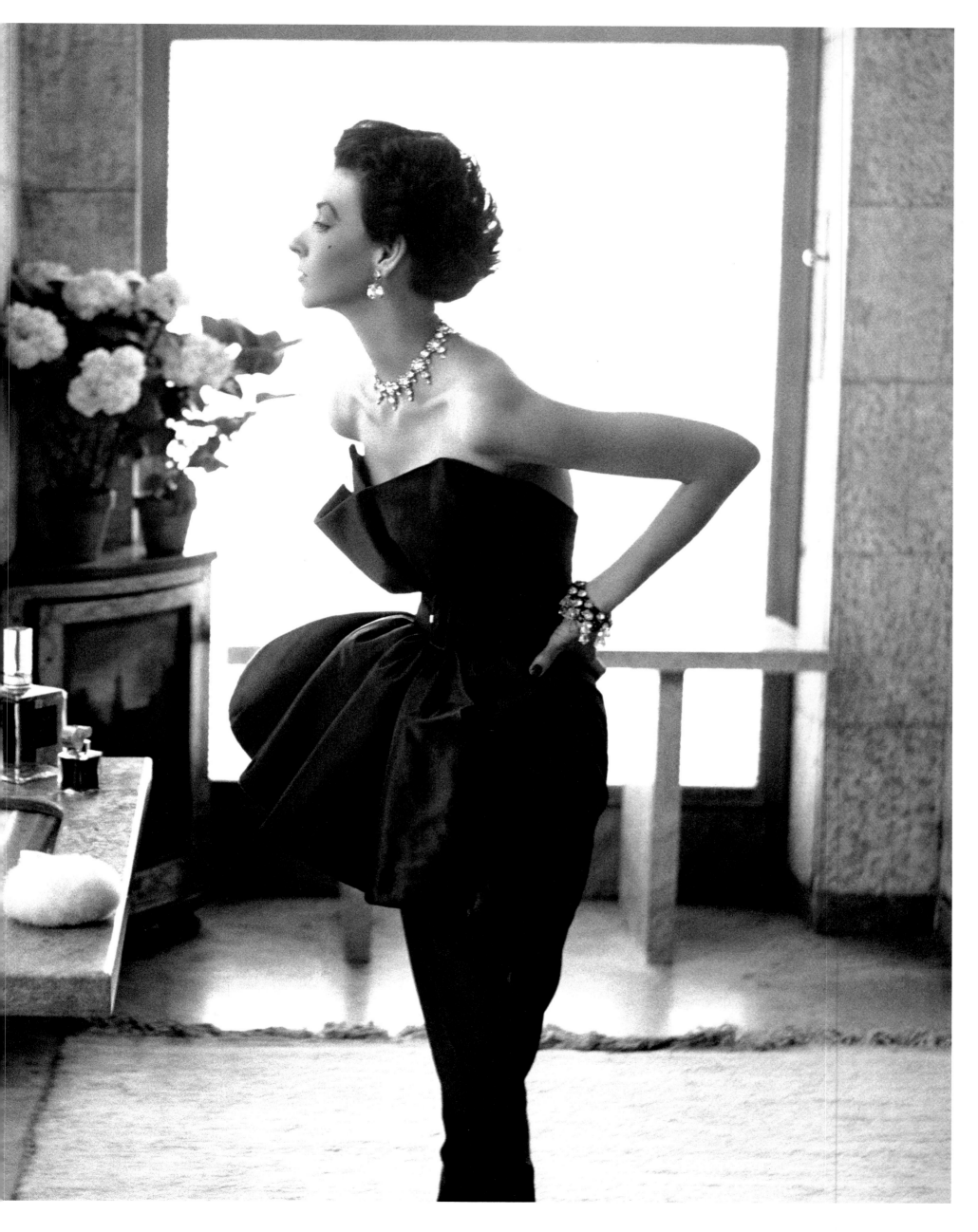

Elise Daniels, model. Turban by Paulette. Pré-Catelan, Paris, August 1948

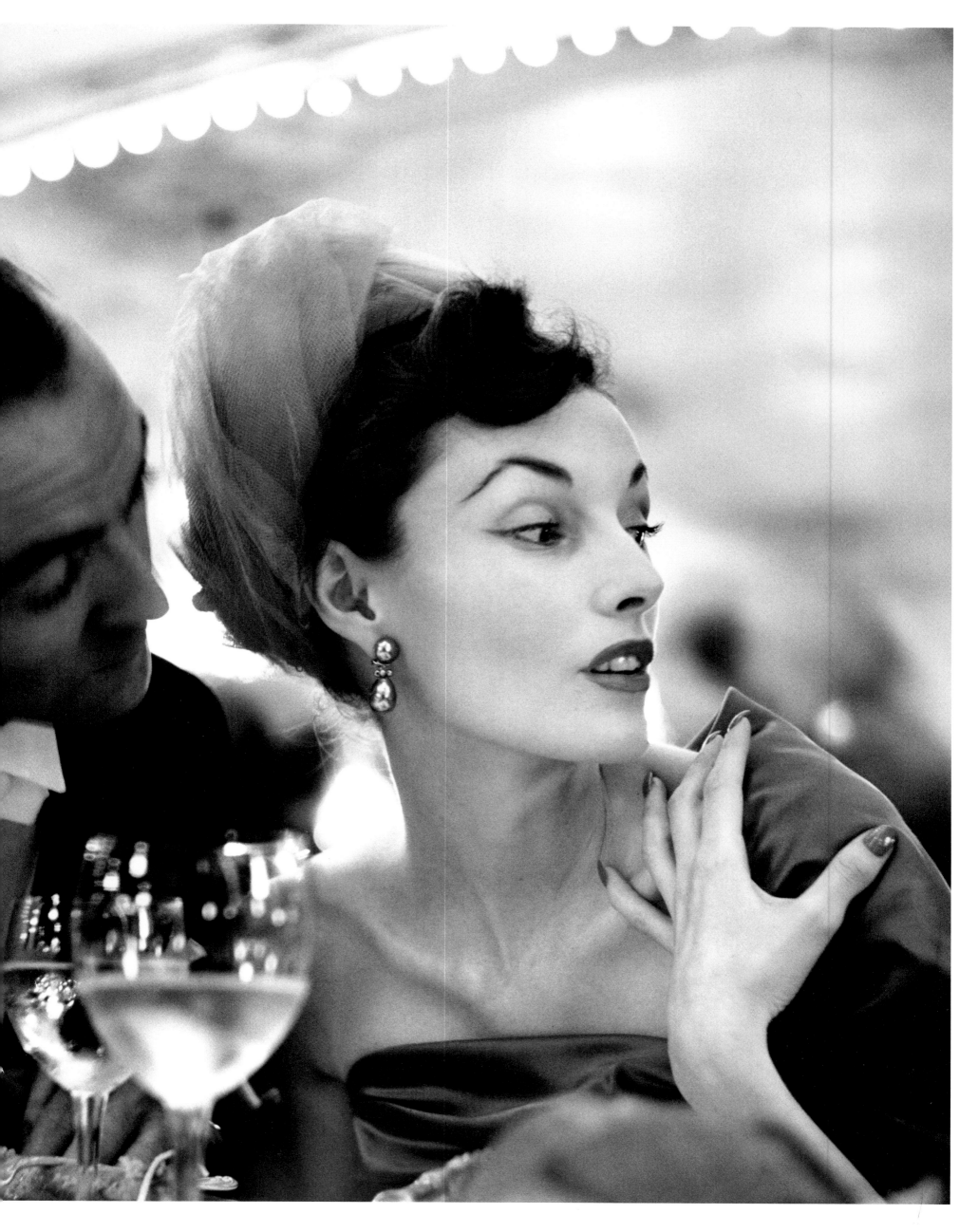

Dovima, model, with Emilien Bouglione and clown. Dress by Givenchy. Cirque d'Hiver, Paris, August 1955

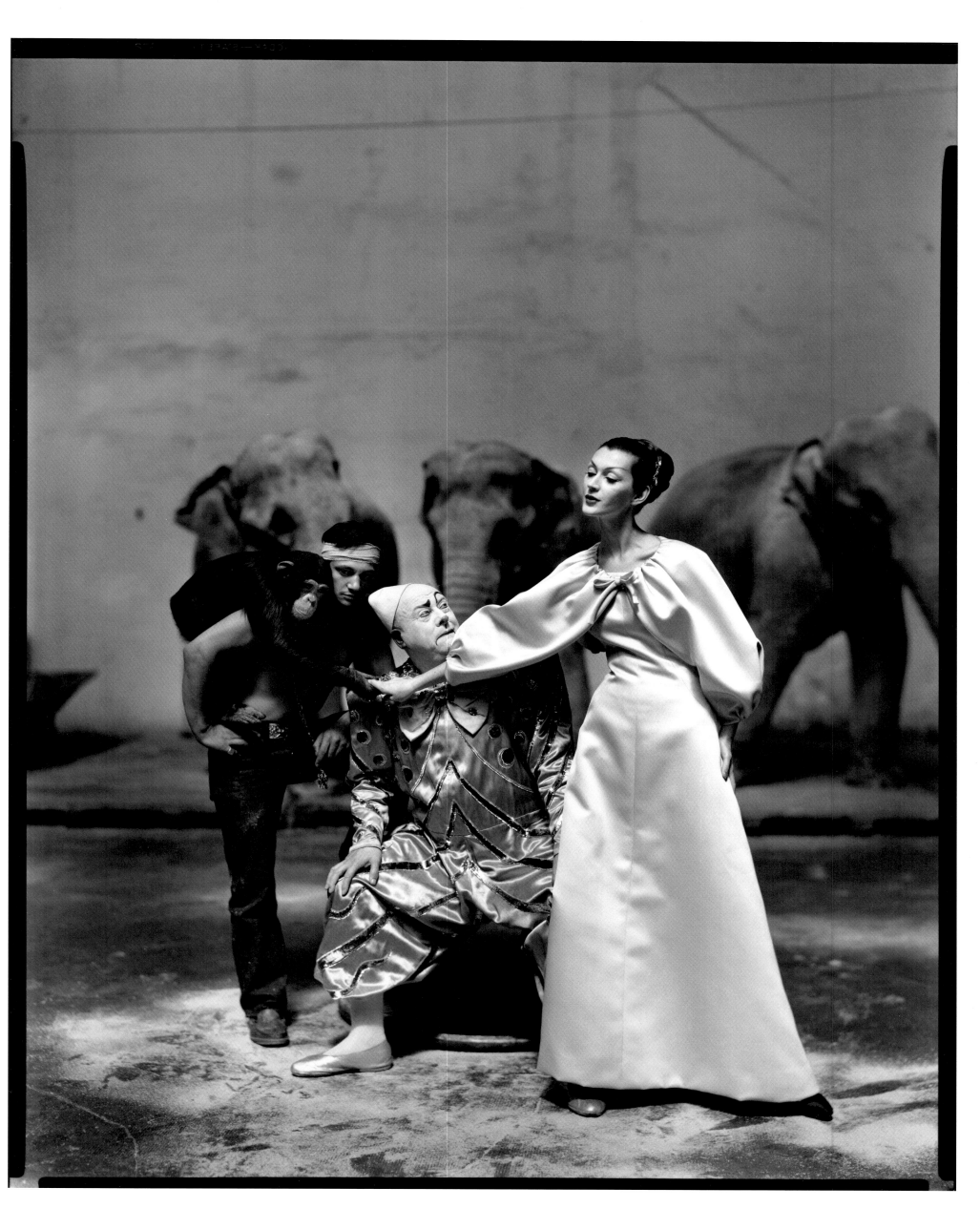

"Dovima with Elephants." Dovima, model. Dress by Dior. Cirque d'Hiver, Paris, August 1955

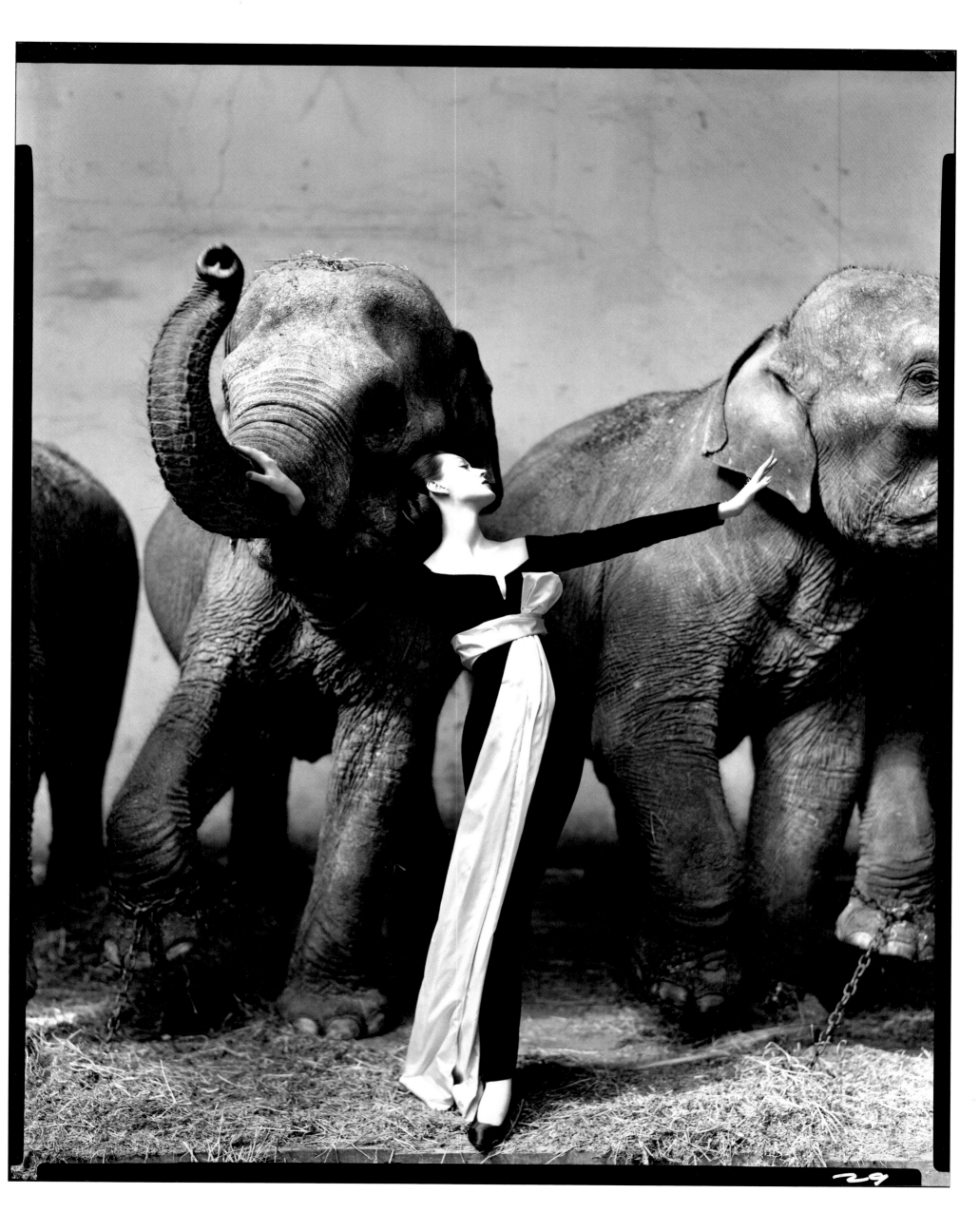

Suzy Parker, model. Dress by Dior. Paris, August 1956

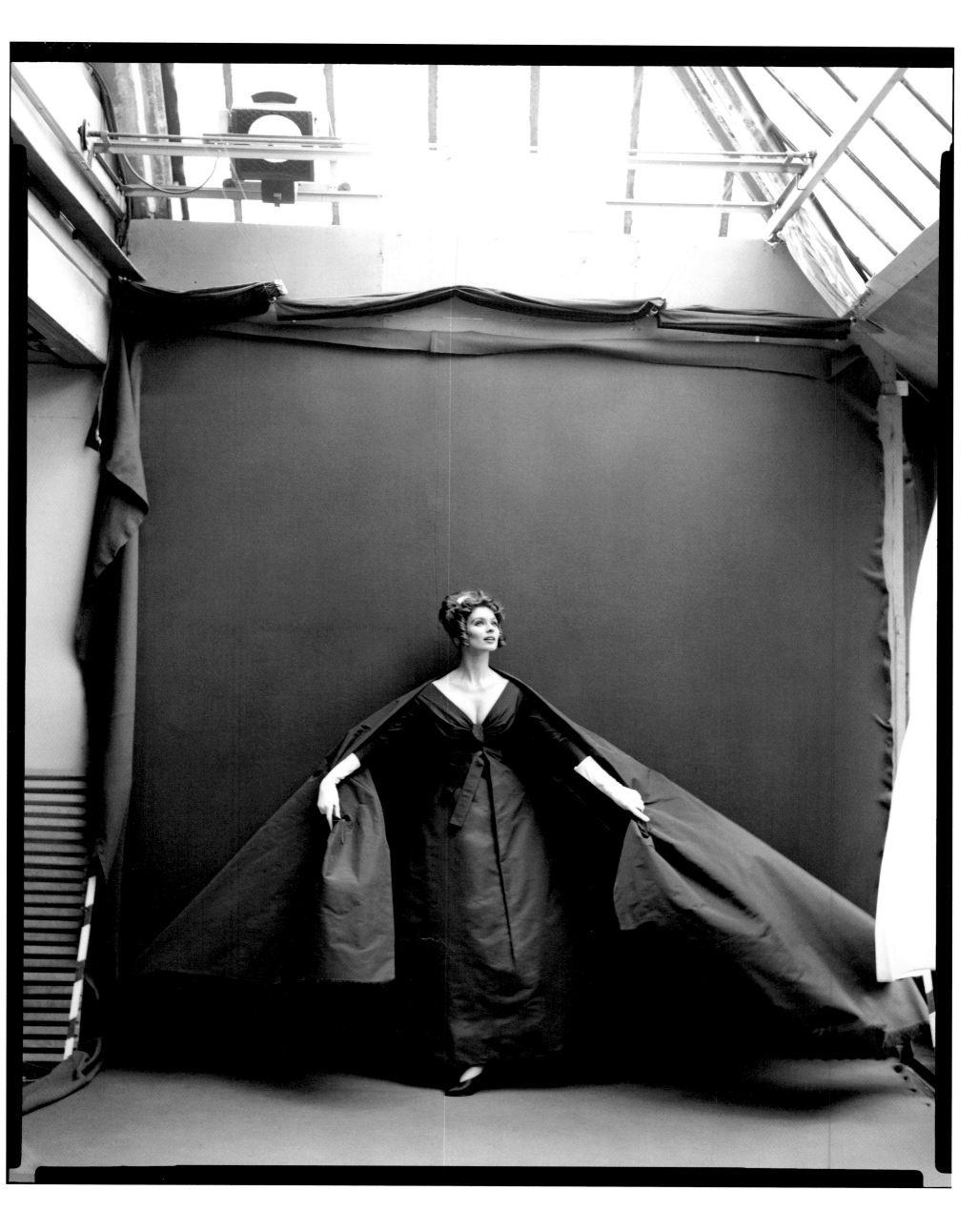

Dovima, model. Dress by Fath. Paris, August 1950

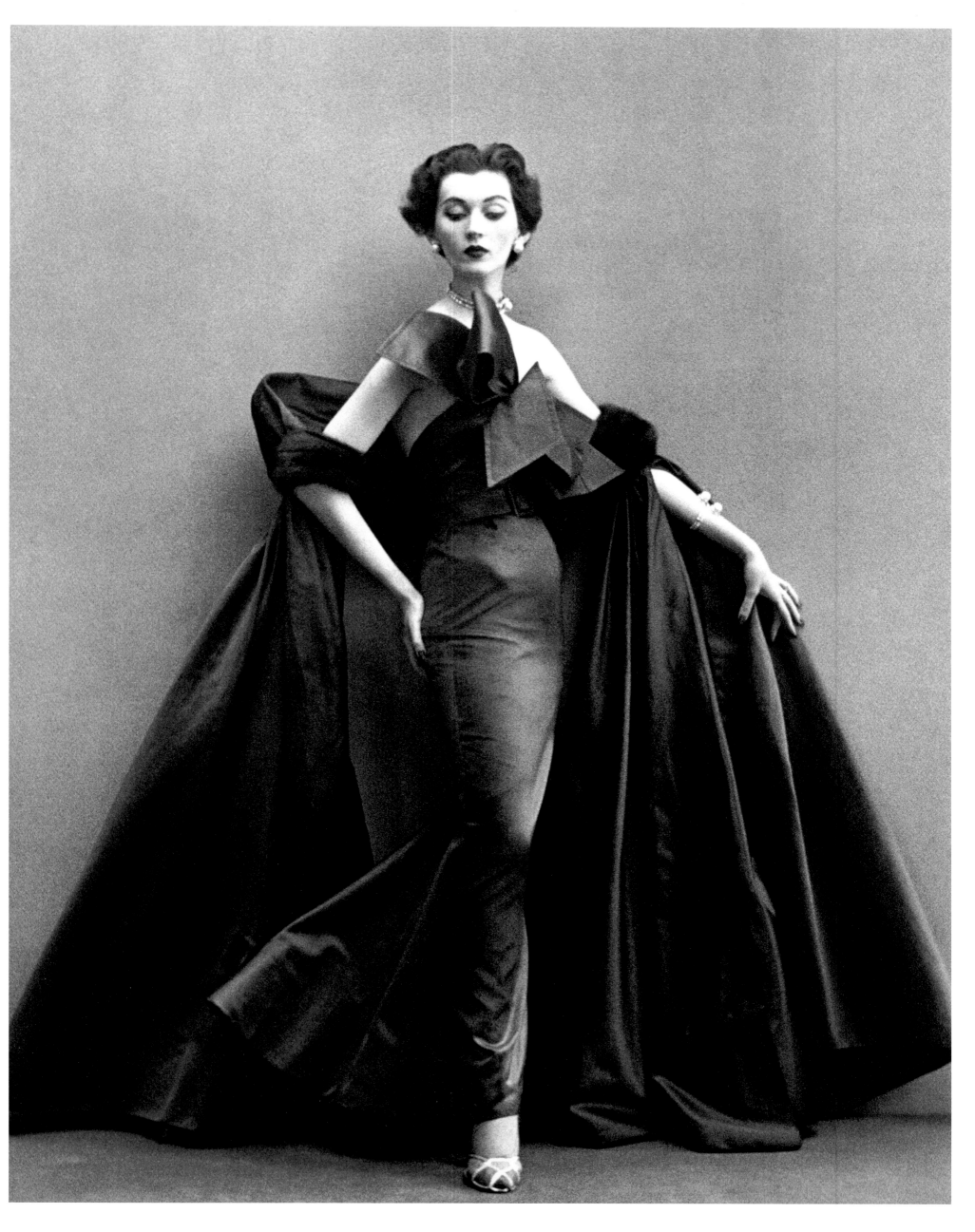

Dovima, model. Dress by Veneziani. New York, August 1958

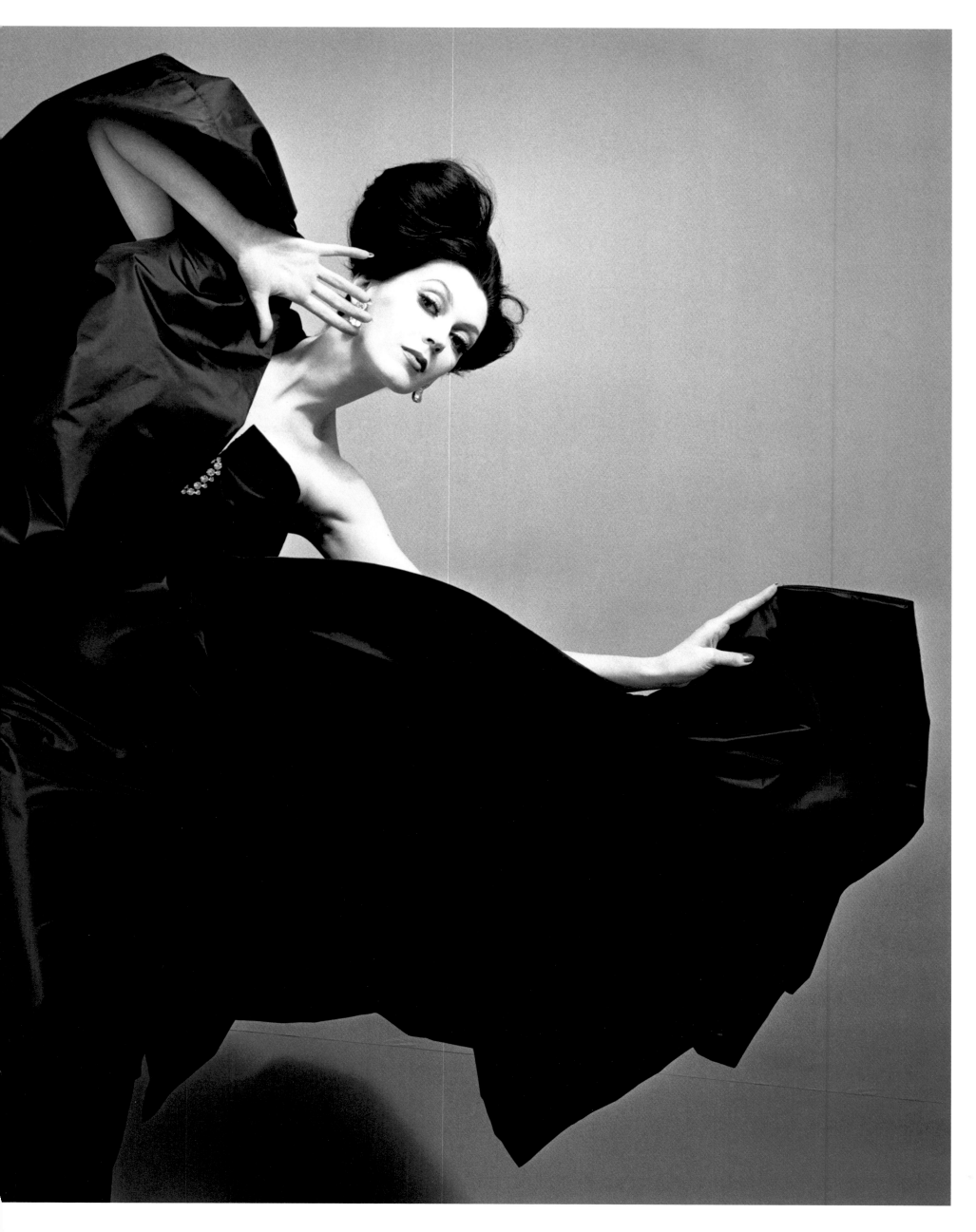

Suzy Parker with Robin Tattersall and Gardner McKay, models.
Dress by Lanvin-Castillo. Café des Beaux-Arts, Paris, August 1956

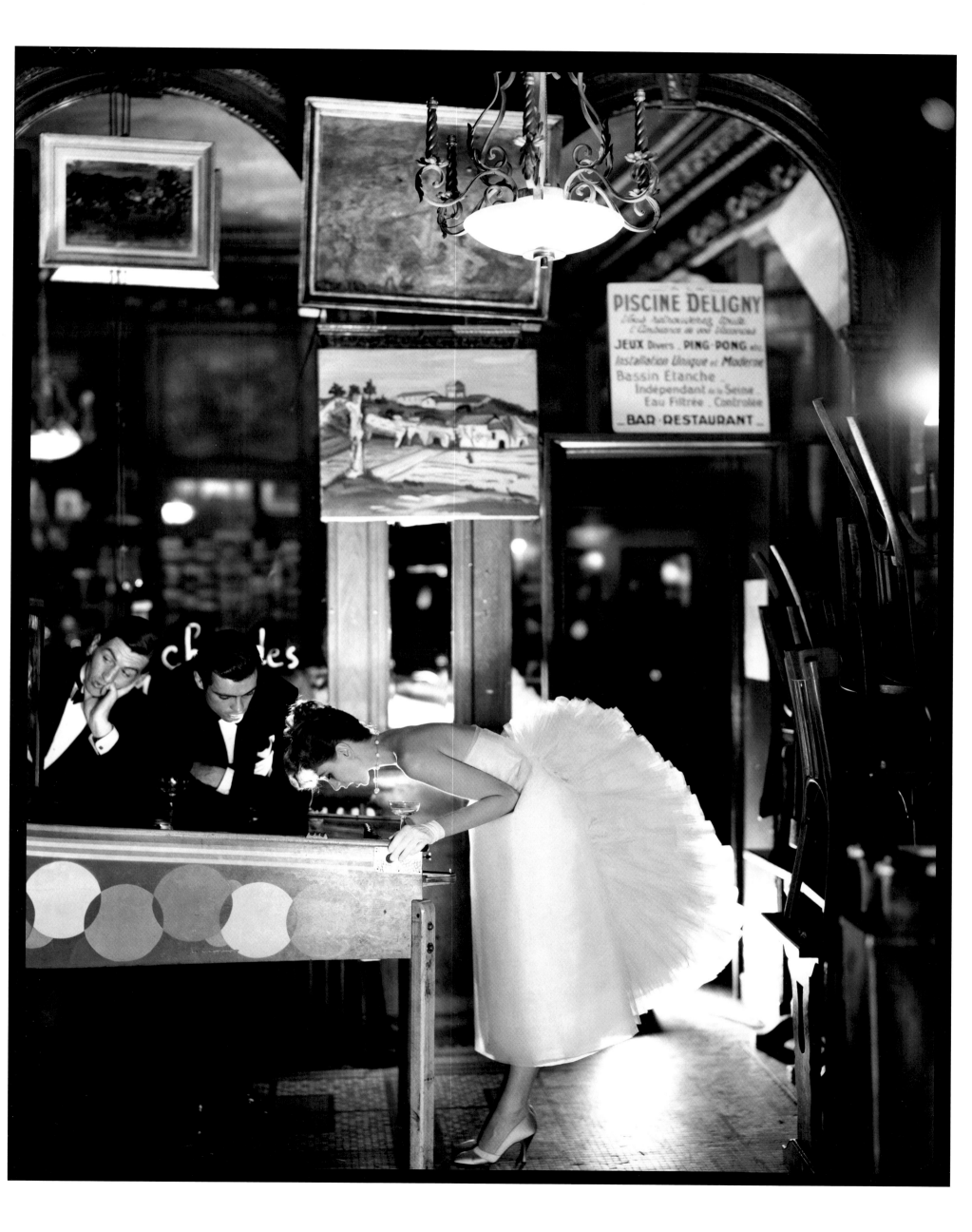

Suzy Parker and Robin Tattersall, models. Dress by Griffe. Folies-Bergère, Paris, August 1957

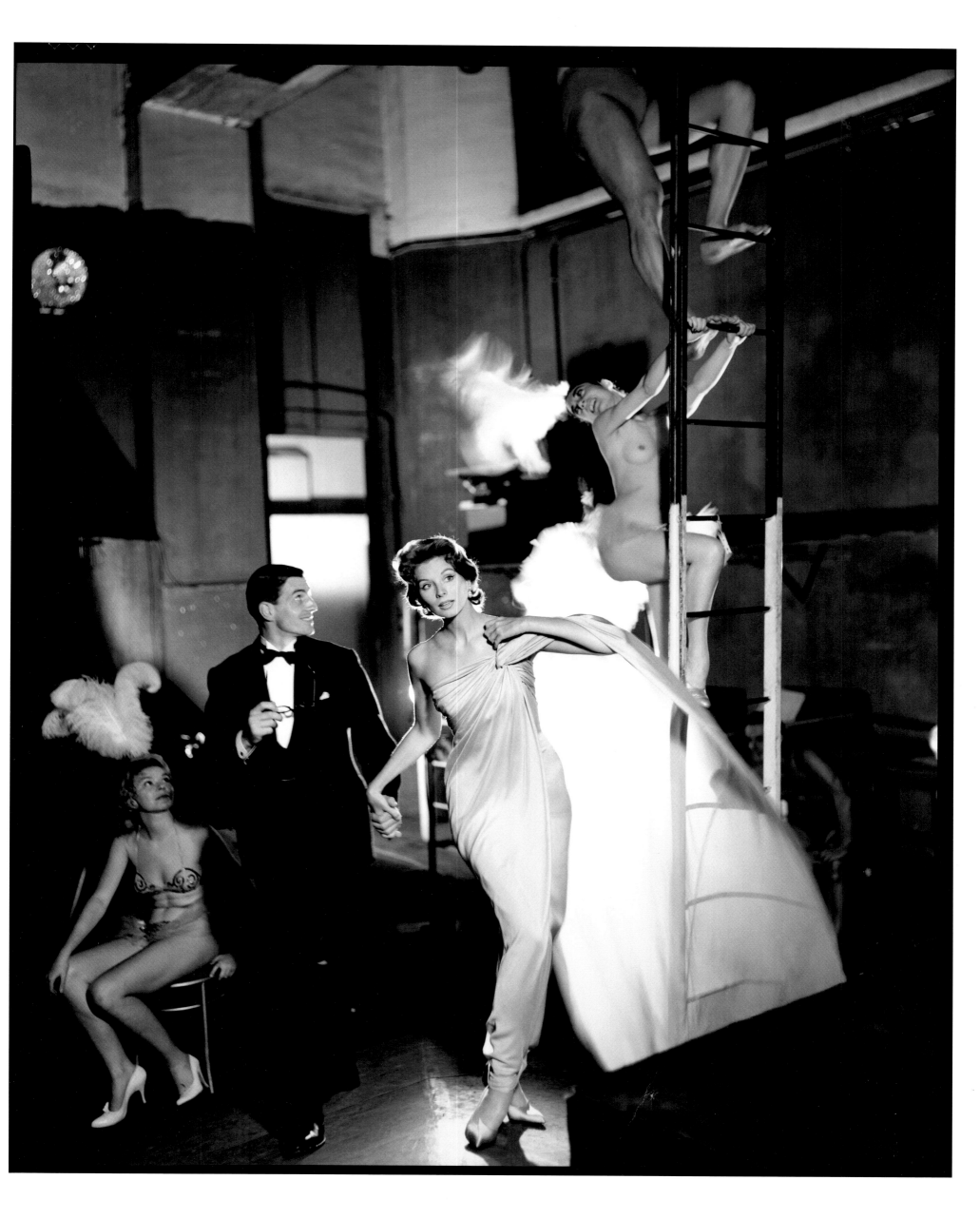

Dovima, model. Dress by Patou. Chez Yvonne, Paris, August 1955

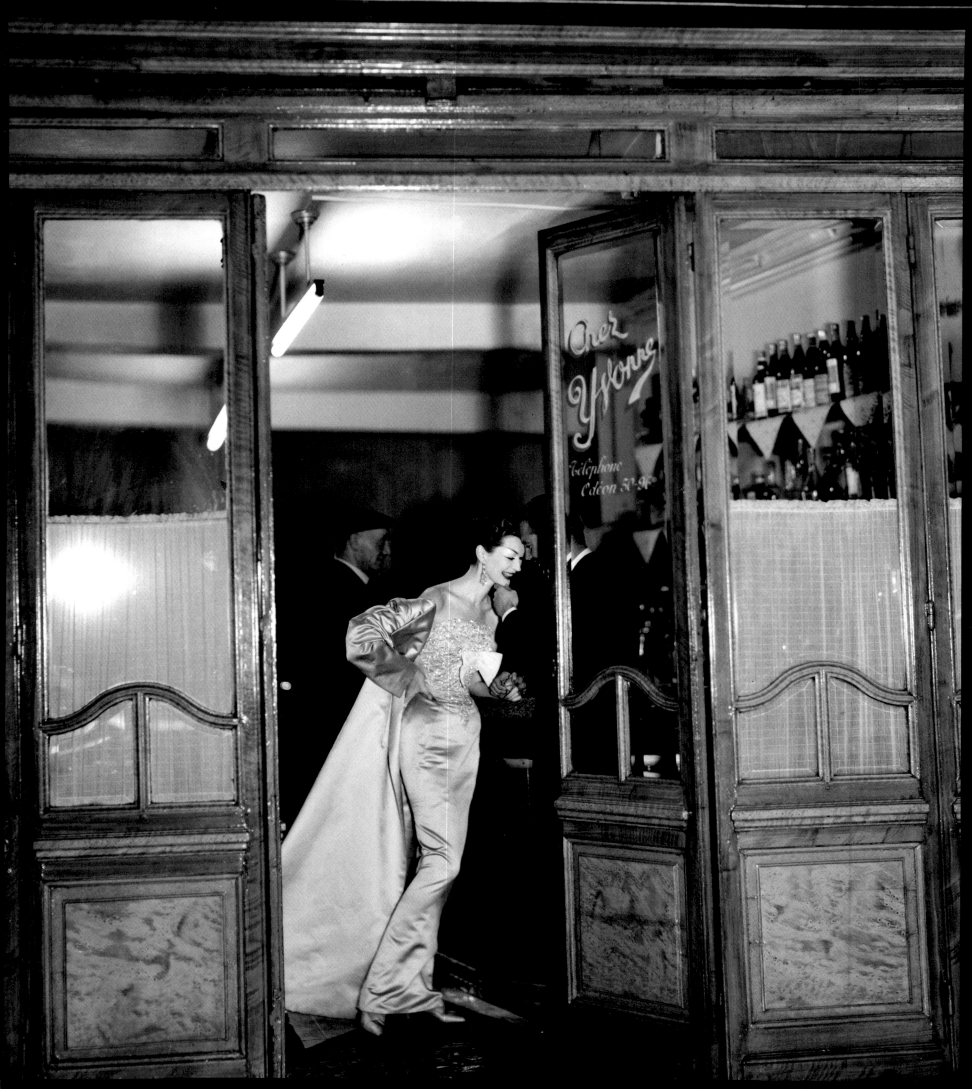

Sunny Harnett, model. Dress by Grès. Casino, Le Touquet, August 1954

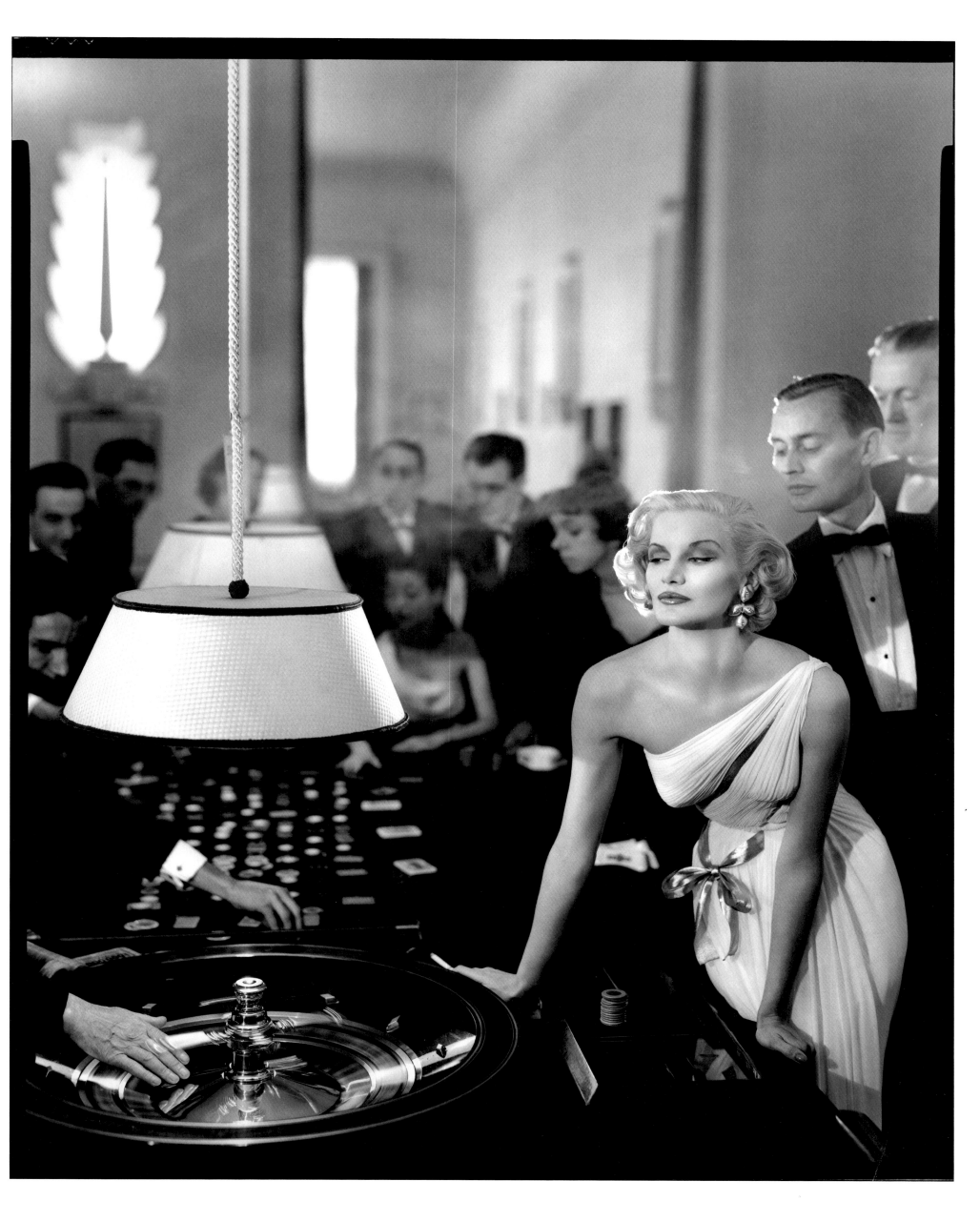

Suzy Parker and China Machado with Robin Tattersall and
Reginald Kernan, models. Dresses by Balmain and Patou.
La Pagode d'Or, Paris, January 1959

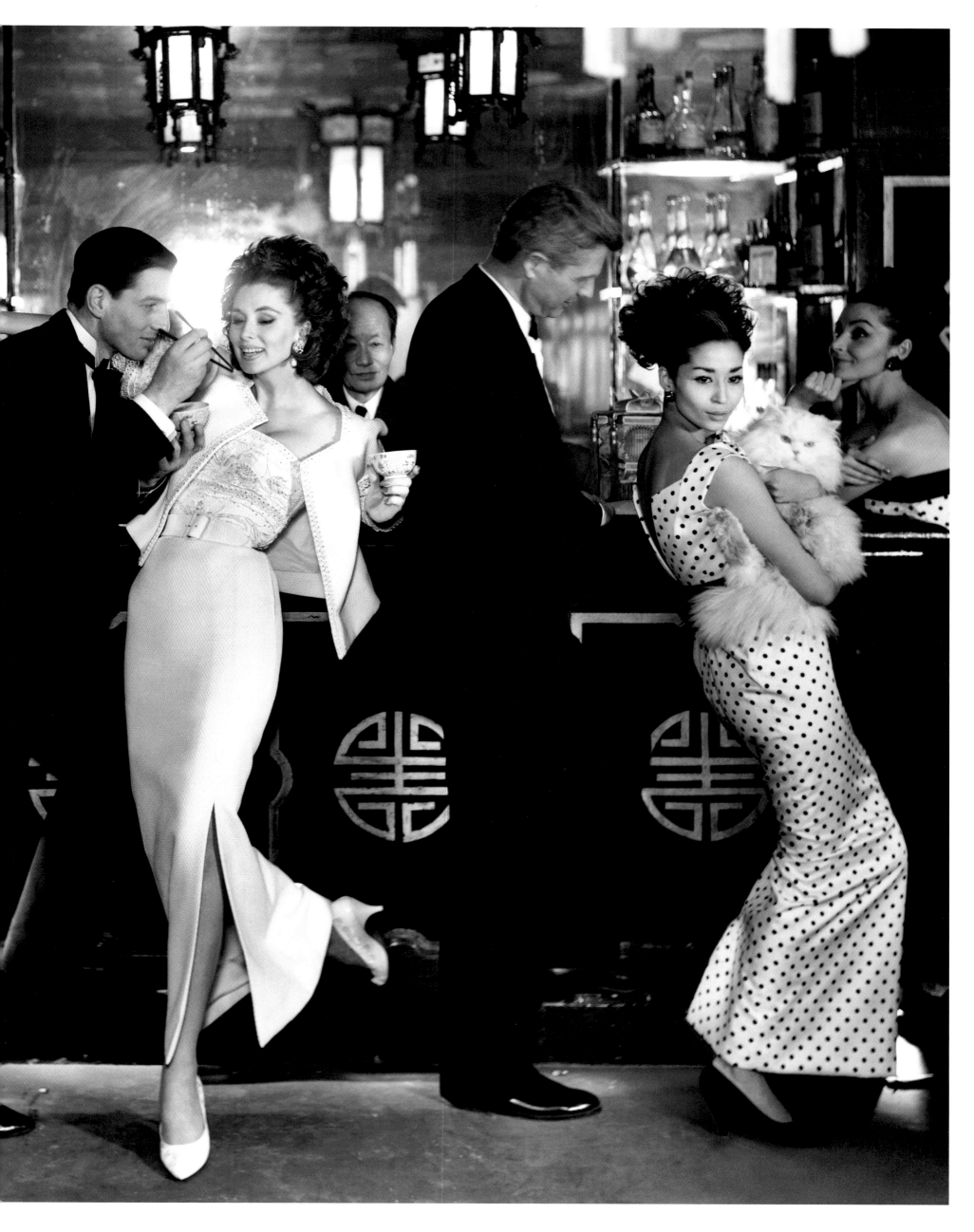

Suzy Parker and Robin Tattersall, models. Dress by Grès. Moulin Rouge, Paris, August 1957

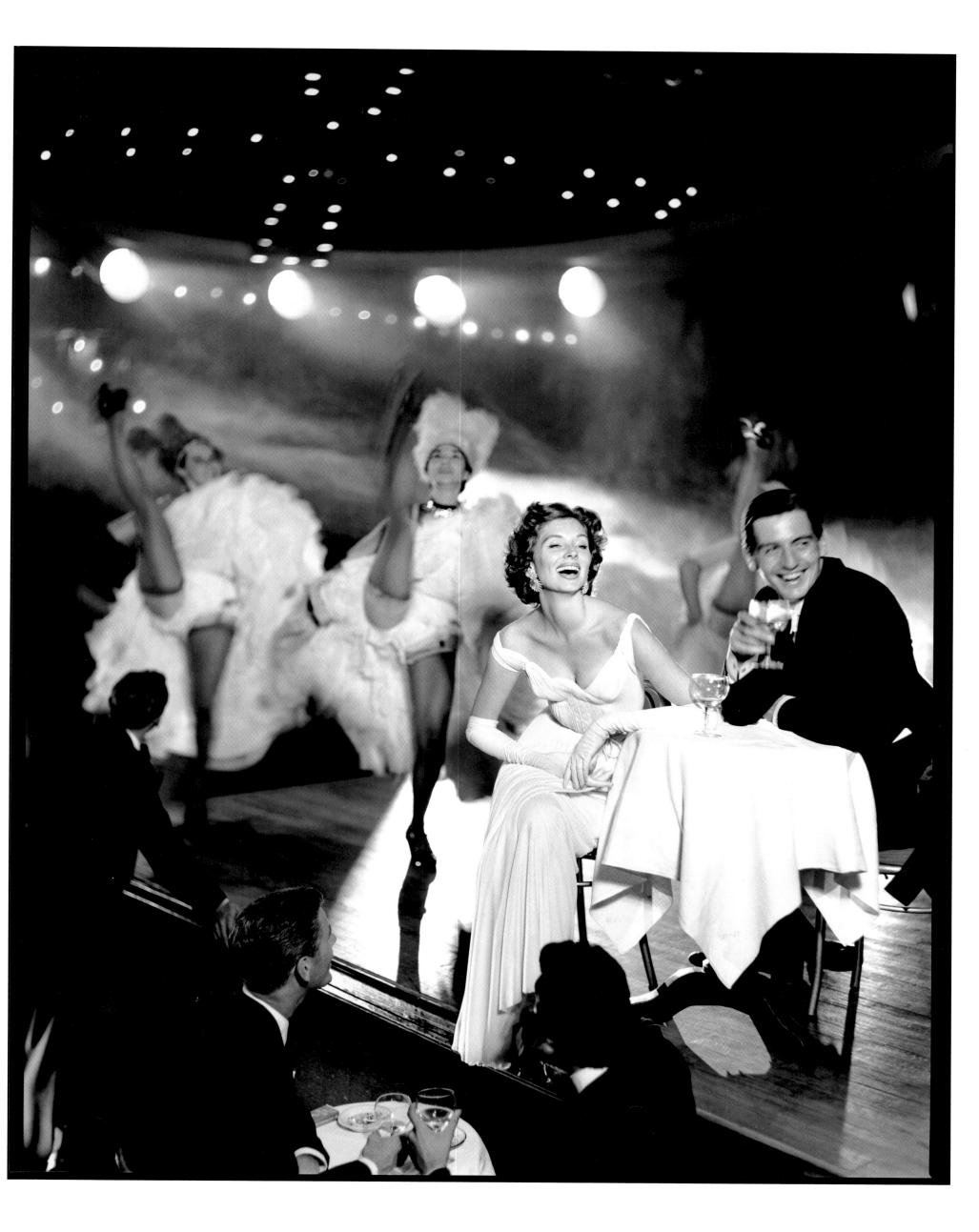

Dorian Leigh, model. Hat by Paulette. Paris, August 1949

Suzy Parker with Gardner McKay and Robin Tattersall, models.
Dress by Dior. Pont Alexandre III, Paris, August 1956

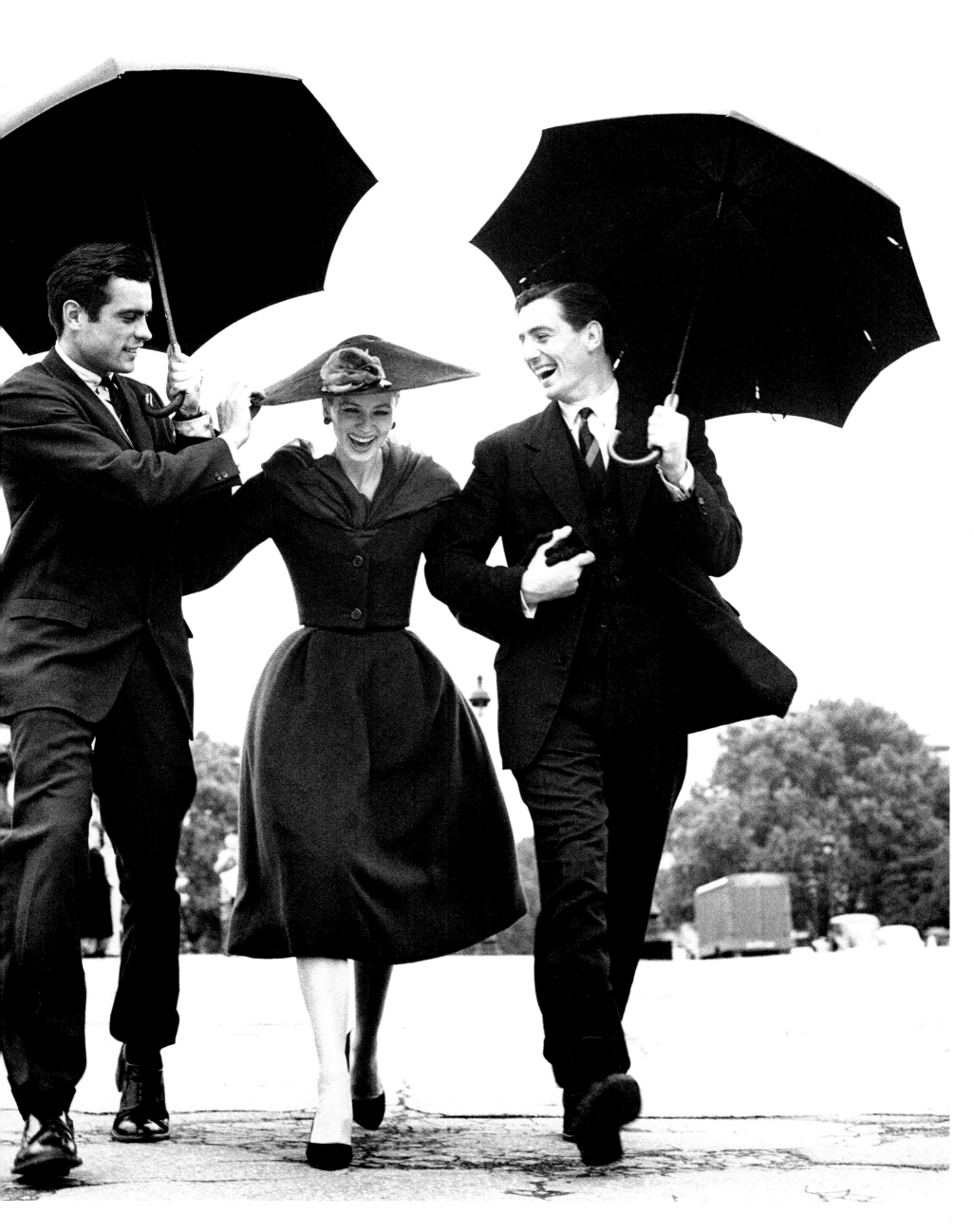

Renée, model. Suit by Dior. Place de la Concorde, Paris, August 1947

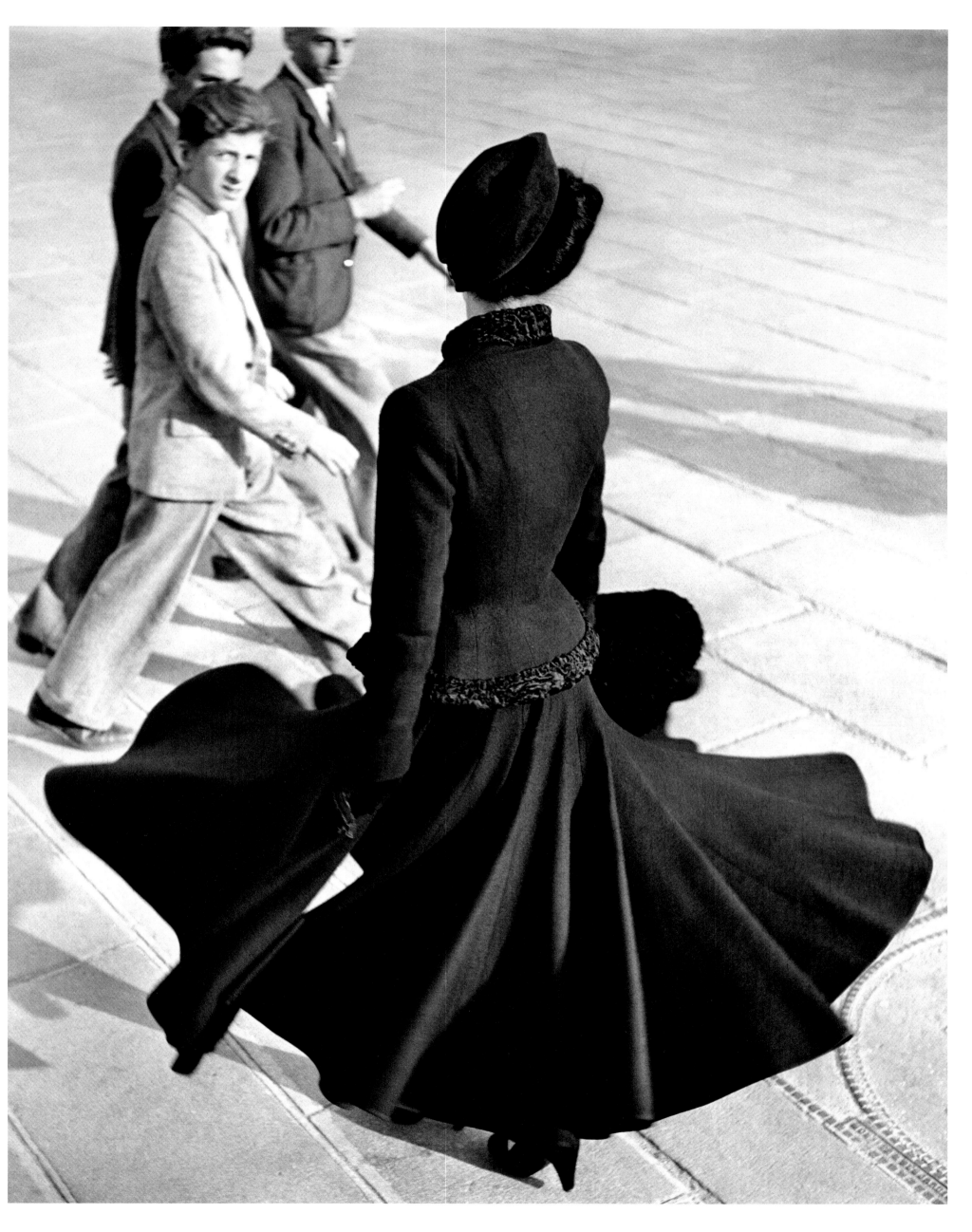

"Homage to Munkacsi." Carmen, model. Coat by Cardin. Place François 1er, Paris, August 1957

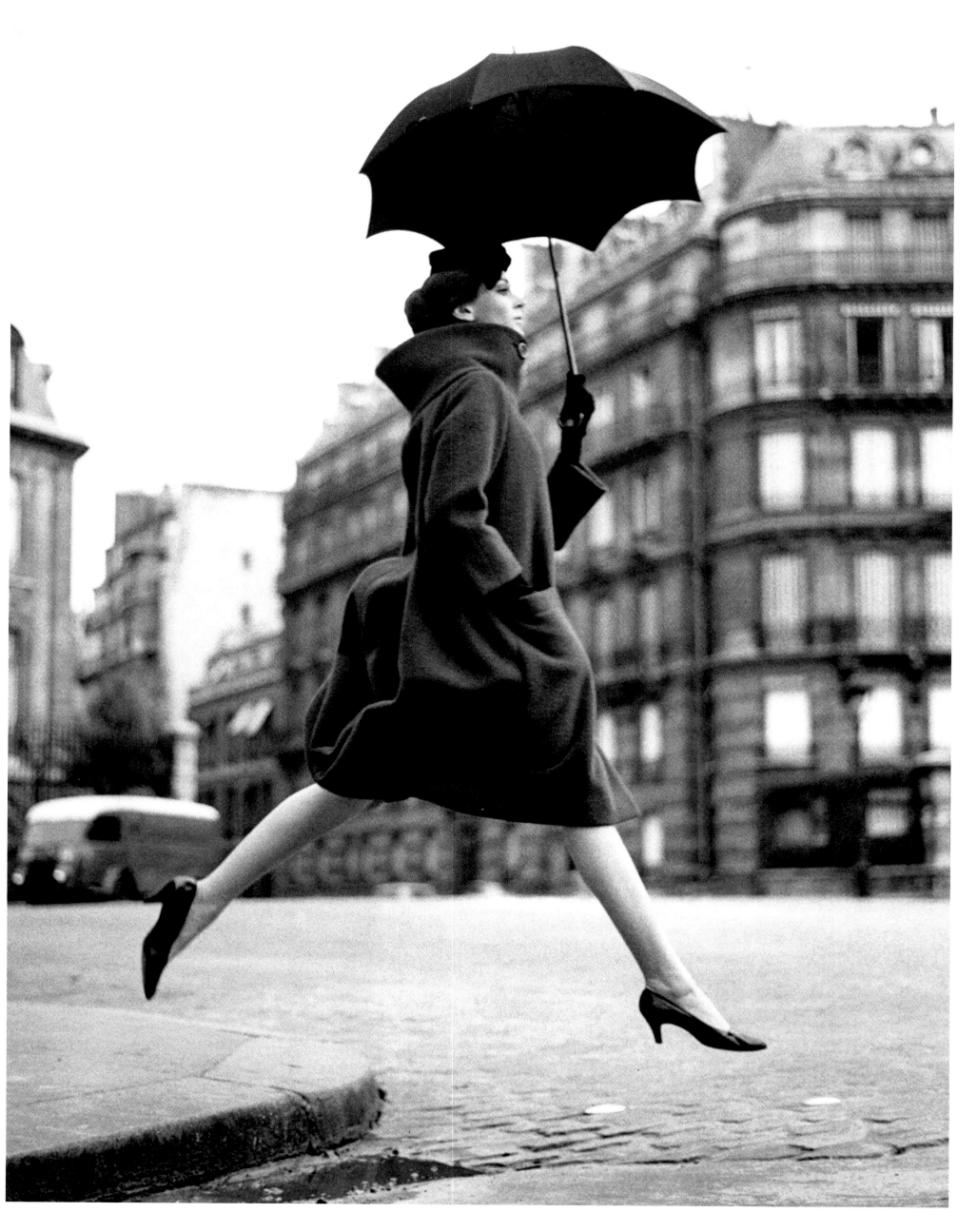

Elise Daniels, model, with street performers. Suit by Balenciaga. Le Marais, Paris, August 1948

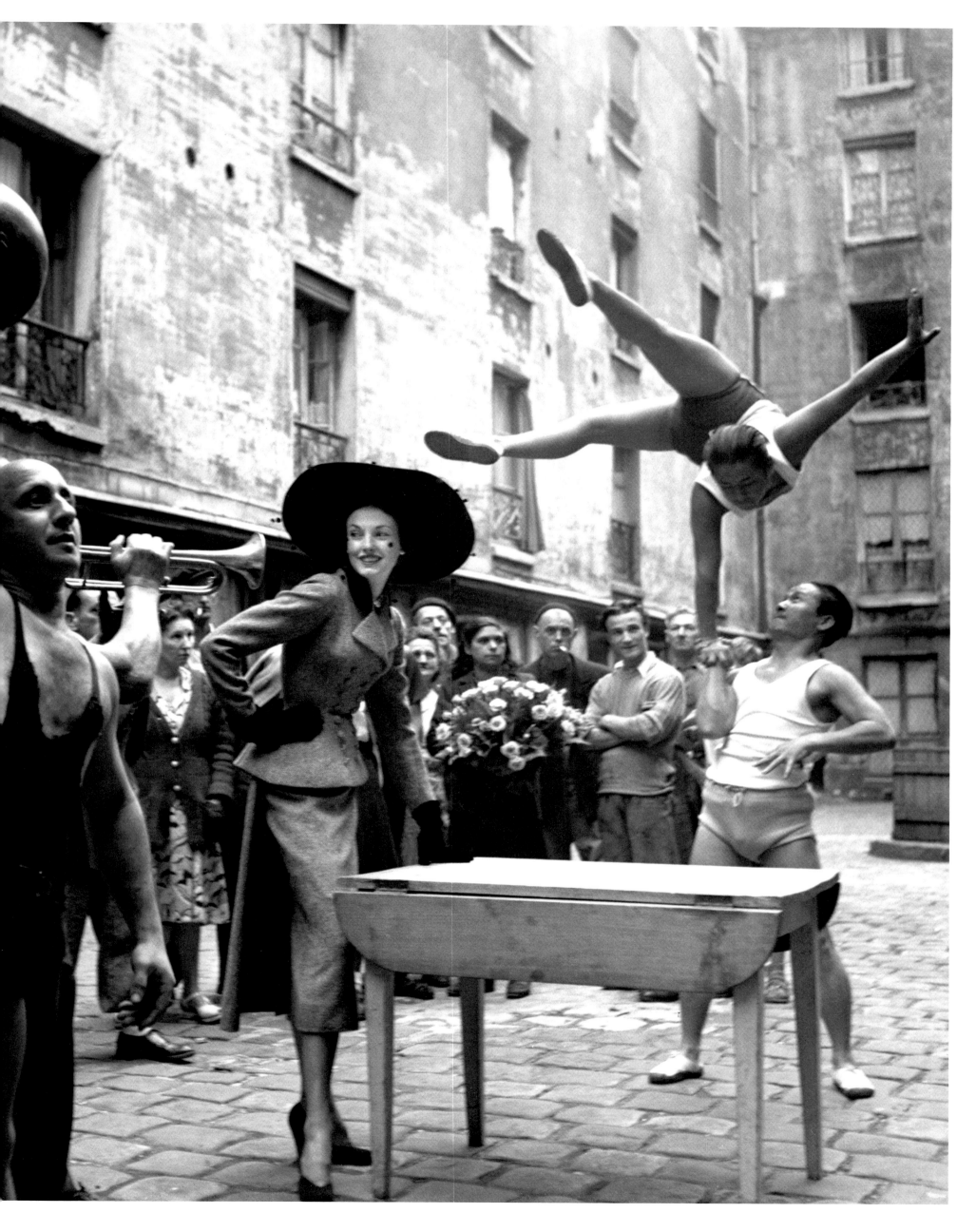

Suzy Parker and Robin Tattersall, models. Dress by Dior. Place de la Concorde, Paris, August 1956

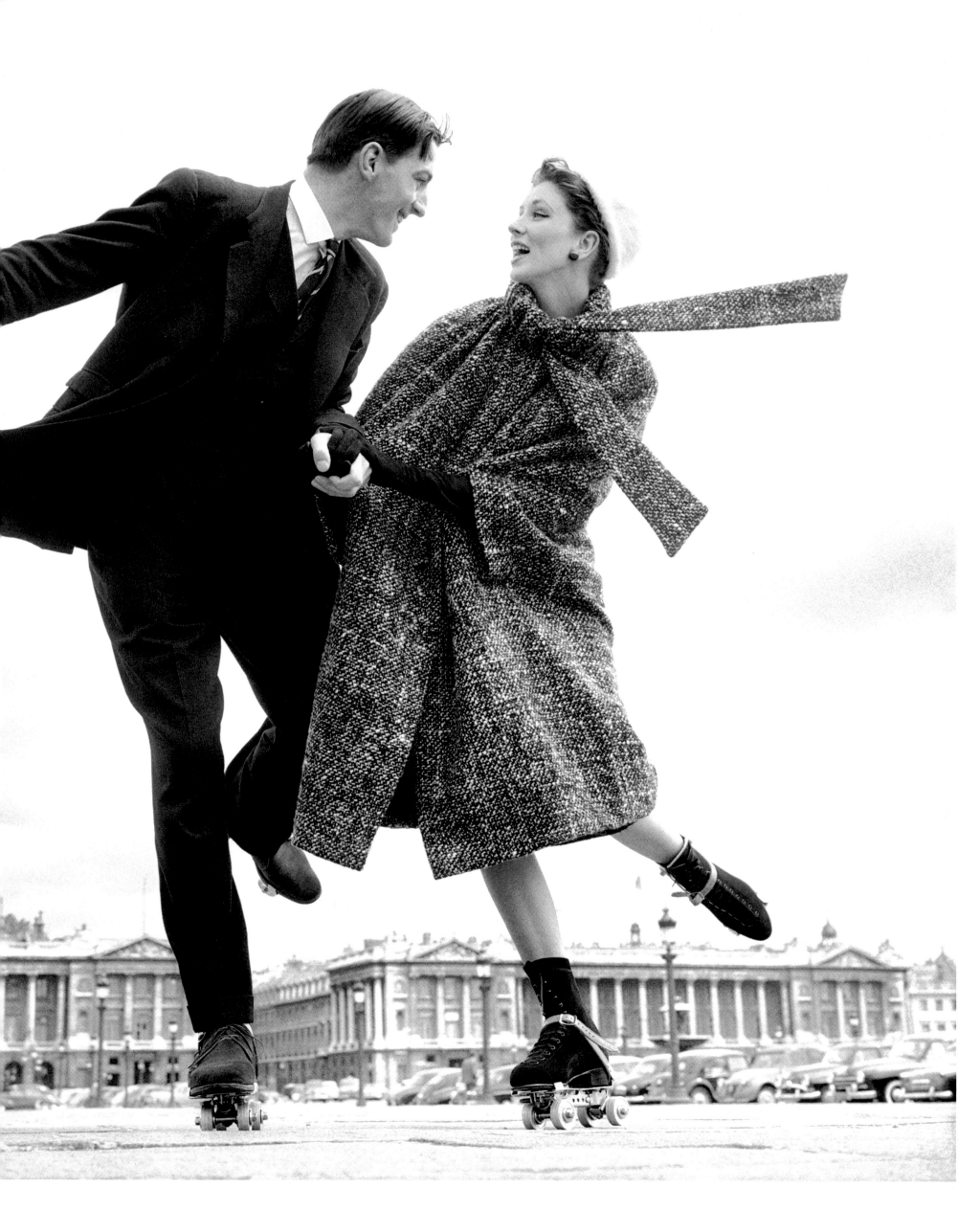

Katherine Hepburn, actress. New York, March 1955

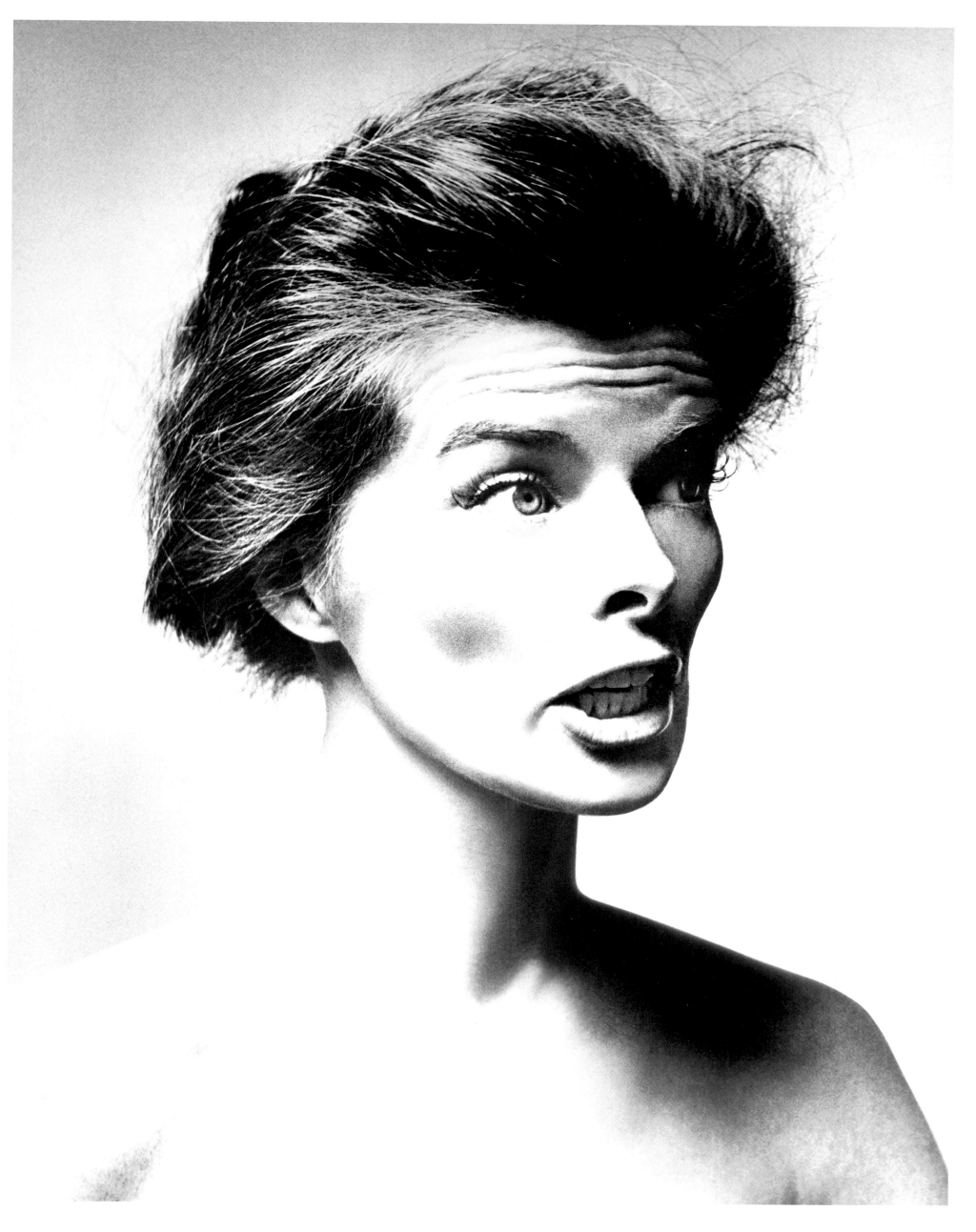

Vicomtesse Jacqueline de Ribes and Raymundo de Larrain, aristocrats.

Dress by Dior. New York, May 1961

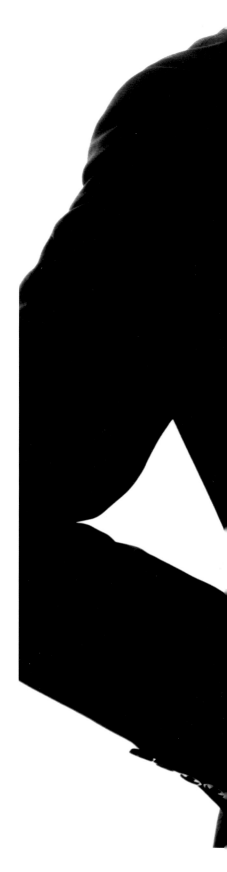

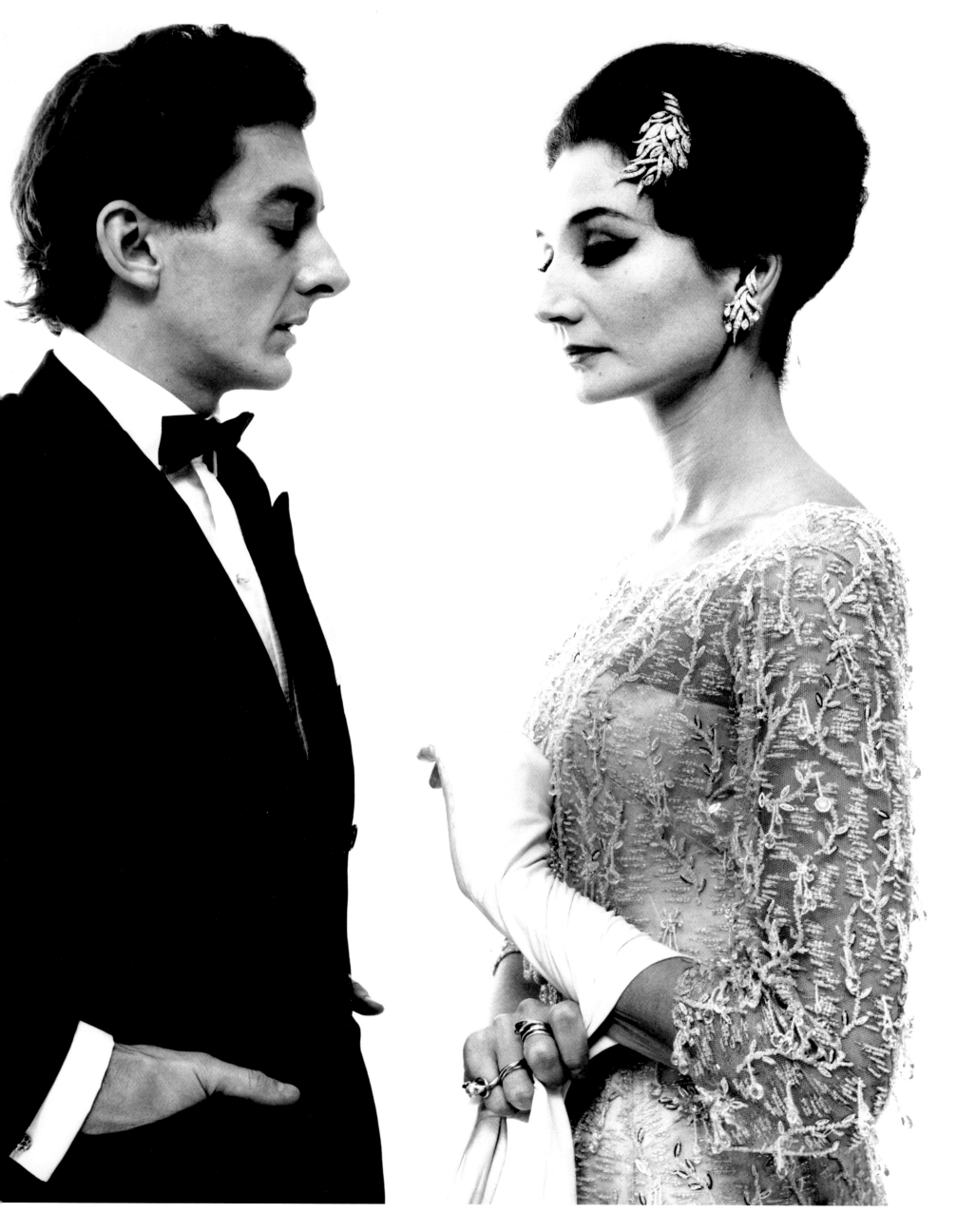

Marianne Moore, poet. New York, January 1958

Pages 74–75: Dovima, model. Dress by Claire McCardell.
 Great Pyramids of Giza, Egypt, January 1951

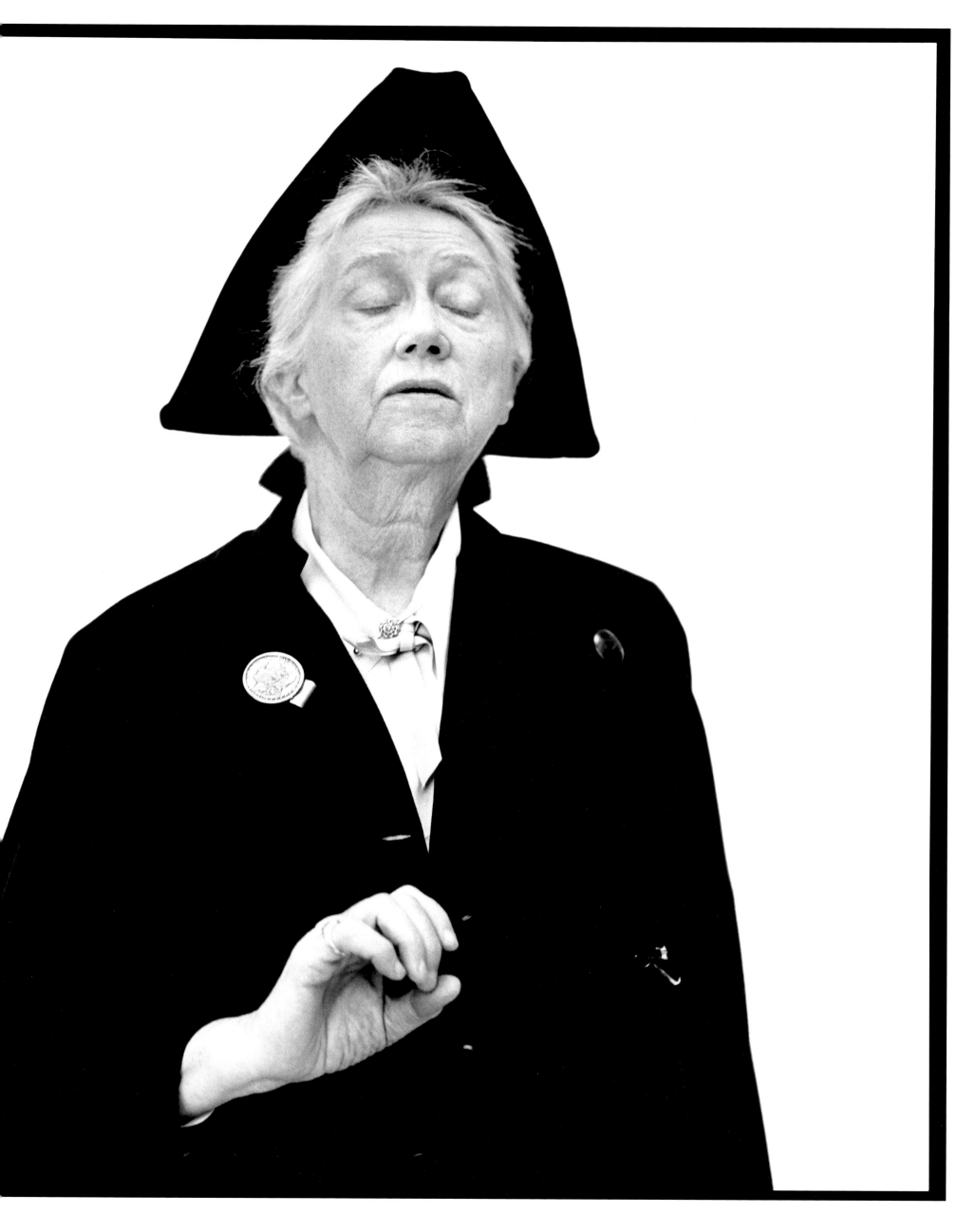

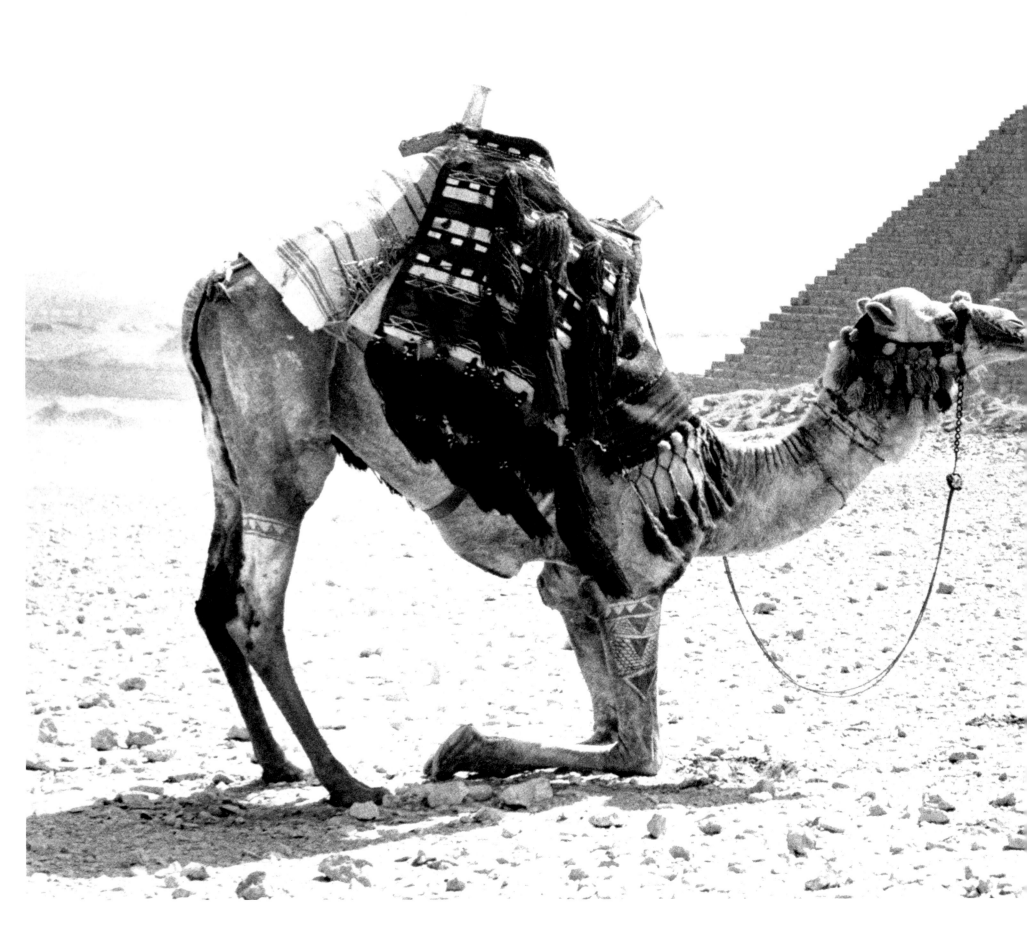

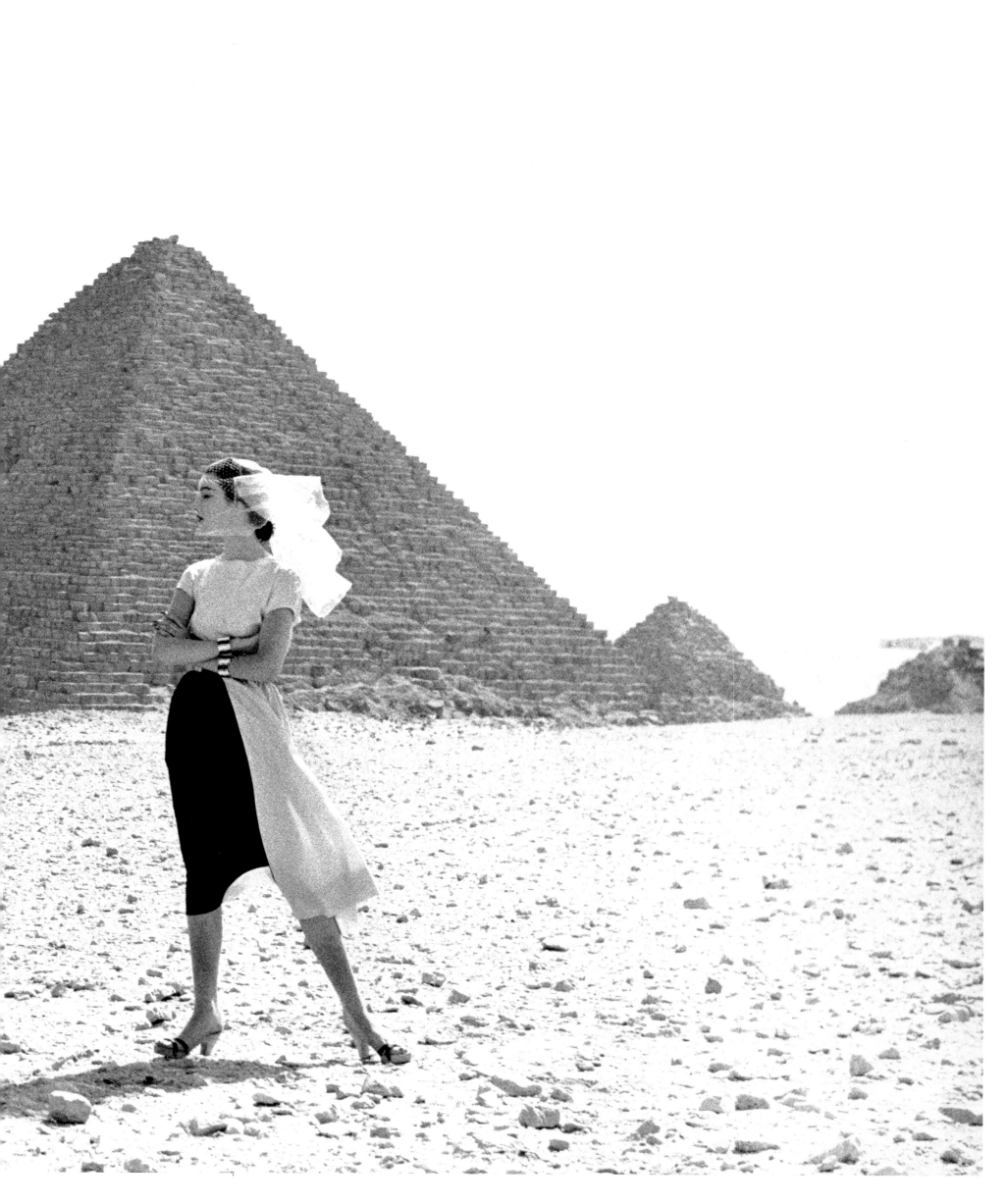

Gloria Vanderbilt, socialite. New York, December 1953

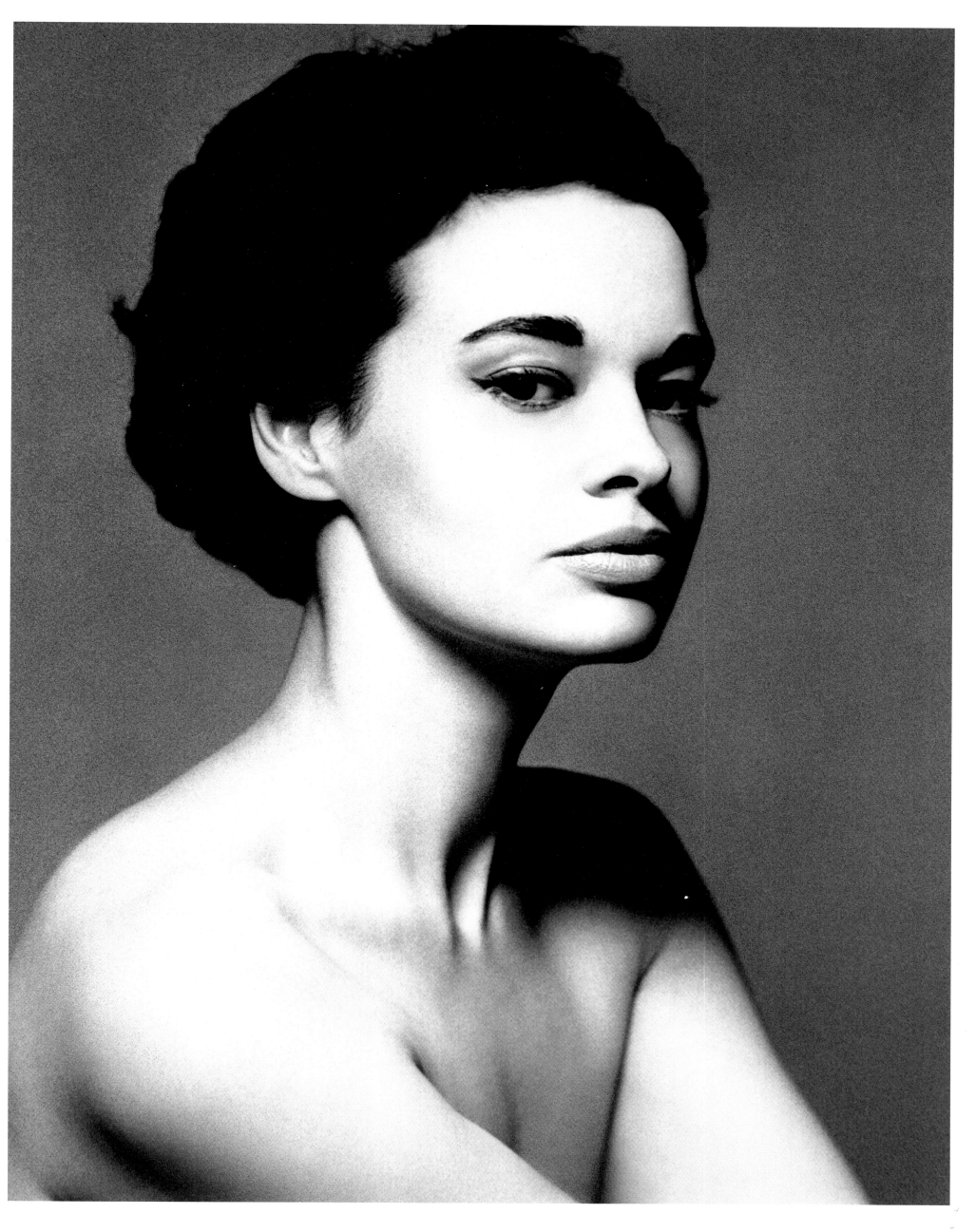

Marella Agnelli, aristocrat. New York, December 1953

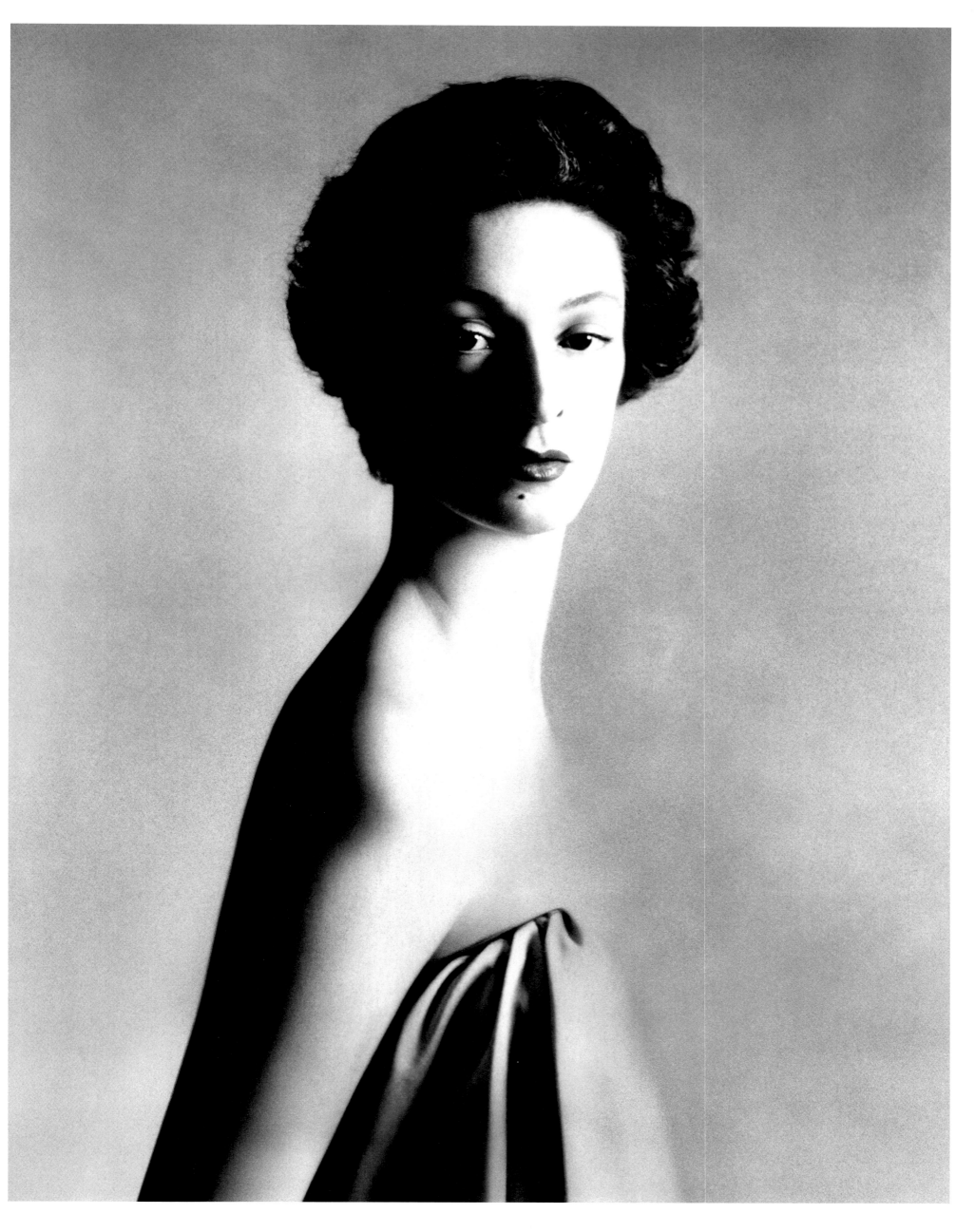

Liz Pringle, model. Bracelet by Schlumberger. Round Hill, Jamaica, February 1959

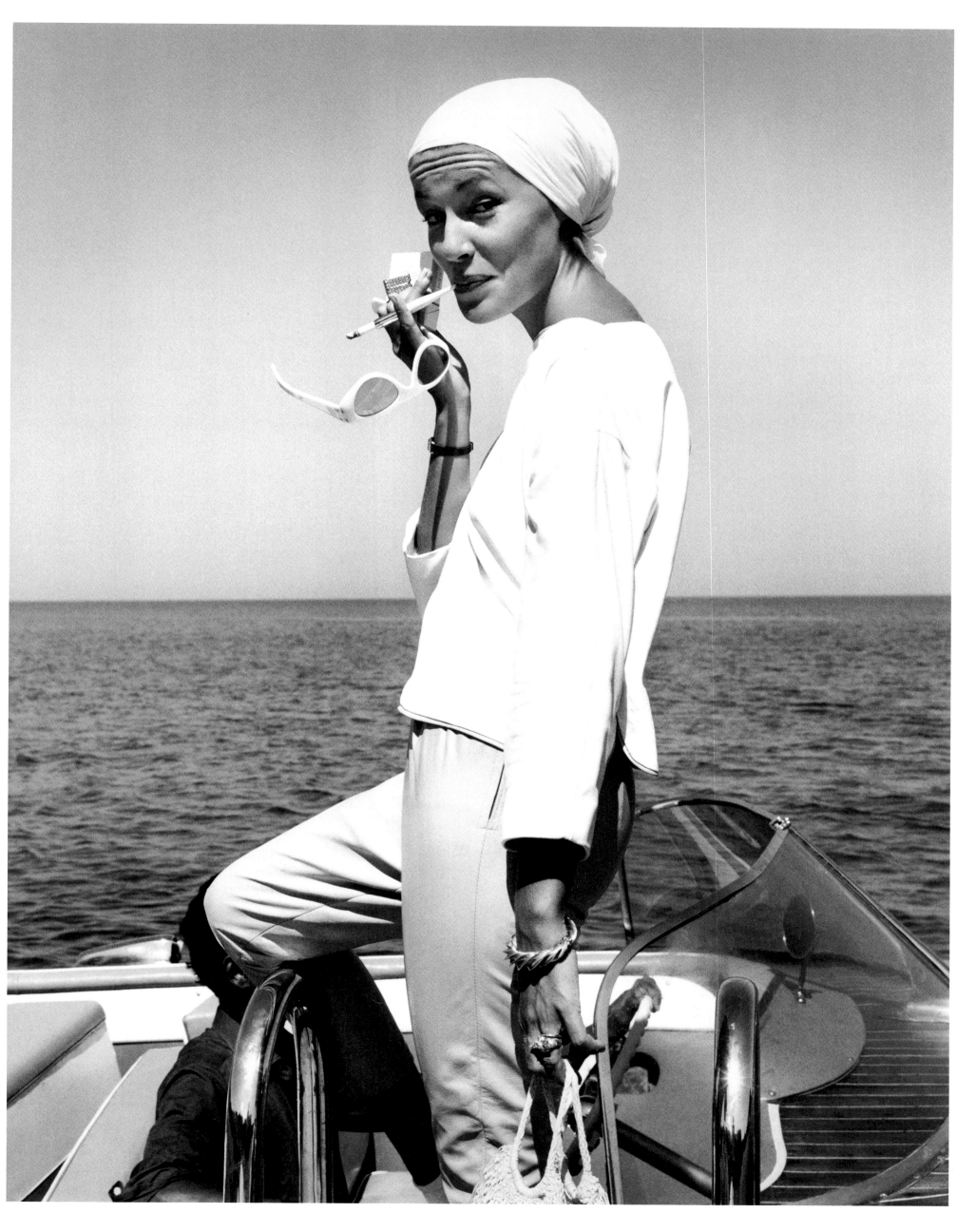

Maria Callas, soprano. New York, February 1970

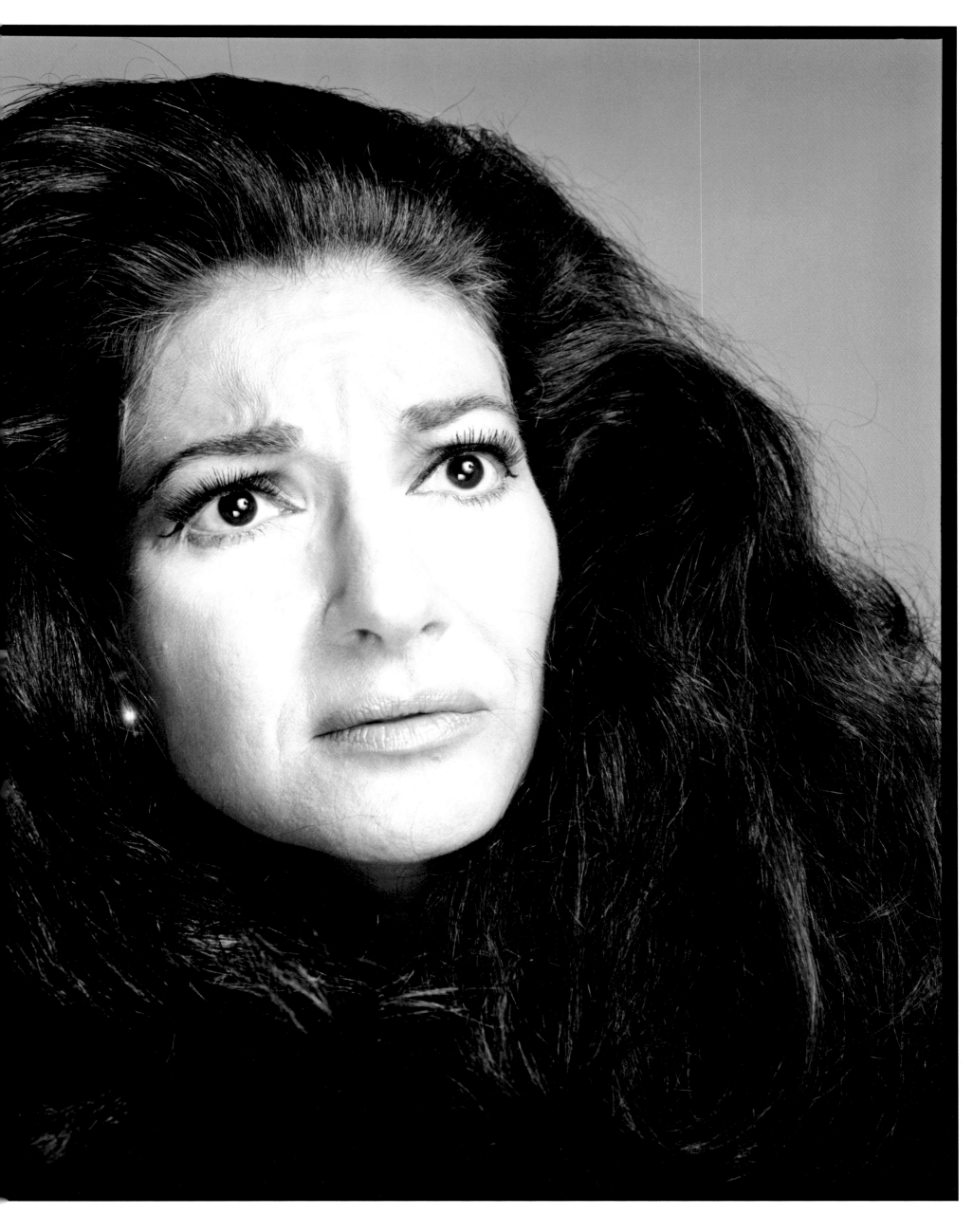

Lillian Hellman, writer. New York, 1953

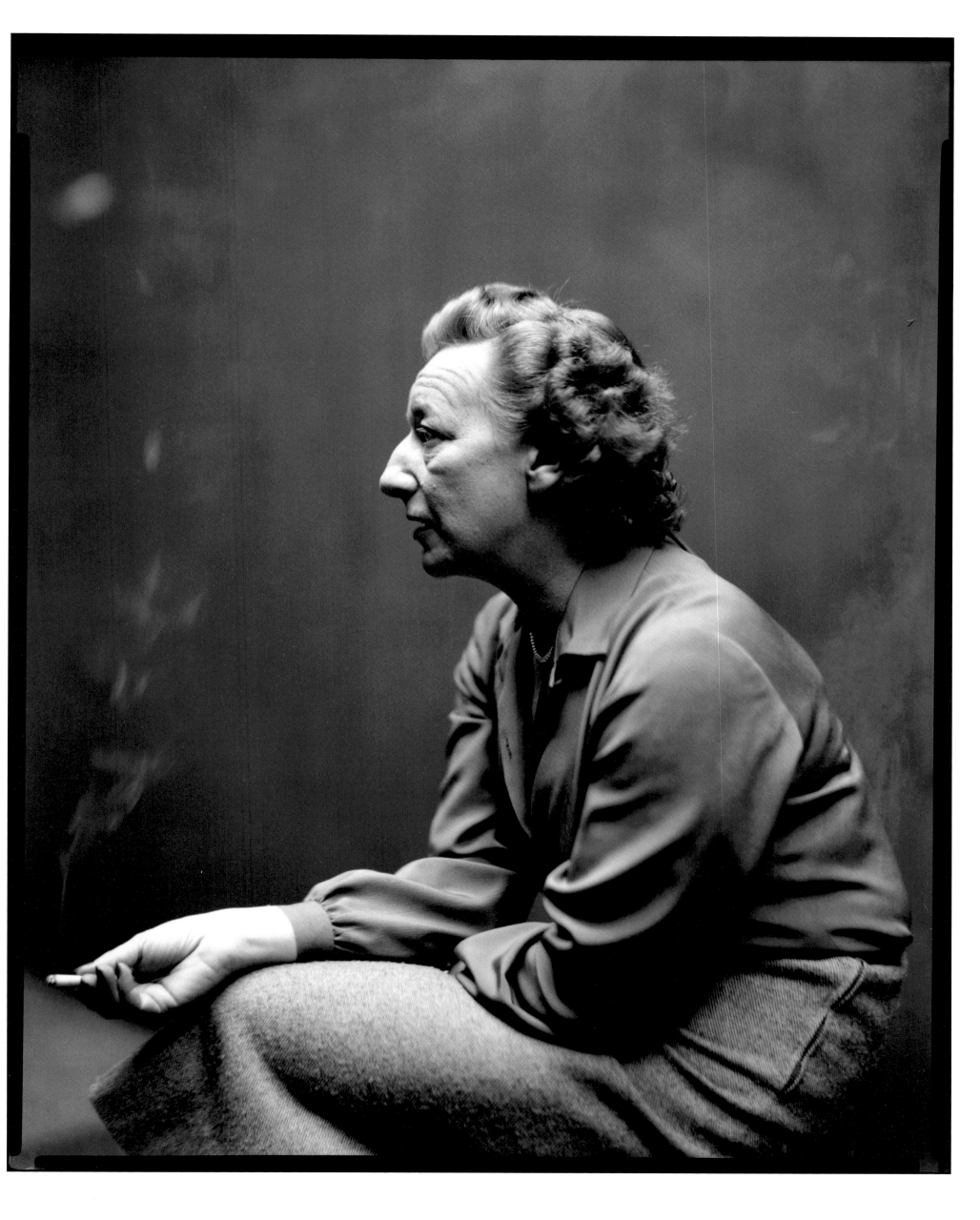

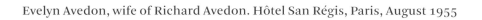

Evelyn Avedon, wife of Richard Avedon. Hôtel San Régis, Paris, August 1955

Marilyn Monroe, actress. New York, May 1957

Pages 90–91: Margot McKendry and China Machado, models,
 with members of the French press. Dresses by
 Lanvin-Castillo and Heim. Paris, August 1961

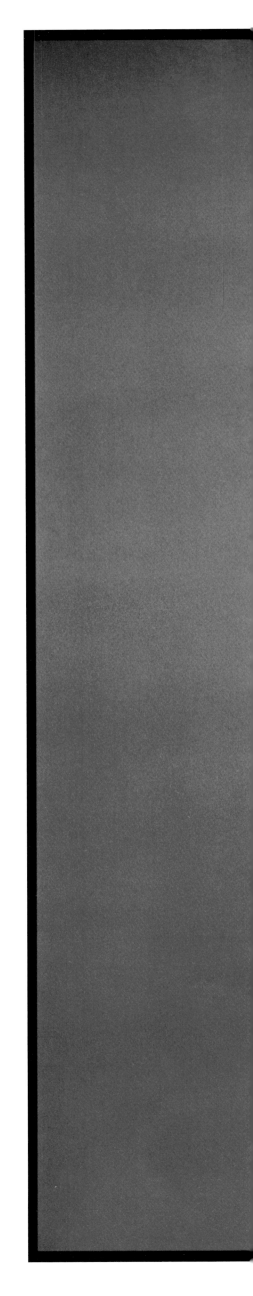

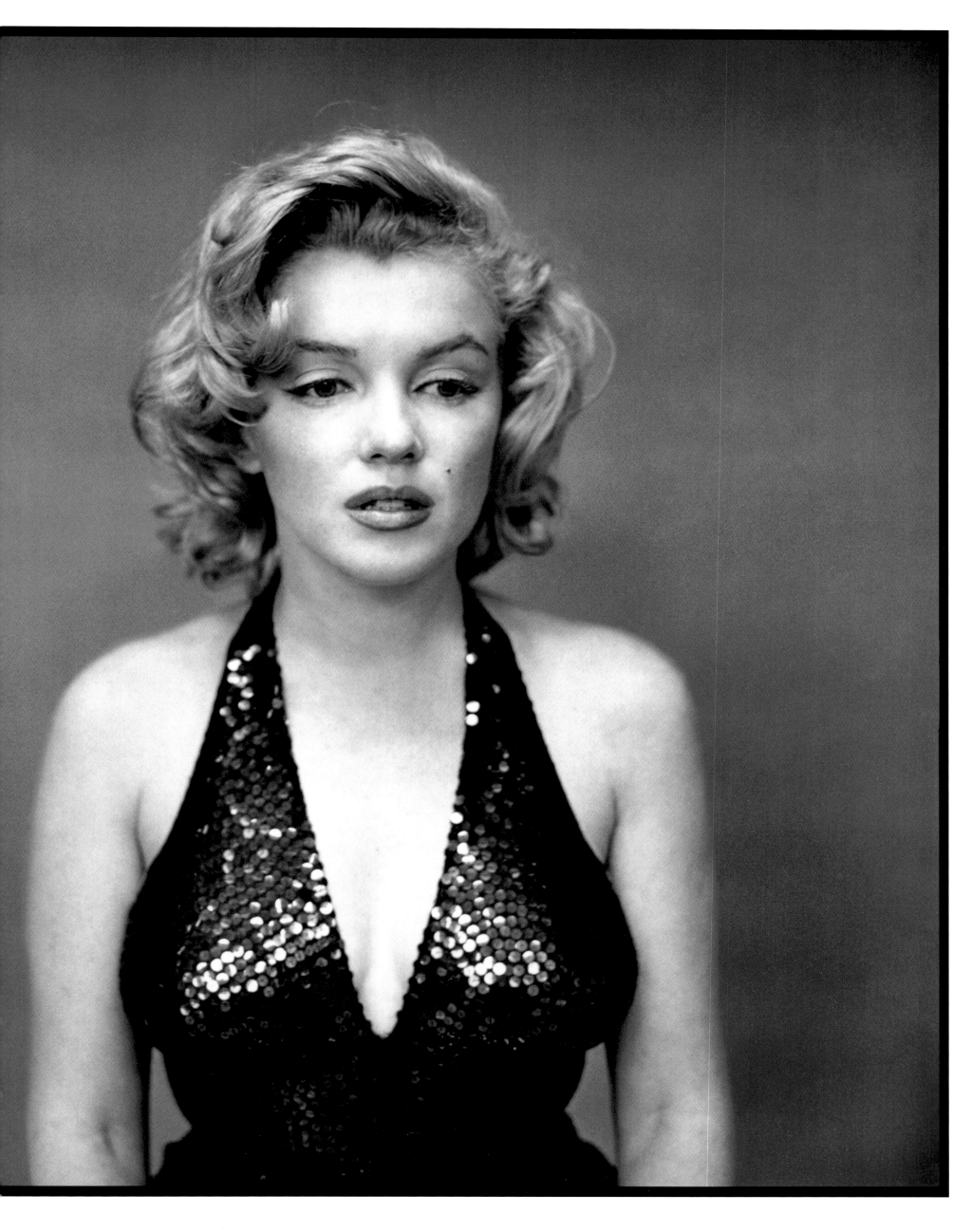

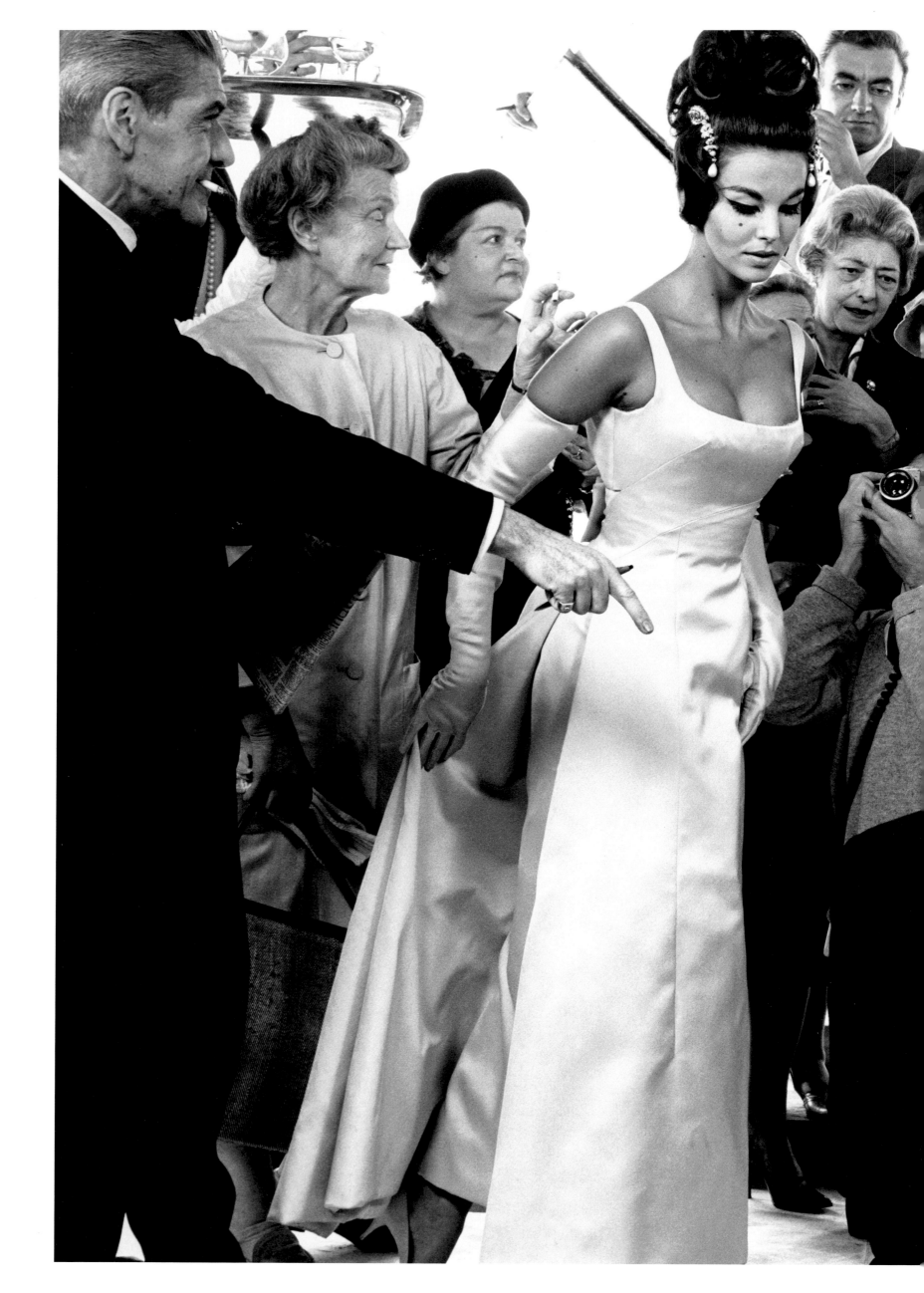

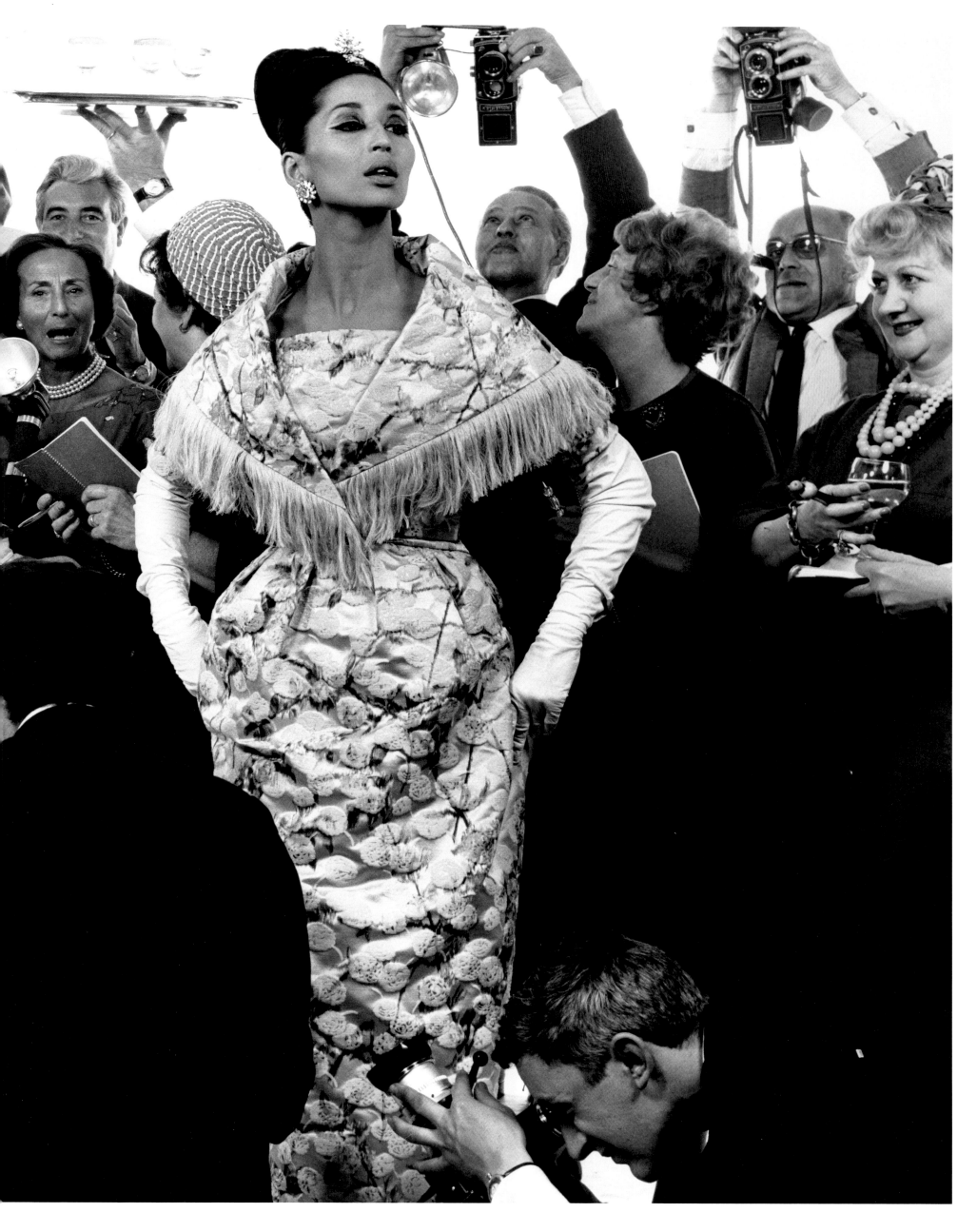

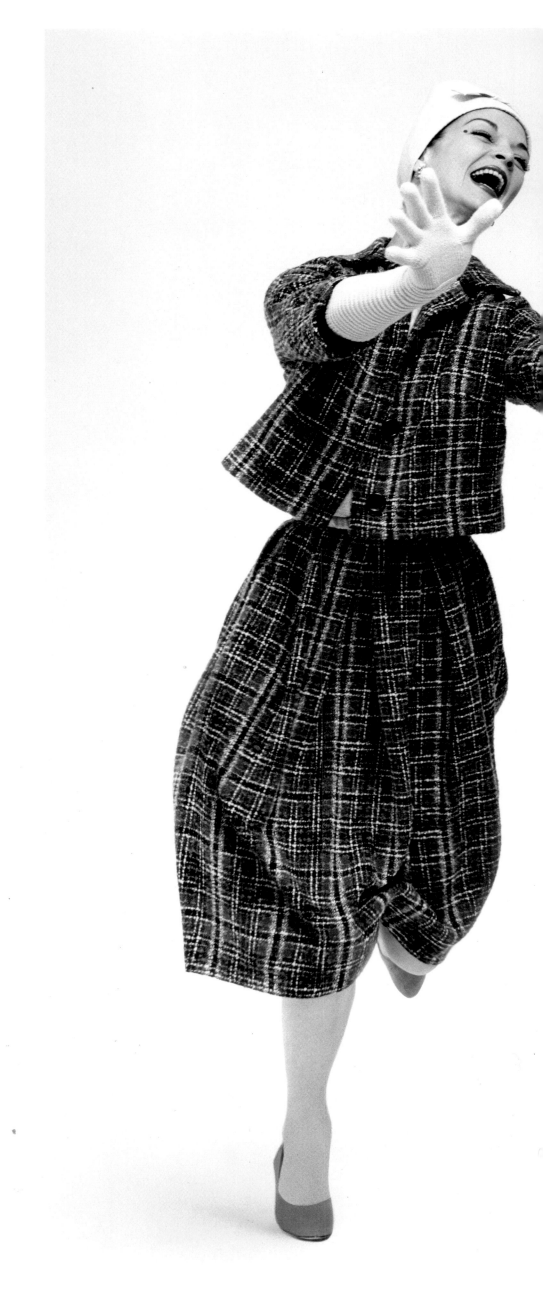

Jean Patchett, Betsy Pickering, and Marilyn Ambrose, models.
Suits by Nelley de Grab. New York, June 1958

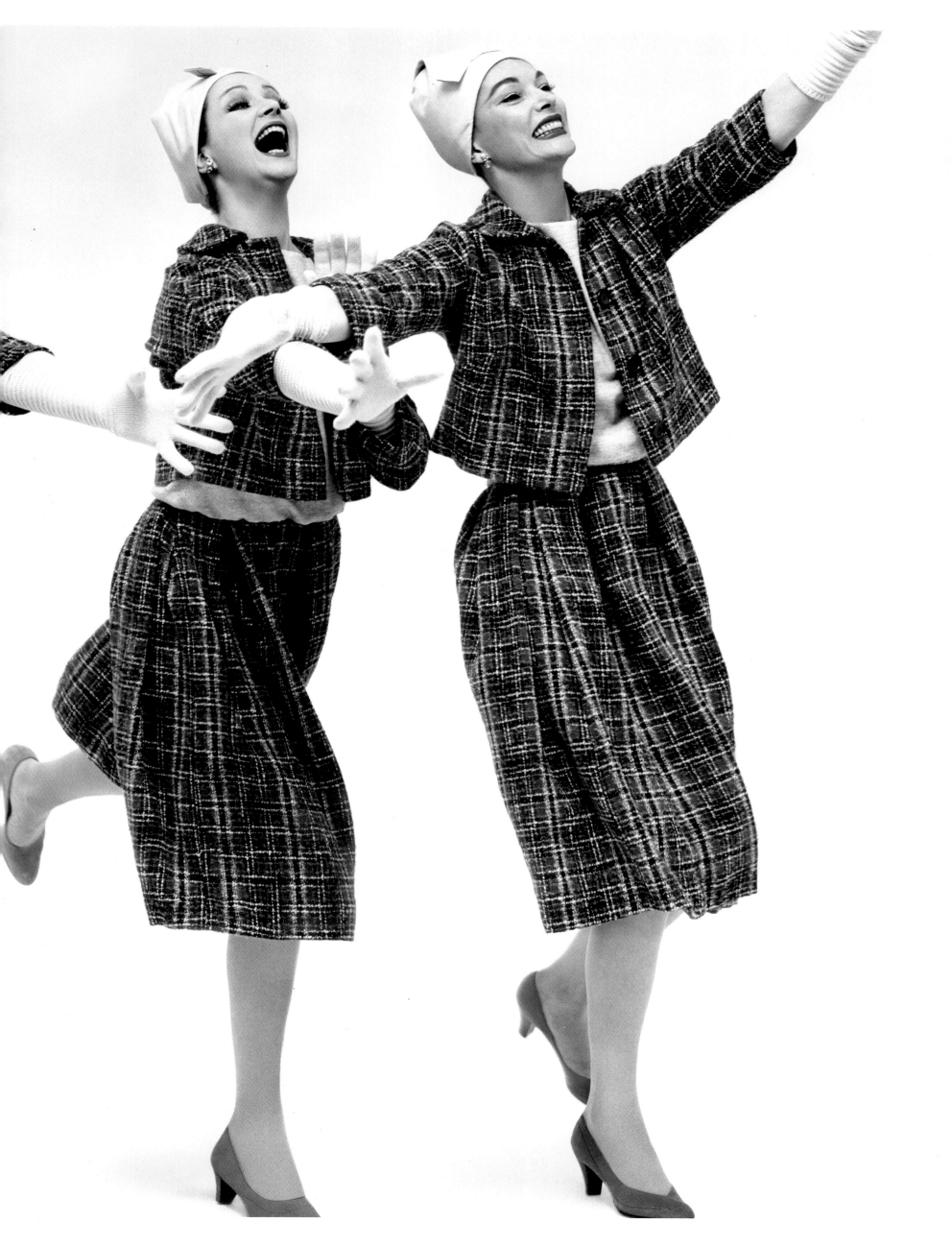

Danny Weil, model. Dress by Abe Schrader. New York, October 1962

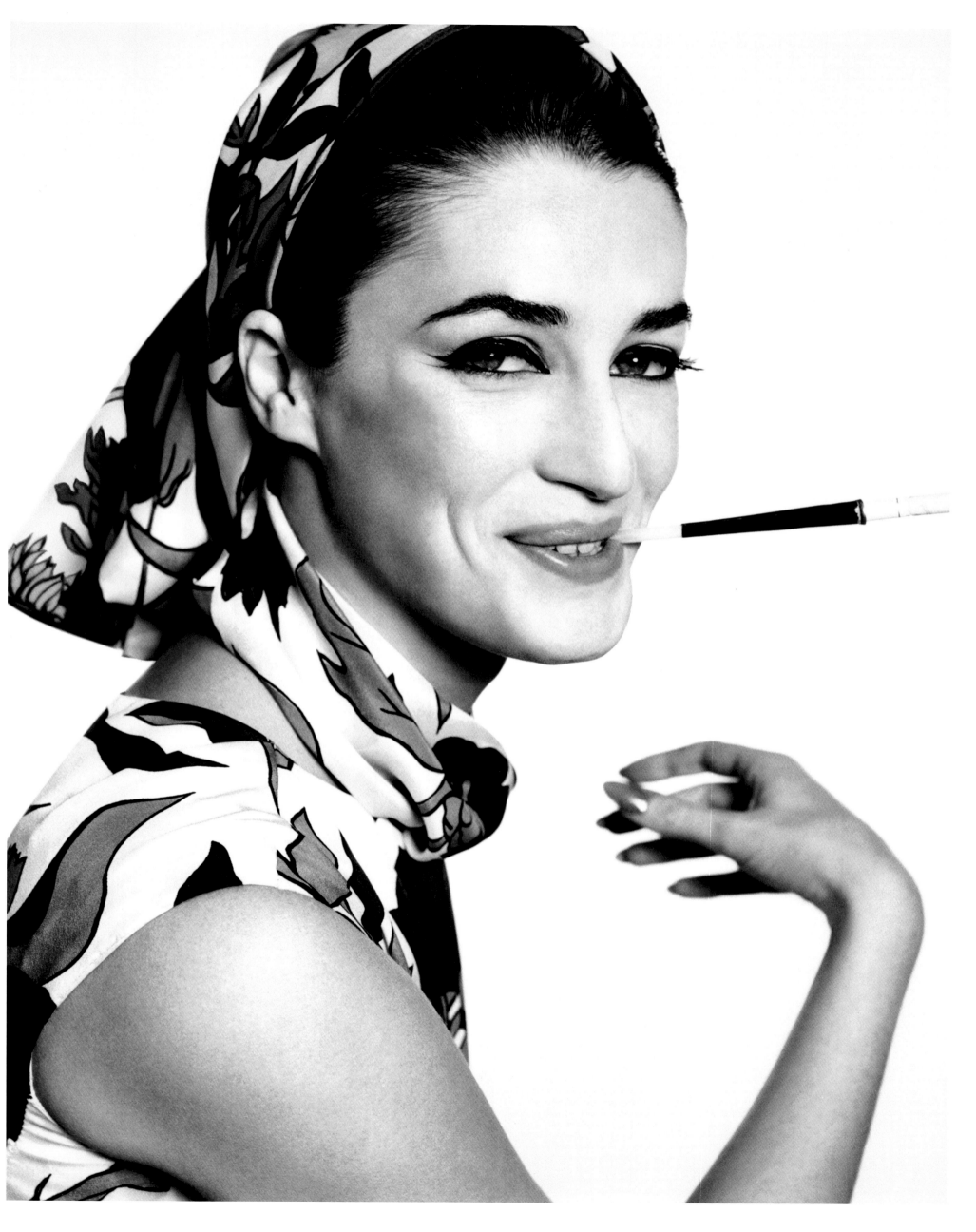

Dovima, model. Dress by Traina-Norell. New York, December 1957

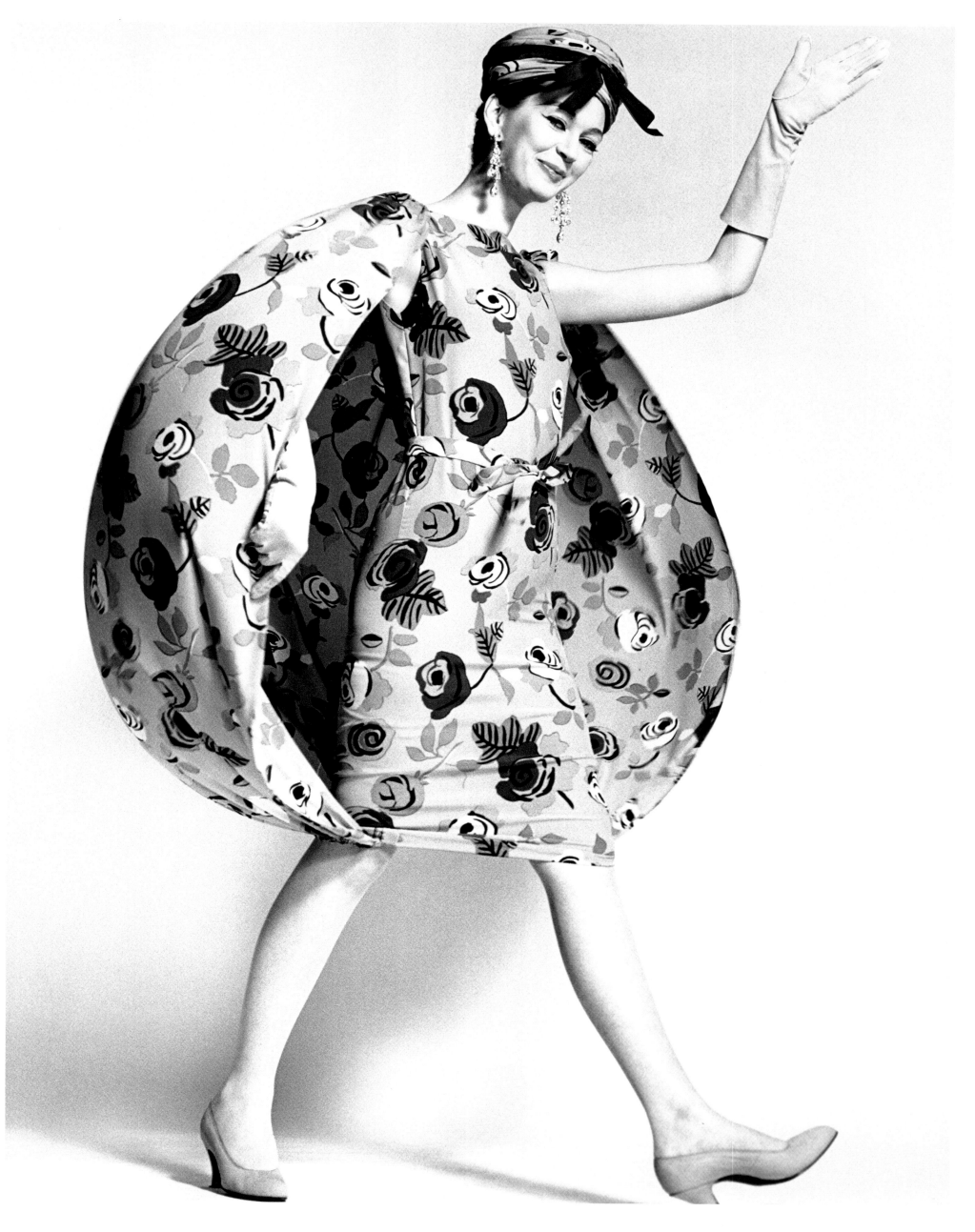

Loulou de la Falaise, muse of Yves Saint-Laurent. Paris, April 1978

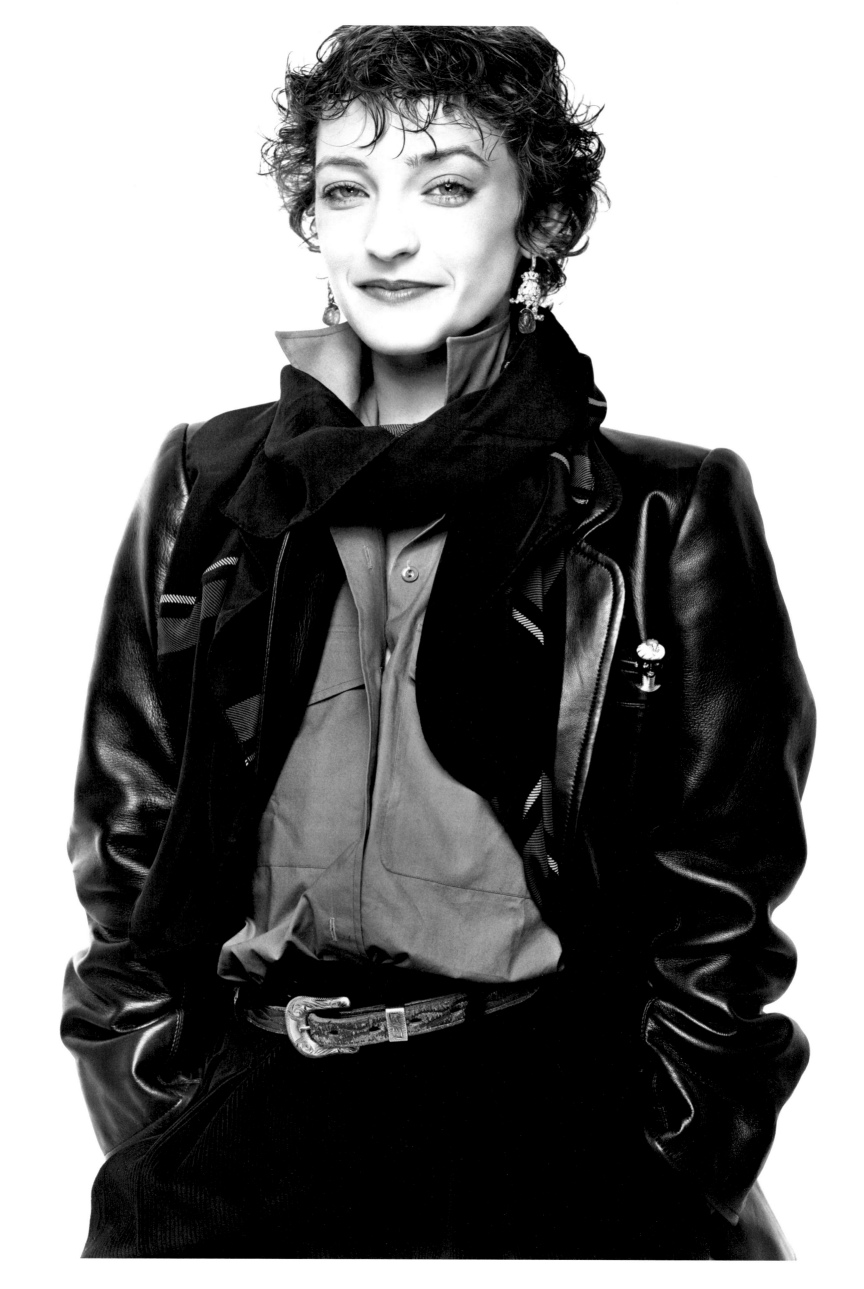

Gabrielle Chanel, designer, and Suzy Parker, model. Suits by Chanel. Paris, January 1959

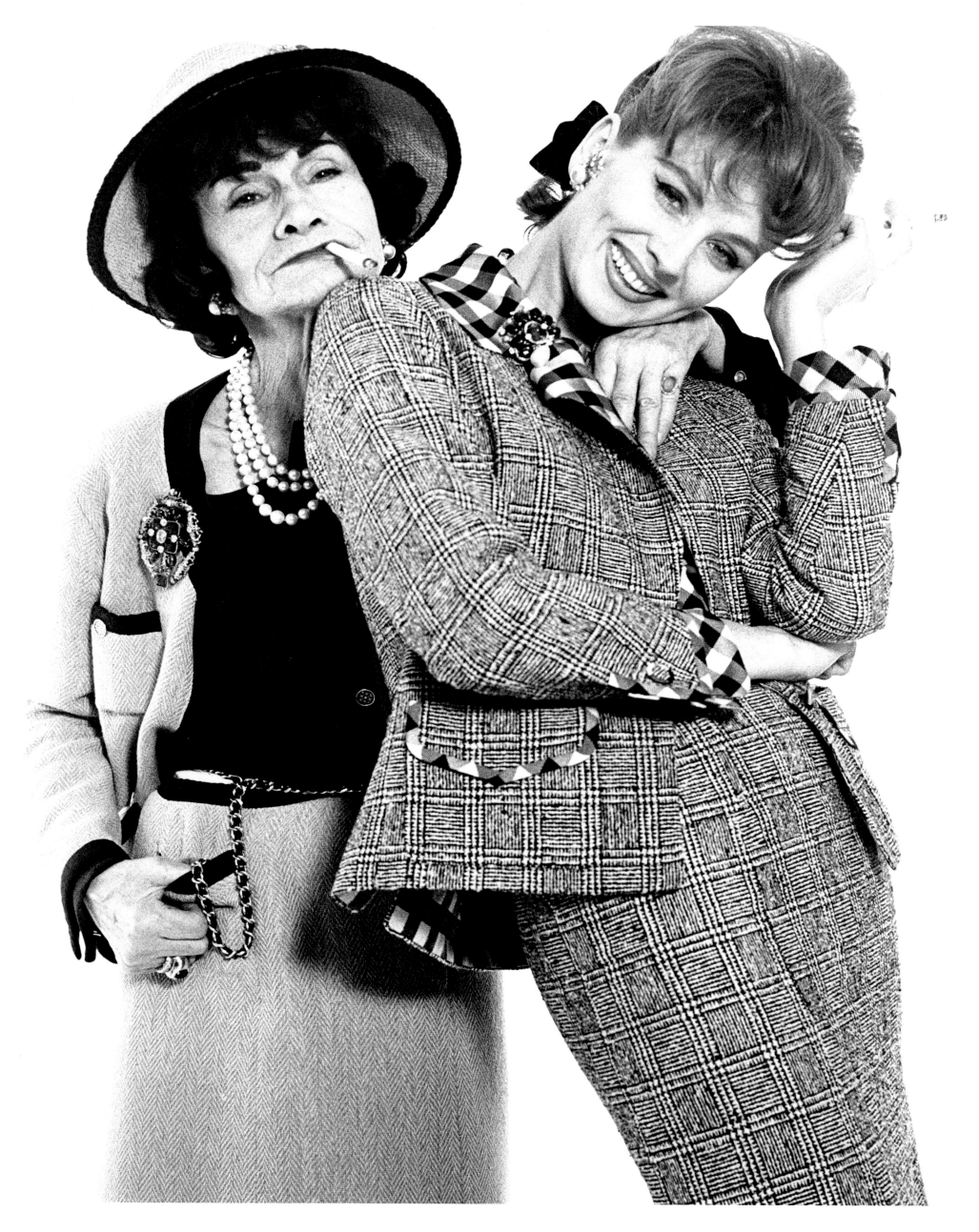

Isak Dinesen, writer. Copenhagen, April 1958

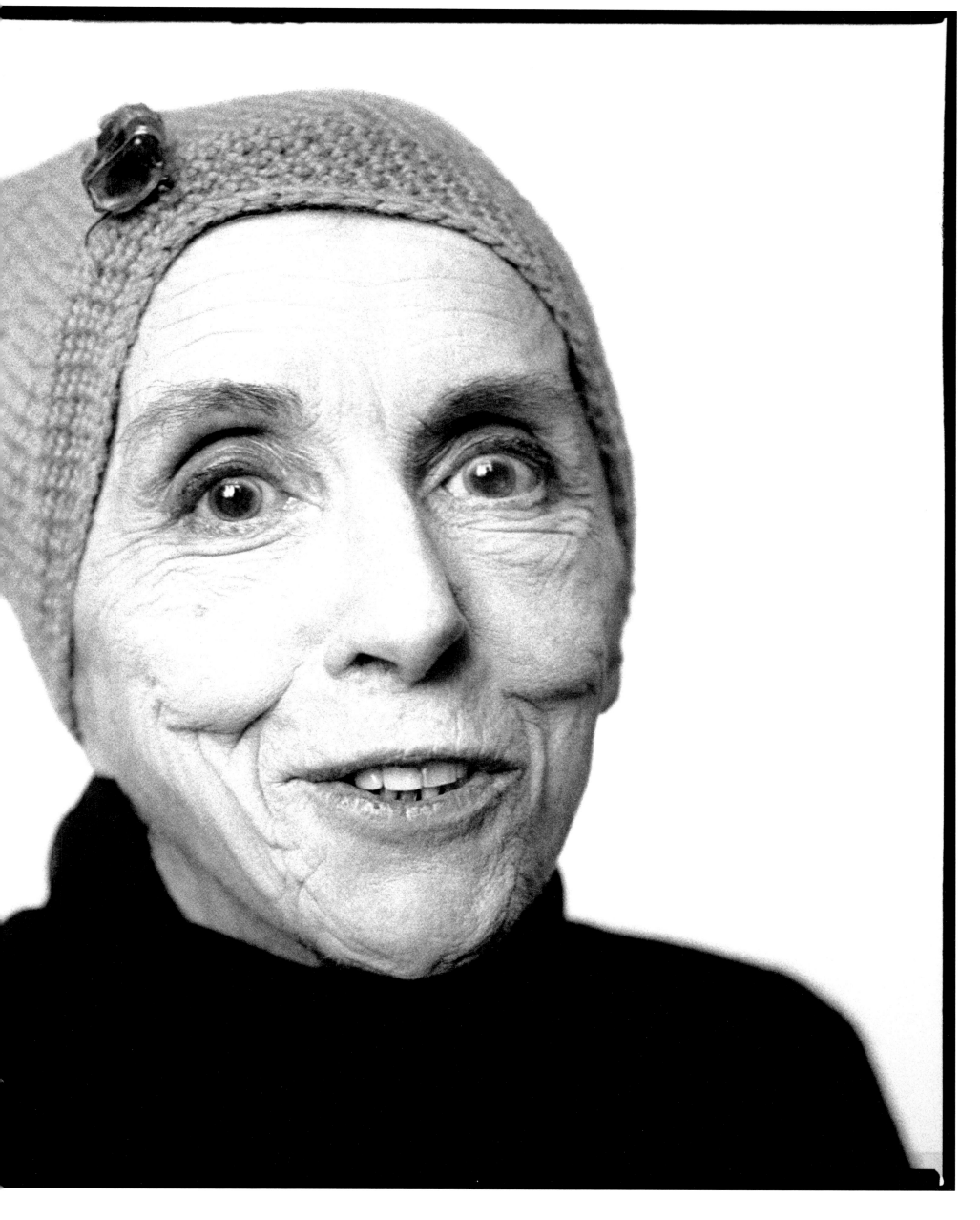

Pages 105–111: "Paparazzi," a satire. Suzy Parker, model, and Mike Nichols, director.

Dress by Lanvin-Castillo. Maxim's, Paris, August 1962

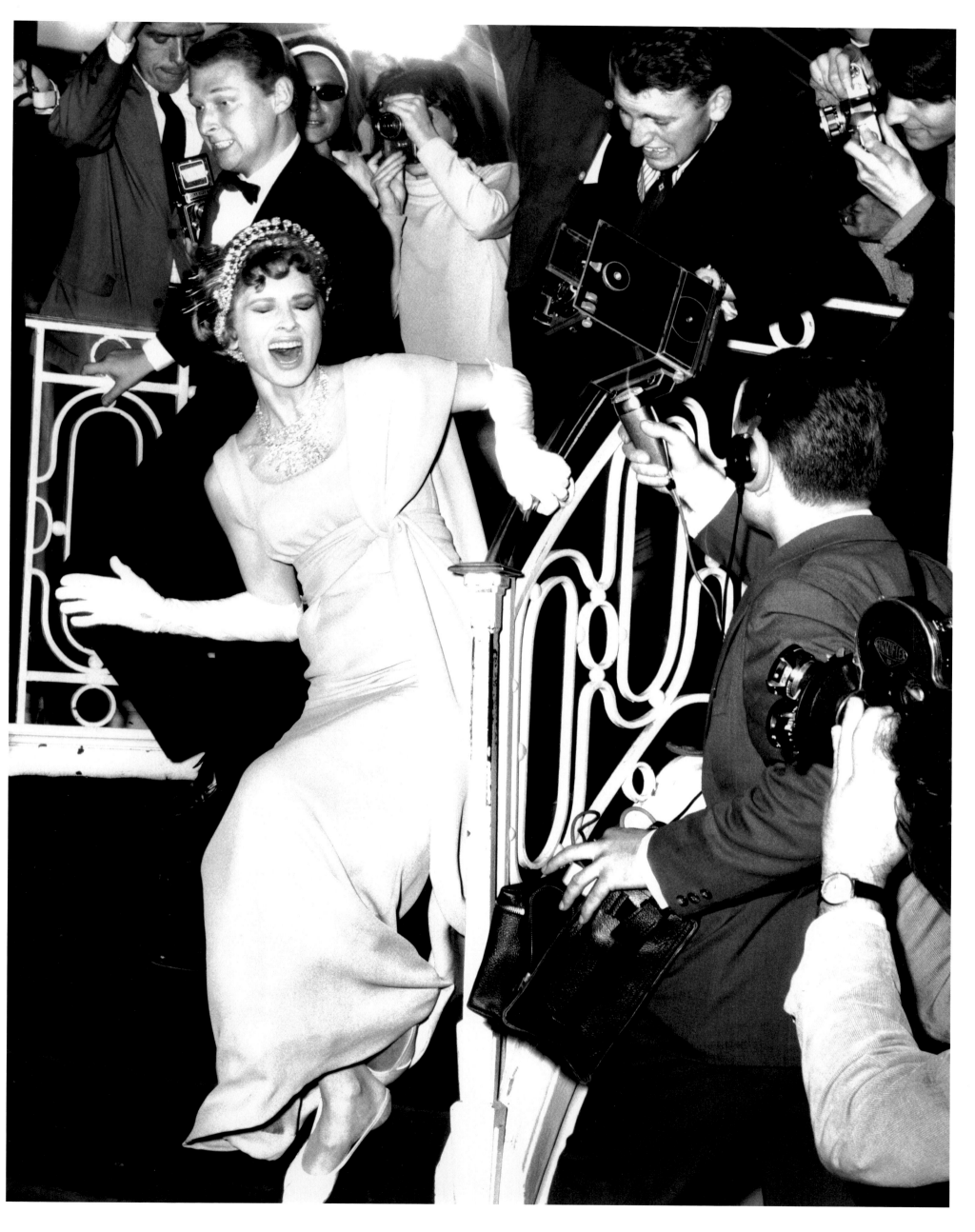

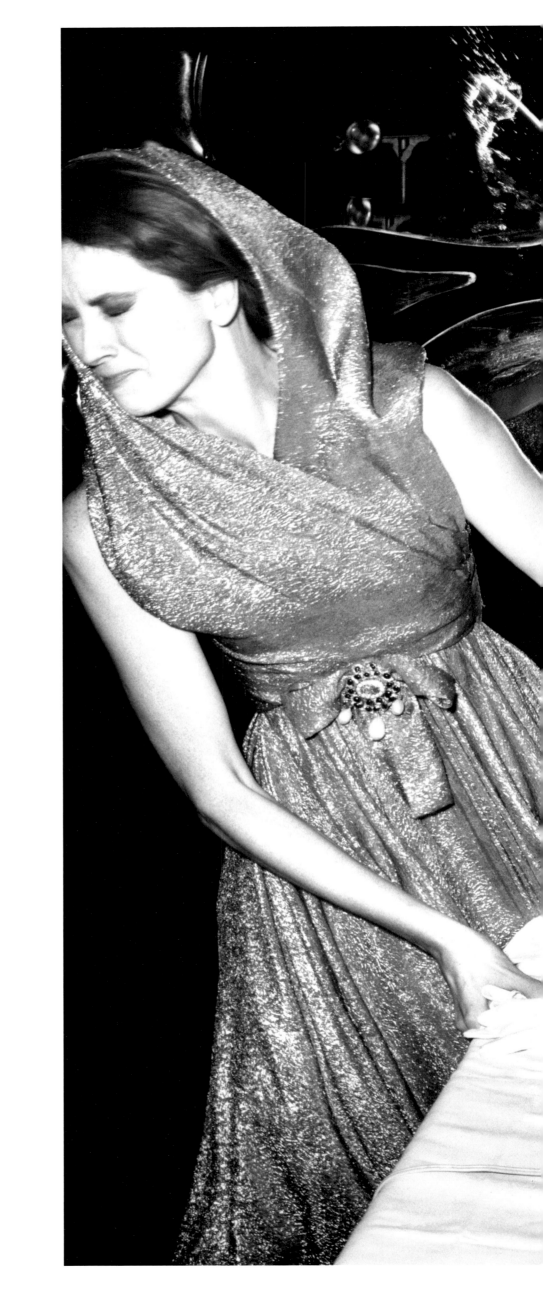

Dress by Dior. Maxim's, Paris, August 1962

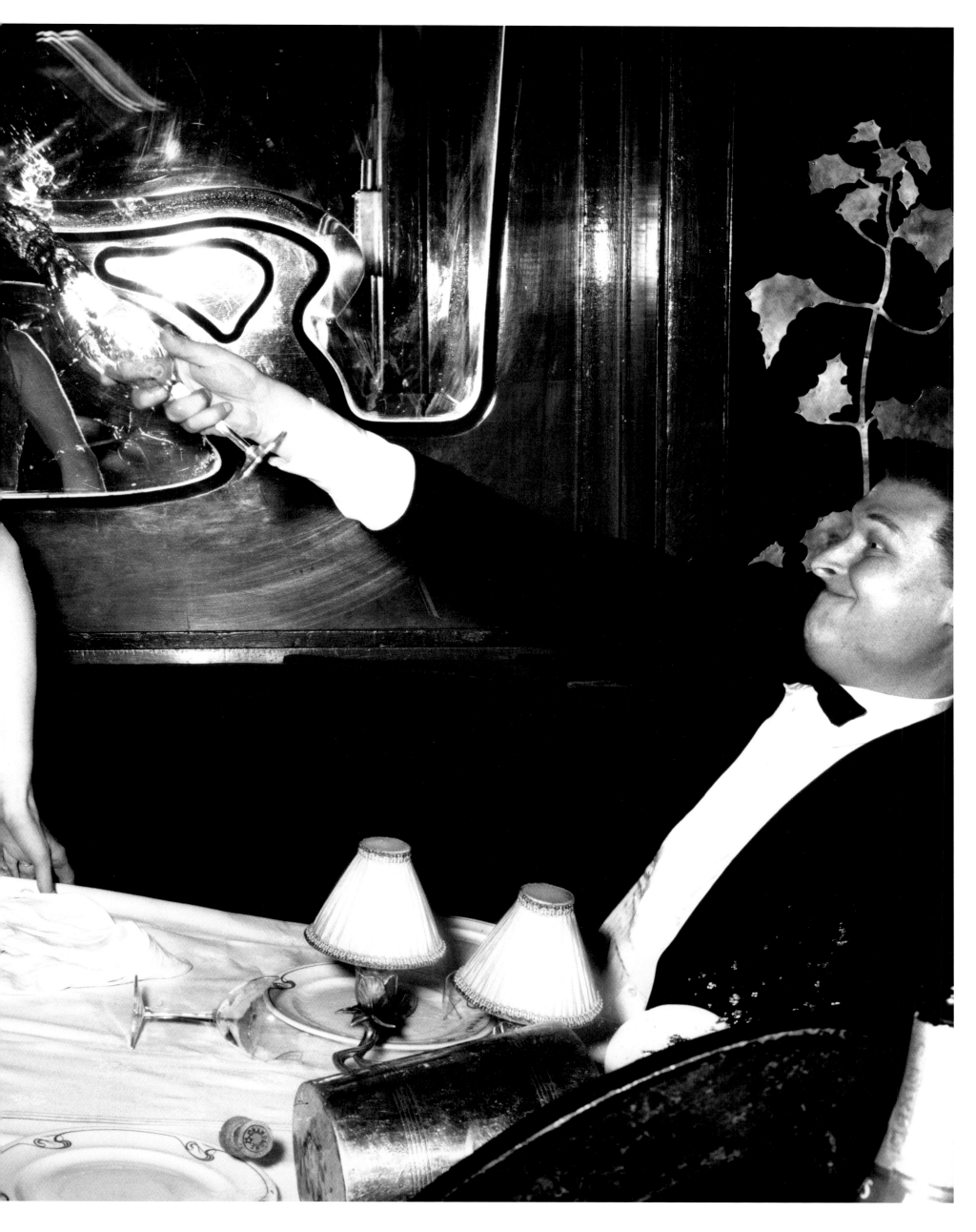

Suit by Simonetta-Fabiani. Rue François 1er, Paris, August 1962

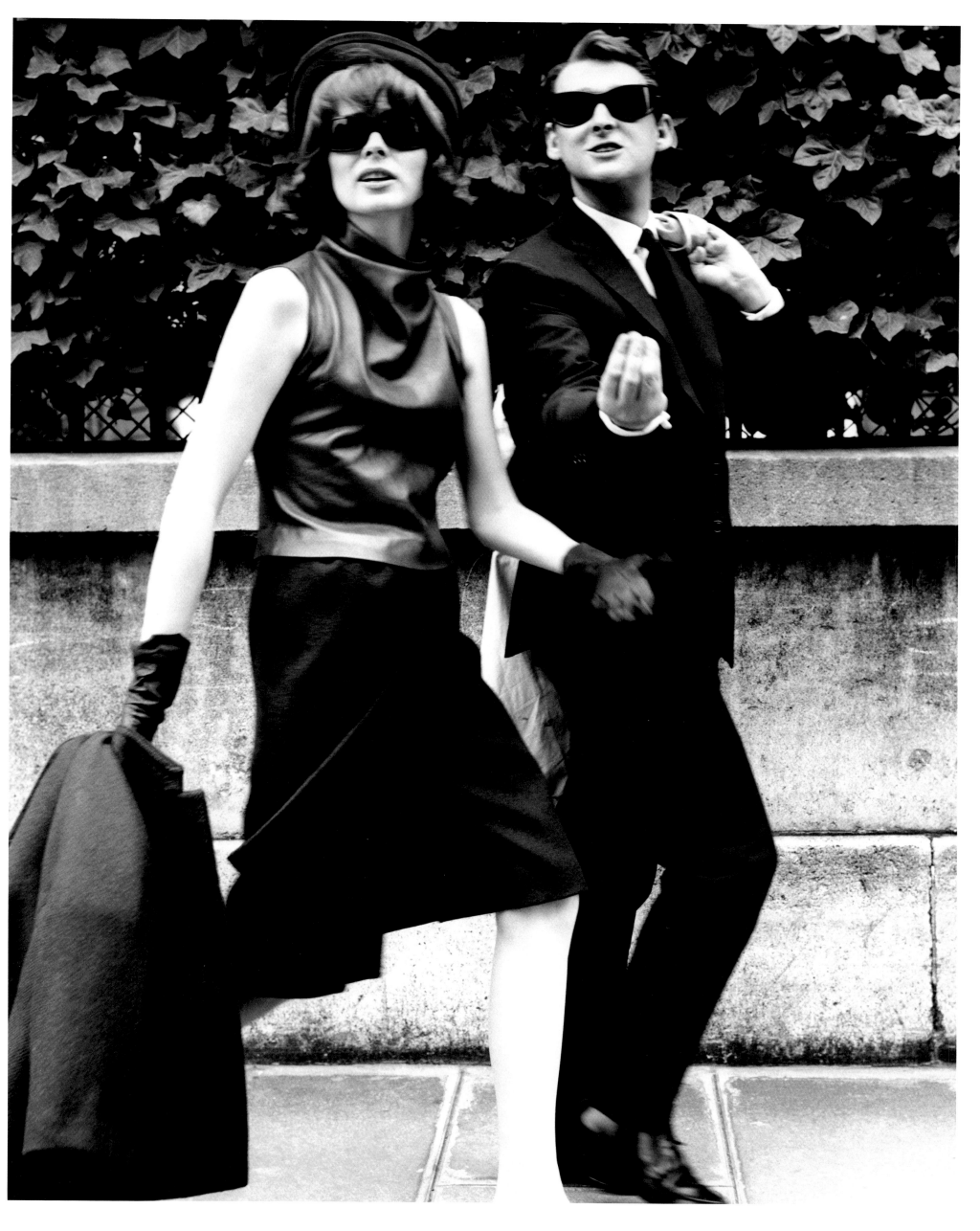

Coat by Yves Saint-Laurent. American Hospital, Paris, August 1962

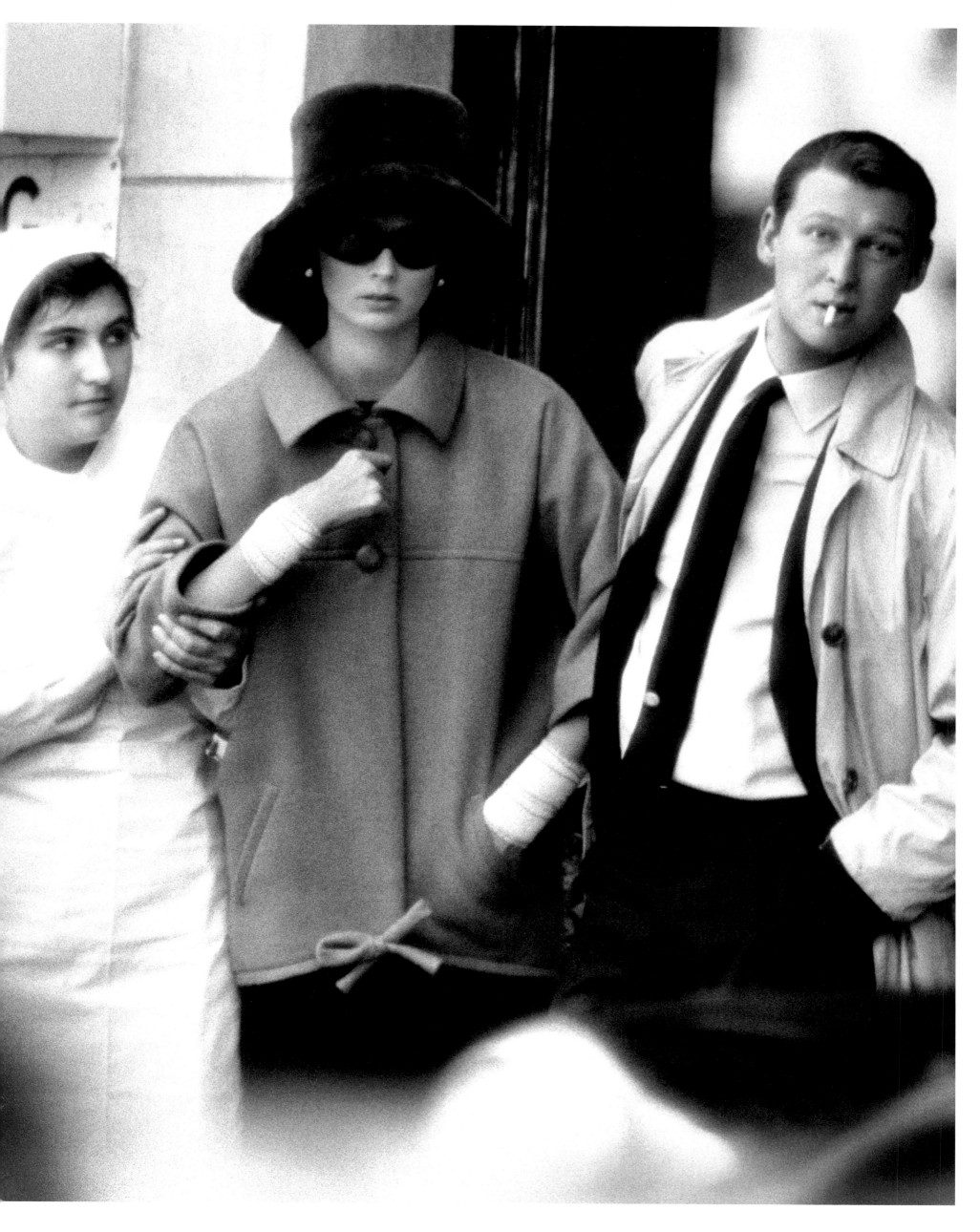

Brigitte Bardot, actress. Hair by Alexandre. Paris, January 1959

Pages 114–115: Claude and Paloma Picasso, children of Pablo Picasso. Paris, January 1966

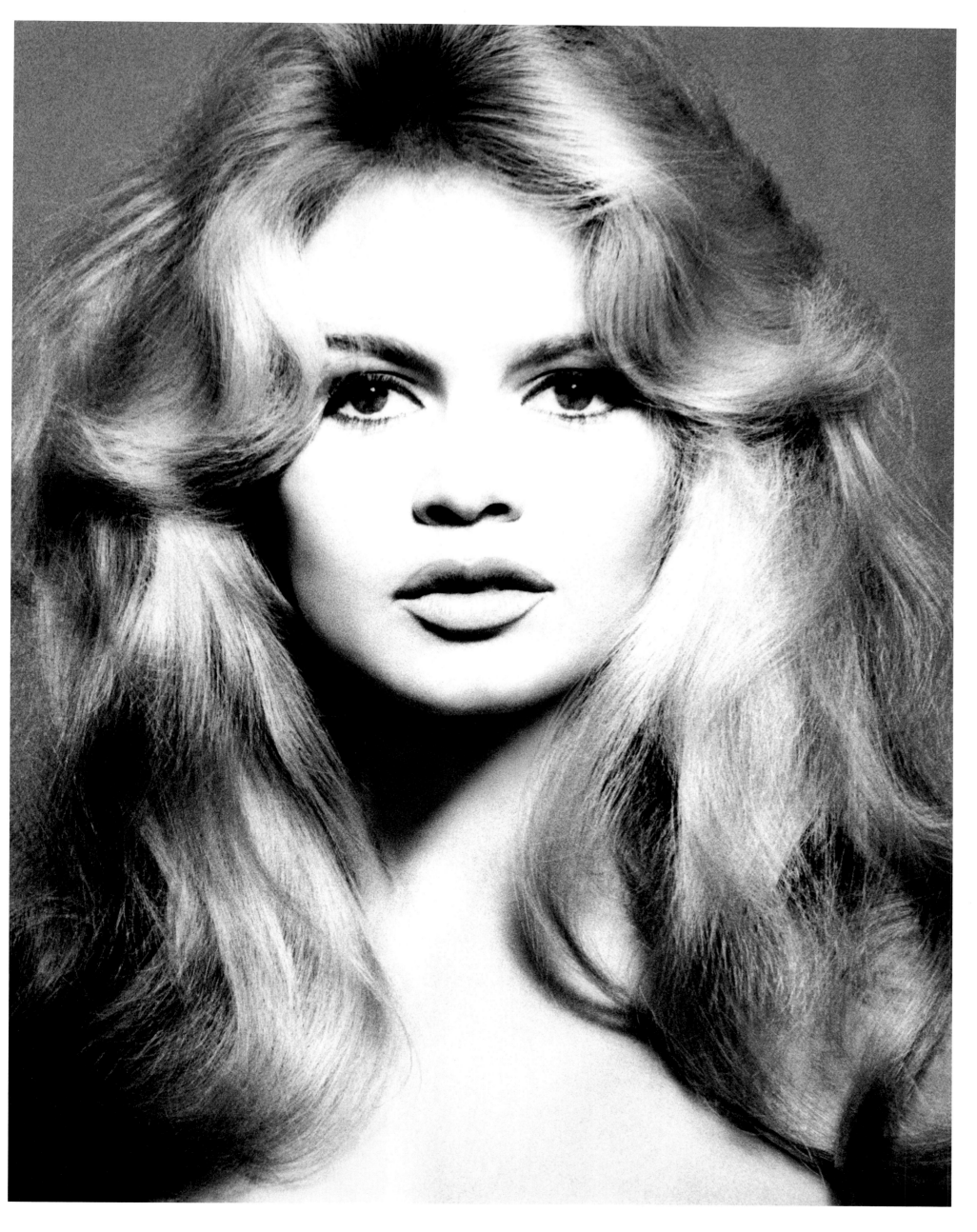

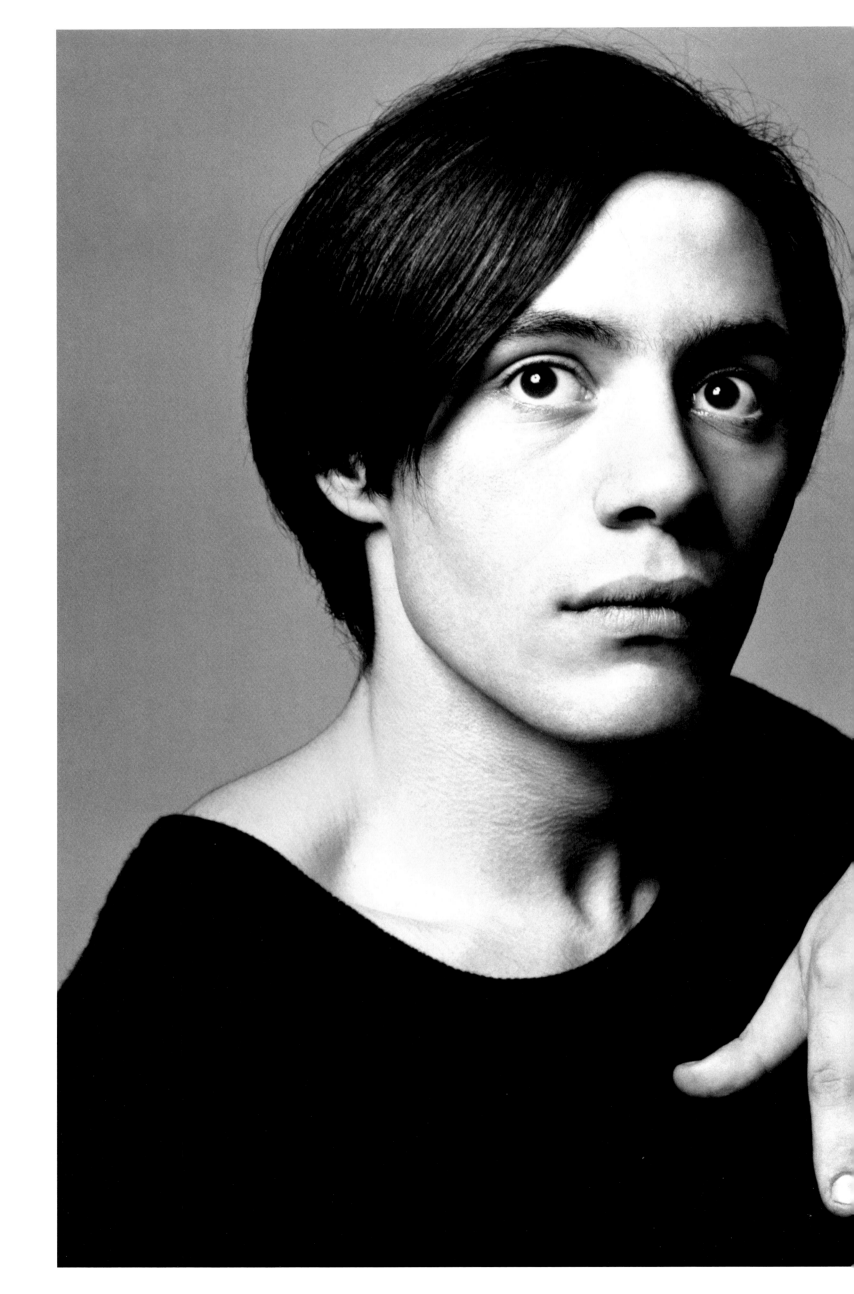

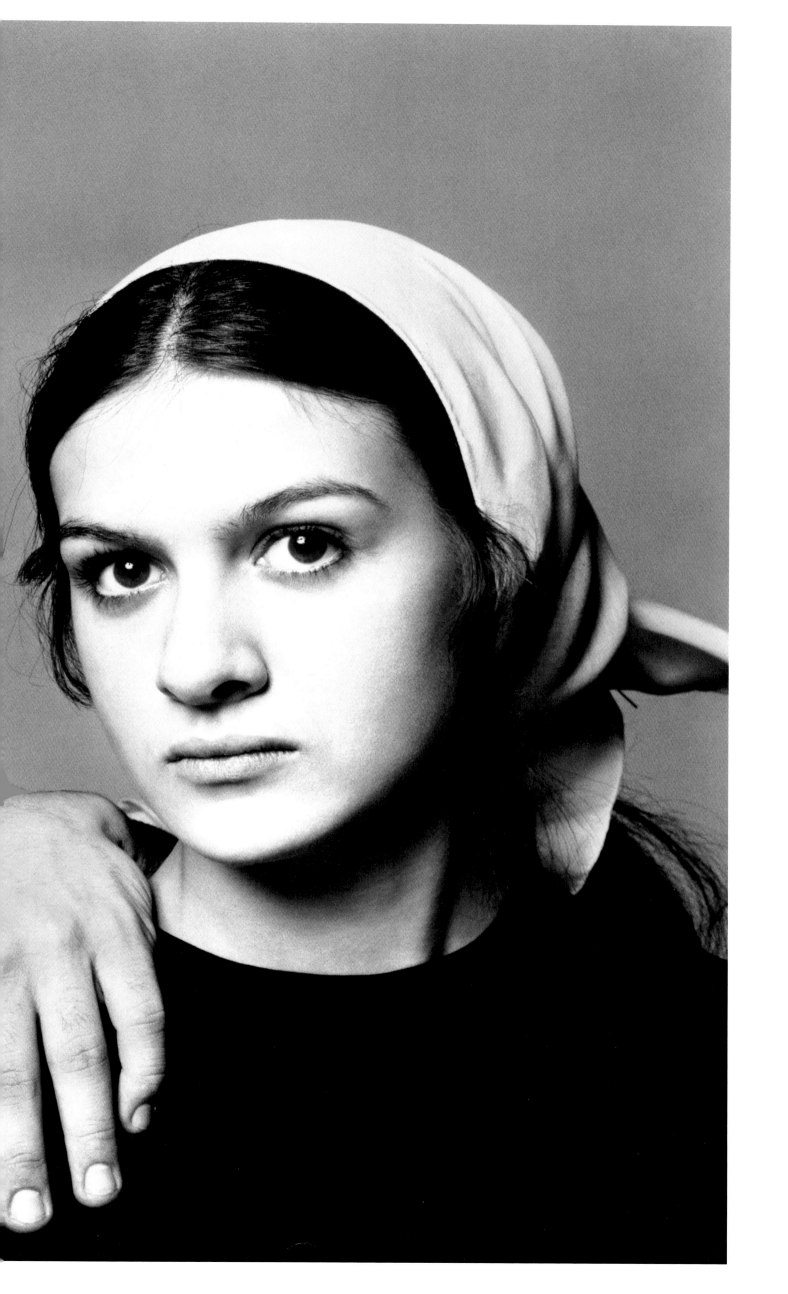

Penelope Tree, model. New York, June 1967

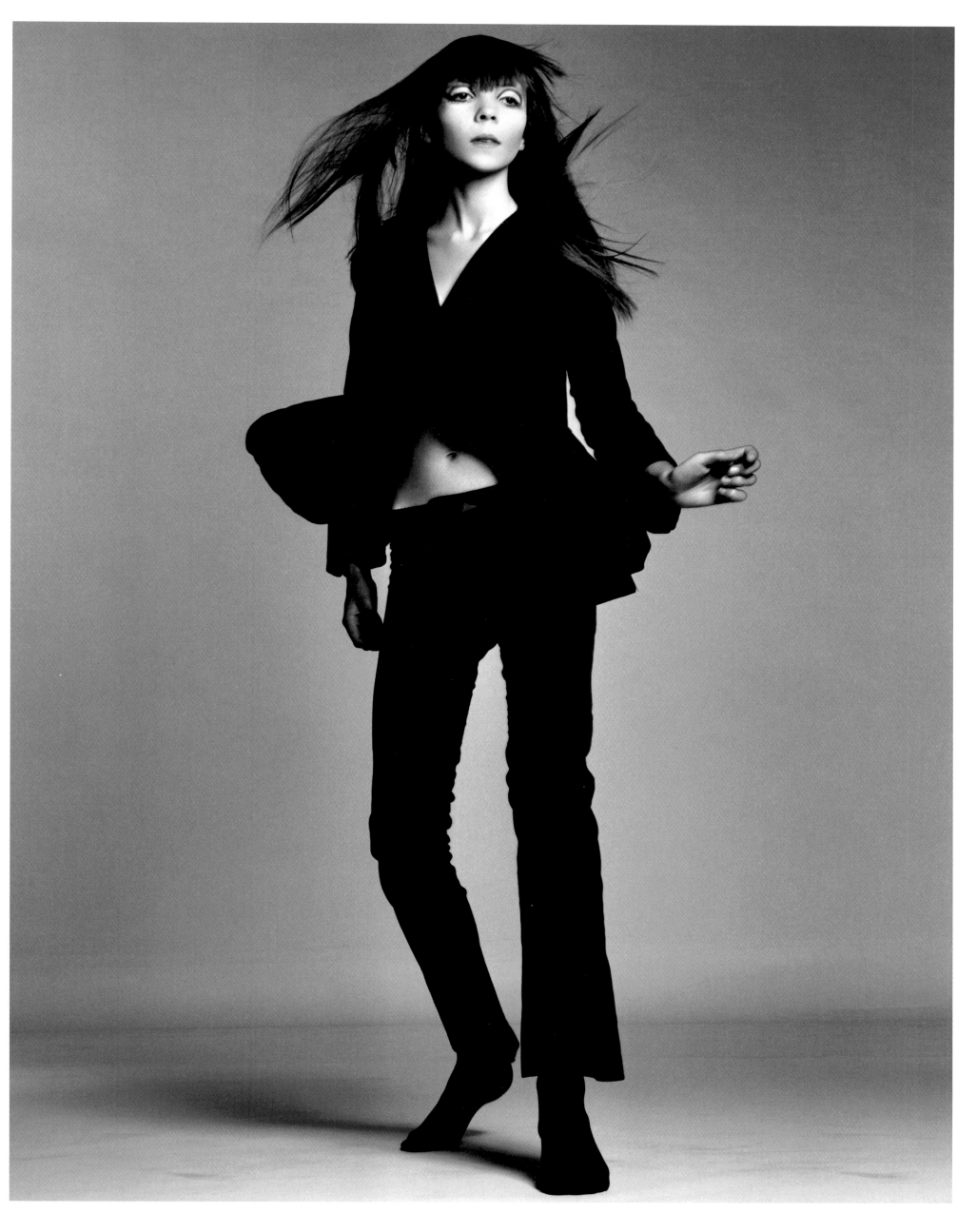

Janis Joplin, singer. New York, August 1969

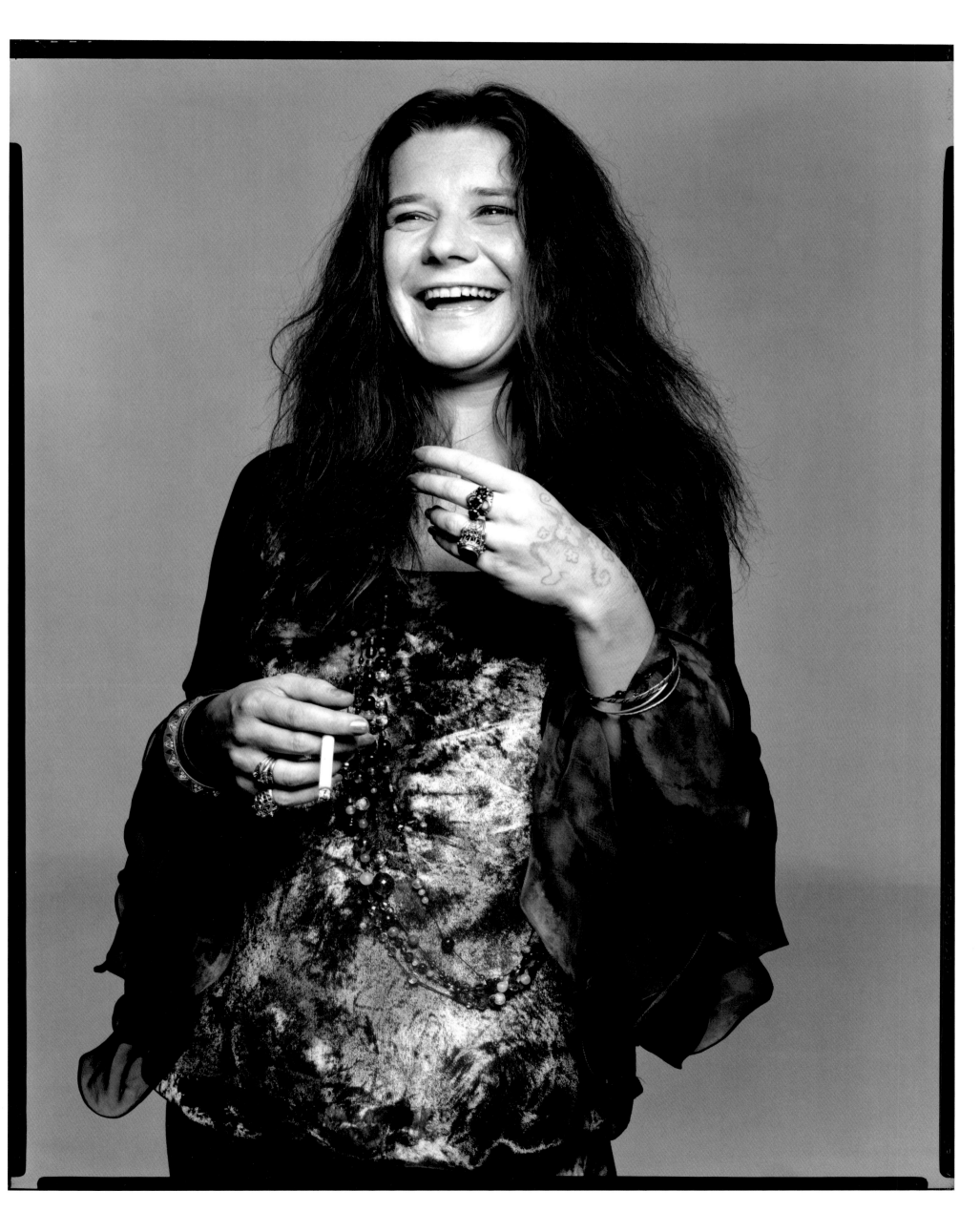

Donyale Luna, model. Dress by Paco Rabanne. New York, December 1966

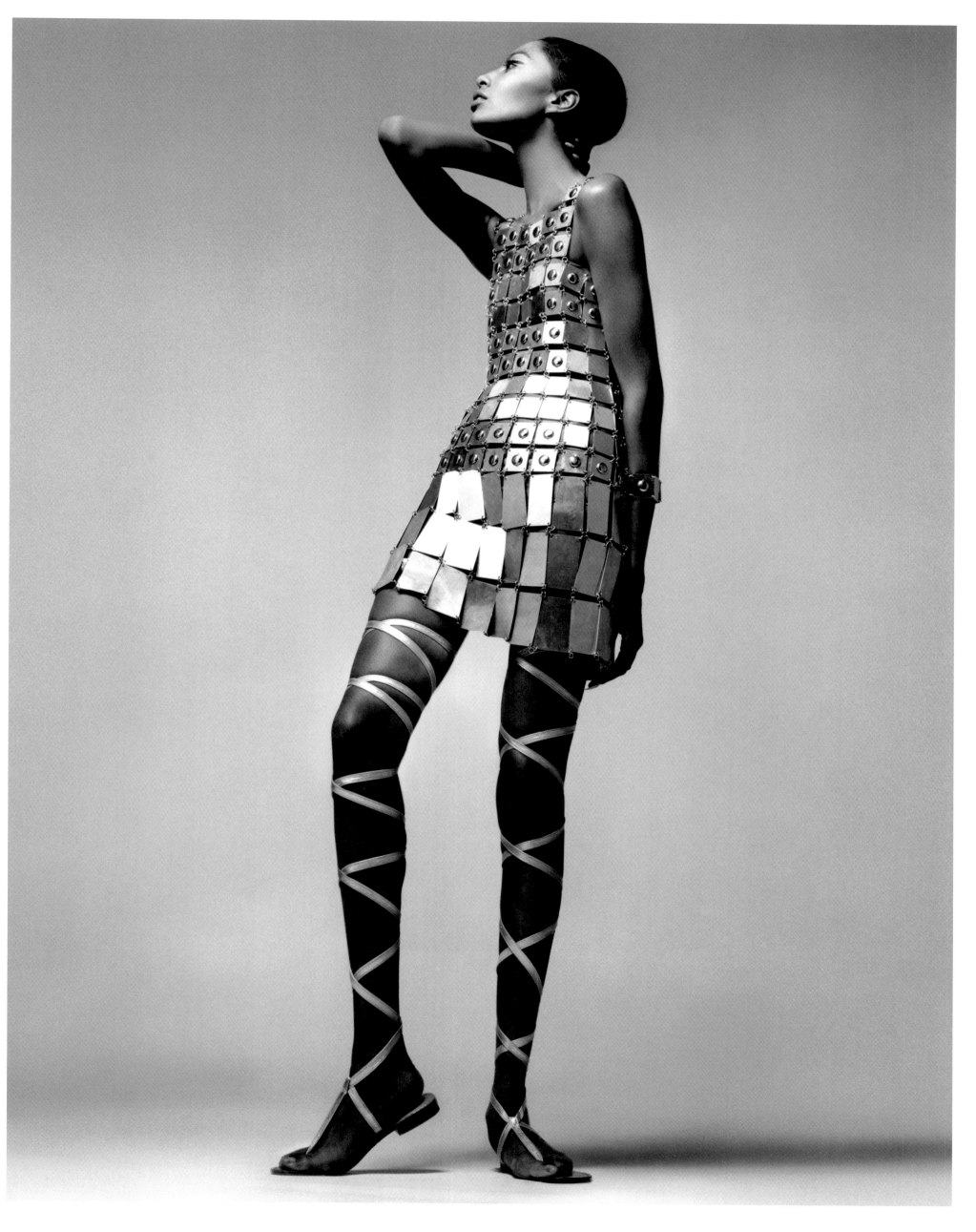

Louise Nevelson, sculptor. New York, May 1975

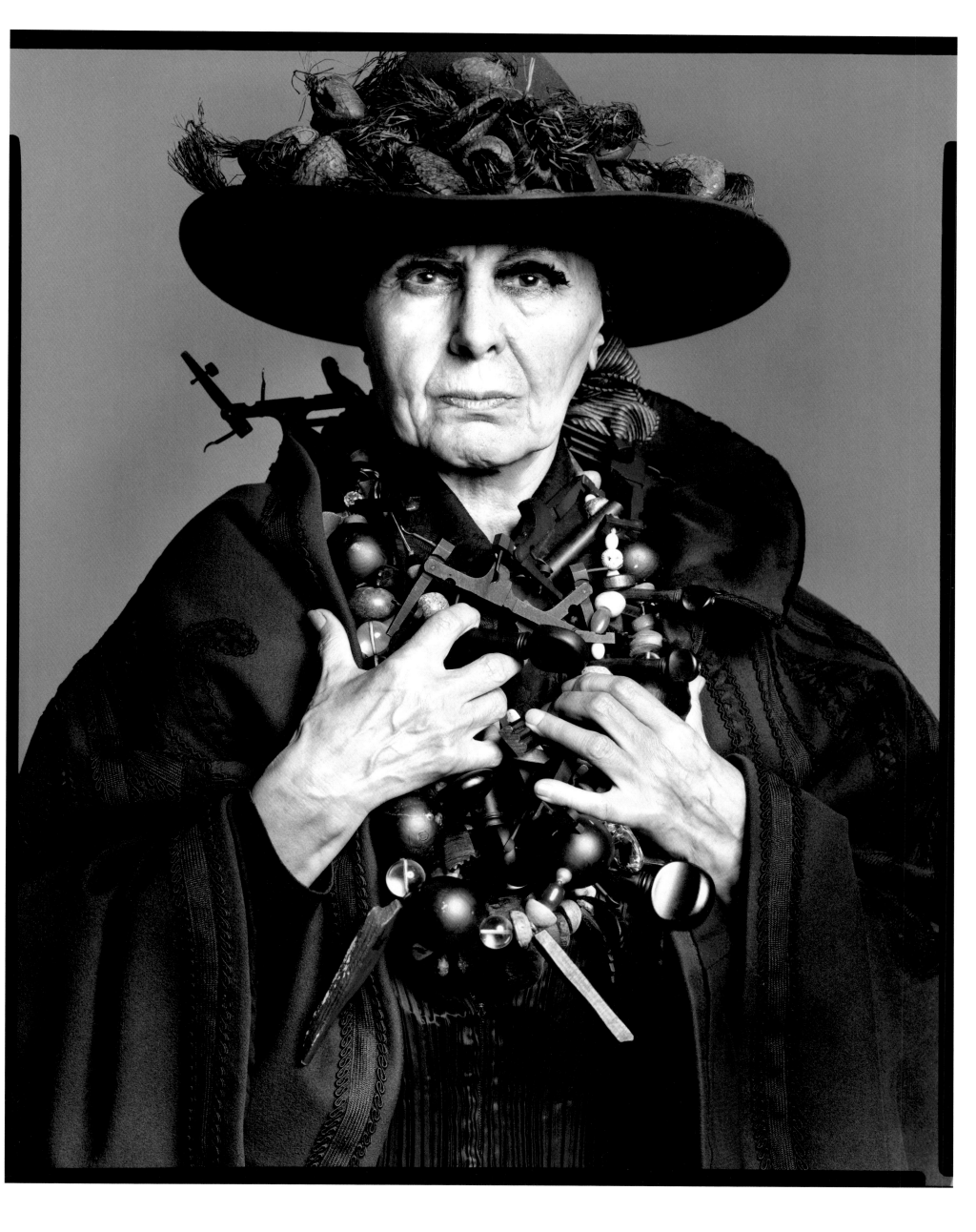

Bianca Jagger, actress. Hollywood, January 1972

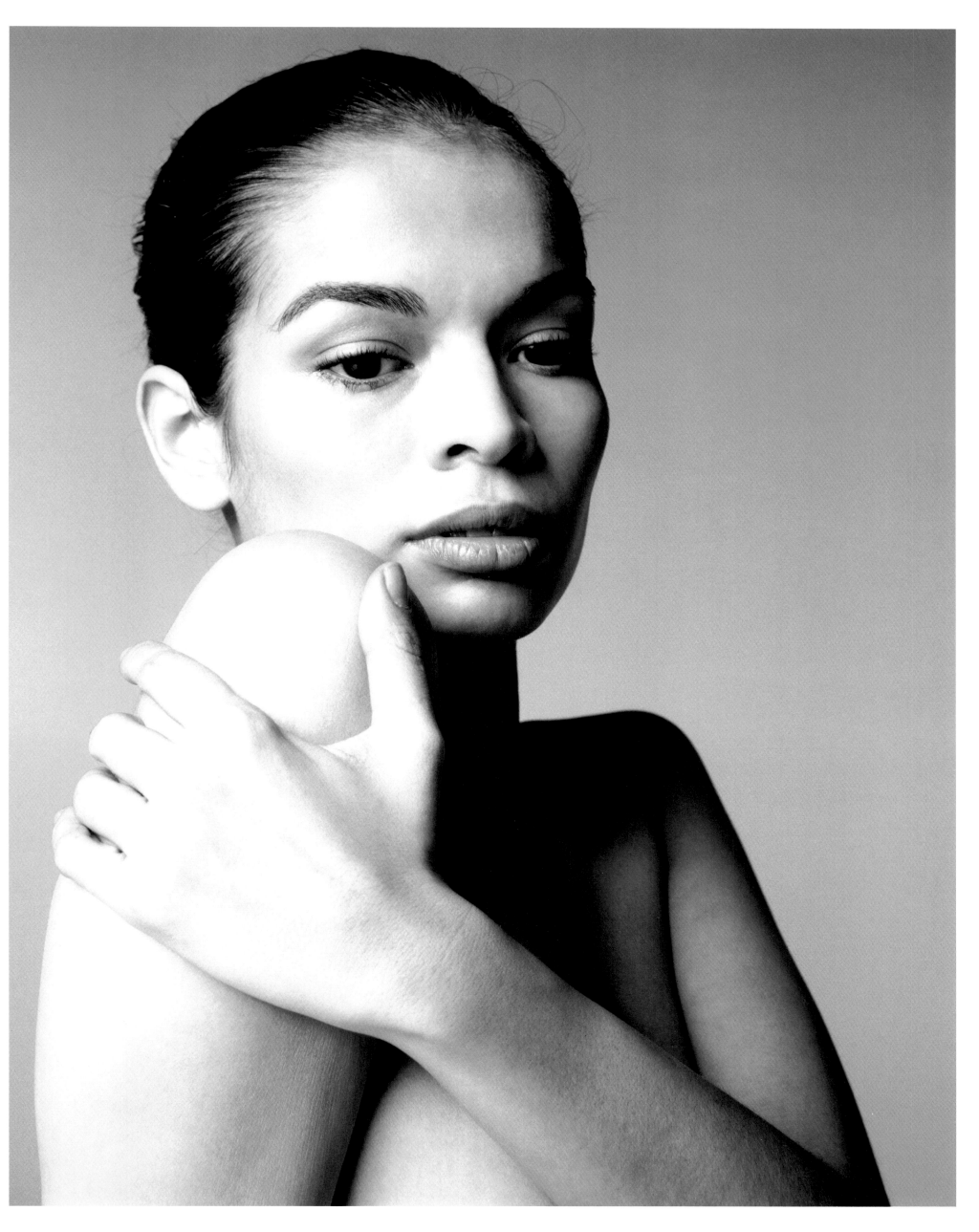

Tina Turner, singer. Dress by Azzaro. New York, June 1971

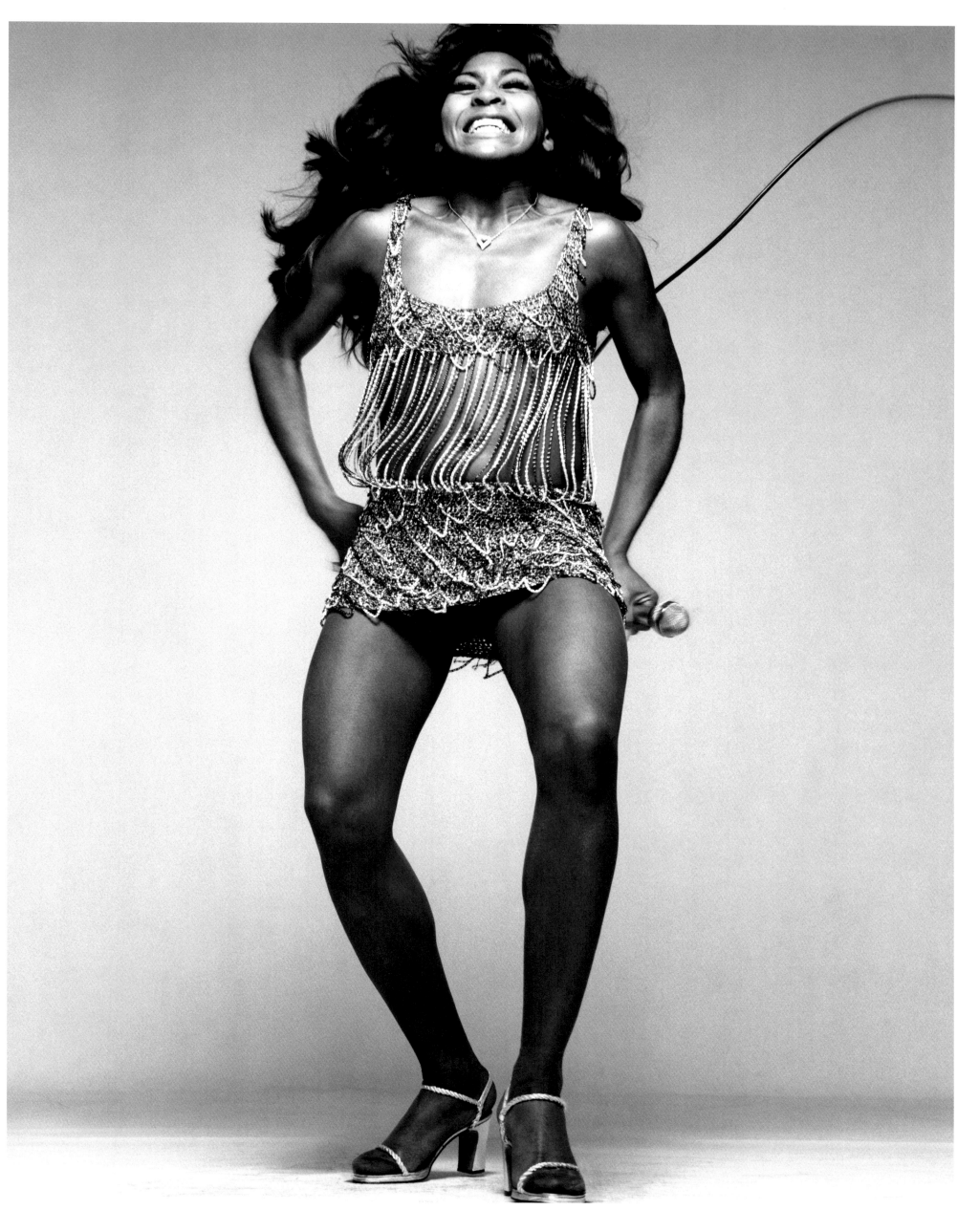

Lauren Hutton, model. Great Exuma, The Bahamas, October 1968

Pages 130–131: Twiggy, model. Hair by Ara Gallant. Paris, January 1968

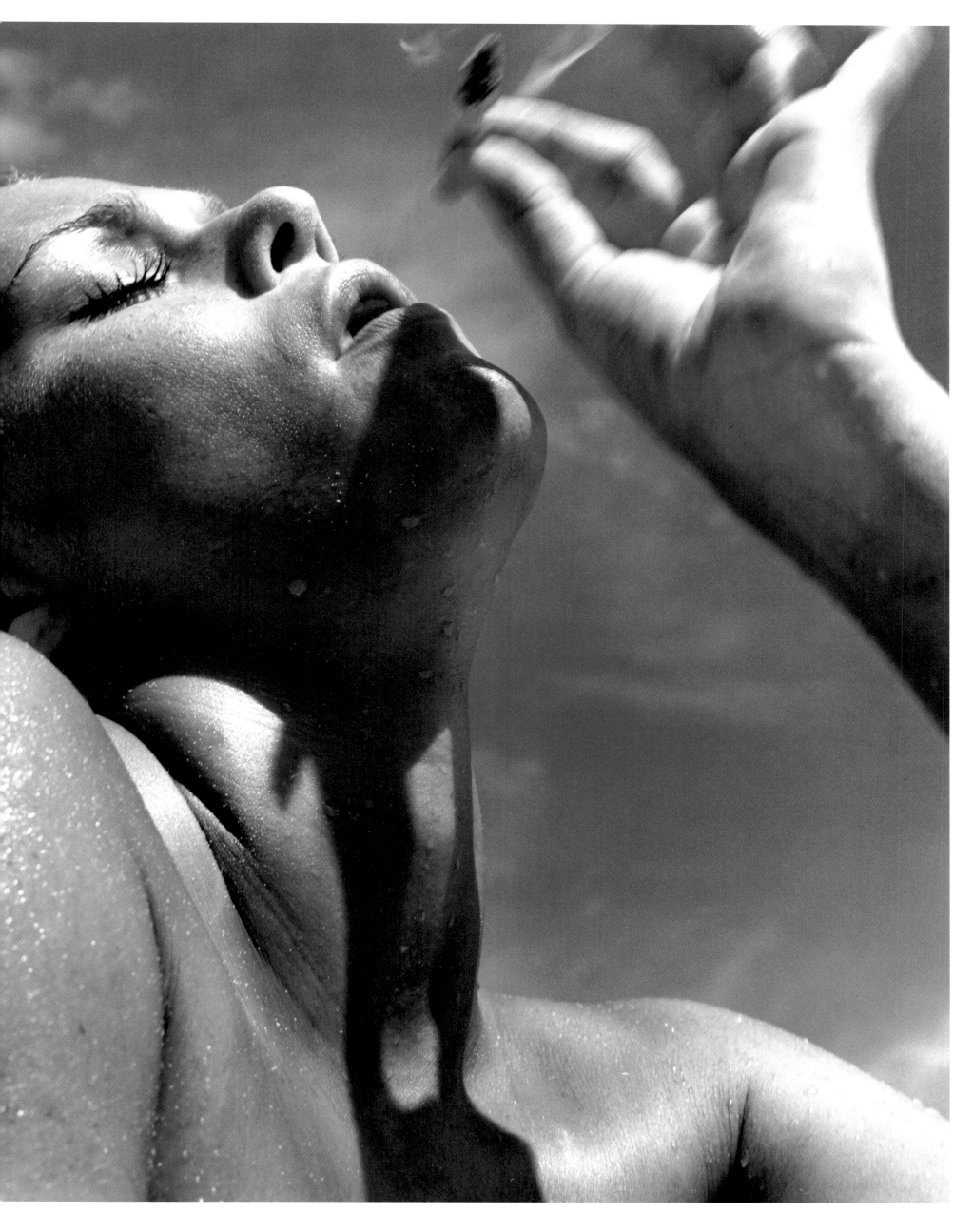

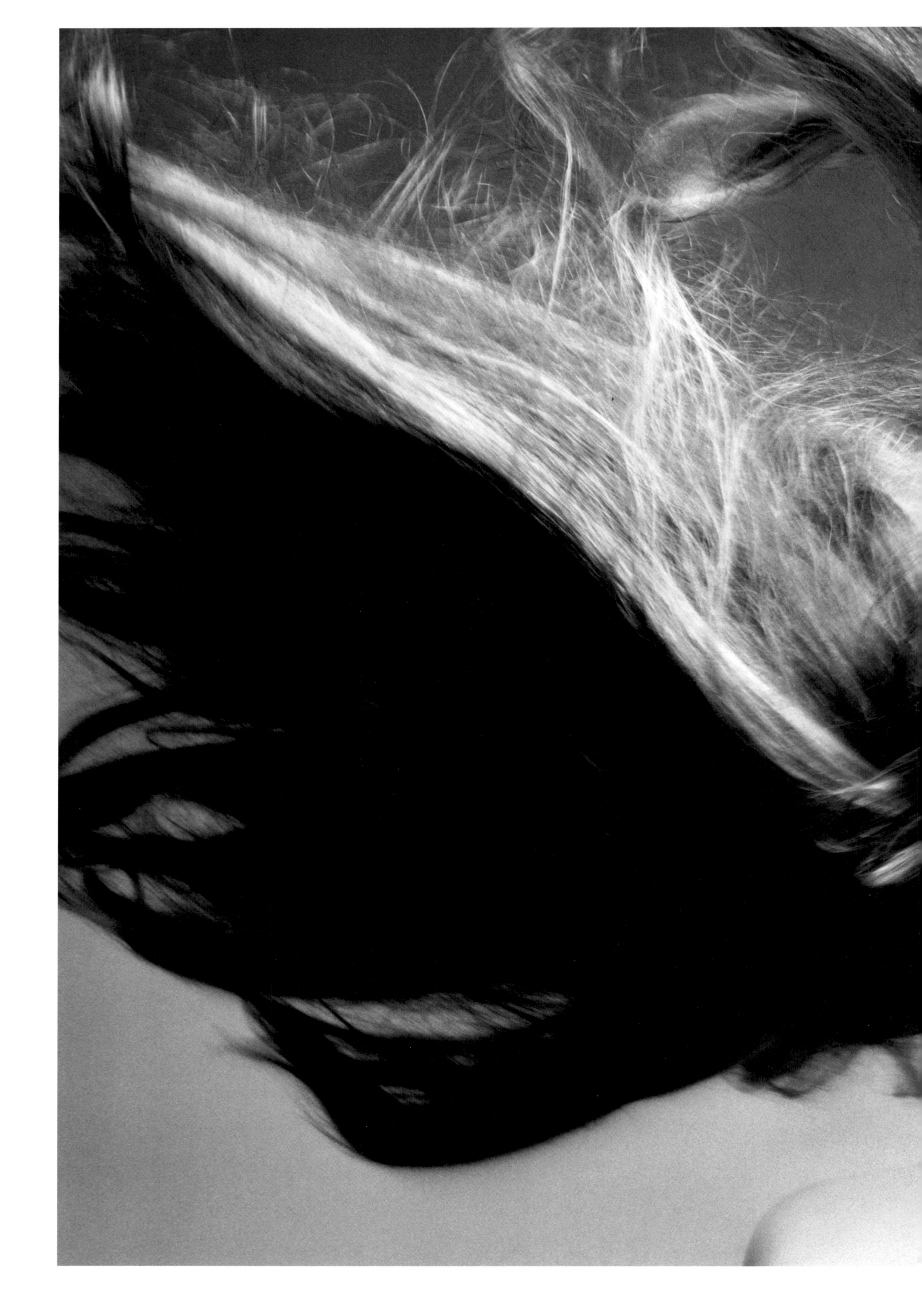

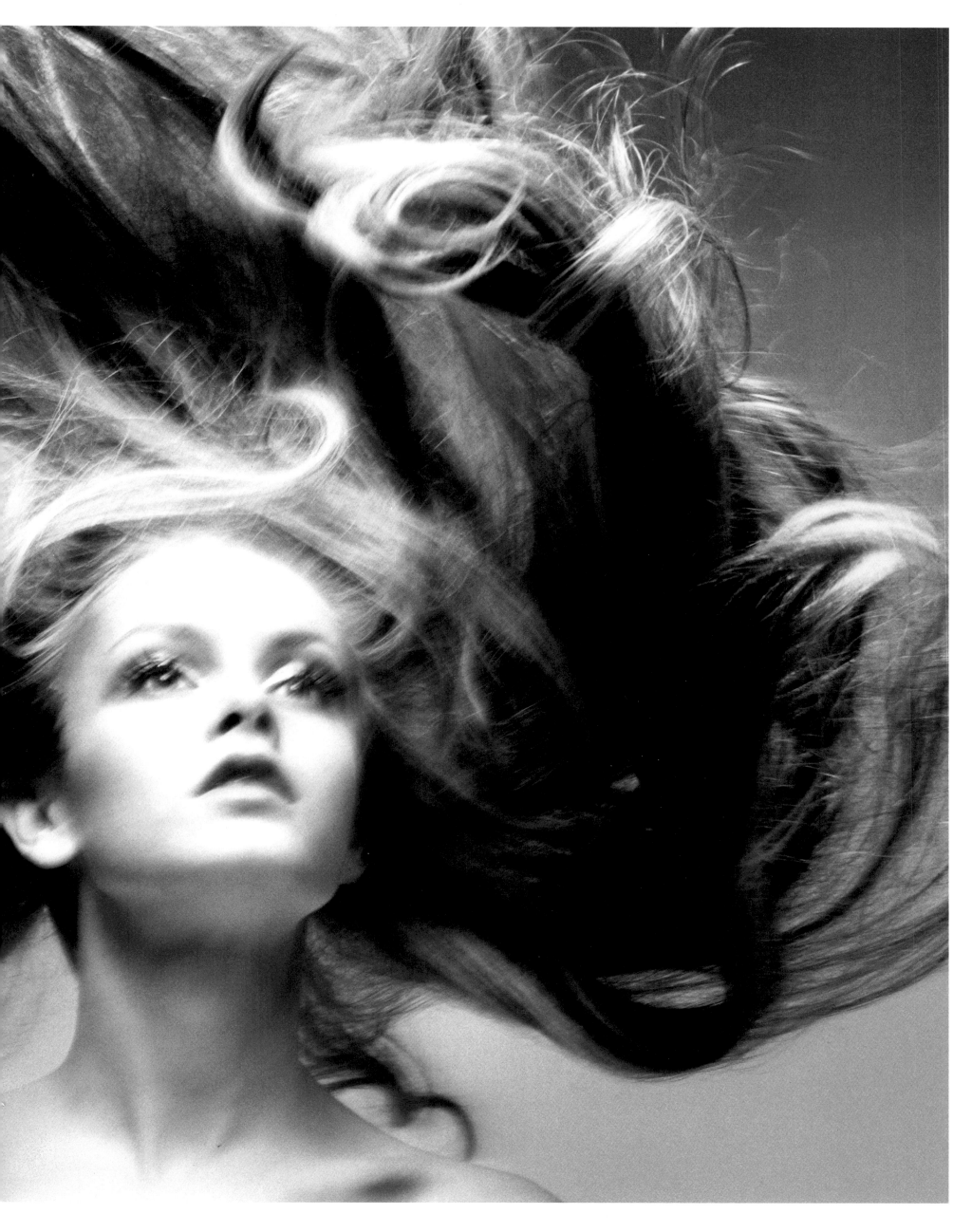

Ingrid Boulting, model. Coat by Dior. Paris, January 1970

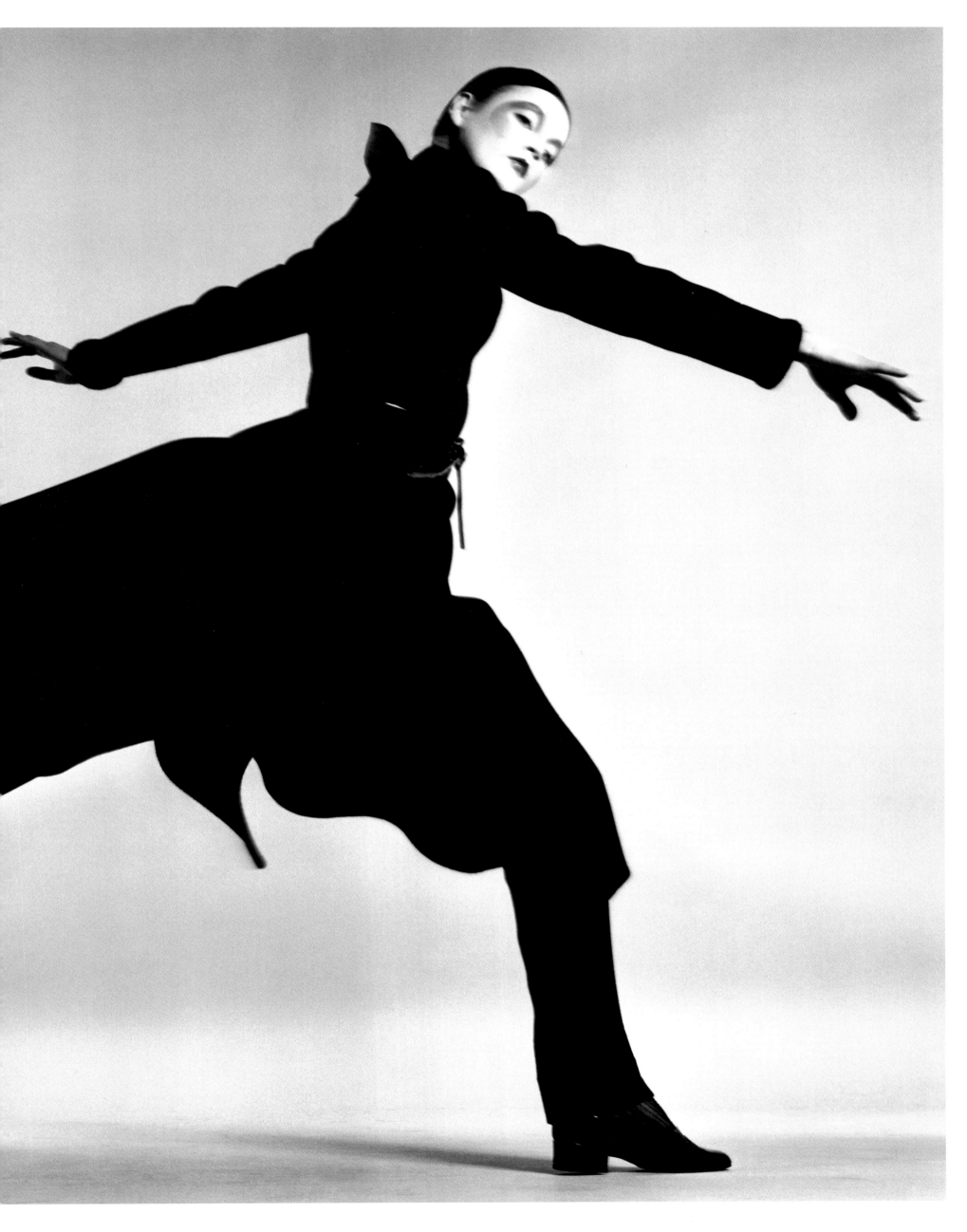

Jean Shrimpton, model. Coat by Ungaro. Paris, January 1970

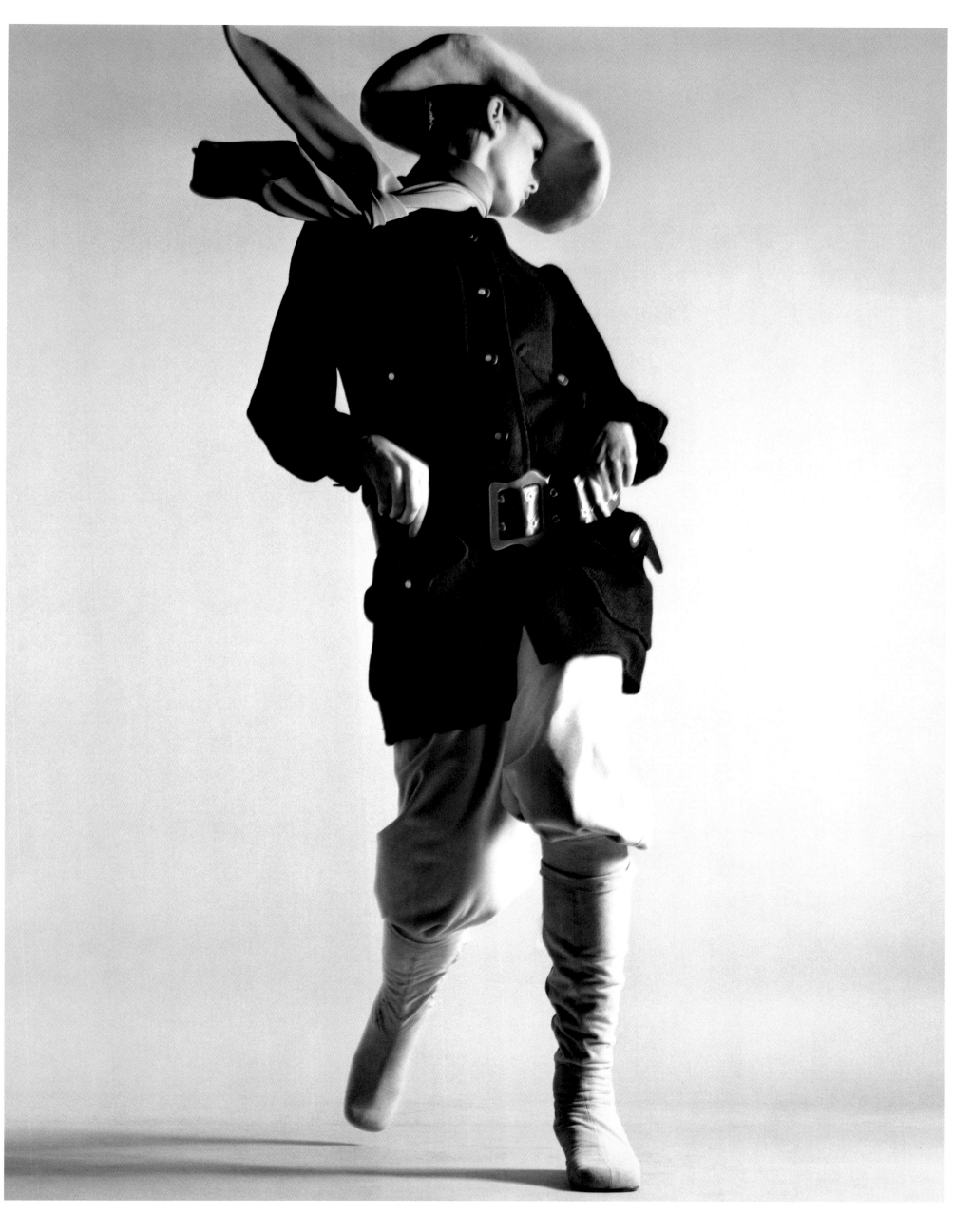

Veruschka, model. Dress by Kimberly. New York, January 1967

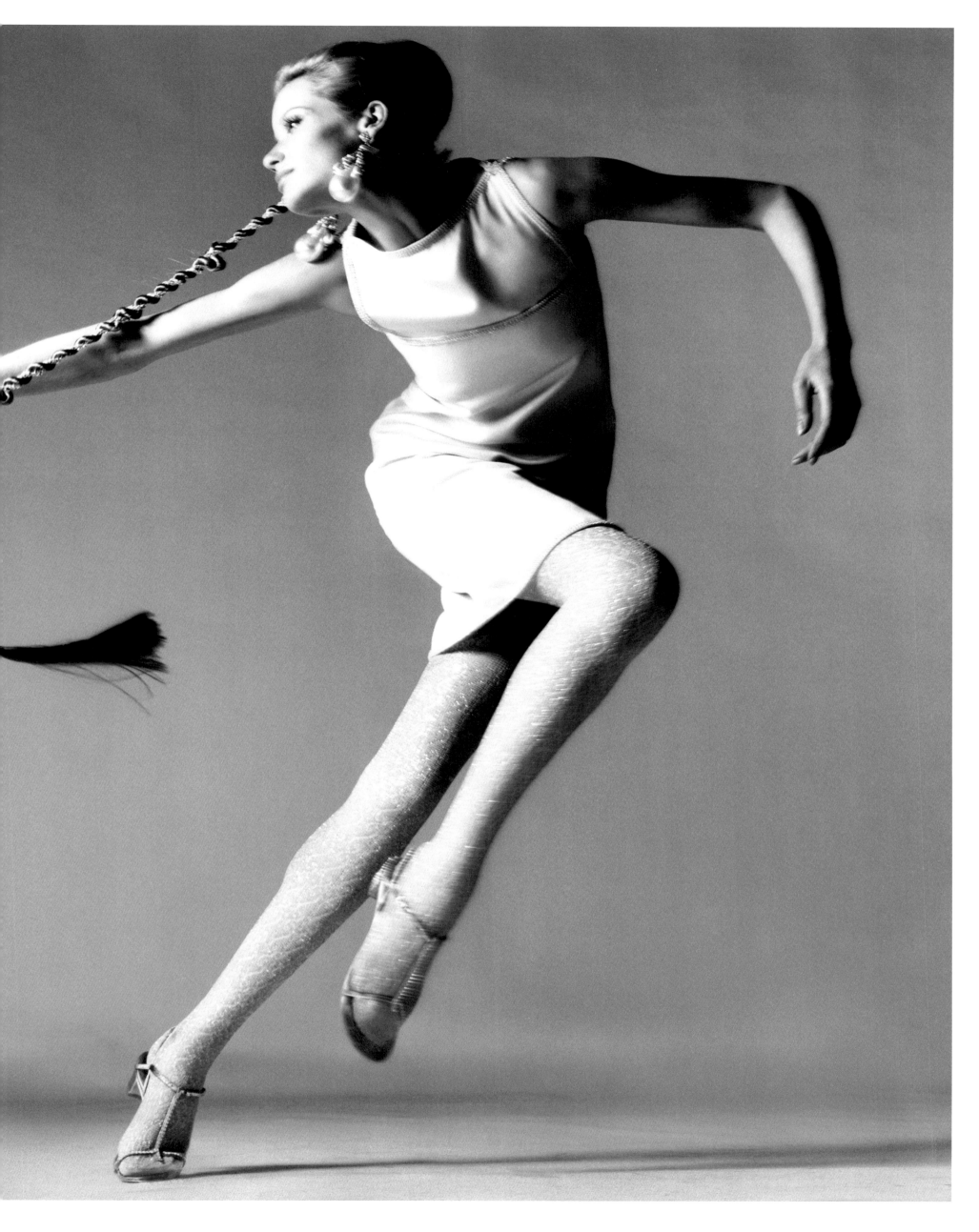

Jean Shrimpton, model. Dress by Cardin. Paris, January 1970

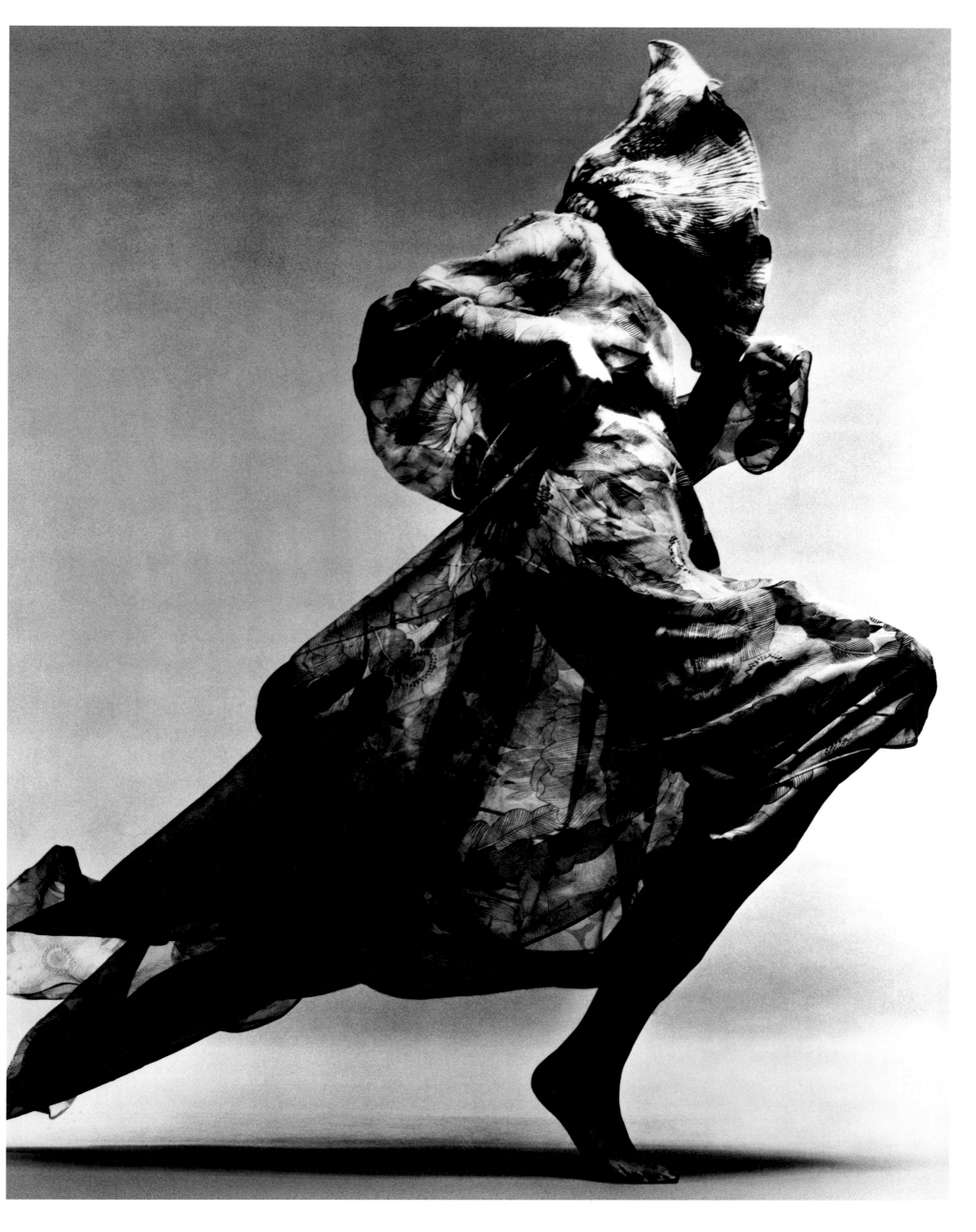

Veruschka, model. Dress by Bill Blass. New York, January 1967

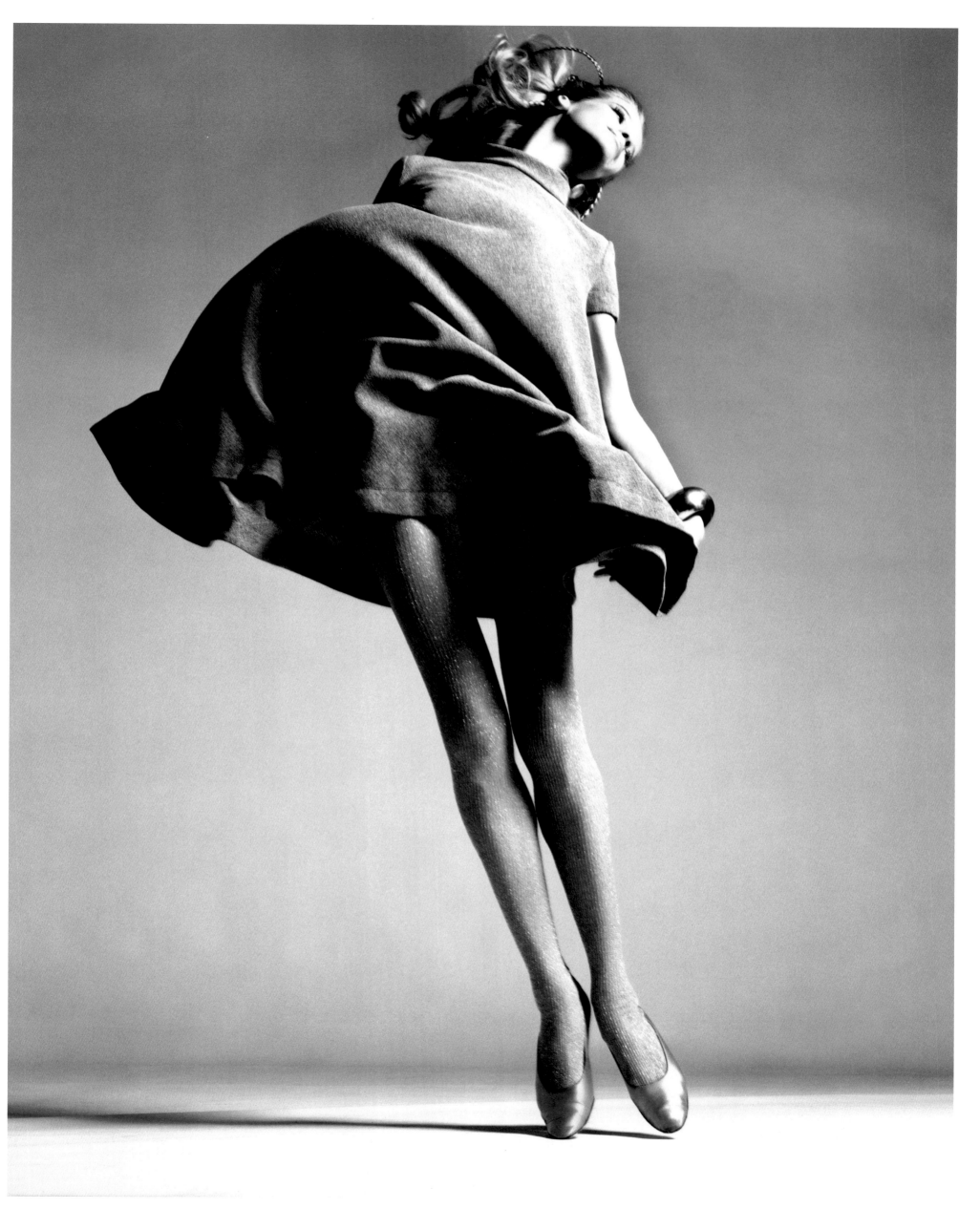

Penelope Tree. Suit by Ungaro. Paris, January 1968

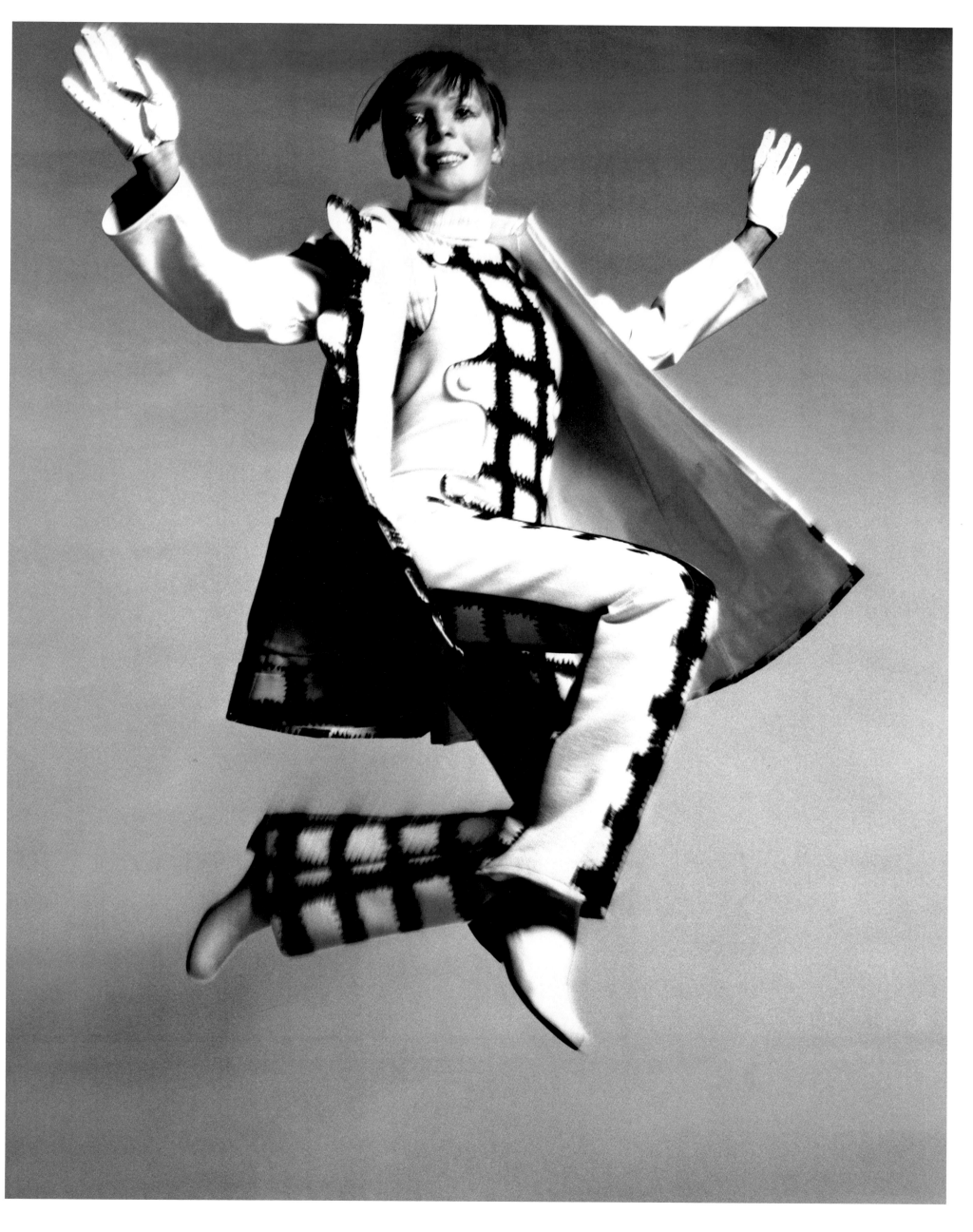

Penelope Tree, model. Dress by Cardin. Paris, January 1968

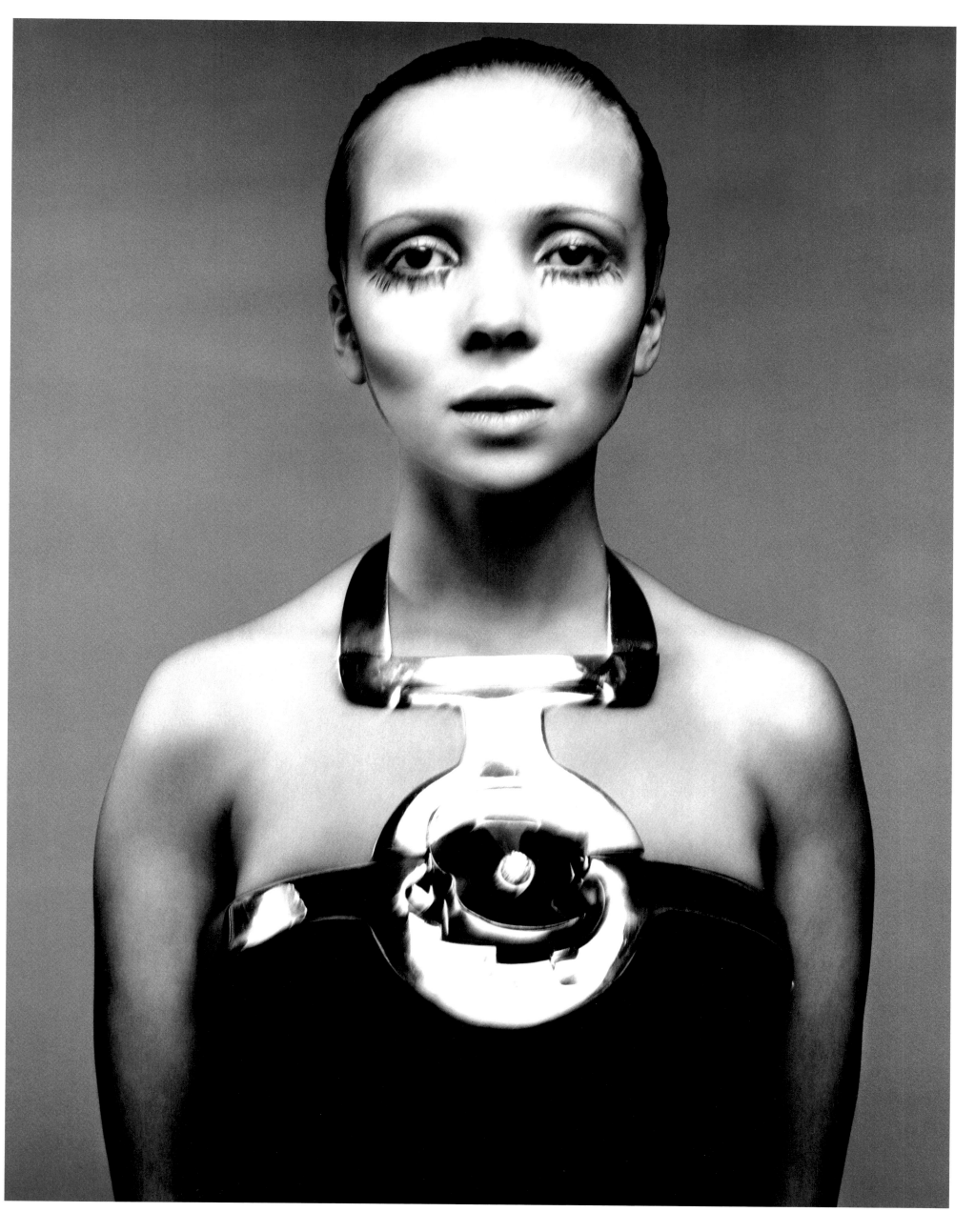

Muriel Rukeyser, poet. New York, July 1975

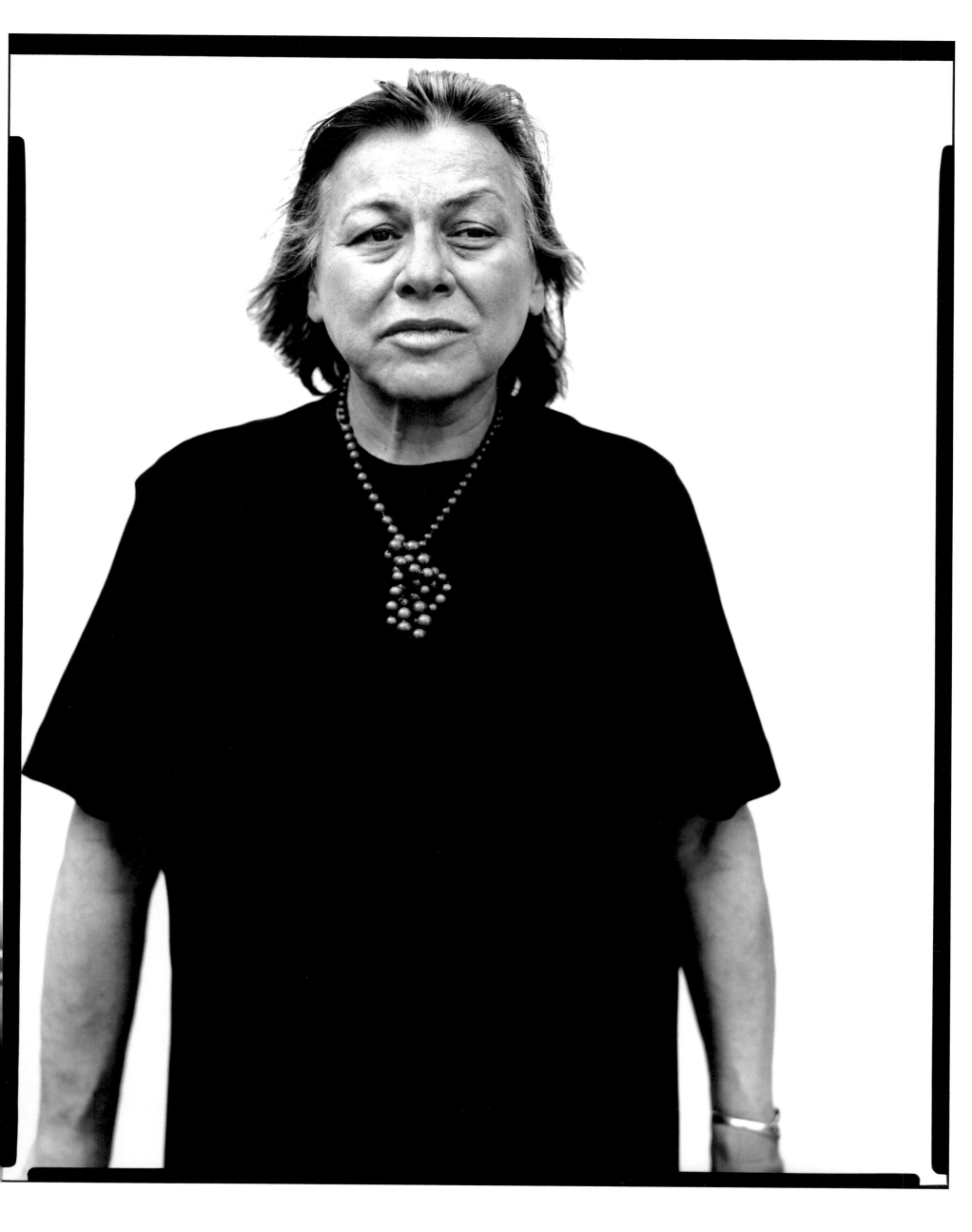

Penelope Tree, model. Dress by Dorcia Originals, hair by Ara Gallant. New York, July 1967

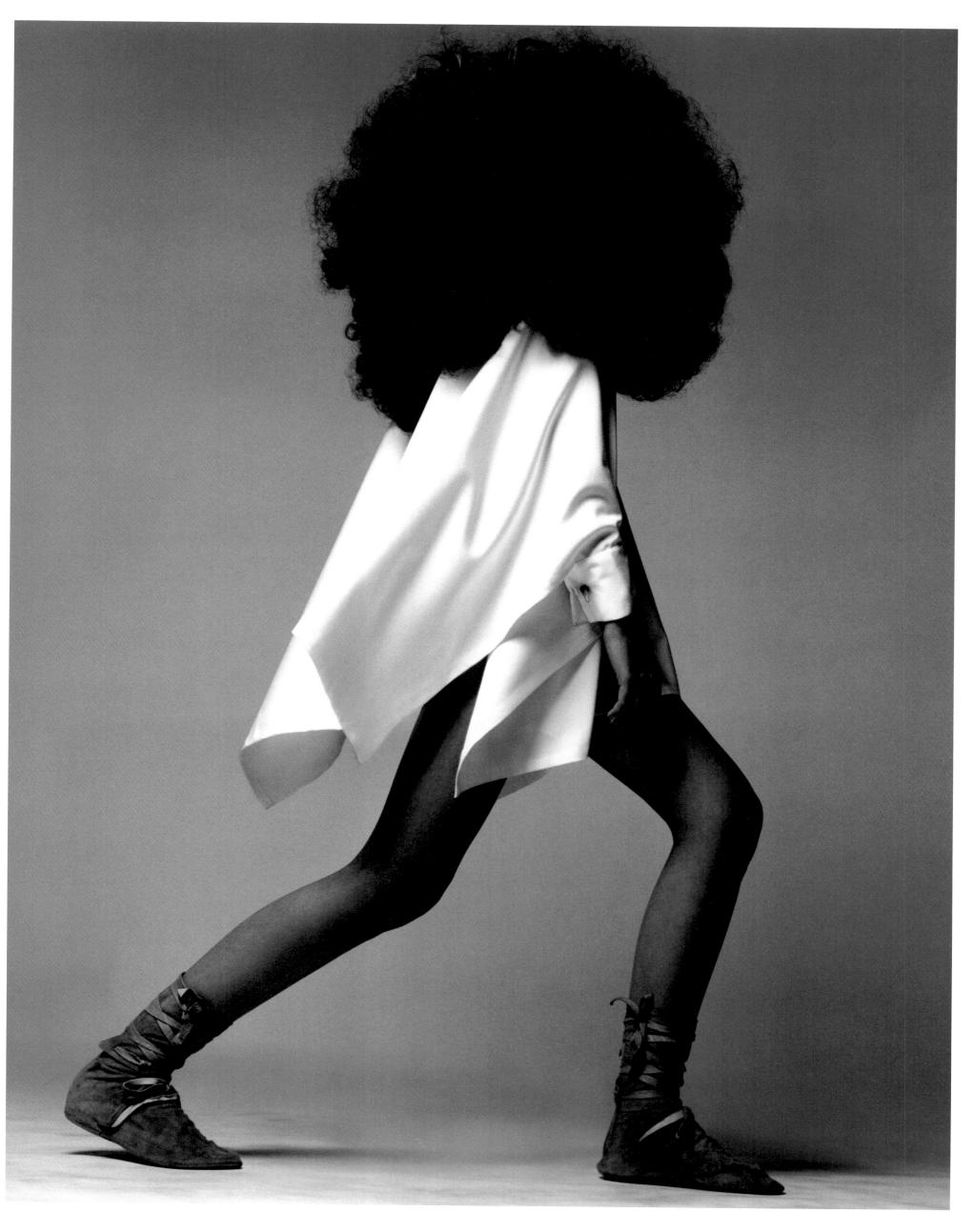

Debbie McClendon, carney. Thermopolis, Wyoming, July 1981

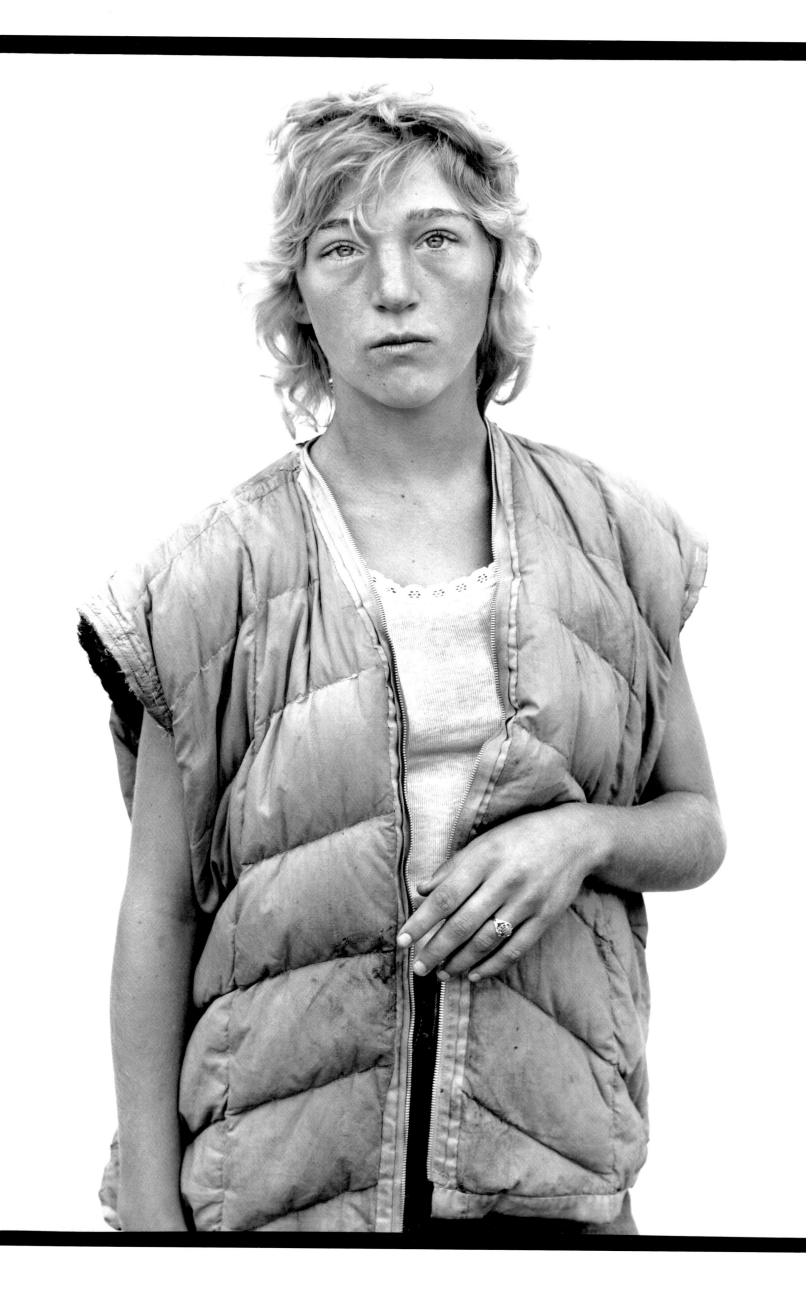

Evelyn Avedon, wife of Richard Avedon. New York, July 1975

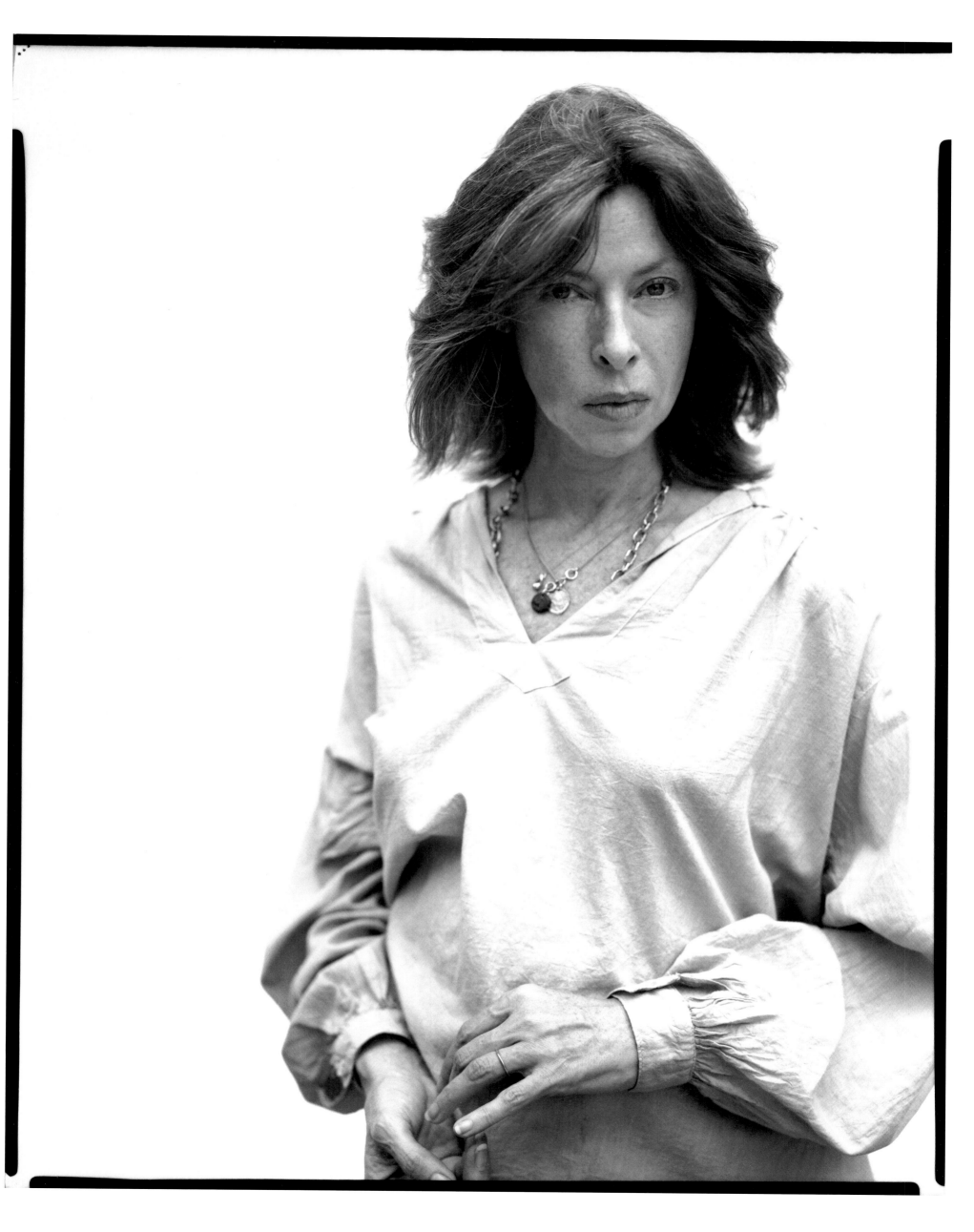

Penelope Tree, model. Mask by Ungaro. Paris, January 1968

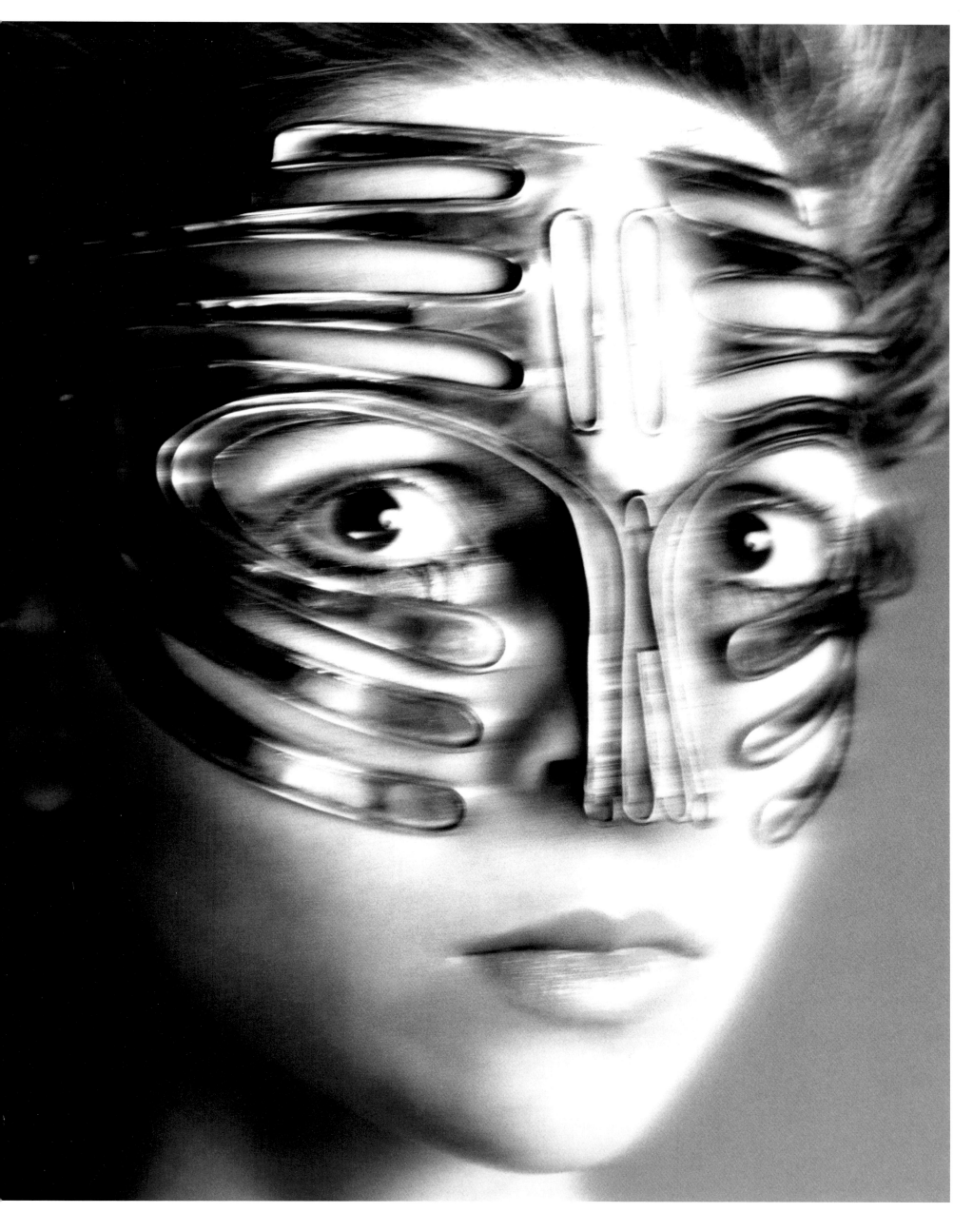

Polly Mellen, fashion editor. New York, August 1975

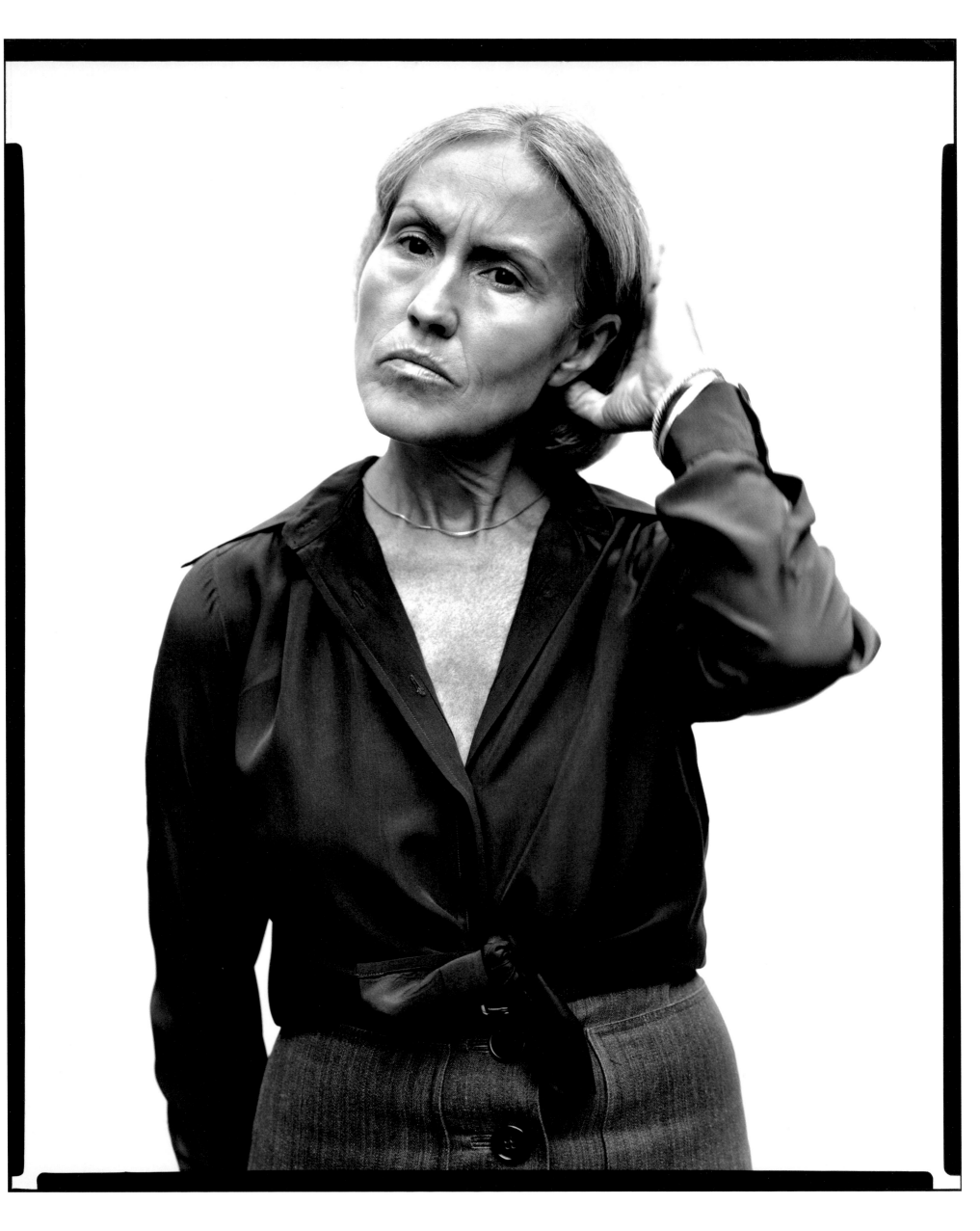

Stephanie Seymour, model. Dress by Comme des Garçons. New York, May 1992

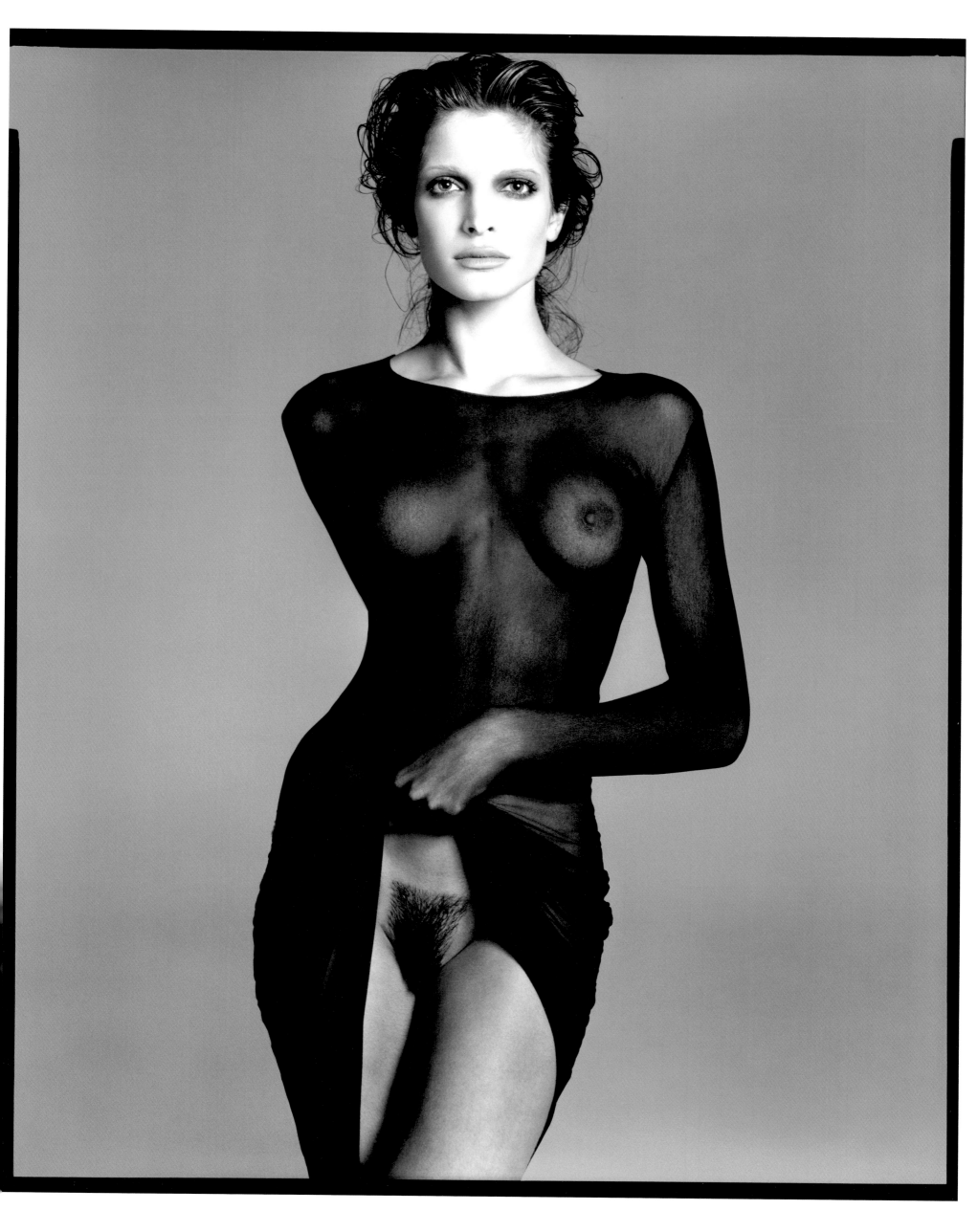

Annette Gonzales and her sister Lydia Ranck, housewife and secretary.
Santuario de Chimayo, New Mexico, April 1980

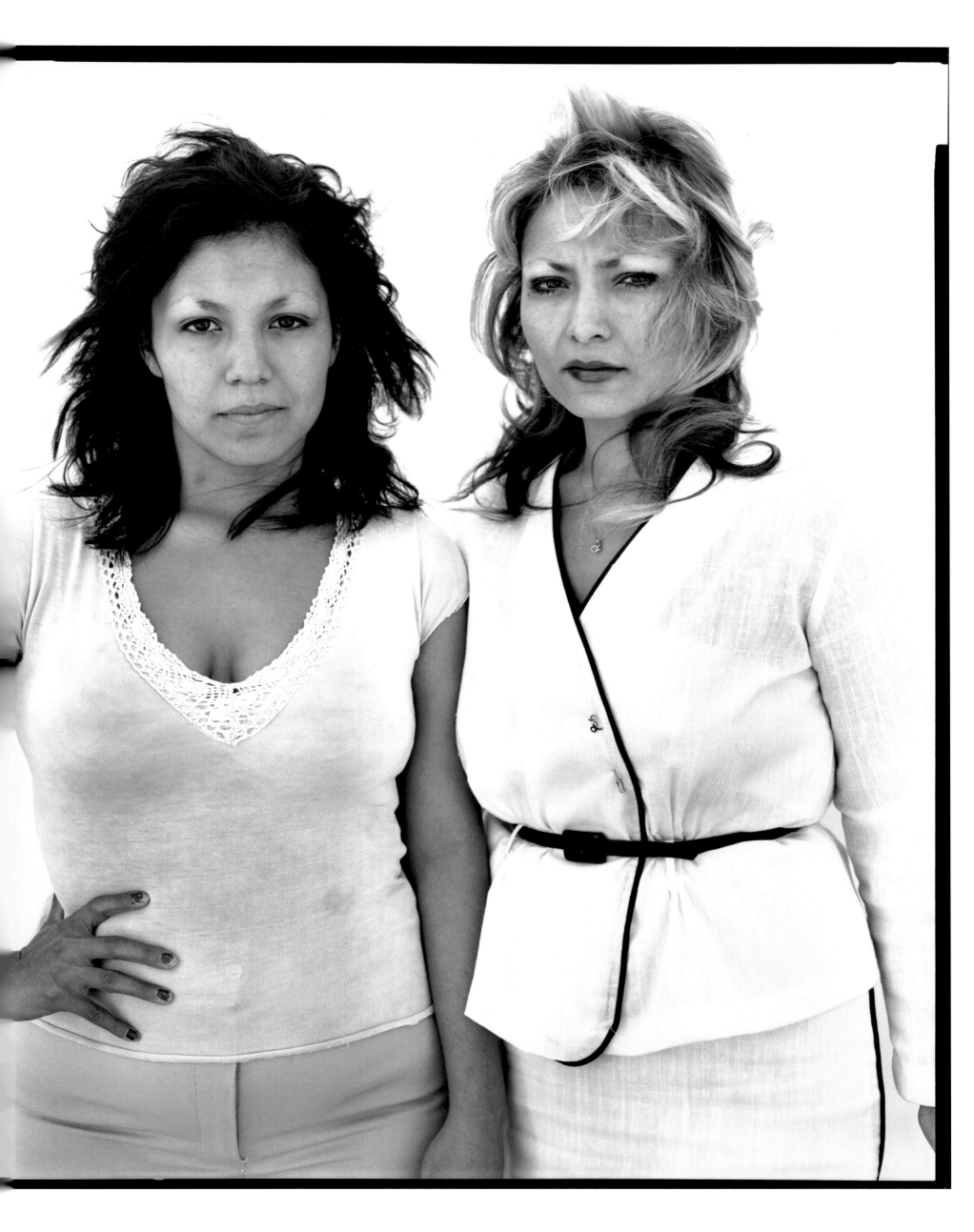

Patricia Wilde, housekeeper. Kalispell, Montana, June 1981

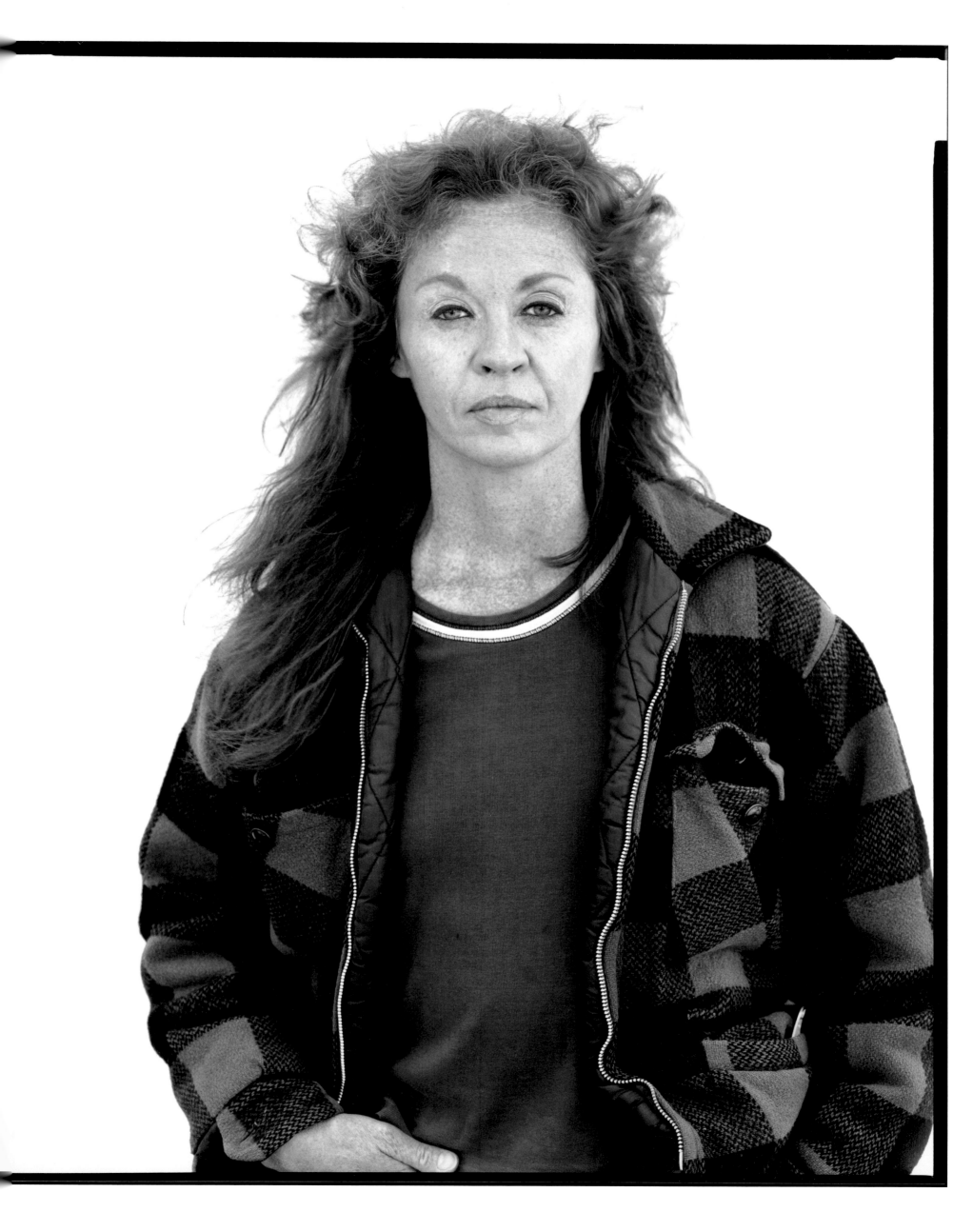

Stephanie Seymour, model. Dress by Comme des Garçons. New York, April 1996

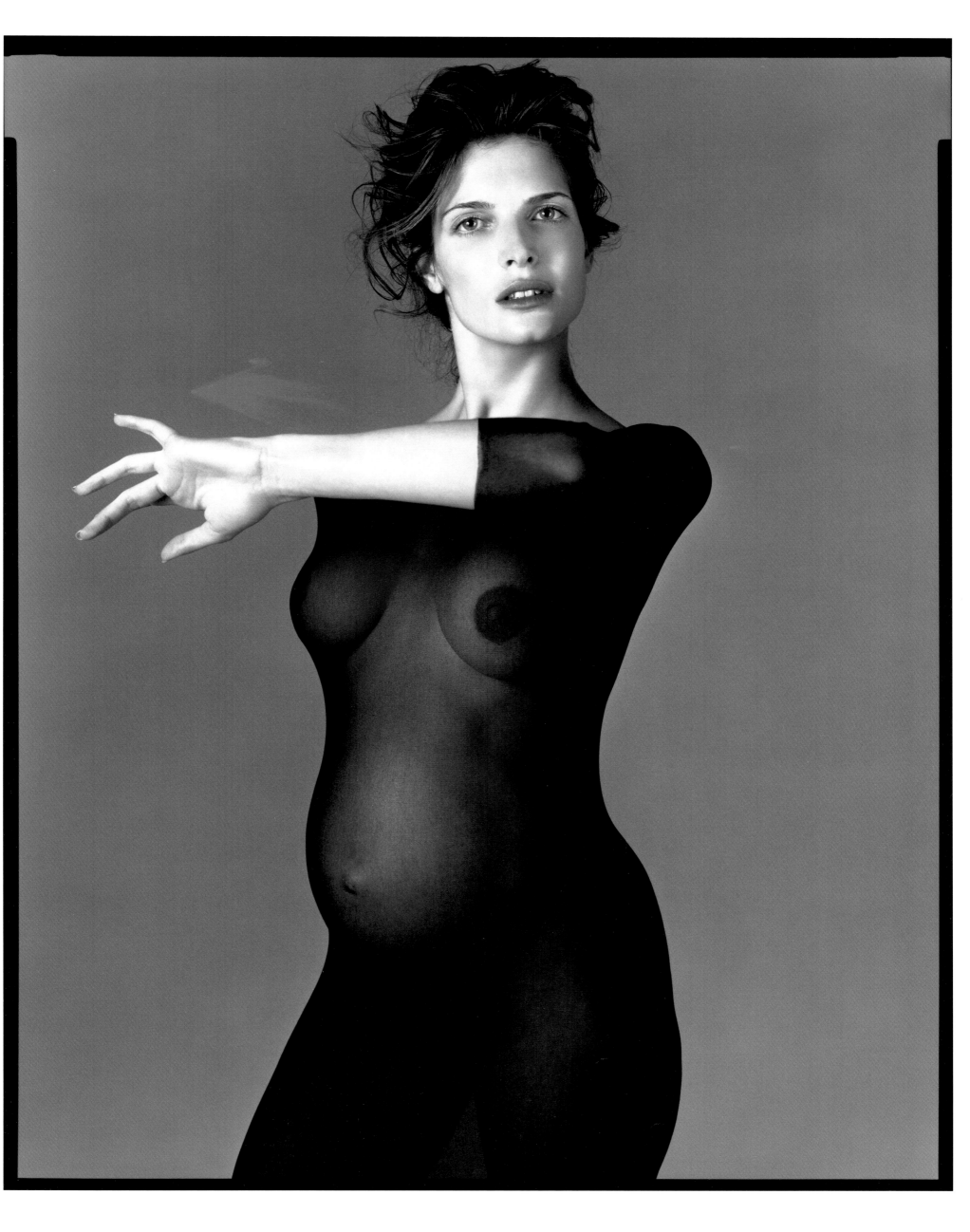

June Leaf, artist. Mabou Mines, Nova Scotia, July 1975

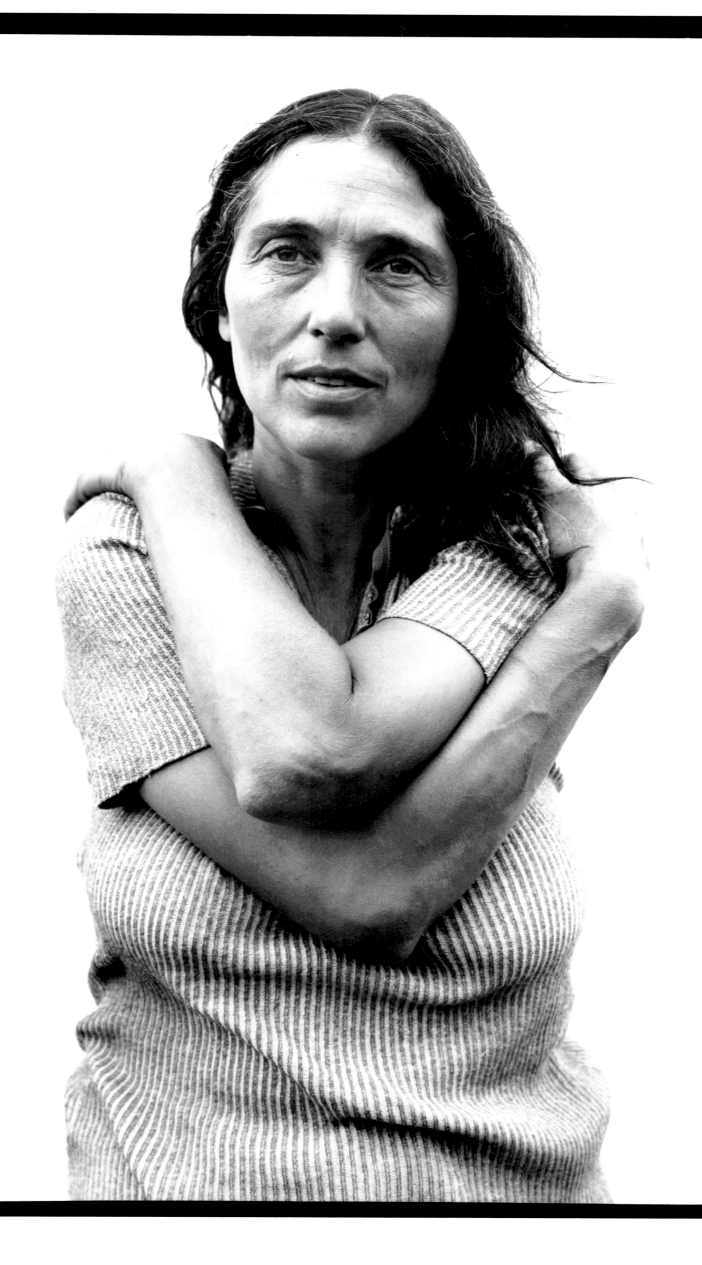

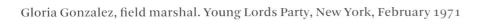

Gloria Gonzalez, field marshal. Young Lords Party, New York, February 1971

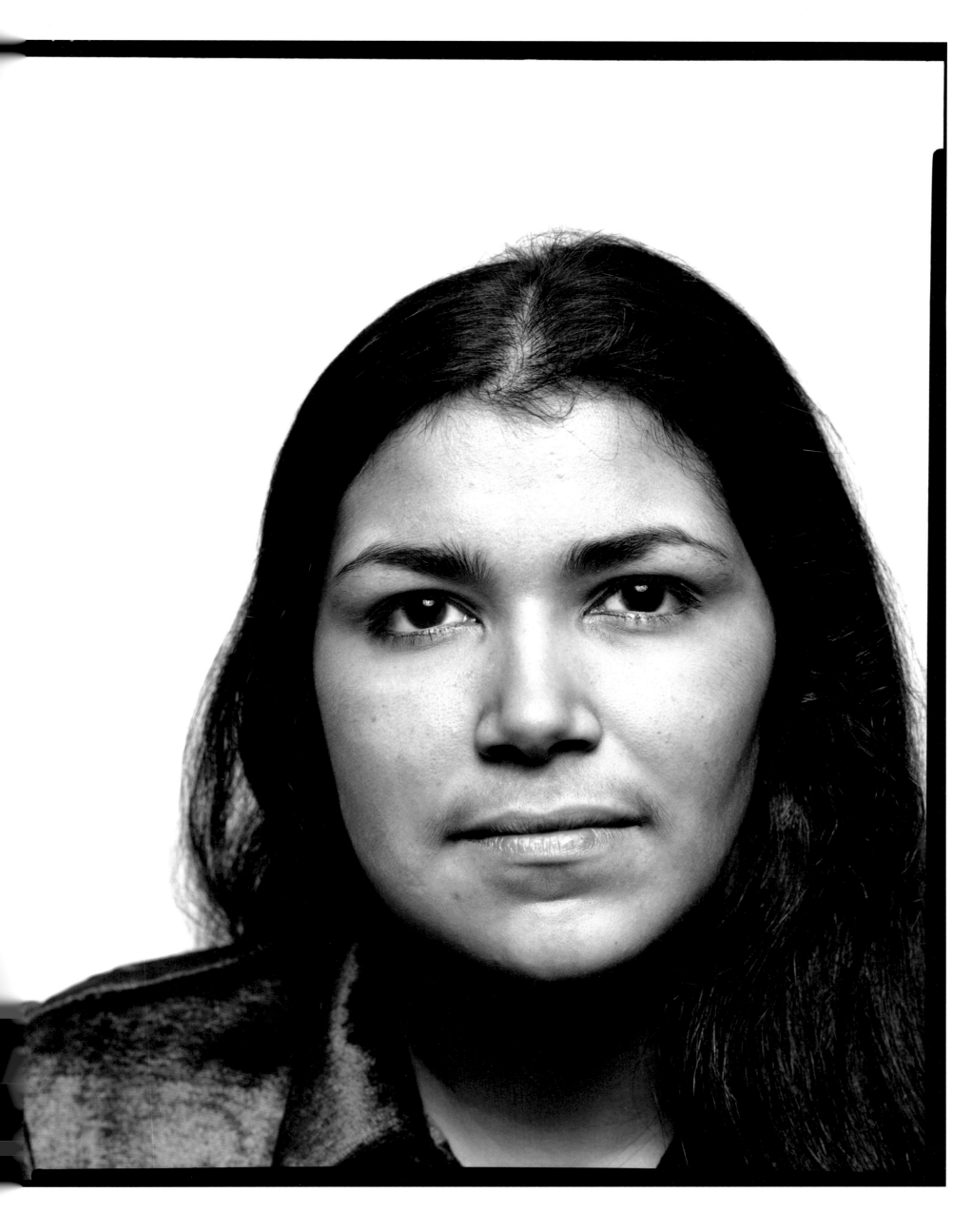

Rose Fitzgerald Kennedy, mother of President John F. Kennedy.
Hyannisport, Massachusetts, September 1976

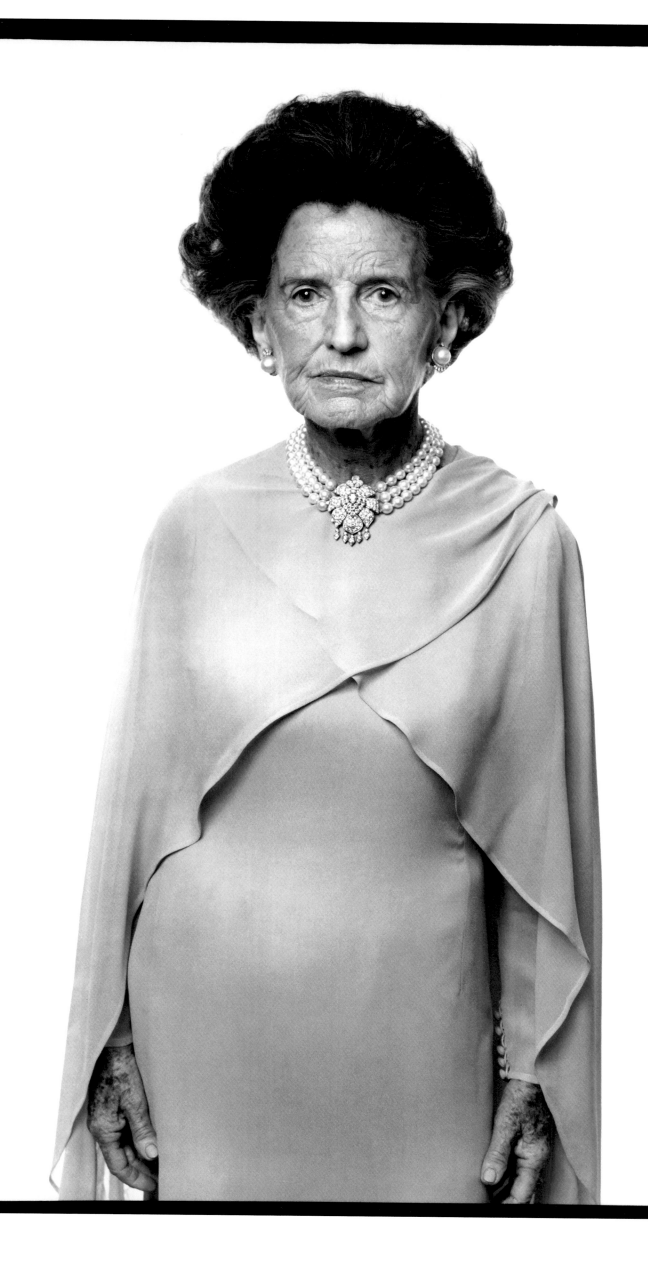

Renata Adler, writer. St. Martin, March 1978

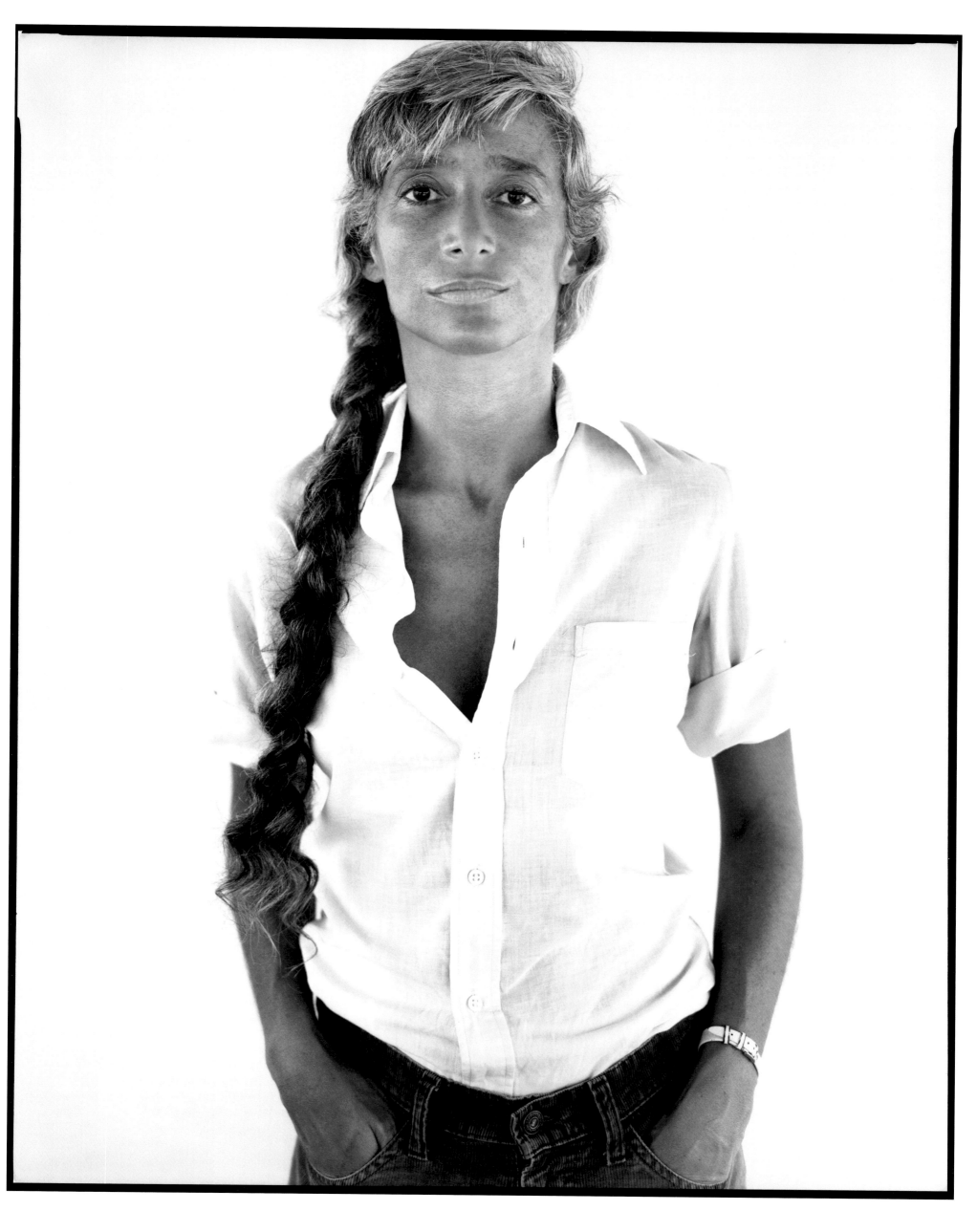

Pages 175–177 : Elizabeth Tilberis, Suzy Menkes, Franca Sozzani, Joan Juliet Buck,
Amy Spindler, Marina Schiano, Grace Coddington, Polly Mellen, André Leon Talley,
Regis Pagniez, and Anna Piaggi, fashion editors. Milan, October 1994

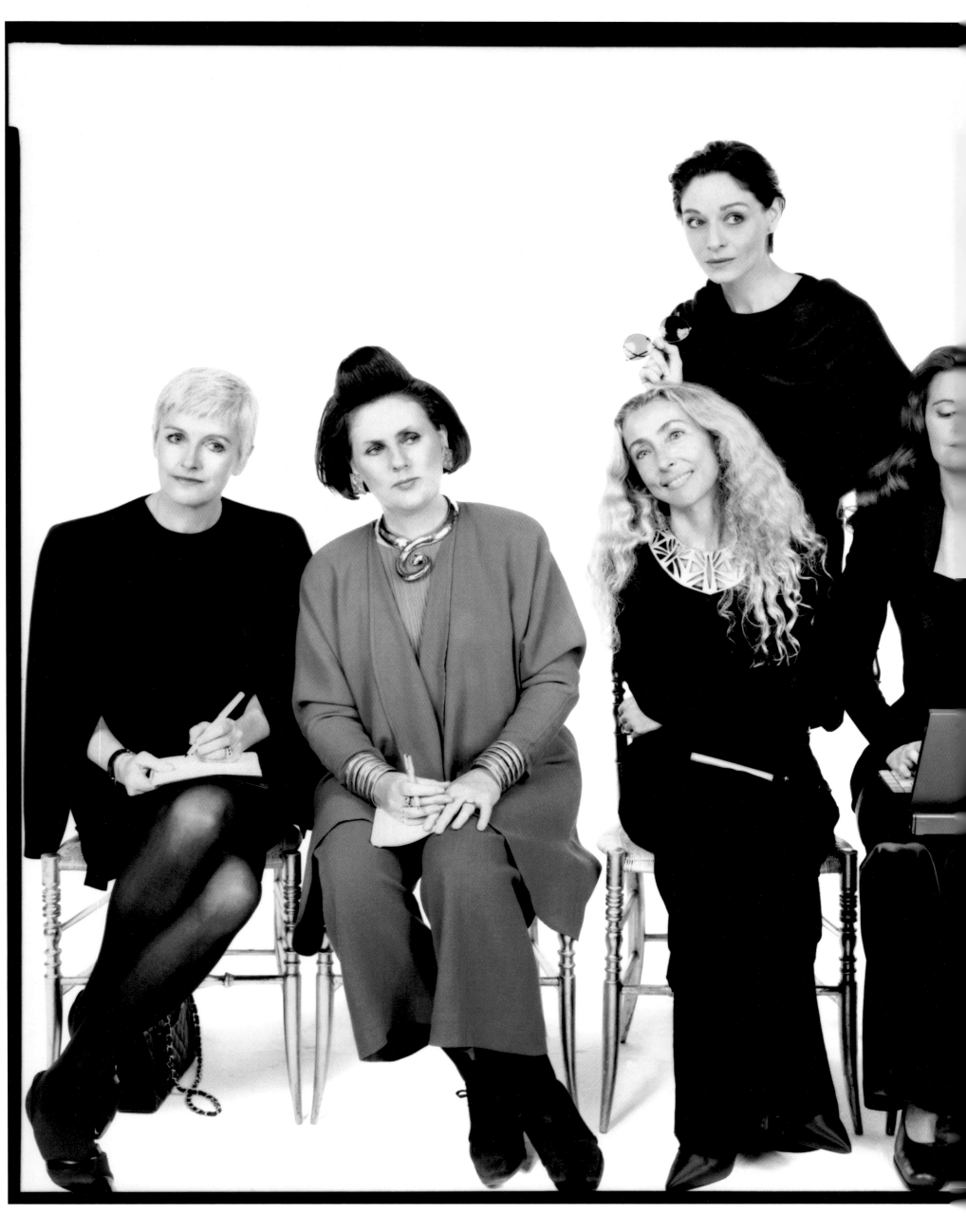

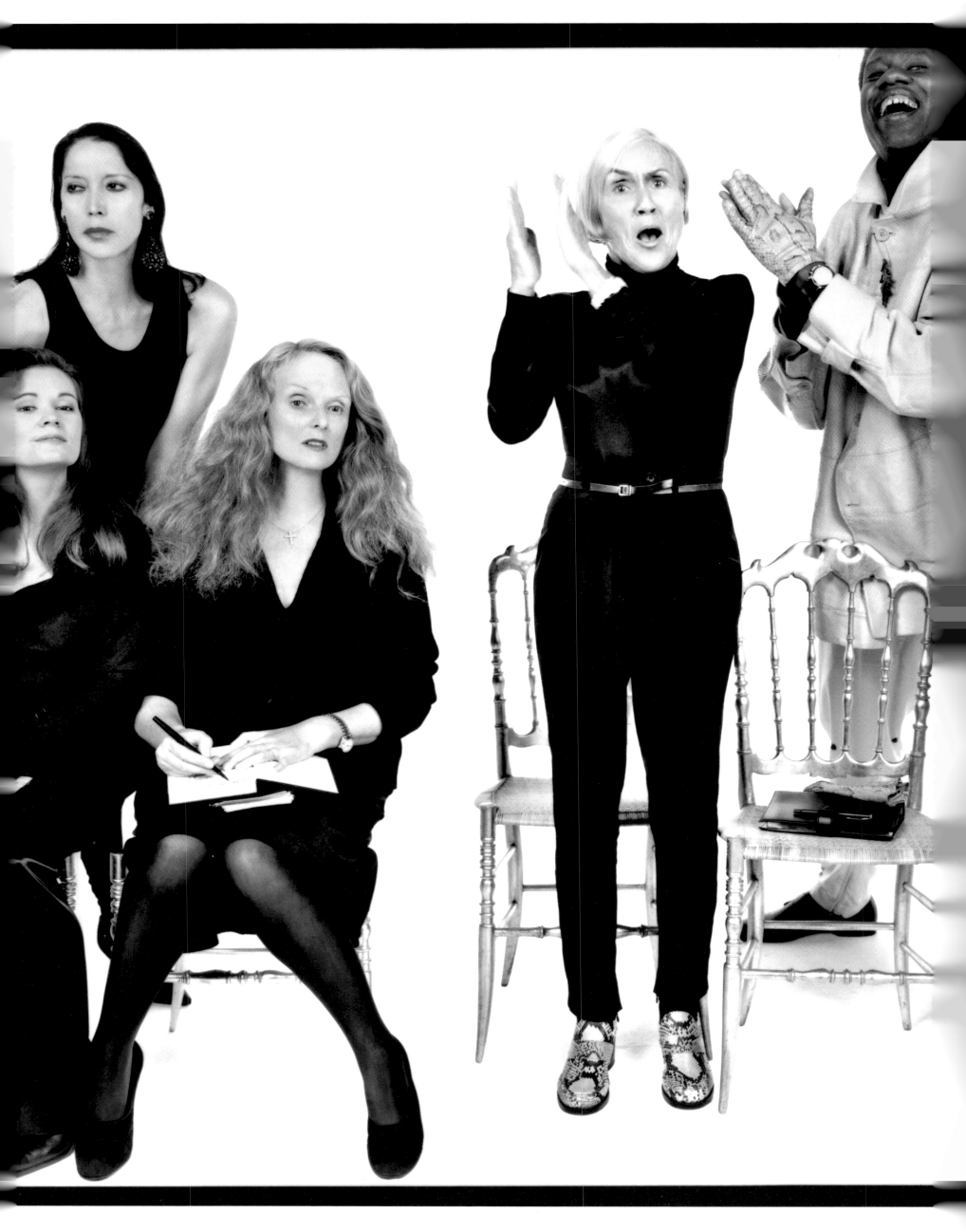

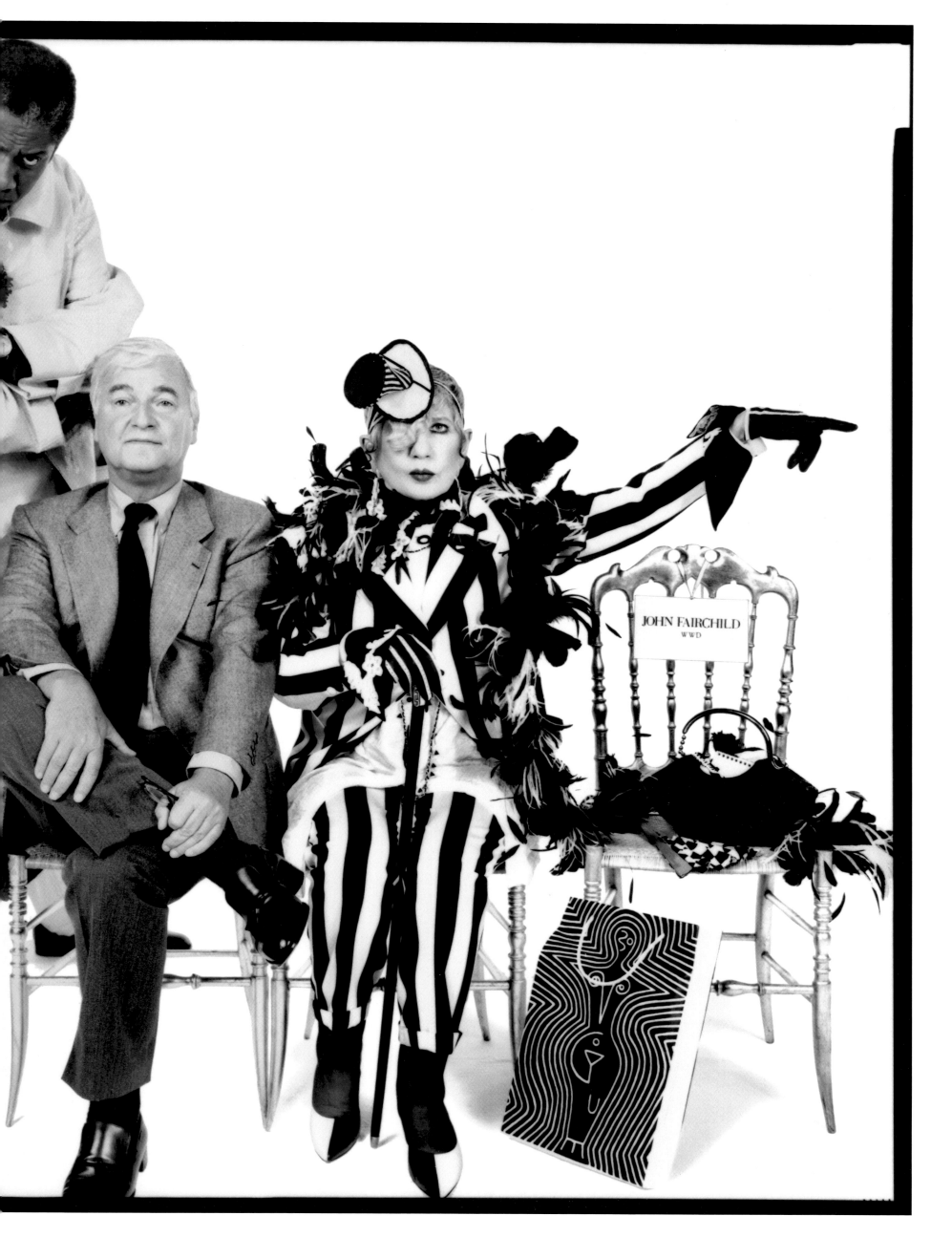

JOHN FAIRCHILD
WWD

Stephanie Seymour, model.
 Dress by Karl Lagerfeld for Chanel.
 Paris, April 1995

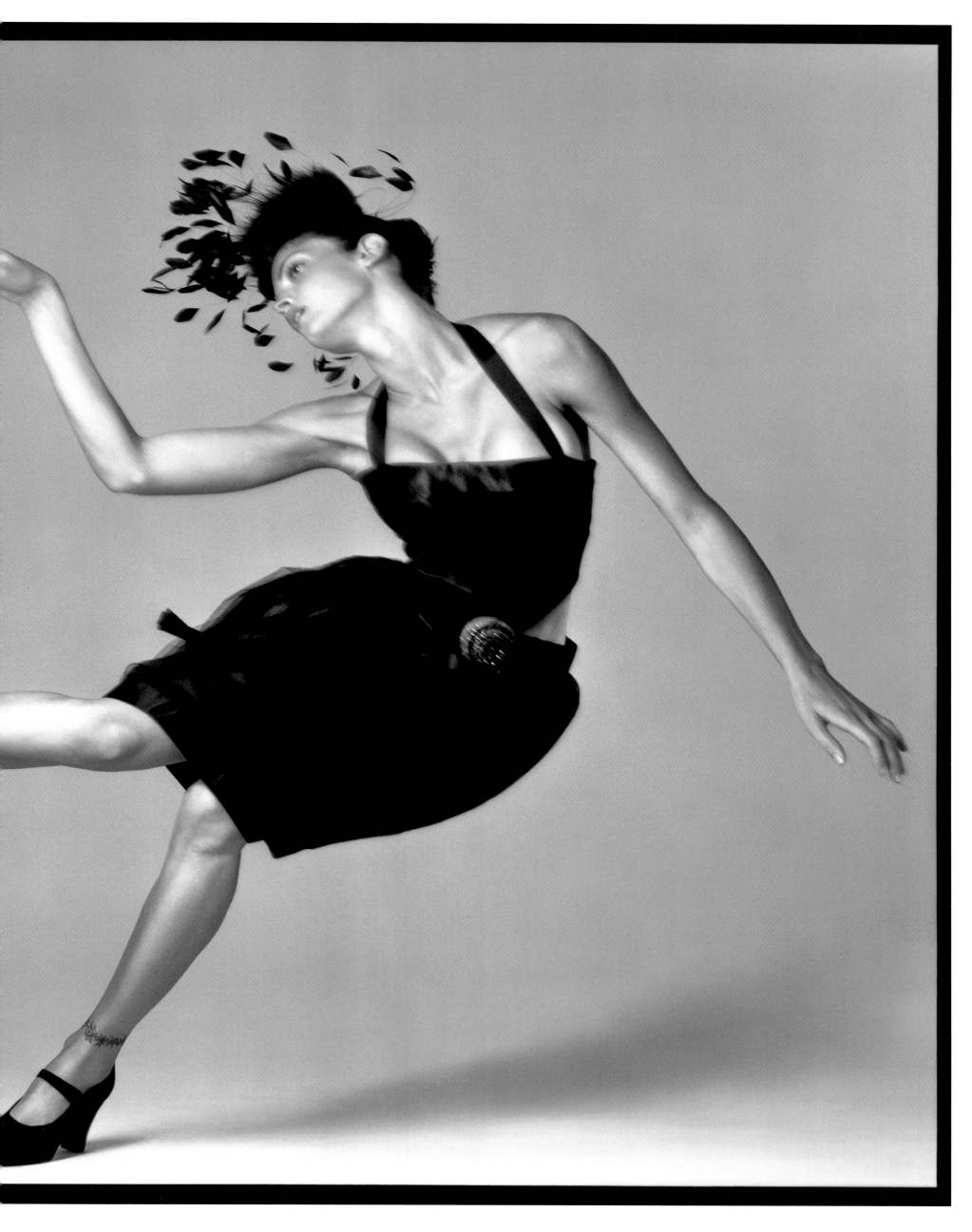

Camilla Nickerson and Neville Wakefield, fashion editors. New York, January 1999

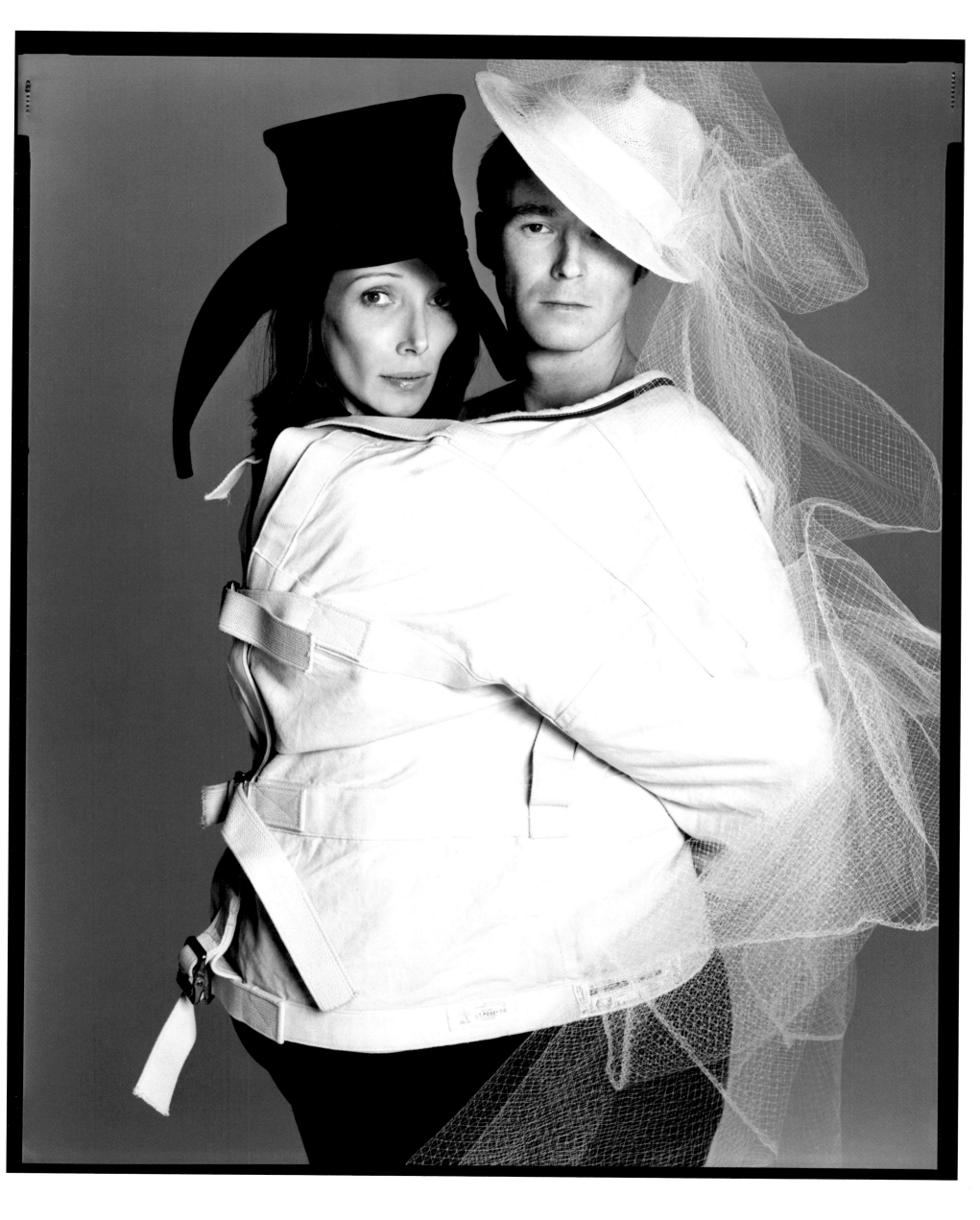

Fiona Shaw, actress. London, May 1995

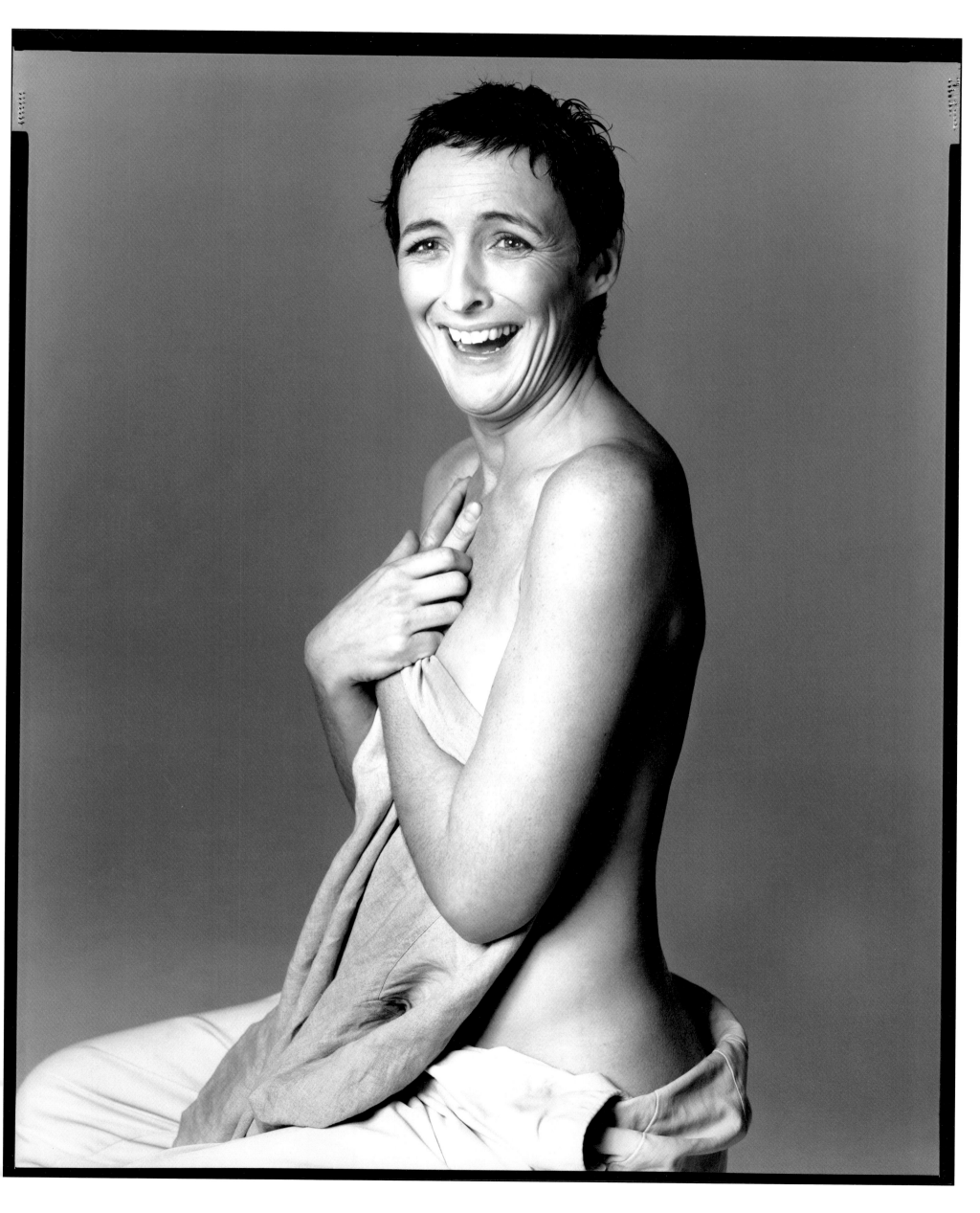

Marguerite Duras, writer. Paris, May 1993

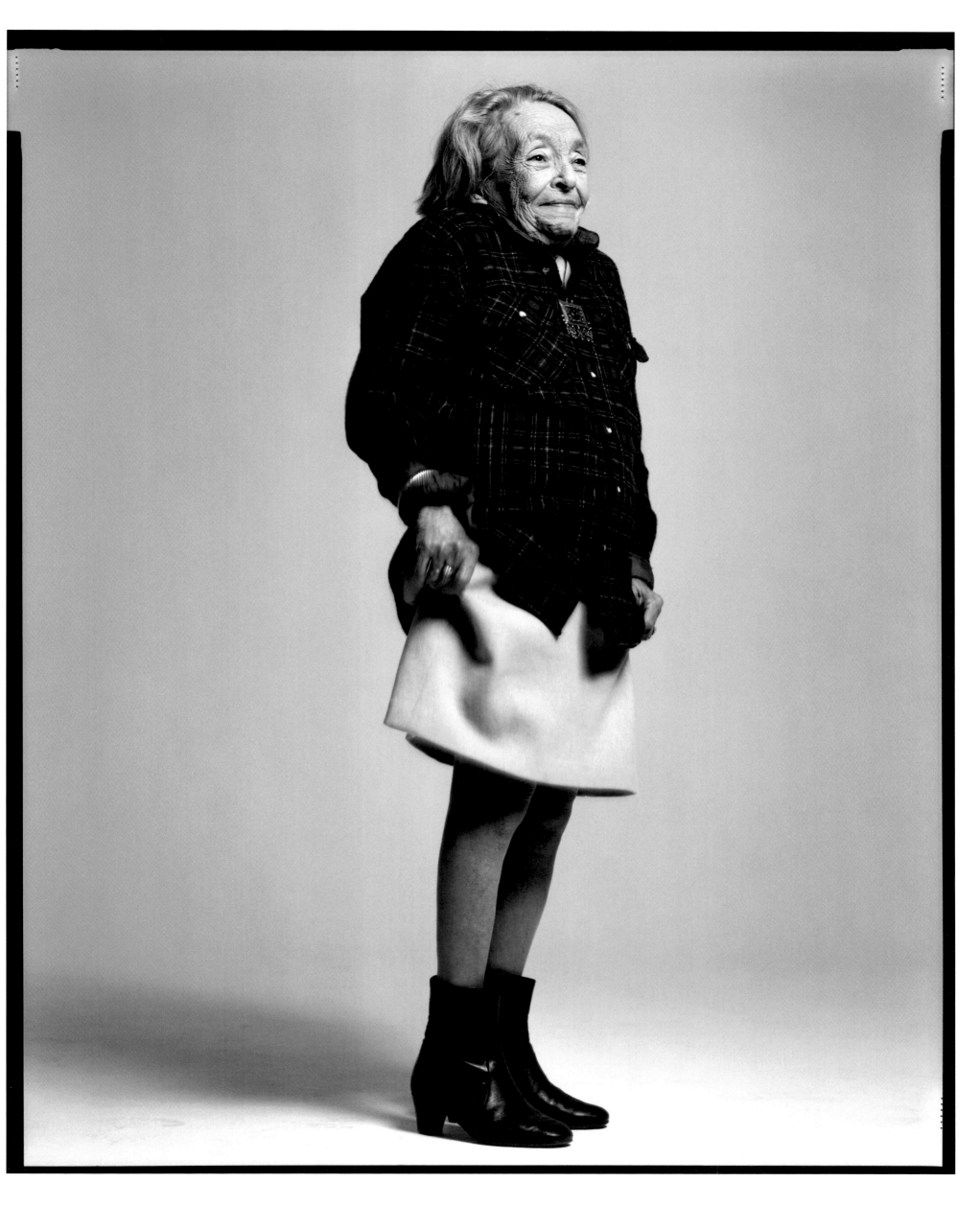

Stephanie Seymour and Azzedine Alaïa, model and fashion designer. Paris, November 1994

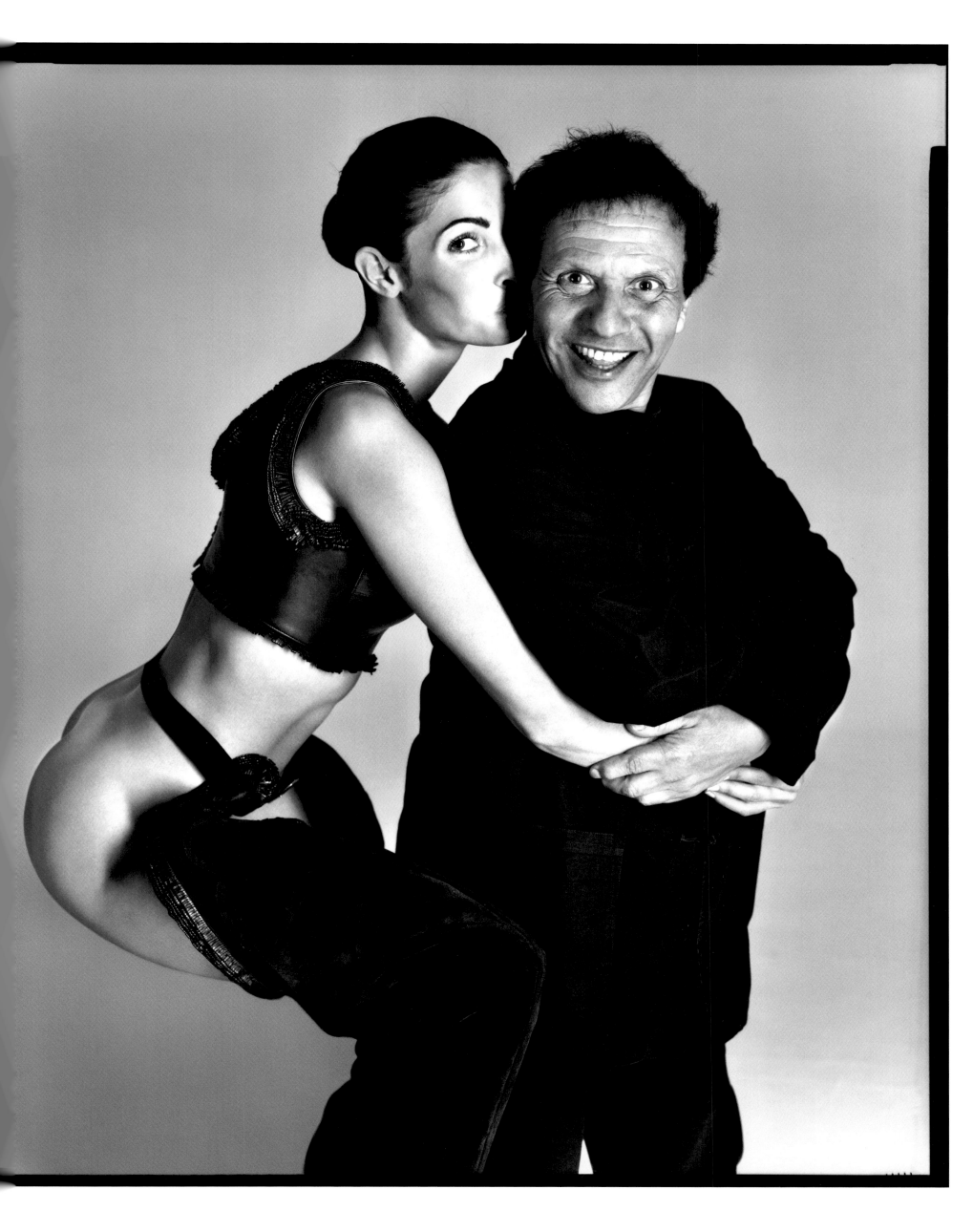

Erin O'Connor and Lionel Vermeil, model and press agent.
Clothes by Jean Paul Gaultier. New York, April 1998

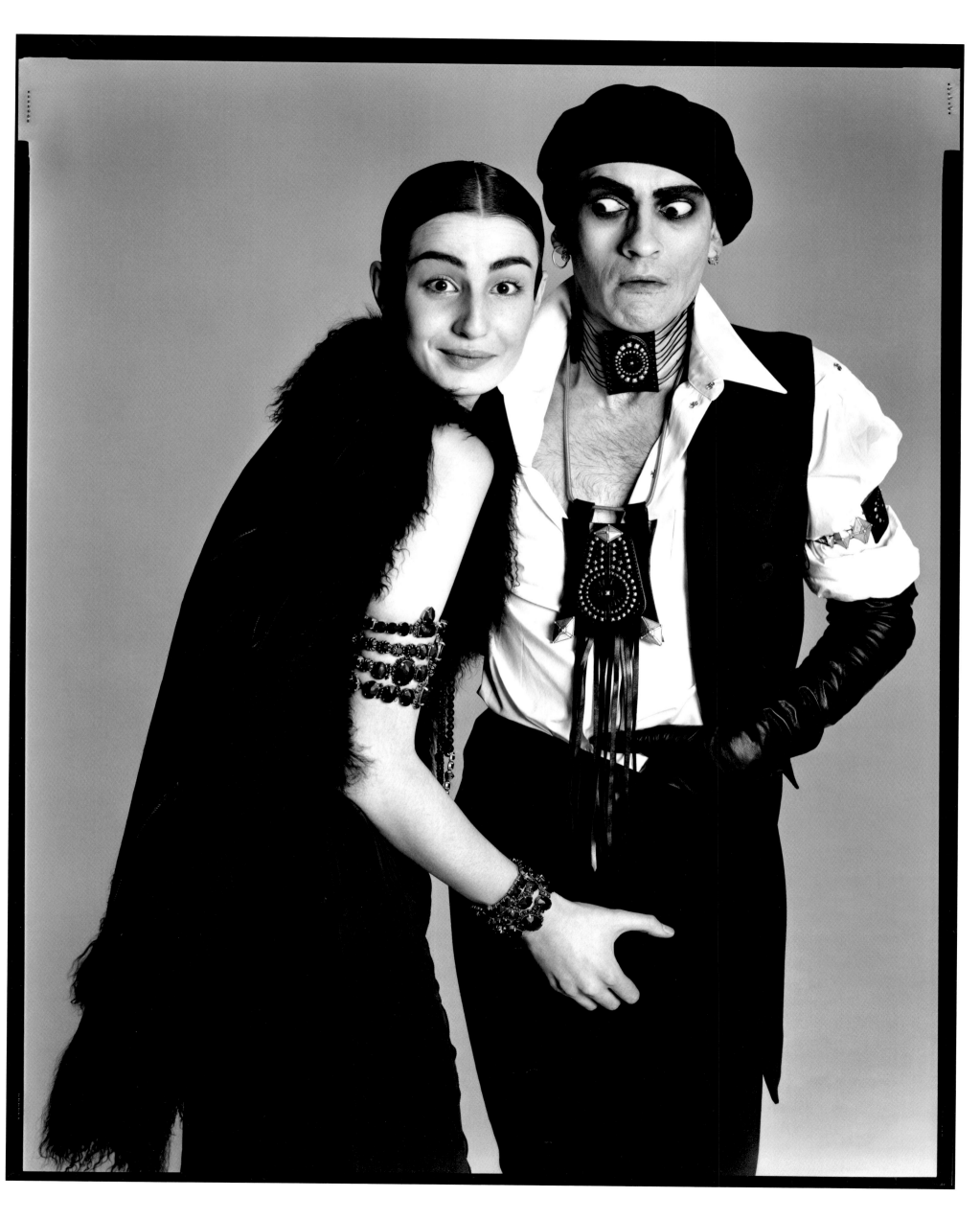

Elton John, musician. Dress by Versace. October 1996

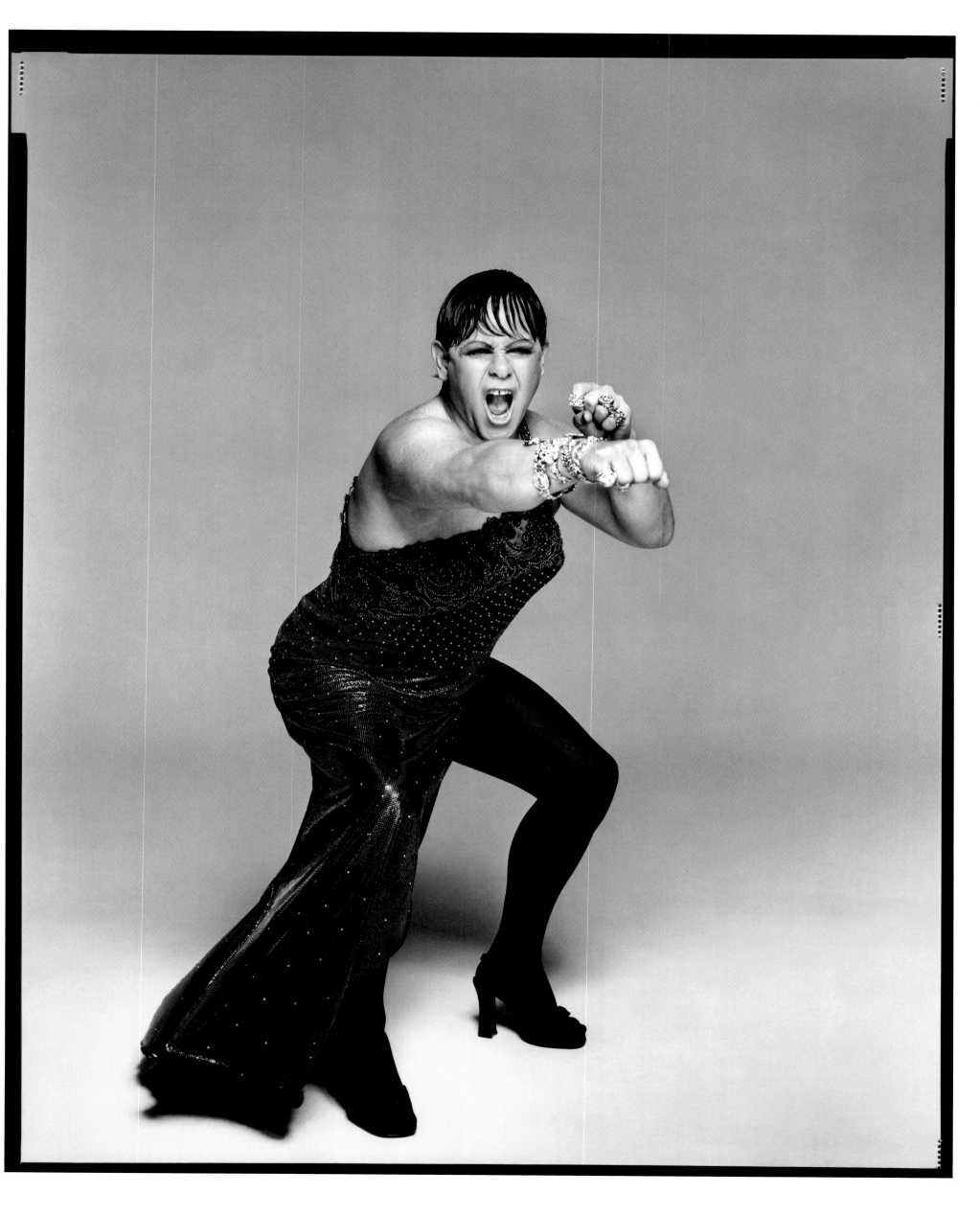

Soeur Emmanuelle, nun. Paris, June 1998

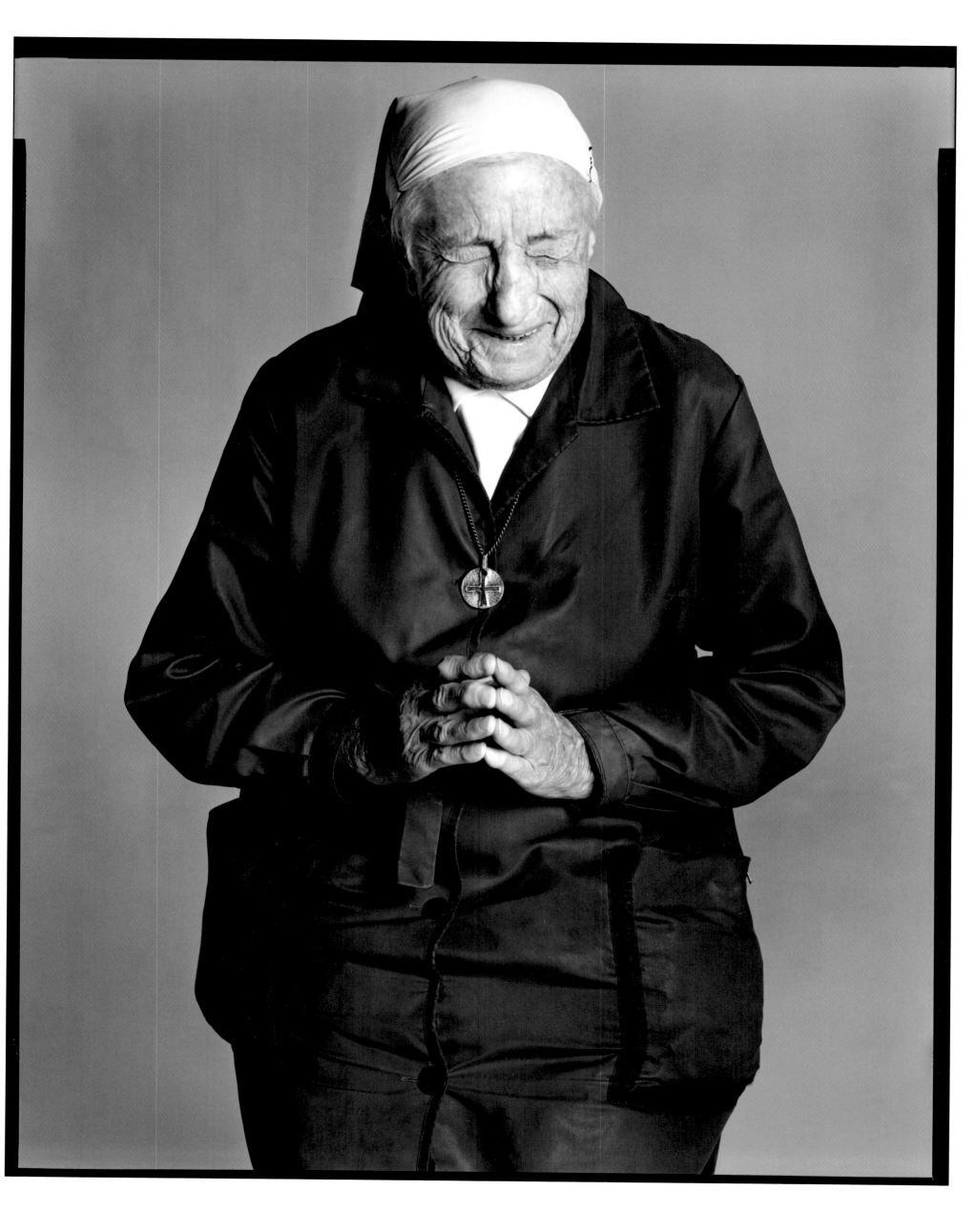

Patti Smith, singer. New York, April 1998

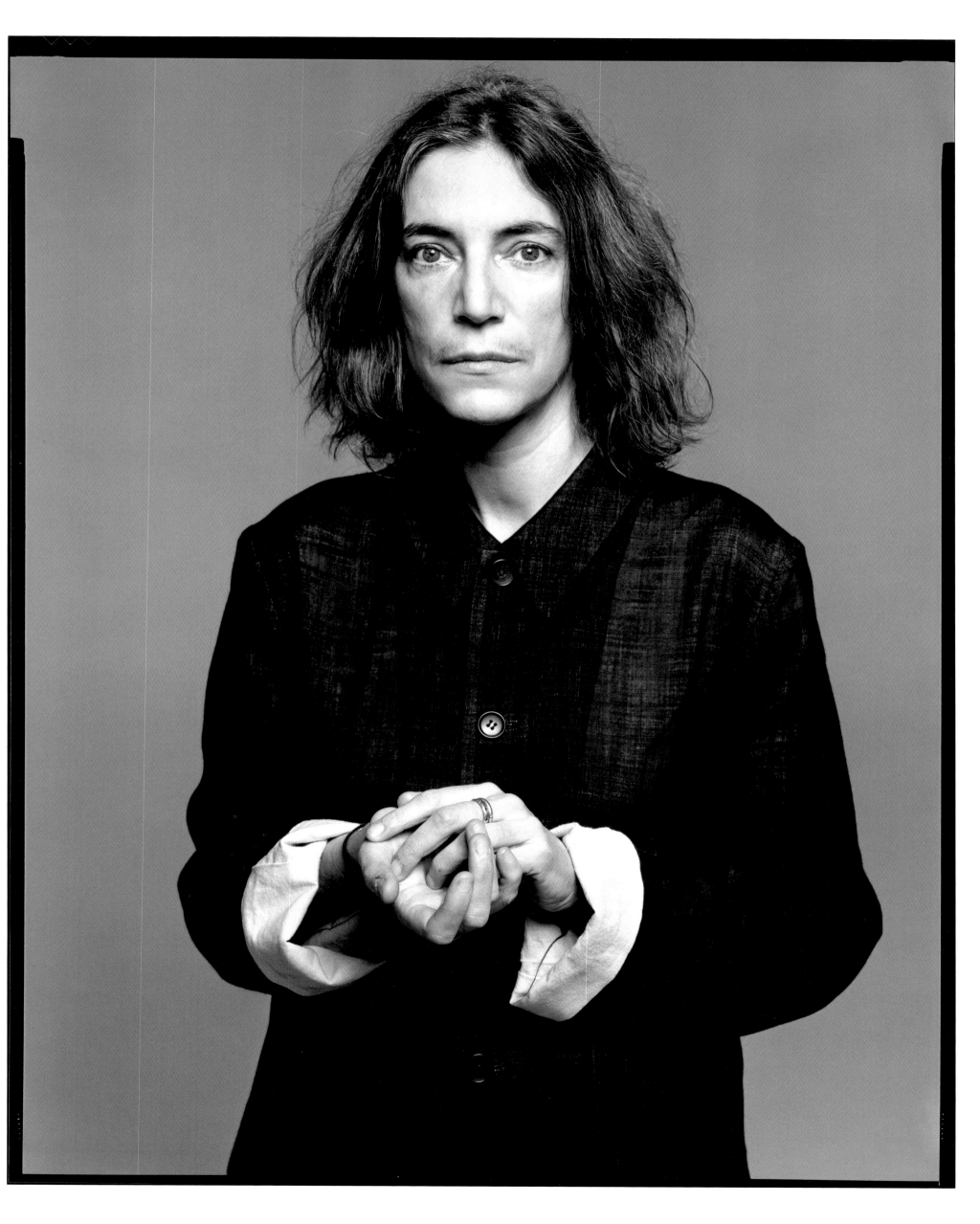

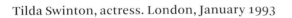

Tilda Swinton, actress. London, January 1993

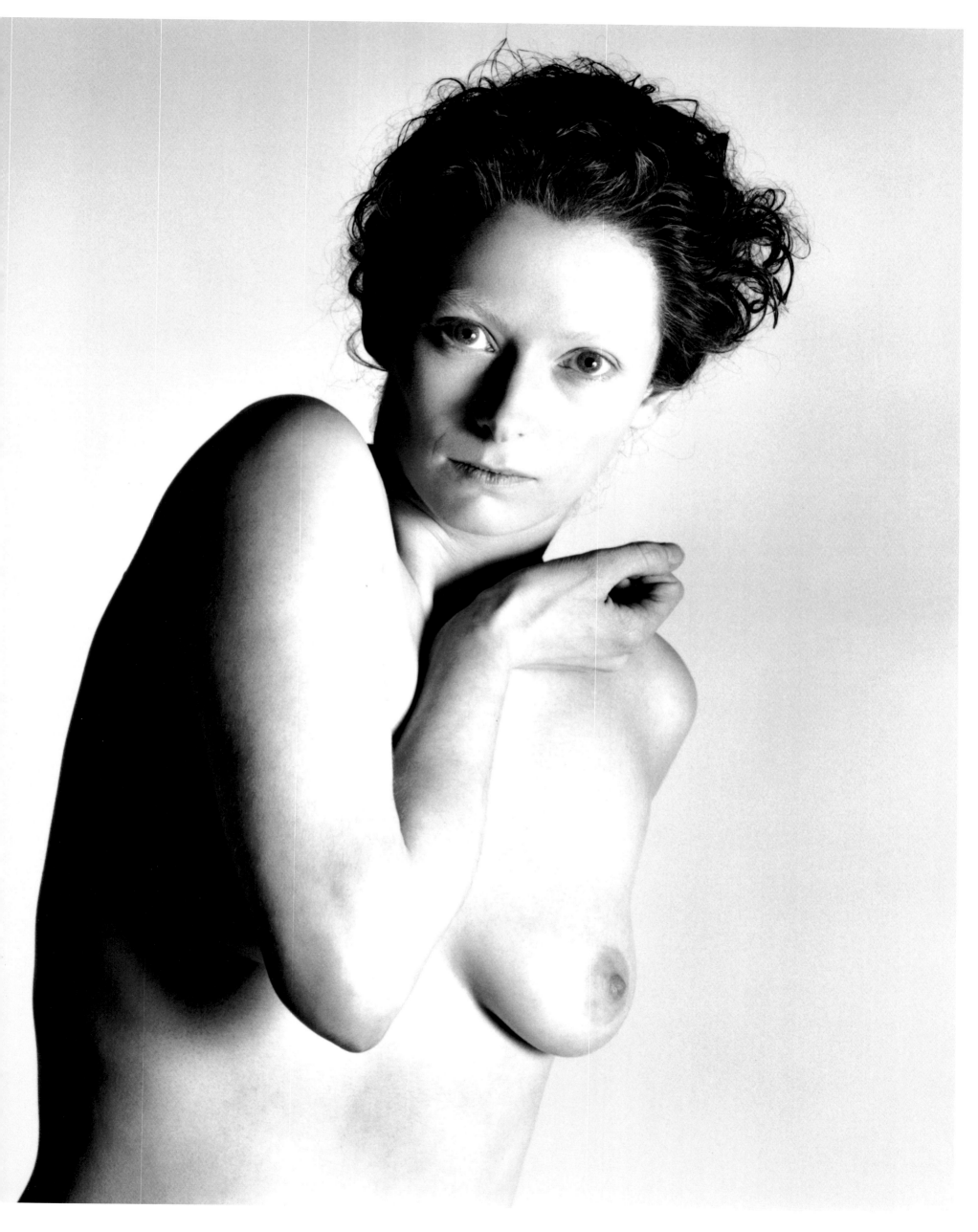

Kate Moss, model. New York, April 1996

Page 201–215: "In Memory of the Late Mr. and Mrs. Comfort," a fable.

Nadja Auermann, model, with person unknown and child. Montauk, New York, August 1995

Page 201: Dress by Alexander McQueen

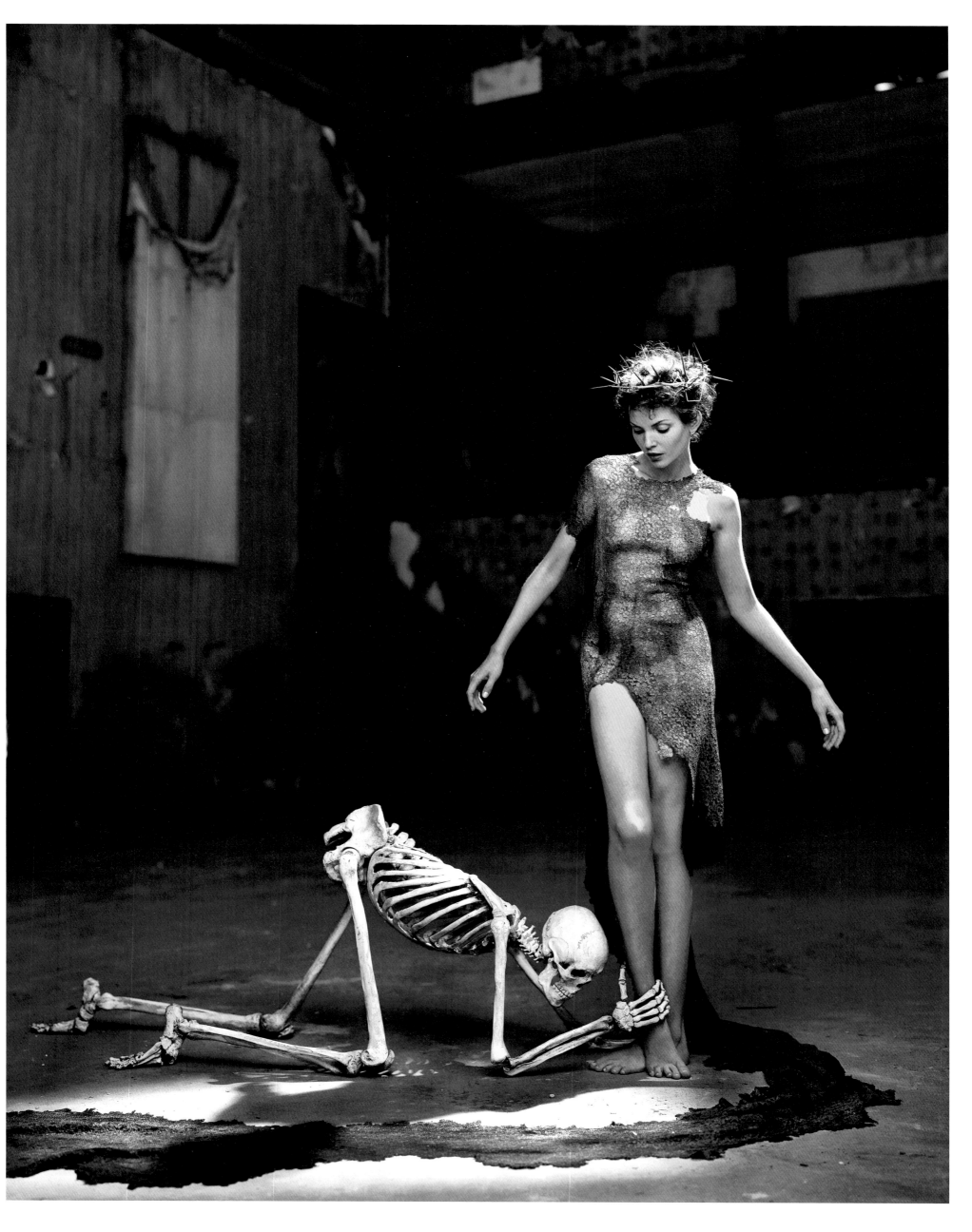

Bustier and skirt by Jean Paul Gaultier,
suit and scarves by Romeo Gigli

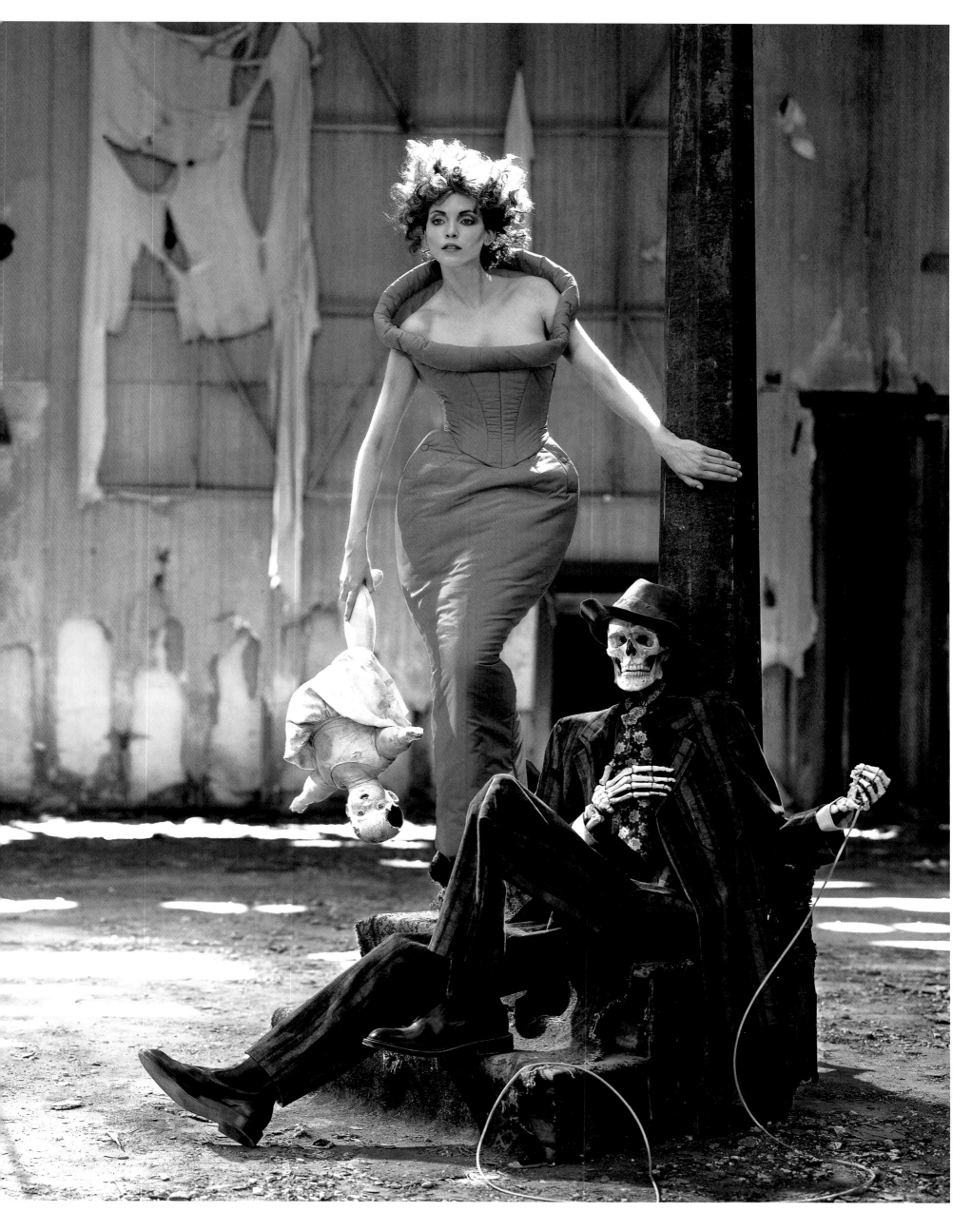

Dress by Issey Miyake, sweater by Romeo Gigli

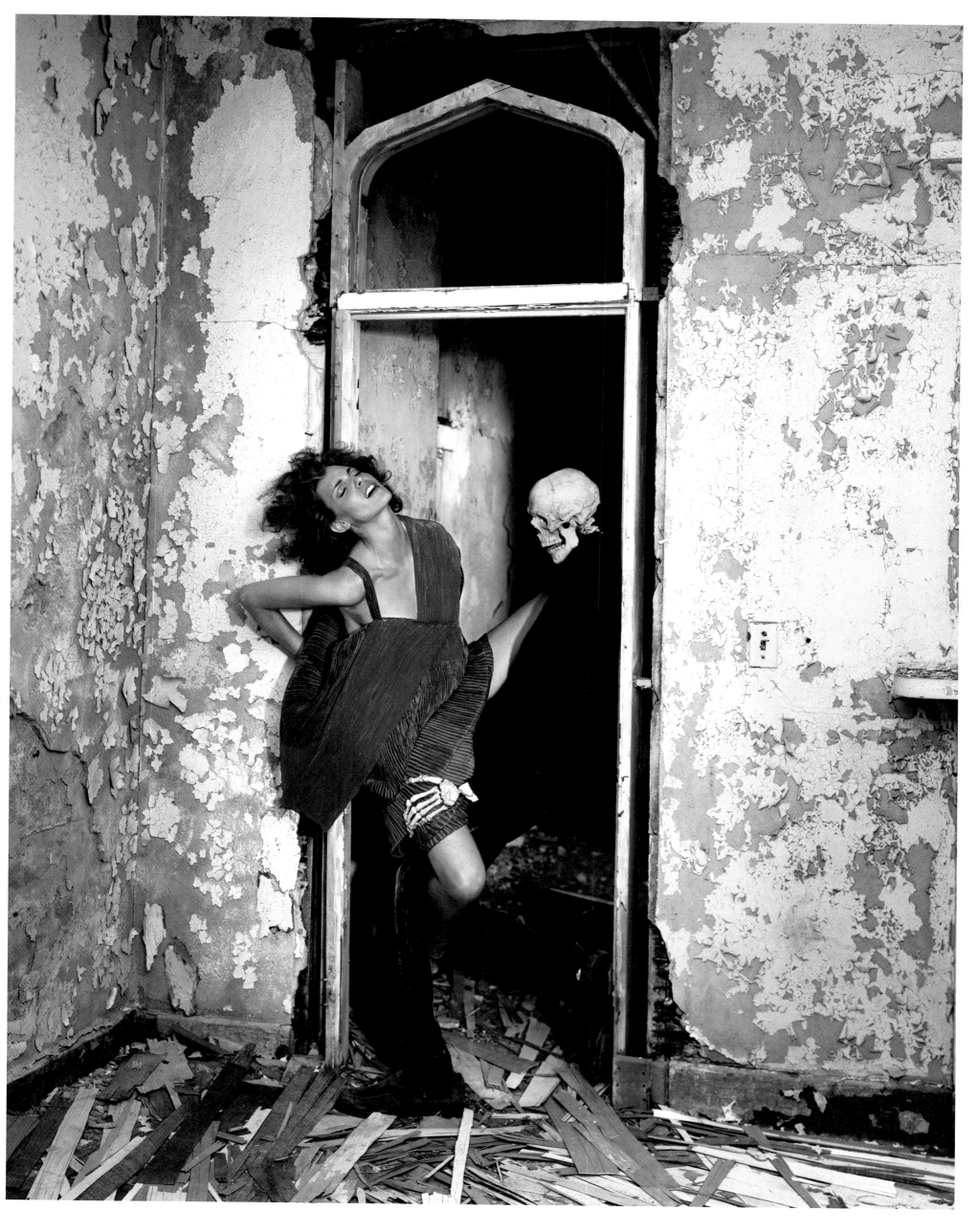

Clothes by Yohji Yamamoto

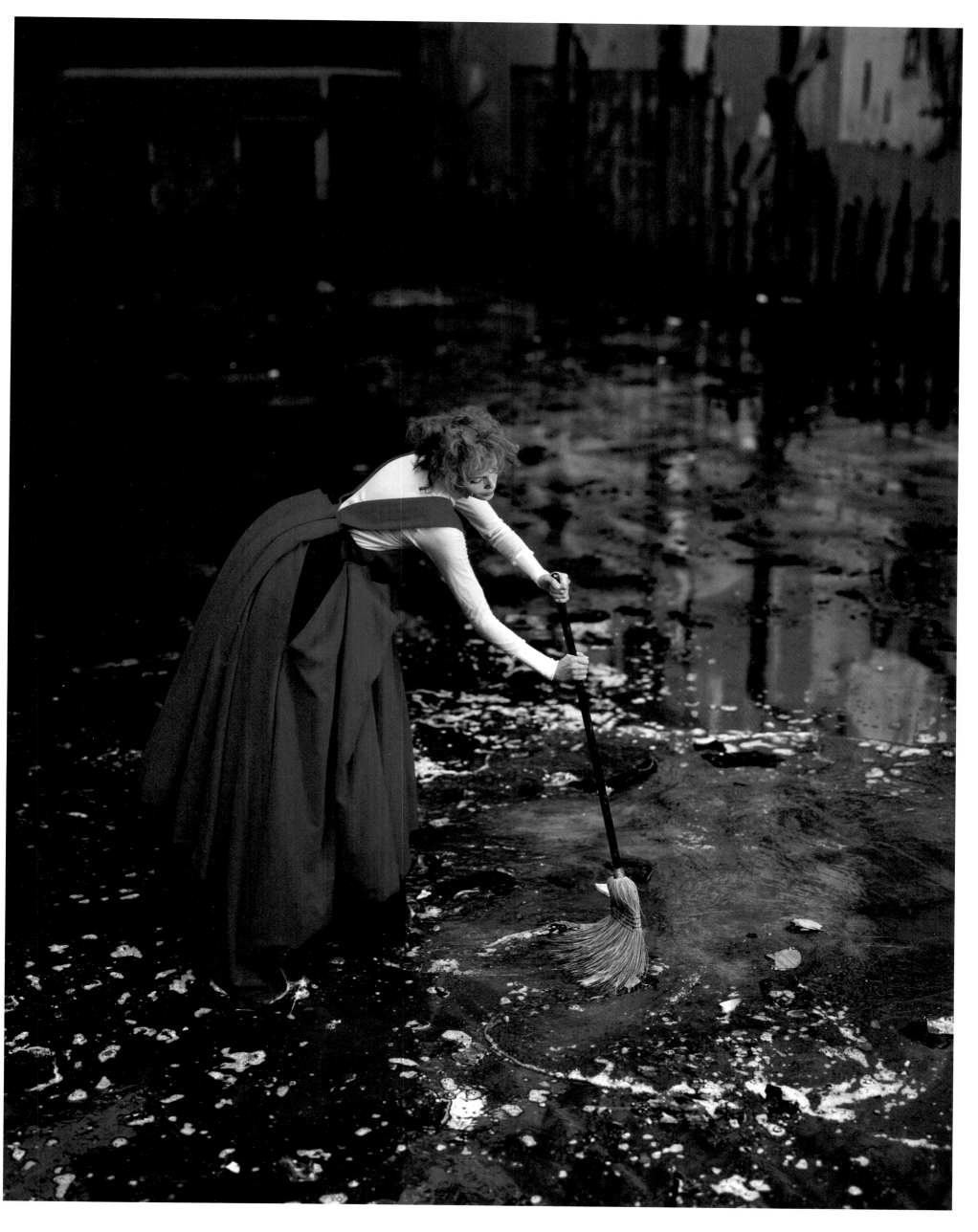

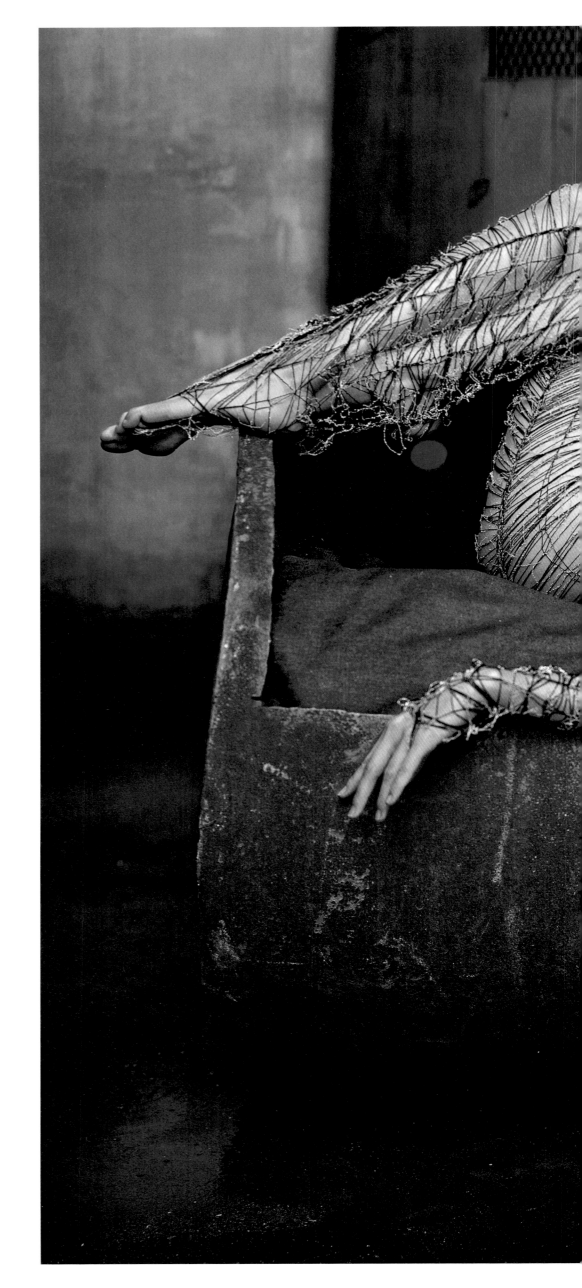

Dress by Hussein Chalayan

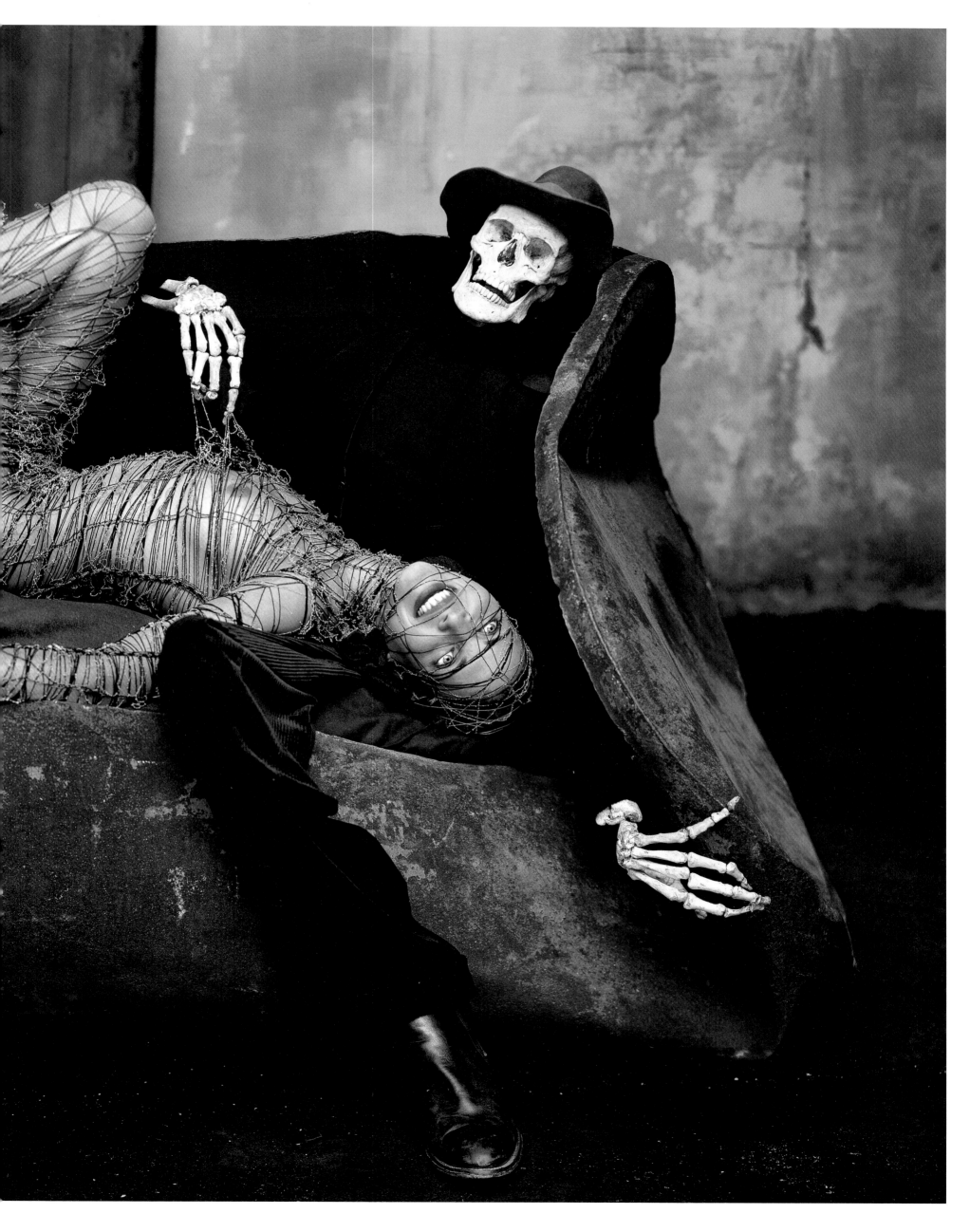

Dress by Hussein Chalayan

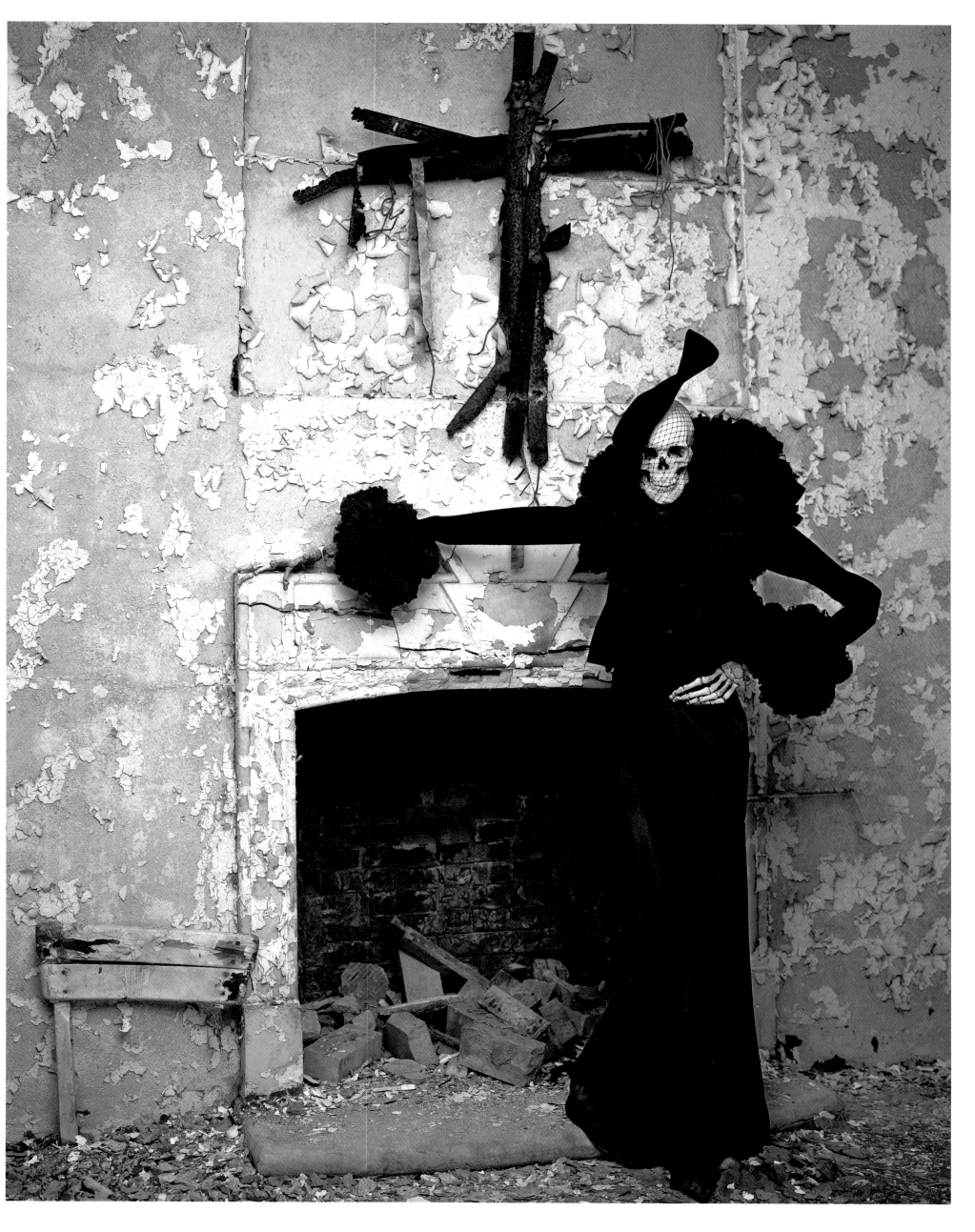

Dress by Jean Paul Gaultier, sweater, coat, and hat by Comme des Garçons

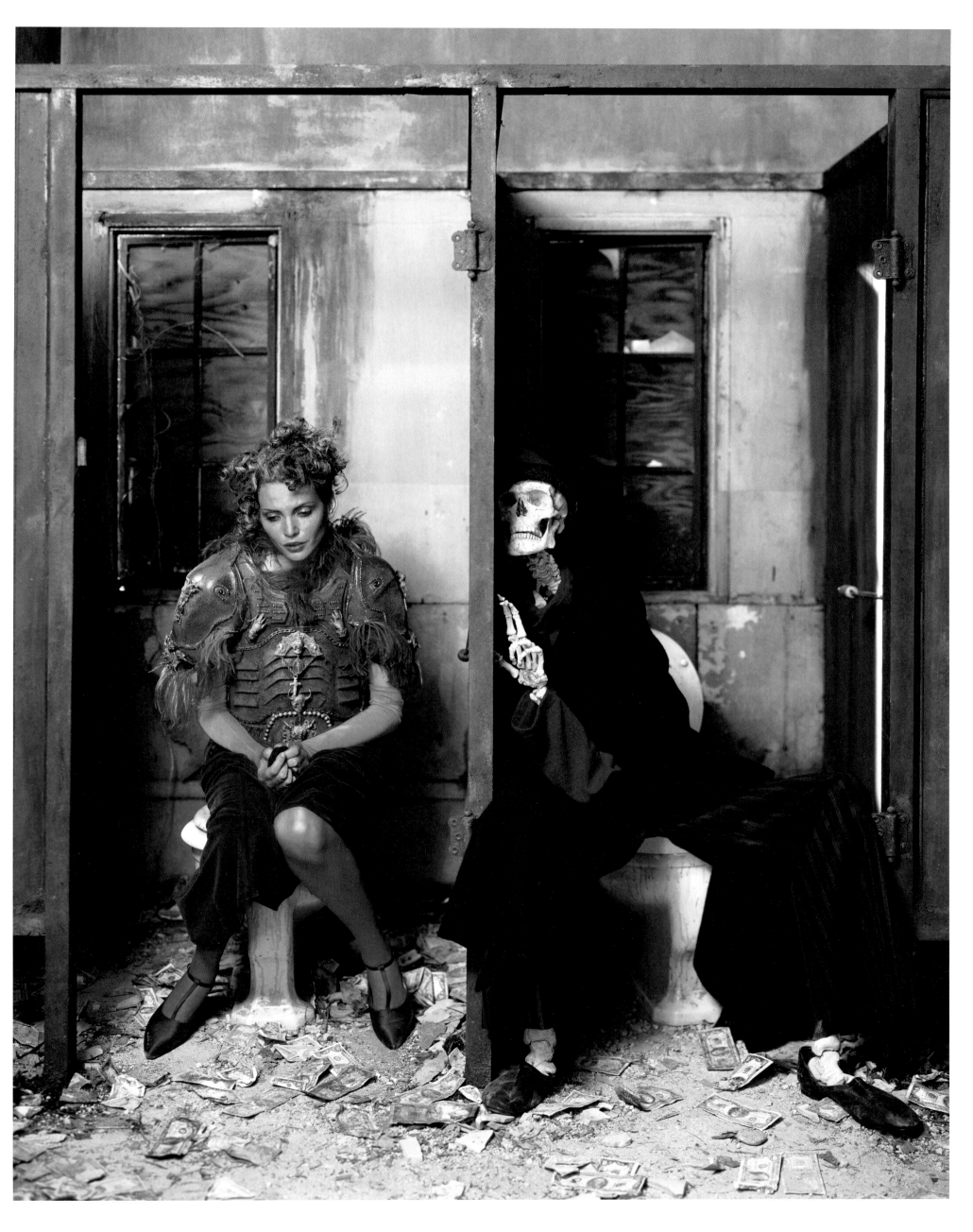

Dress by Geoffrey Beene, suit and sweater by Jean Paul Gaultier

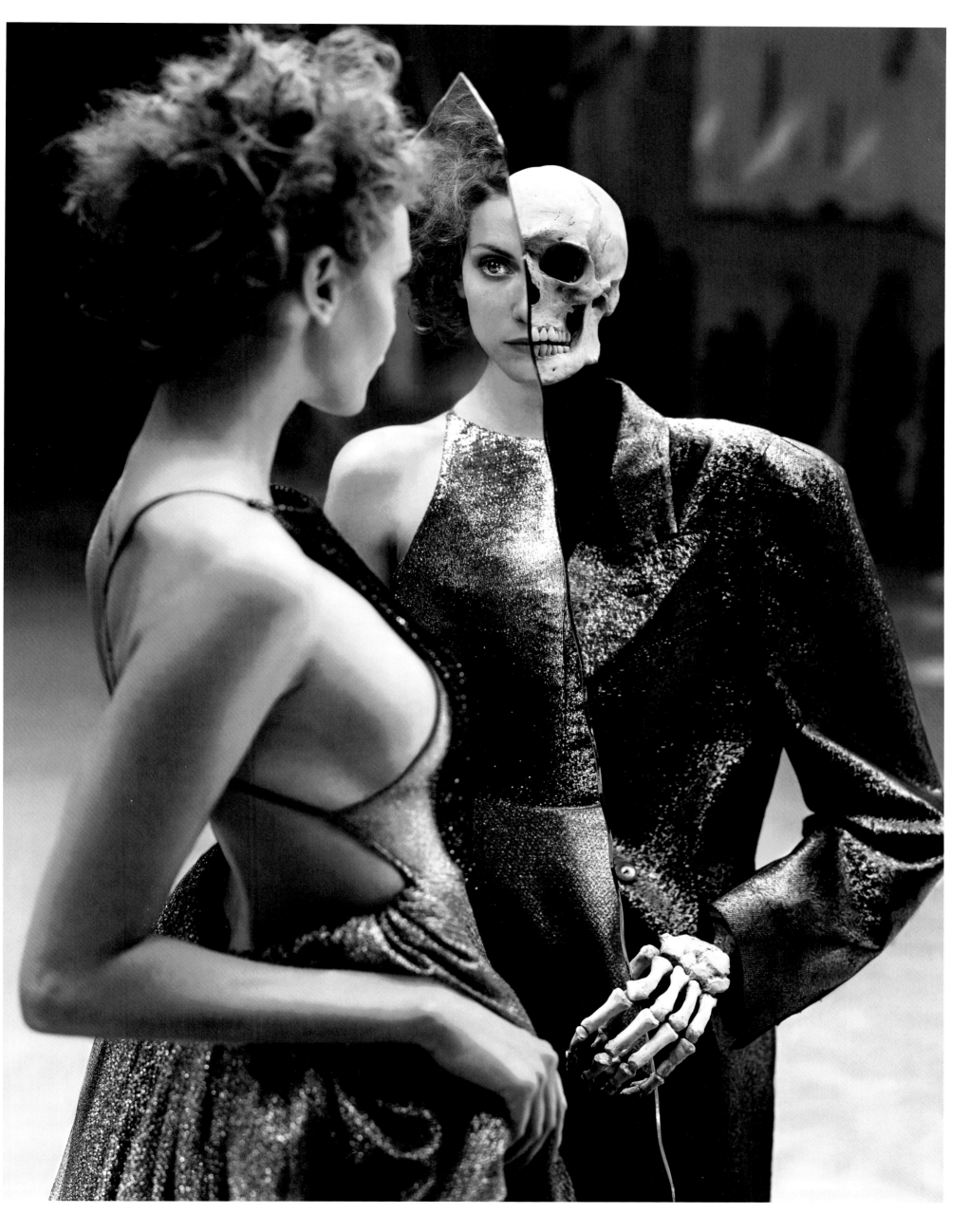

Natalia Semanova, model. Mouthpiece and headphones by Tom Binns. New York, May 1998

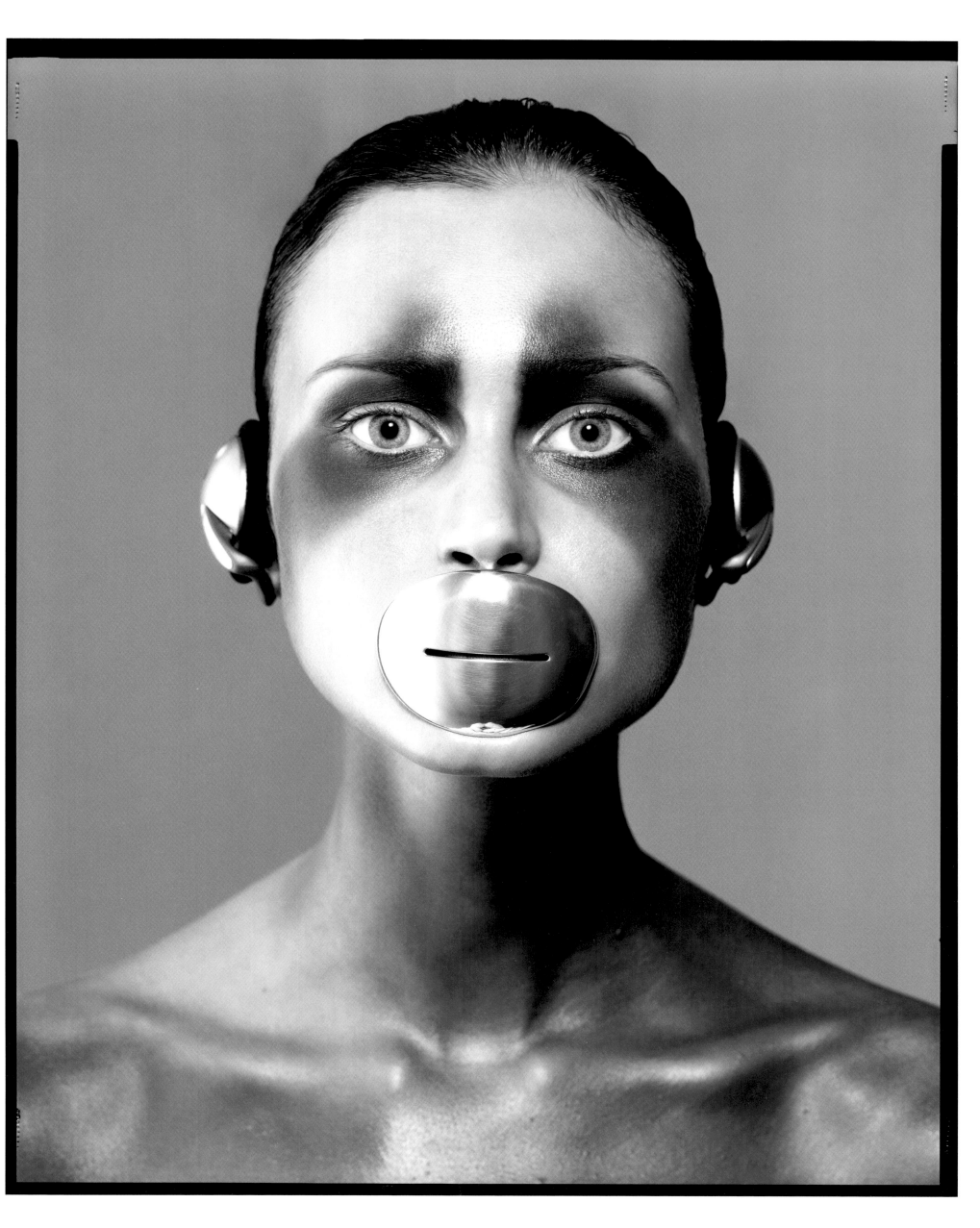

Malgosia Bela, model. Dress by Yohji Yamamoto. New York, March 2000

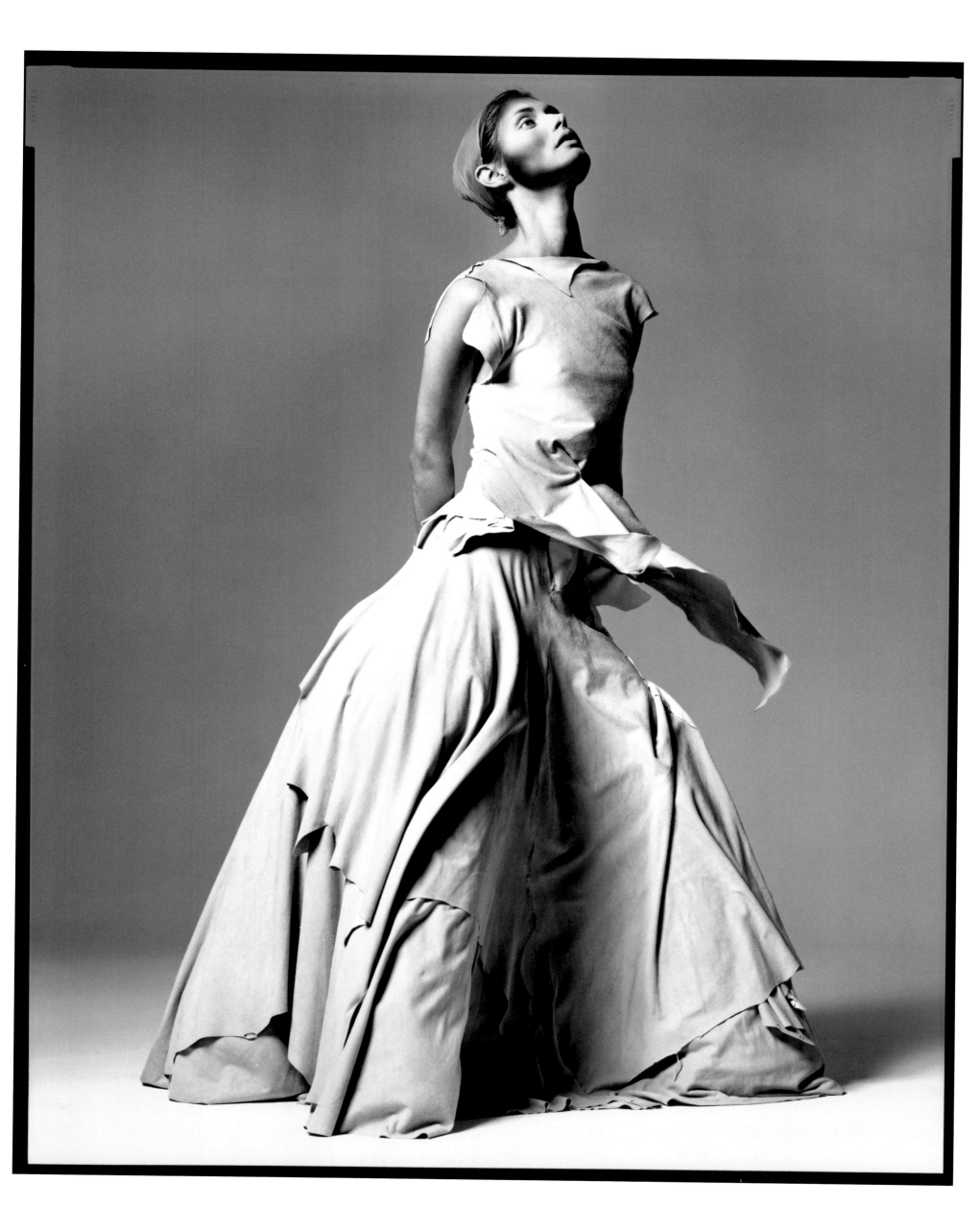

Erin O'Connor, model. Tunic by Versace. New York, November 1997

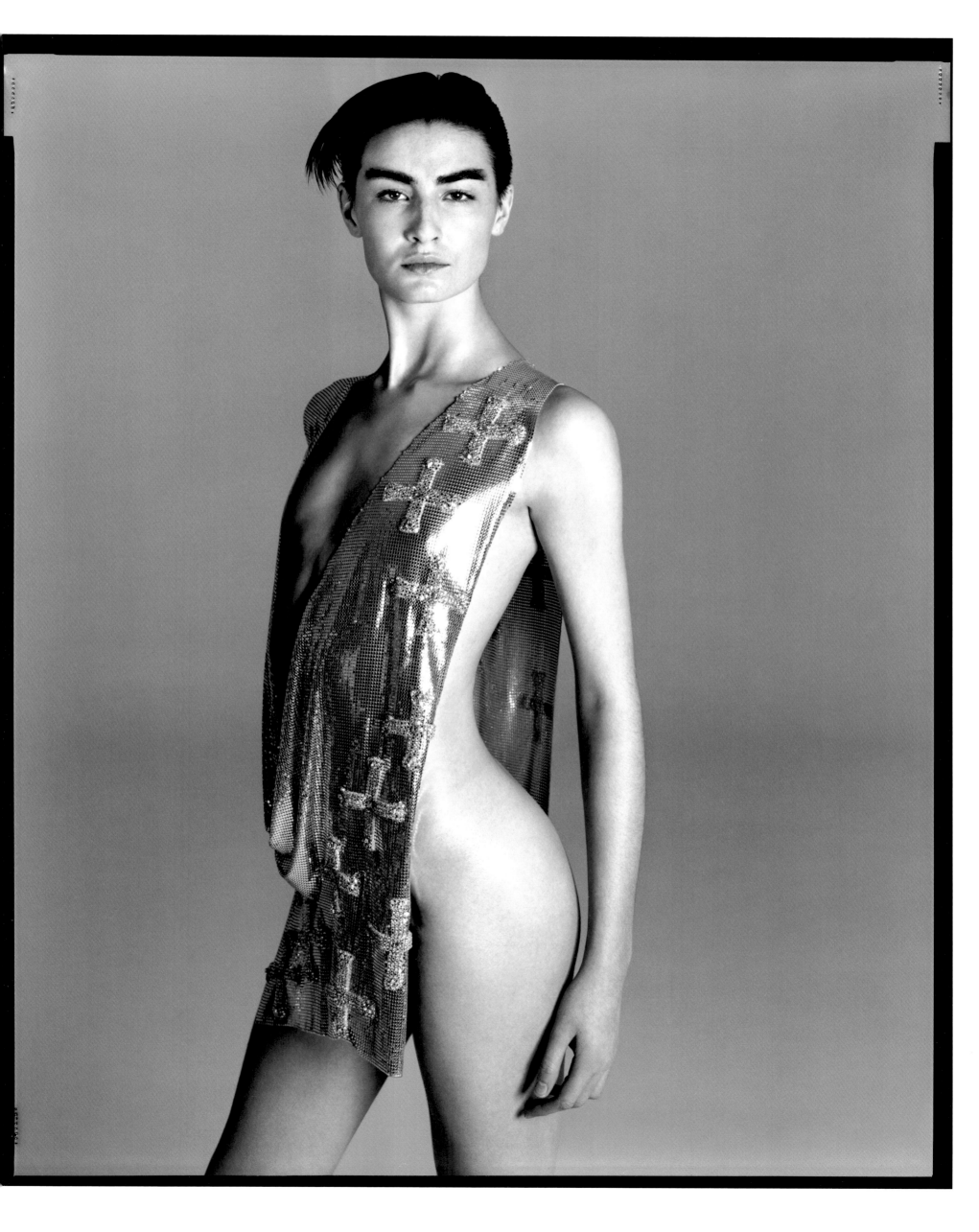

Malgosia Bela and Gisele Bündchen, models. Dresses by Dior Couture. New York, March 2000

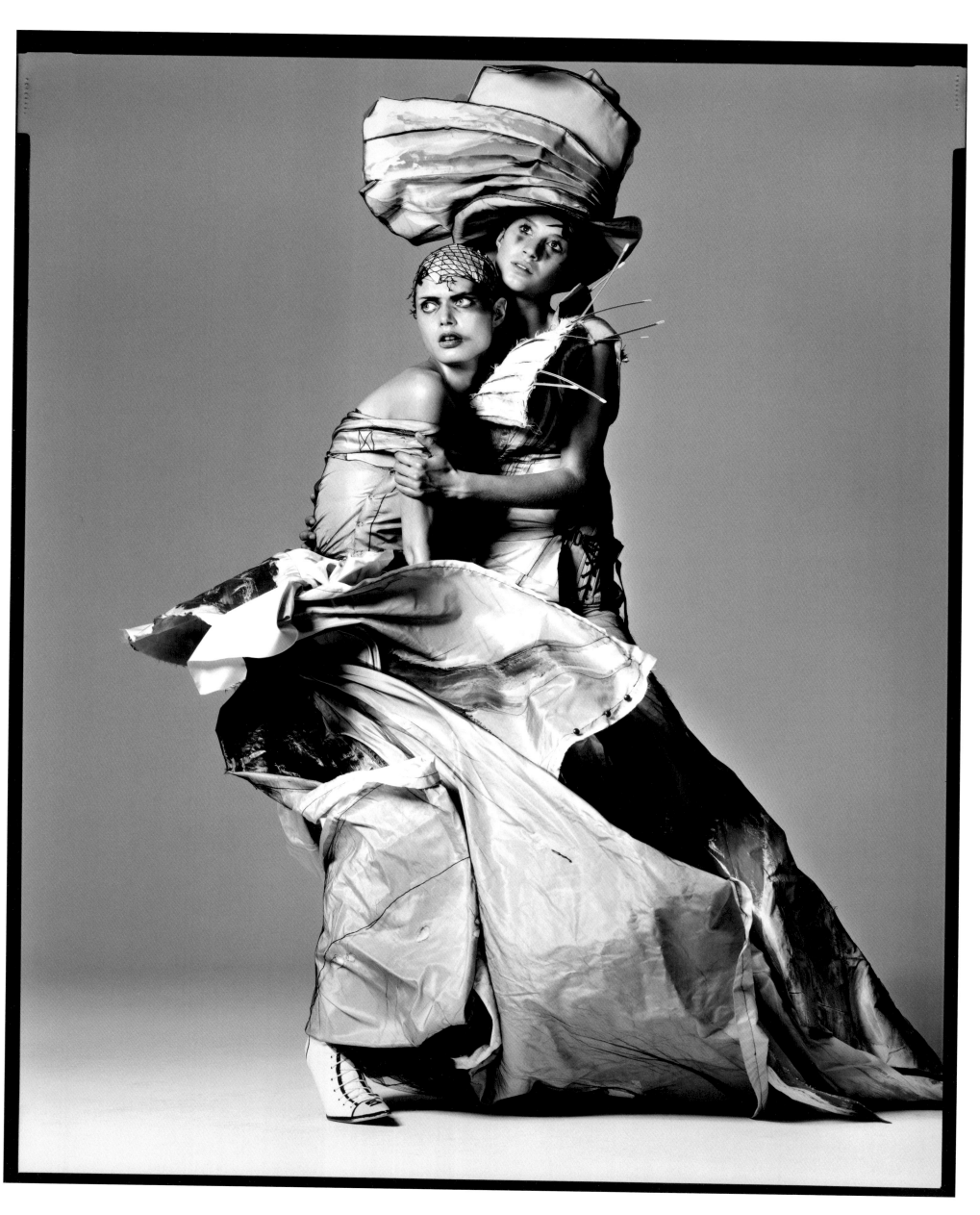

Carmen Kass and Audrey Marnay, models. Dresses by Hussein Chalayan. New York, May 1998

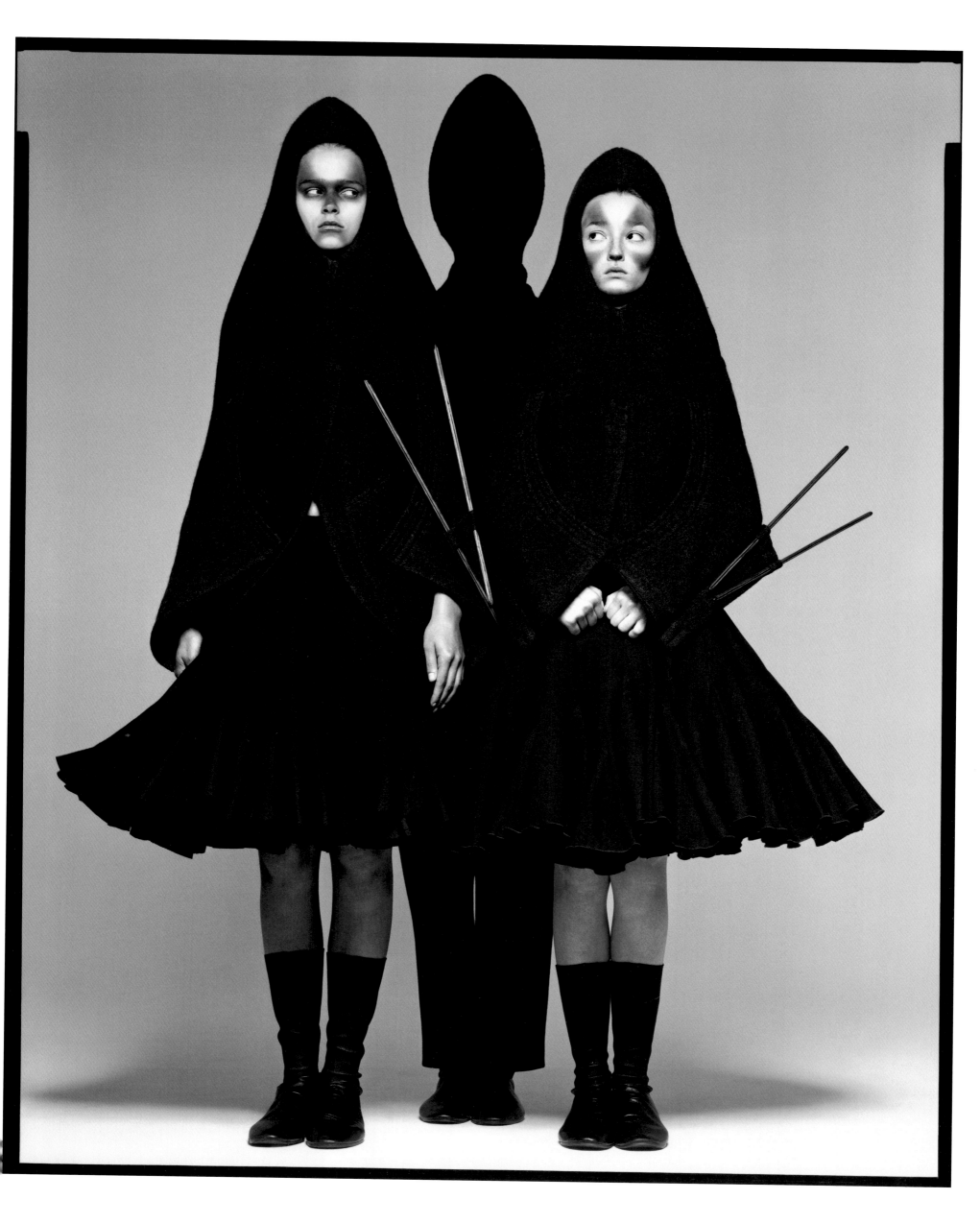

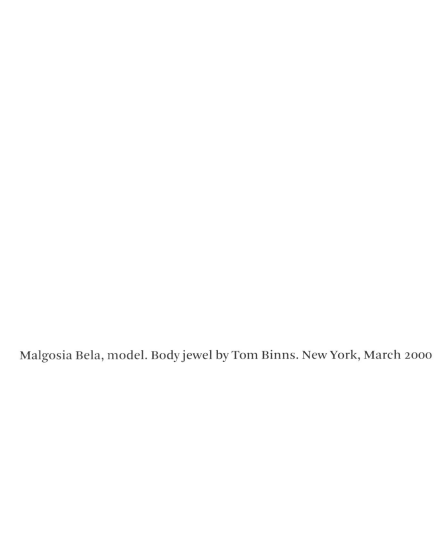

Malgosia Bela, model. Body jewel by Tom Binns. New York, March 2000

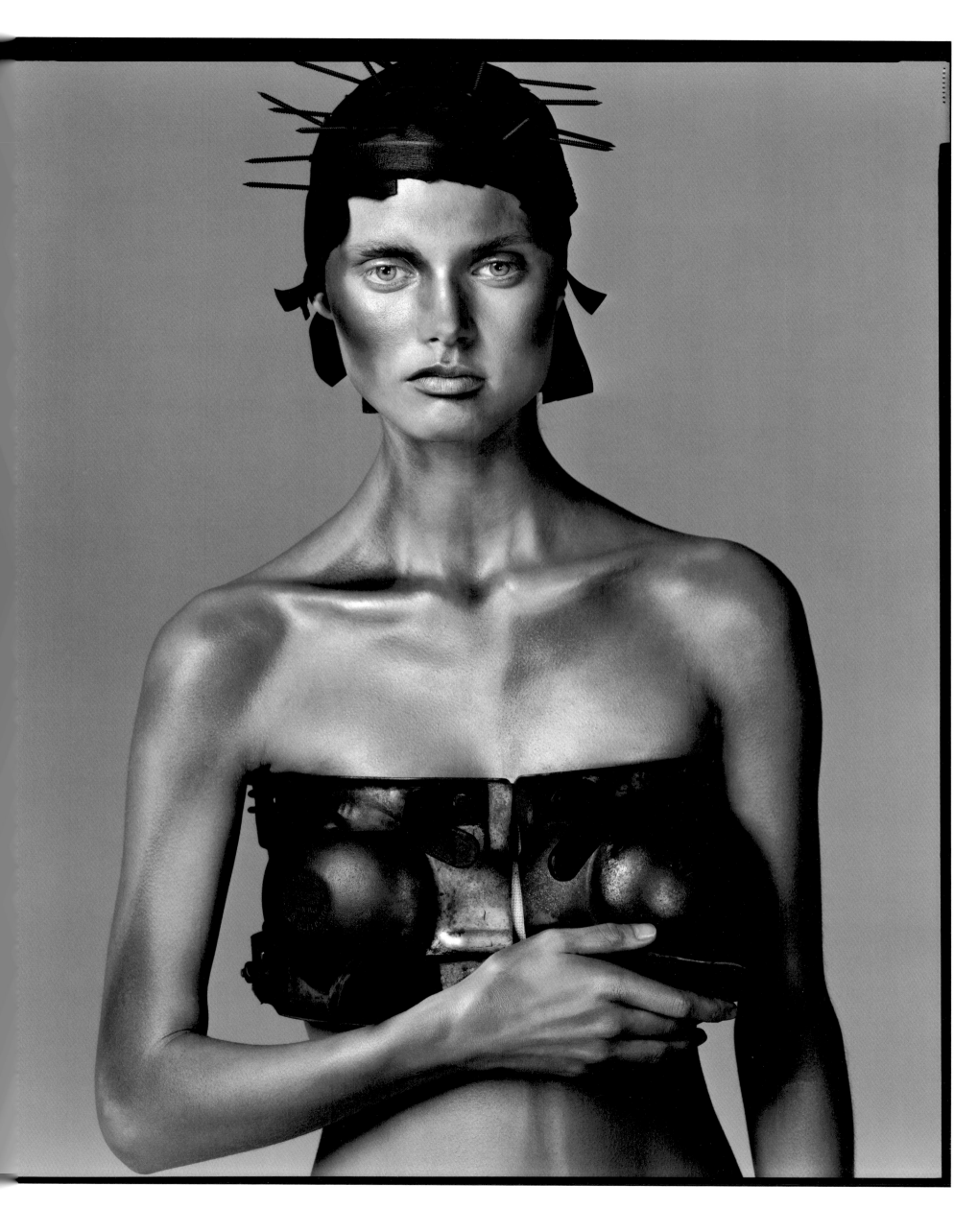

Carmen Kass and Audrey Marnay, models. Dresses by Hussein Chalayan. New York, May 1998

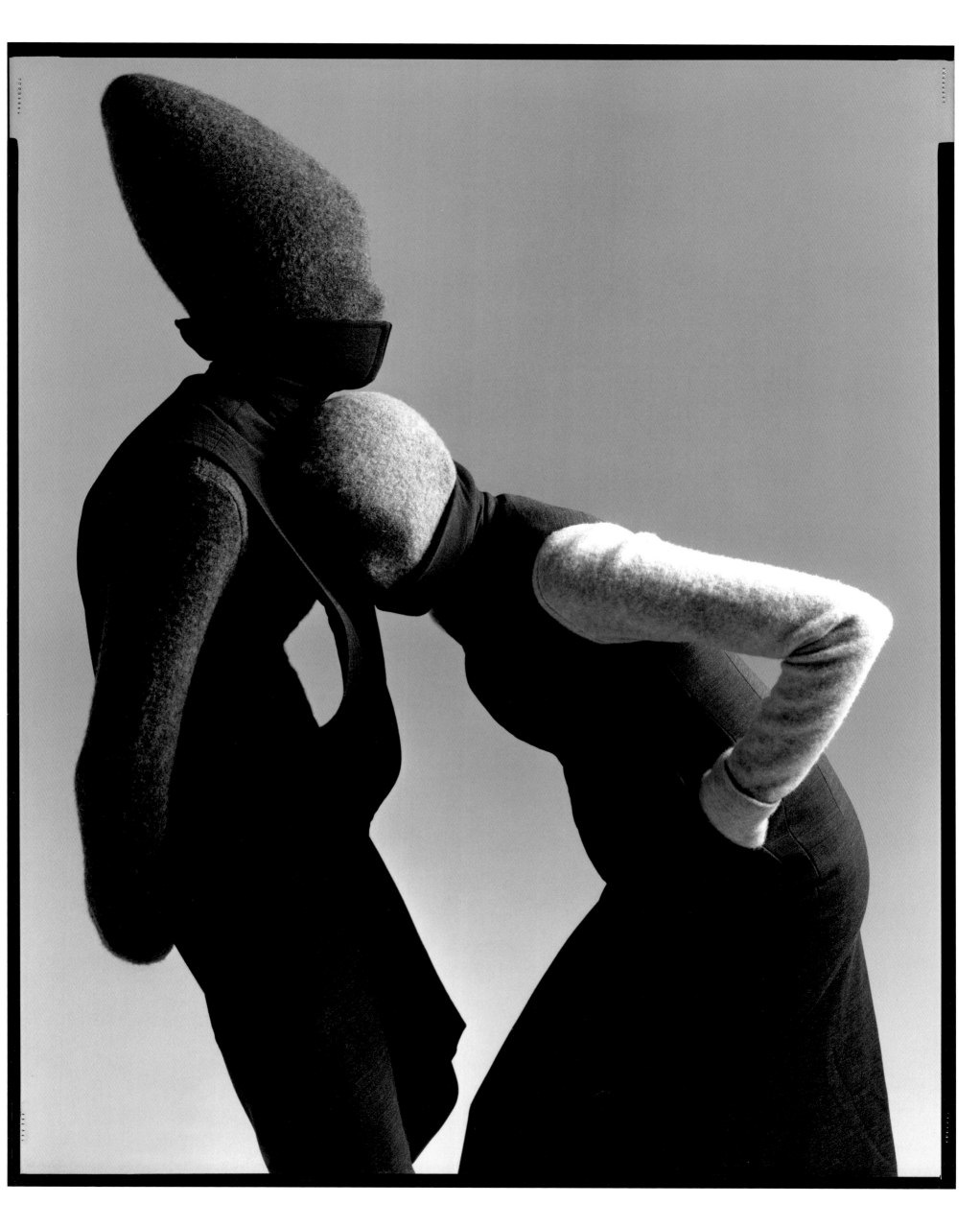

Arundhati Roy, novelist. New York, May 1998

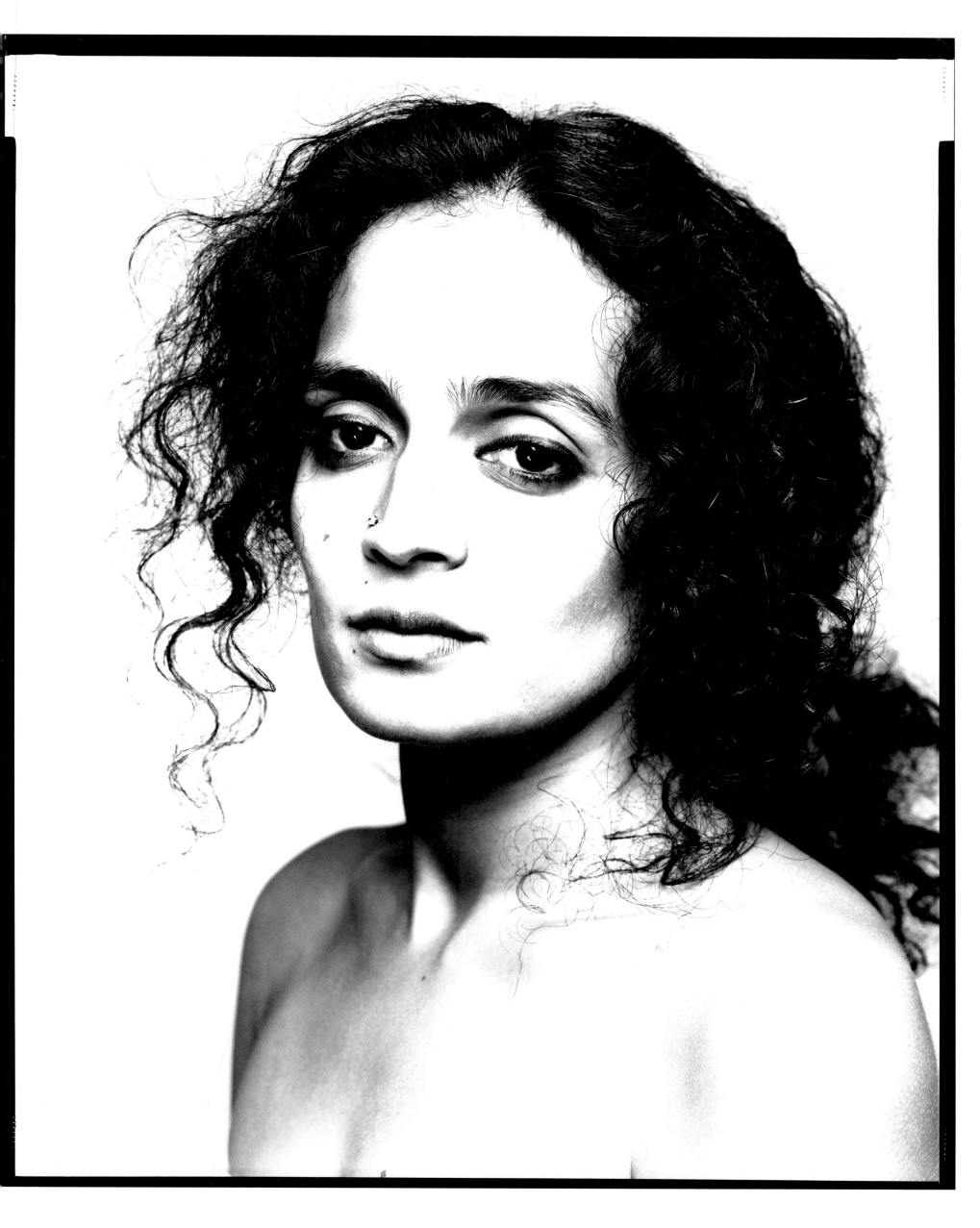

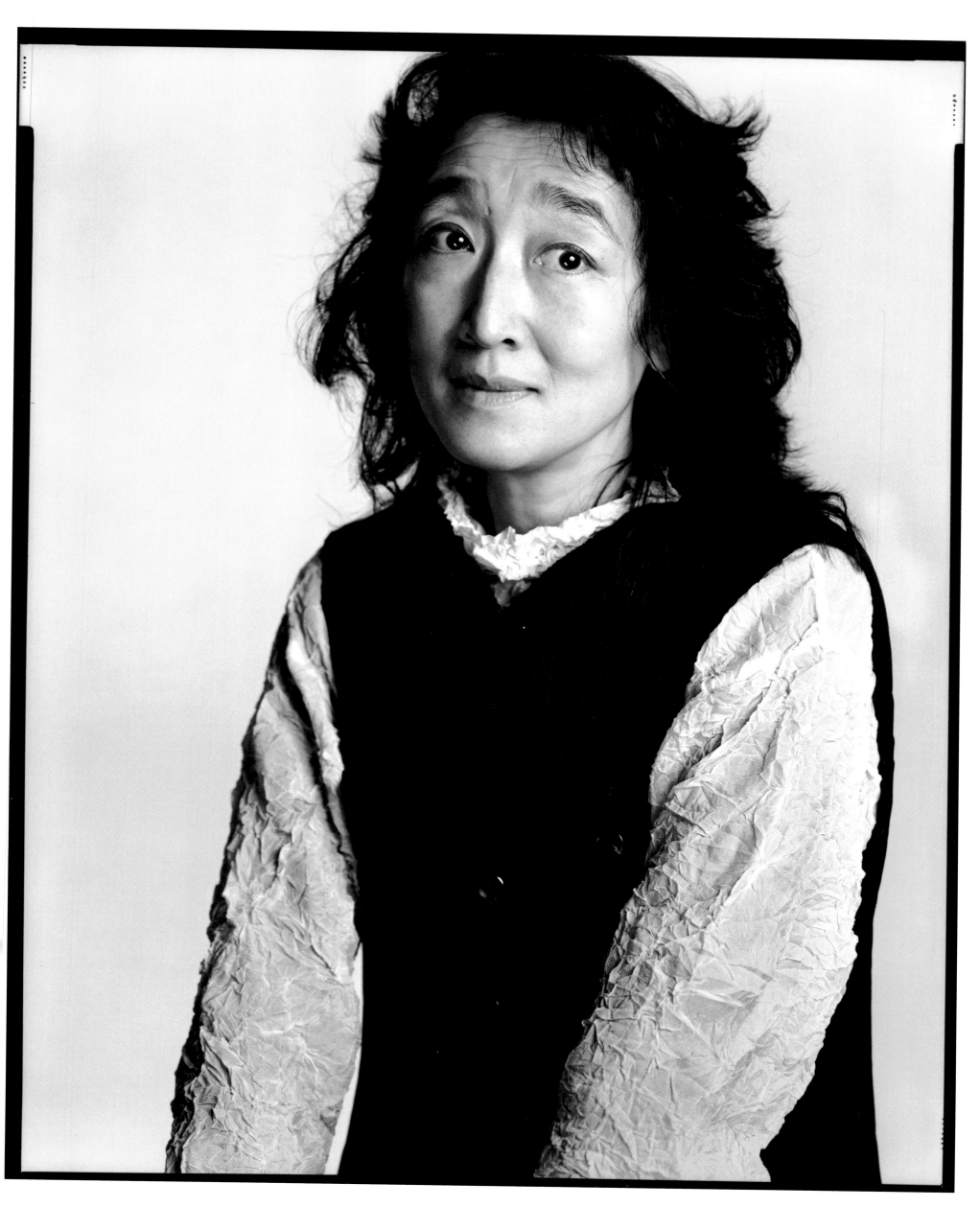

Lorraine Hunt Lieberson, mezzo-soprano. New York, October 2004

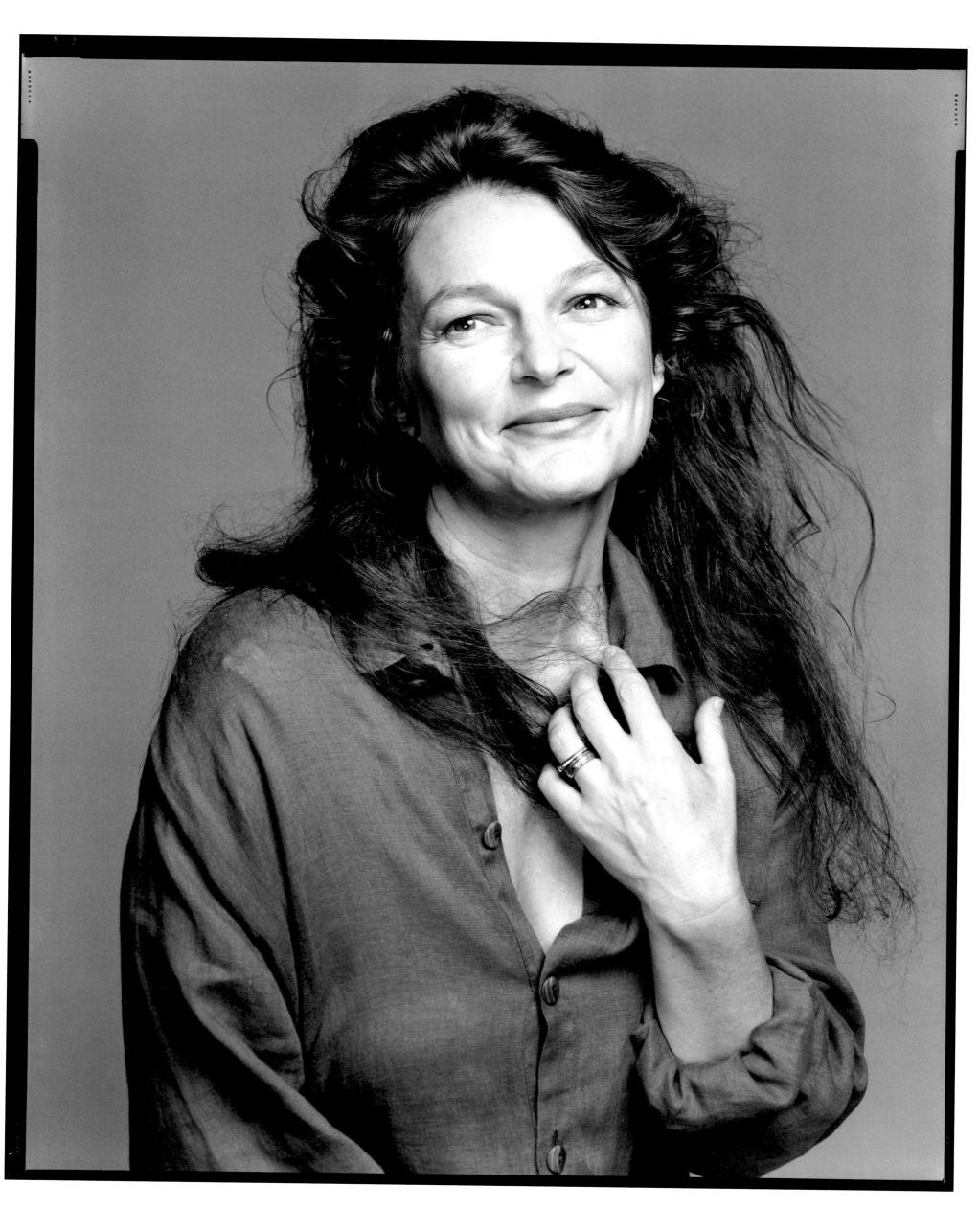

Woman In The Mirror

By Anne Hollander

I

WE CAN SEE the mirror as the hungry eye of art, waiting for the woman to enter the frame and complete herself as a picture. Any picture of a woman is an extension of her mirror, with the artist's eye going further than hers, expanding the creation the woman begins when she sees her own image. Titian and countless others clearly stated this theme in paintings of Venus using her mirror, showing how artists connive with the goddess to intensify the power she generates by looking at her own reflection.

Artists of the camera have been the best equipped for such connivance. Photographers have made people more than ever aware that a woman's picture, her seen self, delivers her essence and is important to everyone's sense of female being. More than that, in the hands of certain modern masters, the camera has confirmed that a large part of the blow women strike at the heart through the eye is delivered by what they are wearing, even if it's only their hair.

Like the bond between women and their image, the affinity between women and their clothes seems older and deeper than that between men and theirs, more mysterious and primordial. There's prehistoric evidence: certain twenty-thousand-year-old female nude statuettes unearthed in Central Europe include an open-work string girdle, carved around the body below the waist, its lower edge hung with tassels. This object is notably an adornment, not a covering. Its sole point seems to have been the mesmerizing effect of the tassels swinging around the pelvis when the wearer danced or walked, or just shifted her weight. Any regular movement would make them stroke her skin as they called attention to her hipline, arousing the woman and her audience together.

Maybe the aim of these stone images was to increase the population, but the erotic effect probably trumped procreative need. Avedon's Tina Turner from 1971 swinging her looping beaded fringes shows the stone-age method still working well (p. 127). His Suzy Parker from the fifties in Paris is a refined example, further suggesting that this pale, outbursting bustle was invented to be worn only for this forward-tipping moment (p. 45). We watch her feel that her bending self and thrusting dress are one, together embodying desire; and that the photograph proves this.

The Avedon fashion photographs are all portraits. They are always of the person inseparable from the dress (or hat or turban, or suit or coat), and his nonfashion views of women from the forties and fifties illustrate the same idea. Like the casual street subject, the fashion model in his photographs is always a particular woman feeling her momentary identity filling whatever she wears, along with whatever she's doing. In the 1940s Avedon was setting the course for the recent cinematic style in fashion photography, where face and posture get more emphasis than what is worn, and the chic lies in the look of the model's whole self, including visible signs of her (or his) unconscious urges of the moment.

When Avedon became a professional fashion photographer, fashion models were not public celebrities, their work had no prestige, and their names were not generally known. The job still carried vestiges of the disrepute attached to artists' models of the nineteenth century, when any woman who posed professionally was vaguely believed to sell her body in other ways. By the mid-twentieth century, a model might be supposed to have some connection with the stage or screen, usually at the casting couch level. People assumed models had only perfect looks, and neither talent nor honor.

Besides that, beautiful women in fashion plates were perceived as doll-like creatures with the nonliving perfection of mannequins in store windows. They were associated more with the feathered showgirls posing on the cabaret stage than with the women who bought and wore the mink and chiffon. Photographers of society ladies and other famous women, who often wore great dresses, aimed to enhance the sitter's personality as painters did, but the private feelings of the fashion-photographer's model were considered irrelevant to her image. Evidence of them might even debase the tone, given the kind of girl she probably was; and the models in fashion plates instead became famous for their "remote" look. Avedon arrived to change all that. He was assisted by ongoing changes in the cultural place of fashion, but the arresting nature of his work helped to move those along.

Fashion had already changed its status before the end of the First World War, becoming generally marketed and publicized and no longer seen as a privilege of the exclusive rich. By the 1920s, well-designed ready-to-wear fashion had acquired economic importance and its own potent chic. Meanwhile, haute couture design, along with all modern design, had gained swiftly in aesthetic prestige and was perceived as allied with modern art. So was photography. Camera artists were developing distinctly photographic styles of realism, abstraction, and surrealism, besides further establishing the artistic credentials of documentary photography.

Printed graphic fashion illustration, already modernized to rhyme with painterly styles such as Cubism, soon gave way to the camera, and fashion photographers began to render modern elegance with abstract, surreal, and documentary effects. They all nevertheless seemed to agree that the fashion model's own soul shouldn't show, even though that also left the dress soulless. The pictures themselves were often very beautiful, and increased the honor of camera work.

During the same period, however, popular cinematographers were purveying sleekly attractive and quasi-natural styles of grooming, movement, and gesture. Thrilling screen stars demonstrated quasi-natural ways to wear the quasi-normal clothes suitable for every social level and kind of occasion. People were learning from the movies about the dress, hair, and behavior of princesses, heiresses and adventuresses, secretaries, phone operators and waitresses, young housewives, old mothers, and sluts. Advertising photography backed all this up, and the whole spectrum of desirably clothed women could be internalized as a set of sleek visual clichés.

This popular stylization of modern fashion occurred in the generation before Avedon began work. Surveying his first two decades of pictures from this great distance, it's now hard to see how radical his fashion work was, in view of the divided photographic milieu he entered. And, now that the millennial camera has swallowed the history of art since cave painting and dispersed it as a set of known visual cues, the post-modern eye can see how smoothly Avedon even then was able to admit the riches of past art into his photographic imagery—as the pioneering moderns, intent on rejection, felt they should not.

Avedon's fashion photography reflects the fact that he started out professionally in that genre, unlike such established artists as Steichen and Man Ray, who occasionally lent their serious talents to trivial fashion. As a novice, while assembling a portfolio to show the art director at *Harper's Bazaar*, Avedon had channeled his already charged photographic imagination into fashion-style images of his beautiful younger sister. It now seems as if the aesthetic dimension of fashion was then claiming him through her. We can see how the wonderfully

dressed woman could always be a potential beautiful sister, a kindred spirit to mirror as he felt and saw it, vibrating all the more movingly through the beauty of the garment.

At the moment of Christian Dior's haute couture revolution of 1947, Avedon made an especially remarkable fashion plate set in a Paris square. He lets some sober Marais onlookers watch the model Renée pretending to display a Dior ensemble to the artist Christian Berard, who plays at being bowled over by its stiff peplum and up-sprouting little hat (p. 25). Instead of conjuring an apparition fusing the model and her clothes, Avedon shows a dressed-up woman and her scruffy admirer comically acting out the fashion game for an audience watching the photographer create the scene. This was truly unheard of and prophetic.

The sensual vitality of Dior's new mode could itself be Avedon's theme. Paris flagstones set off the wide swing and tight waist of Renée's Dior ensemble, while the baggy suits of the passing male trio show ample fabric used quite differently—Avedon shows this sharp contrast between men's and women's clothes mirroring a new mid-century distance between the sexes (p. 61). Renée's skirt-swirling walk shows the photographer's love of the performance in feminine elegance, the way a perfect suit lets a woman play herself perfectly. In another Paris shot, Elise Daniels appears in her suit as a colleague of the street acrobats, striking her own well-schooled pose (p. 65).

In these late 1940s genre-scene fashion plates set in Parisian sites, he might add a male model or two and suggest intimacy among them all, as if associating them with the characters in Henry James novels, who always dress beautifully and have the leisure to let emotional moments reverberate. There's also the Jamesian two-way thrill of the American presence in the Old World. Avedon's female models in Paris all look like candid Daisys and Isabels, the male ones like Continental counts and princes, or well-born Britons having a French holiday. It goes very well with the nineteenth-century flavor of Dior's new designs. Avedon was rendering the haute couture human in the style of great fiction, and meanwhile preparing us for the arrival of the supermodel—named, known, and loved—whose unique self invests everything she wears.

Avedon was also pointing to fashion's reality, bringing it further into the active consciousness of American social observers still believing in its inherent folly, along with the personal nullity of its models. This belief had in part been bequeathed to the twentieth century by nineteenth-century fashion illustration, which was purveyed for decades in a very banal graphic medium. The style itself created a trivial quality for fashion and implied the shallowness of women, still being automatically viewed as The Second Sex. It's worth noting that Simone de Beauvoir's galvanizing title, right along with The New Look and Avedon's first pictures of it, also dates to 1947.

With that in mind, we see the visual feminism built into Avedon's work from the start. In their reflectiveness, his fashion photographs seem to acknowledge how hard it is for a woman to become self-aware and self-possessed, so as to acquit herself well in her time whatever she does, and perform well in her own eyes. He demonstrates that a designer can give her some great visual means, and a photographer can hold up his canny mirror to show that clothes and mirrors are always her allies; but mainly Avedon shows that the quality of the performance depends on her and springs from within. While scanning nineteenth-century pictures, Avedon seems to have skipped the bad fashion plates and studied the atmospheric groupings and portraits of Degas, who loved

the camera, understood fashion, and had fine intuitions about women. Many of Avedon's photographs have his flavor, and many Degas works look forward to cinematic effects like those in Avedon's fashion work.

The universal importance of dress is now an unquestioned given, but it was once considered a shameful secret confined to The Women's Pages, since men were not supposed to show they cared. Avedon showed he knew and cared by always treating the deep relation between women and their clothes in the same way. He looked closely at Zazi the street performer back in 1946, dancing and piping in Rome, the shirt wrinkling under her big sweater (p. 11). Then in 1949, he looked closely at Dorian Leigh modeling in Paris, her chic sleeve catching the sun; and he photographed both embracing the nearest bystander with contagious-seeming and spontaneous-looking laughter (p. 9). He lets us see that these performing women always perform whatever they're doing, including being spontaneous. Their obvious delight seems to come from feeling their female act in its appropriate costume so aptly monitored by the Avedonian eye.

Reflecting the sea change in fashion during this epoch, Avedon launched the fifties with Dovima as a hieratic vision in a dress by Jacques Fath, her hands posed symmetrically between one satin flank and the folds of heavy stole that drop from fur armlets around each elbow (p. 41). This image strongly suggests a particular Zurbarán painting, in which Santa Casilda's sumptuous dress also displays precious armlets, many folds, and great ostensive dignity. In both pictures, the details of the rich gear transcend reality, and there's an aura of sacred ceremony in each. The dim backgrounds are slowly being illuminated, as if both artists were suggesting that behind this impressive

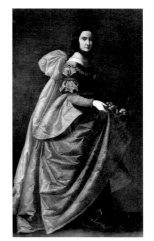

Francisco de Zurbarán. Saint Casilda, 1640. Museo del Prado, Madrid

female figure, a new light is dawning, a fierce religion is at work.

Zurbarán was the exponent of the newly powerful Spanish Counter-Reformation in the 1620s and 30s. Following its guidelines for religious art, he painted many large single images of saints, combining detailed realism for the dressed figure with an austere, mystical atmosphere. Here Avedon seems to follow his example so as to expound the French haute couture as a new holy institution, at a time when its swift postwar success was providing true salvation to the French economy and to France's international prestige. Dovima's personal flavor made her the right model to render the couture unearthly; it's her authoritative bearing and emotional intensity that seem to sway the heavy elephants, quiet the nervous monkey, and bring the camel to its knees.

Meanwhile, standard Romantic fantasy inhabits the nude-filled backstage at the Folies Bergères, where Suzy Parker plays an other-worldly nymph in thin silk leading a susceptible swain away from trouble. In the morning, still holding hands, nymph and swain speed across the Place de la Concorde on roller skates, her immortal draperies now of tweed (pp. 47 and 67). As the decade ends, we watch Avedon let such whole-hearted Romanticism solidify into a convention and begin to flirt with self-parody. When Suzy and China Machado are joined by others at La Pagode d'Or in 1959, they now pose as if posing. Their exaggerated

posture and extreme hair are backed up by static mirrors, and the dark-suited men's feet form a chorus line of shiny shoes (p. 53).

Avedon uses photographic caricature for his 1955 portrait of Katherine Hepburn, capturing the whole woman in a few deft lines and patches of shadow that instantly convey the sound of her inimitable speech (p. 69). By contrast, he elaborates on the way Marianne Moore and Isak Dinesen impose themselves through surface quirks and quaint accoutrements, outer layers wrought up over decades to clothe their active inner lives. Avedon makes bright-eyed Dinesen's hat-brooch into a third eye set high on the skull, and he lets Moore begin his procession of shut-eyed literary men, emphasizing the gentlemanly symmetry of her cloak and tricorne (pp. 73 and 103). Avedon backed up these two writers with the dead white he so often used, to sharpen the separate details of the subject's person by leaving out the forgiving light of common day. His blank white is like the flat gold used by early Flemish painters behind sacred encounters or personages, to replace natural landscape or indoor details. Incorruptible gold stood for the changeless eternity that opposes the minutiae of human life, which the artist would depict with excruciating accuracy to emphasize the contrast.

Avedon makes supernal white seem an apt environment for his double portrait of Jacqueline de Ribes and Raymundo de Larrain (p. 71). These two face each other nose to nose as if they were ancient Assyrian deities carved in relief to commemorate a famous battle, in which the two had favored opposing sides. Their close placement displays their common godly status, with its required physical perfection and frozen modes of dress and gesture. The artist records no affinity between them, except their common disdain for mortals—they might, like many obsolete warring divinities, be brother and sister. We can imagine the actual battle carved in miniature, raging below the soles of their divinely shod feet while they rise into white eternity. But eternity can also be shown to exist in the present moment, when the photographer conjures the light on surroundings to bless the instant. Avedon did this for his beautiful wife, in a room where her odalisque arms rhyme with the roses and her satiny figure lights up the furniture (p. 87).

Avedon's worldly backgrounds for fashion often suggested cinema. The model Liz Pringle is sheathed in sportive white against sea and sky, and her flat-chested look brings to mind the quasi-free heroines of the Hepburn movies, where a thin and willful rich girl wears fearless white, echoing the "madcap heiress" character in silent films such as *The Sheik* (p. 81). Pringle looks spare and eccentric, a Hepburn plus cigarette, minus speech; and there's a strong man somewhere in the picture, just as in all the movies.

In Lillian Hellman's nonfashion portrait, however, Avedon suggests a nineteenth-century photograph (p. 85). Hellman looks strong-minded in the classic manner, stable and competent, her naked cigarette posing as a sharp pencil. This, combined with the torrent of light and the dark ground, indicates the writer of producible dramas—she might be at a rehearsal. But the photographer also lets Hellman's strict profile and draped clothing resemble those on a Roman coin, stamped with the image of a seated sage or lady. Hellman seems to play the part, at ease in an immortalizing medium reaching back to when drama began. She opens her mouth, probably to object to what's happening on stage.

Hellman's resemblance to old photographs and ancient coins supports a common belief of the time, that to be seen as serious art, photographic portraits of women had to allude to female portraits by painters, printmakers, and sculptors, or by earlier photographers who had invoked them. Despite Stieglitz and other giants, photography in 1950 still wasn't universally acknowledged as serious art on its own terms, and especially not for creating visions of women. Many people still assumed that no modern photographer could produce the equivalent of Leonardo's Mona Lisa, and apart from the technical, there was an underlying reason for this.

Photography for advertising, fashion, and film publicity, plus commercial cinematography, had taken over the empire of the female image and was steadily tightening its visual grip, soon to be strengthened by television. In the world of art, such camera work was then judged to be a licit kind of pornography, miles away from serious painting and artistic photography. In the 1940s, just before this early period in Avedon's career, the glossy publicity images of Lana Turner, Betty Grable, and Rita Hayworth were somehow perceived to be produced by the stars' beauty, not created by skillful photographers. In any case, those image-makers didn't count as authentic portrait artists, even though the whole world was affected by their work. To be respected as art, photographs of women had to show no trace of promotional sheen and display much kinship with respectable media.

Avedon was the first photographer to destroy false barriers between serious and nonserious photography, perhaps because he grew up feeling the force of those old assumptions. Impassioned by photographic portraiture, but necessarily despising slick publicity work and mannered artistic effects, he got a fashion-photography job. Immediately his talent asserted itself and he began thrusting his unlooked-for personal portraits into the glossy fashion pages of *Harper's Bazaar*. As a result of this, fashion photography and fashion altogether began to undergo new changes of category and status.

More than that, back in 1947 Avedon was already beginning the demolition of false barriers between serious and nonserious figurative art, long righteously thought of in terms of high and low. Photography acquired its final permission to be directly incorporated into the tradition of serious female portraiture because of Avedon's work; Warhol and Cindy Sherman were to come. By 1957, we find Marilyn Monroe against a dark and uncertain horizon, in an enduring masterpiece that combines elements of a Goya portrait with vestiges of a publicity photograph and a movie frame (p. 89). In freely allowing such a mixture, Avedon showed that he was now certain of his own unique force in the portrait genre.

He doesn't strive for these suggestions; but he need not strive to keep them out. He's in the same place as Goya, successfully undertaking professional challenges while following his own obsessions—Goya, too, persuaded his royal and noble sitters to show their private faces to him. Meanwhile, Avedon could not only unselfconsciously plumb the strategies of painters ancient and recent, just as Goya did, but allow the whole multiform photographic ambience of his own time to be of use to him.

Nearing the last of the 1950s and of her short life, Marilyn seems to fear that her persona won't go over in future decades. Her blond looks had always followed the classic ideal of rounded, adipose harmony, a sweet invitation to pleasure expecting no violence and projecting no insolence. In this picture, she seems to feel her beauty losing power; she looks ready to turn away from the mirror.

A DOUBLE SPREAD of 1961 takes much further the already self-conscious posing of China and Suzy in 1959. Now China and Margo are posed as models dressed and coiffed to be photographed at a collection, coolly undergoing a staged push and shove by the media (p. 91). In this milieu, we don't observe their private selves expanding to inhabit their clothes. On the contrary, they are presented as key figures in the fashion industry, proud of how well they do their job. Encompassing that, however, is the strong emotional effect of the image itself, which allows us to see two huge exotic birds surrounded by a group of zoo staff intent on caging them. The ogling woman at far right seems about to extend her wineglass to China to lure her.

Wearing fringes and embroideries, China lifts her jeweled head, Margo bows hers above unadorned satin—they could also represent Resistance and Resignation, fancifully costumed allegories who stand aloof from bustling humans. This fashion plate mocks fashion coverage, shown to embody fashion madness, which arises from the risky fashion business and its hysterical promotion. As before, Avedon has made the models look perfectly beautiful and the exquisite dresses entirely intelligible; the difference between this picture and the ones of Suzy in Paris from fifteen years earlier is the presence of a new fantasy about Fashion.

The unexpected death of the great Dior in 1957 at the age of fifty-two, after an exhausting career of only twelve years, was followed by the thrilling ascendance of the modest, bespectacled twenty-one-year-old Yves St. Laurent. The master's invisible, gifted assistant suddenly inherited the empire of design at the famous Maison Dior, and the world of fashion became a locus of high drama. New vigor enlivened the cult of the dress designer, which had been a marked but low-intensity cultural fact since Charles Frederick Worth invented couture in 1858.

St. Laurent, obviously a genius, began to shift feminine looks into a new register, following Chanel's early 1920s precepts about tailored ease for women. He became an international celebrity, charming as any movie star, everywhere expressing love for his work and love for doing what women wanted. Chanel herself had already done her part for the cult by reentering the profession, uttering more of her quotable aphorisms ("A woman without perfume has no future!") and renewing her personal fame. These personalities helped turn the world of fashion into a new, high-level form of theatrical myth, and Avedon became its best visual expositor, devoted as always to the mysteries of individual self-presentation.

His 1958 image of Three Graces leaping toward us out of nowhere shows them apparently rejoicing in the revolutionary looseness of their suits, after ten years of Dior's strict upholstery; and he even photographed one of the new, body-skimming dresses on the impeccable Dovima, posing her as a balloon about to leave the ground (pp. 93 and 97). In both he recorded that careful hats and gloves were still necessities, despite the new lightness of female being; but Dovima's direct gaze now draws attention to how seldom Avedon's fashion models looked straight at the camera during the forties and fifties. By the early sixties, female sexual freedom was to become a constant public issue; new codes of behavior would soon give women acceptable ways to show desire and make approaches. Before long, every magazine cover showed a beautiful woman smoldering intensely into the lens, and newsstands looked amazingly steamy. Everyone quickly got used to this.

The sixties eventually changed everything, beginning with Suzy—Avedon has her already abandoning romance in 1959 and looking us in the eye, to acknowledge the triumph of the Chanel suit (p. 101). The great designer revived her infinitely flexible creation in the middle fifties, perfectly timing its rebirth just as The New Look was getting old. Chanel, in eclipse after closing her Paris couture house during World War II, was delighted to find herself a new success and still a legend. She still wore hats, too, but Suzy's tousled hair and girlish bow rhyme perfectly with Chanel's insistence on mobile sensuality for female suits. We see this quality in action as Coco's sliding hand adjusts the blouse, and Suzy's caressing cheek approves. No gloves for this tête-à-tête, and each woman has her own way with a cigarette. Chanel at seventy-six shows her own way of preserving eternal youthfulness: simplicity and soft fabrics for the body, vivid jewelry for drama.

In 1962 Avedon showed Suzy apparently having a dream she couldn't help, in a satirical fashion sequence sparked by the public behavior of the adulterous Taylor-Burton couple and the fuss about it in the press (pp. 105–111). Avedon again shows clothes to perfection while inventing strange circumstances for them, now with nightmarish photographs of chilling veracity. We see the model dreaming she's a notorious actress losing her cool in public—but Suzy's professional spirit dominates, and her historical costume is really a ball dress by Lanvin-Castillo. When the dream turns grim and the star tries suicide, Suzy survives to model a St. Laurent coat with her bandaged wrists.

This kind of thing had never been done before in fashion photography. We're now used to fashion promoted in fantasy narratives, where a current actress's couture clothes pose as a film's costumes; but in '62, when Avedon's fake Burton-and-Taylor sequence appeared in *Harper's Bazaar*, many anxious readers thought it was all a true story about Suzy Parker and Mike Nichols—a response showing that Suzy had become the first supermodel, always herself whatever part she acted. Public fashion-fantasy came to be built around the likes of her, women whose personal lives mattered only because of their being and their beauty, first made real by this photographer's talent and sympathy.

In another realm entirely were the serious beauties, whom Avedon portrayed as if for all time. He put himself in competition with the great painters who could make a woman's portrait so compelling that her identity would reside forever in the artist's picture, like Mona Lisa, even if her name were known—and it's likely that Avedon's monumental portrait of Marella Agnelli will outlast all general knowledge of that lady's life and connections. His painterly license let him use lighting and composition to lengthen her neck and suppress her shoulder, subdue the details of her coiffure and then add unidentifiable folds to her bust, all to abstract her from present life without seeming to. Like many deathless others, she claims her own place in any epoch by meeting the viewer's gaze and doing nothing else. Similarly, Avedon flattened and outlined Gloria Vanderbilt's head and shoulders, to give her the Matisse-like look her strong face suggests, at the same time aligning her portrait with other early-twentieth-century painters' work—Picasso, Modigliani, Leger. These two women wear no adornments that might fix them in their own period, or even posed hands that might create a dated emotional atmosphere for them (pp. 79 and 77).

Brigitte Bardot had already been immortalized in movies, and seemed on a different track from Agnelli and Vanderbilt. Avedon ignored Bardot's cinematic persona and filled the frame with her tresses,

officially to feature the work of the coiffeur Alexandre de Paris. He recast them in a fictional shimmer, to suggest Rossetti's legendary beauties, whose luminous hair had been deliberately painted to recall Titian's prototypes, especially his Magdalen. With this whiff of Titian, Avedon was obliquely linking Bardot to the many Magdalens of art history, whose loose hair always stood for penitence and devotion as well as sexual license. He then gave her face the melancholy timbre of Botticelli's Venus, to reveal her spirit and let us infer her curves (p. 113).

During the sixties the model became a celebrity, there was no need to demonstrate her humanity, and chic clothes ceased to require detailed inspection. In sharp dissent from the demanding elegance of the fifties, when grown women set the fashion and raw girls were not players, the sixties mode shifted to make chic women's clothes look childish. Hatless heads and flat-shod feet began to look extra big, the curves of the torso vanished, and hemlines went up to the very top of the thighs where Shirley Temple had worn them. Dresses lost their careful structure and became simple little smocks and tunics. During this time, fashion photographs tended to be shot from a low viewpoint, to keep the legs and feet prominent and the trunk diminishing upwards; but Avedon would let the short dresses billow immodestly higher and blur the torso even more, as his models skipped and jumped, their girlish locks flopping. He emphasized their seductiveness, showing heedless-seeming child-women as the opposite of innocent.

The spirit of fancy dress invaded fashion in the later sixties. Peasants, cavaliers, pirates, and gypsies eventually turned up, along with African tribeswomen, cowgirls, and white huntresses on safari, or outer-space and ancient warriors clad in plastic scales and thigh-high sandals. Fashion for women tended to use the masculine versions of theatrically historic modes—male pirates and cavaliers, not big-skirted, low-necked female equivalents of the period—so that cross-dressing was implicit in the fashion. Some styles invoked that stage tradition, suggesting female singers dressed as Cherubino or actresses as Peter Pan.

During all this pageantry, Chanel bowed out, having done her work—one of her early contributions had resulted in the female adoption of trousers, the defining male garment for centuries. Once forbidden to respectable women and therefore worn only by whores, fast aristocrats, eccentrics, and stage performers (not to mention mine workers and fisherwomen), trousers were provisionally accepted in the first half of the twentieth century and became universal women's wear only in its last quarter. The launch year of this final shift was 1967, when the cavaliers were rampant, although about a decade was needed to accomplish it. Meanwhile the infantile style was soon over; it had been a final bid for the powerless look. Female autonomy was going into actual effect, and trousers seemed to chime visually with the new fulfillment of that old aspiration. Beginning with St. Laurent, famous couture designers began offering high-level ready-to-wear fashion for busy professional women, including trouser suits with other tailored separates and dresses. Jeans for both sexes, always classic and rebellious at the same time, thrived then and survive now, covering the globe as the universal sign of retreat from all conventions but their own.

In Avedon's early fashion work, the faces had sent the personal messages. In the late sixties and early seventies, the bearer of news became the whole body, interacting with its covering. Avedon held his fashion art of this period to a high modern standard, keeping paramount the aesthetic impact of the entire image, making it both coherent and current. He did this with the shape of the solitary woman's figure suspended against the neutral ground, whether she skipped in a Blass minidress, lunged across the frame in a black Dior coat, or leaped straight into the air in a white Ungaro suit. For tailored clothes, corners were sharp, coattails and trouser legs led their own crisp or wrinkled lives. For fluid styles he let the model sweep along in waves of flowing stuff that took its own shape, through which he let her show as armature and pilot. He managed to make these effects seem born of the woman's fantasy, realized through her body's responses to the fabric, the tailoring, or the linked plastic pieces (pp. 133–143).

The face was now part of the formal composition, as in the modernist Munkacsi's fashion photographs, and it could be absent, turned away, or covered by hair or cloth. Avedon clearly indicates that each of these women inhabits the photograph, not the clothing, and that she and the garments are fused in art, not life. The model is costumed to dance for his lens, not dressed to go dancing. One exception is the beautiful 1967 fashion portrait of Penelope Tree in her navel-baring black pants suit, where the taut personality of the model invests every curve and angle of the clothes, and we think we see the real woman turning inside a real moment (p. 117). Avedon was echoing the new female desire for easy-to-wear clothing based on modern masculine principles and often on masculine forms—a few garments combining to produce a flexible, expressive envelope for the entire body, not significantly padding, weighting, distorting, or denying any part of it.

Avedon fashion photographs in this period showed women as active organisms, not poised apparitions; and since the clothes were meant to convey immediate meaning and not achieved beauty, they were photographed so as not to require close study. Avedon had long since shown that the best fashion plate was a portrait; but now the fashion portrait even seemed to need no fashion, just a supermodel such as shiny Lauren Hutton, apparently smoking a joint under the Bahamas sun wearing only false eyelashes (p. 129). Built into this kind of image was a new denigration of fashion, a reactivated feminist feeling that the whole enterprise was a centuries-old trap and subsequent prison. High heels and uplift bras were being viewed as oppressive instruments of the patriarchy, and some women boasted of not owning a skirt. The personal, even the intimate, had become fiercely political. As always, we can see Avedon's sympathy for this impassioned point of view, and we get a sense of his nascent distance from fashion and its forces.

On the other hand, Avedon shows his nonfashion subjects in these two decades participating in photographic theater as naturally as models do. The stage performer Janis Joplin looks right at home in fluttery hippie mode, her cigarette and big laugh making us think she always looks like this, even if nobody takes pictures or glances her way. By contrast, Louise Nevelson rises before Avedon's mirror as a multifaceted piece of her own sculpture intent on being displayed, her great hands exercising her métier on her self. Avedon suggests that for performing in the world, both Joplin and Nevelson need carefully composed costumes and self-defining gestures. We see each thinking herself mirrored at her most real, with self and art in perfect harmony (pp. 119 and 123).

Realer than either one are the Picasso children, whom Avedon portrays as if they embodied the whole tragic aspect of Spanish history. Paloma's plain kerchief and the look on both faces suggest generations

of youthful saints, servants, and peasants, centuries of mute fear, hope, grief, and patience; they display no trace of papa's hungry self-regard (pp. 114–15). Their alert stillness gives them their painterly look—they don't pose; they watch and wait and keep their counsel, like the solemn young torchbearer in El Greco's *Burial of Count Orgaz*. The look goes beyond Spain: they also resemble the boy Arshile Gorky and his young mother in the artist's double portrait (made from a 1912 photograph), each enduring a difficult life with a beautiful closed countenance.

Avedon gave these three pictures the rich, gray backgrounds that imply the movement of feeling; but the white recurs with distinctly emotive flavors. The once-blissful wife now moves unhappily across the frame, as if pushed by the ruthless nothingness at her back (p. 153); and behind St. Laurent's muse, Loulou de la Falaise, the bright white spices up her 1977 style of male-inspired chic (p. 99). Avedon even makes Loulou's wayward hair and crushed leather resemble those he photographed on Andy Warhol and Gerard Malanga ten years earlier, also against white; but in this decade Loulou wears jeweled earrings and full makeup with her tough masculine gear, calling attention to this male-female mix with her knowing smile.

Between 1979 and 1985, Avedon abandoned the urban East to roam the West and make portraits of hundreds of strangers for an exhibition and a book. Many different American women who weren't models and didn't consider themselves portrait subjects looked into his camera, and he made them appear unaccustomed to performing or to mirrors. You can't tell their jobs by their clothes, and Avedon records the occupation of each, recalling August Sander's scrupulous labels for his pictures of people from different social groups.

This project has a purgative look, as if it were meant to purify the lens clogged by the career, to get thoroughly away from fashion in all its forms including big-time politics, art, and entertainment. Now we are looking at the local bartender, pawnbroker, hairdresser, and physical therapist. Just as with Sander, art is sovereign. Avedon permits no intrusive flavor of the amateur snapshots these people might take of each other. Everyone goes straight out of context and up against the eternal white, so the camera can dwell exquisitely on every lock, quirk, crease, and gleam. Windblown hair frames faces that are slack, bitter, wry, very young, and not young; but the intuitive photographer makes each look like someone in a Willa Cather novel, a detailed, self-contained universe of truth and consequences.

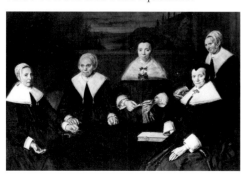

Frans Hals. The Regentesses of the Old Men's Home, c. 1664. Frans Halsmuseum, Haarlem, The Netherlands

The worn countenance of Rose Kennedy in 1976 looks very like one of these American faces backed up by white and set off by work-clothes, even though the Kennedy version is couture chiffon with pearls and stiff hair (p. 171). Avedon pointedly disconnects those phenomena from Rose's aged face, and she seems unconscious of them. Her clothes make Rose seem more like a figure from a seventeenth-century Dutch group portrait, where the painter carefully rendered the velvet and linen finery of the women administering a charitable institution, and then registered the harsh lines of their unsmiling faces above it.

Looking at Rose as one of them, we can imagine a strong will, perpetually buffeted by rivalries and enmities, rage, and pain forced down under a show of calm, and at length congealed into fatigue, cynicism, and unquenched resentment. We can trace very little facial history of unquenchable joy, and neither Rose nor the Dutch ladies seem to enjoy wearing their rich garments. Fine clothes are just a necessity of public life, like posing for portraits.

III

DURING THE EIGHTIES, corsets came back into fashion with a vengeance, some imitating the most rigid ones from the libertine eighteenth century. Female freedom was now a reality, and avant-garde chic had stopped expressing any longing for mobility. High fashion instead began to promote a knowing indulgence in antique forms of constriction and extension, adornment and exposure, sometimes offered in perverse substances and combinations. Designers such as Galliano, McQueen, Versace, and Yohji Yamamoto seemed to signal that everyone was now free enough of history's burdens to kid around promiscuously with their visual aspect. During this period, Avedon was keeping his fashion camera at a distance.

In the nineties, however, Avedon presented Stephanie Seymour going to a different kind of new extreme, raising the skirt of a transparent black dress to unveil her pubic triangle. Stephanie's intent look makes her gesture seem ceremonial, the revelation of a sacred treasure and weapon—the origin of the world, the face of the medusa—while displaying a personal adornment. This well-barbered fur is to be admired for itself; the graceful image stands on its photographic merits and rejects all claims to shock value. Stephanie pulls up the black folds as if she were dancing a classic sarabande (p. 159).

In a later picture, we find serious Stephanie still dancing in transparent black, now celebrating the dome of her pregnancy; and in both, one of her arms is absent while the other does something startling. In still another picture, she falls in a gangly, dancelike faint while wearing a Karl Lagerfeld dress (pp. 165 and 179). Avedon seems to choreograph Stephanie as Balanchine did his muse of the moment, creating idiosyncratic ways for her to move that enhance her personal charm. These photographs show no impulse to objectify the desirable creature; the woman's own bodily sensibility is what engages the watcher.

Fashion changed decisively for Avedon as the second millennium was ending. By then, the camera's power over fashion was supreme, and public perception of it was wholly created through visual media. Women were buying garments because they saw images of them on the screen or page; they looked into shopwindows and mirrors to see how both they and the dummies measured up to camera views of celebrities. Avedon, now an Old Master, could display a new relation to fashion by consciously exercising that supreme power, this time not to promote fashion but expertly to subvert it.

Since his pictures had helped create fashion while it was thriving, his new pictorial indictments implied that high fashion was now mocking its own importance, ceasing to take itself seriously, hollowing itself out. Avedon extended his mockery of fashion's facilitators and promoters to include stressed, hardworking editors and press agents and the occasional model and designer, all playing at being half-mad and silly, as chief victims of fashion's hectic pace and global scope.

His figuration of destruction was most notable in a 1995 sequence published in *The New Yorker*, announced as Avedon's Return to Fashion. This was enacted in a twenty-five-part, full-color pictorial narrative featuring a married couple, played by the model Nadja Auermann and a male skeleton, sometimes shown with their infant, played by a broken doll (pp. 201–215). All action occurred among the picturesquely wrecked décor and furnishings of the huge, deserted Montauk Country Club, where, to indicate their pleasure in having their picture taken, Avedon's first image in *The New Yorker* sequence showed the couple photographing themselves. Auermann appears throughout in extreme avant-garde fashion, and the skeleton wears super-loose-fitting male versions, except for the one time he poses alone at full-length, his glamorous and becoming female ensemble suggesting Schiaparelli in 1940.

It's a rich photographic ballet, the story of an intense spousal amour that turns morose, becomes a fierce struggle and ends without hope. He wins, as he must, but only by losing. In the final scene he orders her out, into sunlight and greenery with her torso clamped forever into a thick wooden corset. Fashion wins, at a dreadful cost; and the lifeless baby has vanished, a George-and-Martha fantasy never meant to breathe. Avedon didn't want to sprinkle this flow of troubling imagery with distracting names, so readers only found out which designers had enhanced the charms of Death and the Maiden from the credits at the end.

He was drawing on the long pictorial tradition of The Dance of Death, begun by artists in the late Middle Ages and immortalized by Hans Holbein, where Grim Death in his clattering bones is portrayed as a kind of clown, harassing, courting, offending, and cajoling his prospective victims. Like those artists, Avedon deliberately provoked shuddery giggles during his long sequence, which includes the couple undergoing fierce trials by fire, wind, and water besides playing piggy-back and having sex. In one scene Nadja suckles the Galliano-clad doll as the skeleton grins fondly. In another she's alone, frantically scratching the leprous wall and bloodying it with her painted nails.

In 2000, another Avedon fashion sequence appeared in Nicole Wisniak's wonderful Parisian magazine *Egoïste* with the title "Paradise Lost" (pp. 223 and 227). Readers knew that high fashion was doomed even before looking at the pictures, where models in strange Dior draperies clutch each other in fright, or the model's breasts are gripped in iron, her face mournful under a cap of thorns. Again in superbly composed and lighted photographs, Avedon was emphasizing that there's very little desire or delight in any of this, still less when jewels stop up a model's mouth and ears, or models' heads are cancelled by designs that turn them into aliens (p. 229). Avedon now seemed glad to suggest that fashion may bring suffering, and to dwell with heavy comedy on hysteria and dread. He was no longer expounding the mercurial nourishment fashion can give, or the enabling pleasure women find in the burden of its lightness. His models' faces and bodies now register fake bafflement and dismay; and Avedon reflects high fashion's millennial view of itself as a cool, cruel joke, an obsessive exercise in the absurd.

Going beyond fashion, Avedon had taken up nudity again. In Western erotic history, the chief duty of women's fashion was to emphasize the currently attractive nude female proportions, and artists kept stamping their images of ideal nudity with the desirable shape of current women's fashion. Clothes in pictures looked right only if they seemed to contain the ideal nude, and nude pictures looked right only if they showed the correct nude costume based on clothes. Thus Goya's Naked Maja seems to wear an absent dress supported by an absent corset that invisibly separates her breasts, straightens her back, compresses her waist, and emphasizes her hips.

But in the opposing kind of picture, such as those by Rembrandt and Lucien Freud, the painter portrays a woman's unique naked body as the extension of her unique face, the better to illustrate her personal completeness, not her degree of allure. Such a view of nudity suggests that in real life a woman may represent her erotic self through modish clothes and adornments, using Venus's girdle to bring out her appeal; but her actual nakedness—as Manet and Degas also indicated—brings out her whole character.

Avedon's nude photography brings it out, too; and one of his secrets is to include the face and hands along with the breasts and thighs. In his work we find no deliberately faceless torsos, in the Irving Penn manner, and no glimpses of female self-absorption, in the Degas mode. Instead, Avedon insists on a direct gaze into the lens—the "Olympia" effect, showing the nude subject's wish to be present, aware, and entire. Avedon's photograph of the model Kate Moss, famous for being thin when dressed, displays an unexpectedly lively naked form and outline, a corporeal wit missing from her dressed images, and a more vigorous personality than they can show (p. 199).

Another Avedonian secret is to accompany the nude image with no fabric at all. This is highly effective, since generations of artists felt they must add folds to nude figures in the manner of antiquity, to validate modish bareness as art, often painting real clothes to look like draped cloth. Occasionally we see Avedon doing this, and thereby making a great difference between the half nudity of Fiona Shaw (p. 183), whose clutched-up shirt and tucked-down trousers he photographed as if they were drapery (with her face mocking it) and the nakedness of Moss, who lives in a world without textiles.

In an art-historical nude photograph of the actress Tilda Swinton, Avedon lets her suggest waist-length Baroque images of the virtuous wife Lucretia from early Roman history, often portrayed as recently raped and about to kill herself. But she was not ashamed: Lucretia killed herself (one story goes) to force her rebel-general husband into taking prompt military vengeance on her tyrant-prince rapist, whose downfall would permit the rise of the Roman Republic. Swinton's straight gaze, rough hair, and self-addressing arm combine—along with the total absence of woven stuffs—to make the woman's strength of mind the subject of the nude picture. Avedon shows her owning her body, maybe even ready to give it up in a good cause (p. 197).

Avedon often demonstrated that glittering feminine attire looks great on men—not just on androgynous bodies, but on any compelling performer—just as plain shirts and pants look great on women. His work in the American West moreover reflected the fact that ordinary modern clothes no longer look strictly male or female, as they routinely did from the twelfth century up through the first half of the twentieth. During that long stretch, dressing in the clothes of the other sex was always a huge move, producing instant hilarity or outrage, and perfect disguise. Such attitudes were only dislodged in the 1960s.

Since then, the rising sense that all clothes are changeable costumes—as opposed to fixed customs—has allowed the vast apparel business to borrow from the whole world and the whole past, from films, show biz and the military, from professional sports and heavy

manual labor, and has allowed the public to mix everything up. Changed notions of sexuality and collapsed boundaries between youth and age have encouraged people of all genders and generations to dress more or less alike, so that casual clothing and hairstyle can vary more in detail but less according to sex and age than ever before in modern history.

Conventional male and female clothes, now offering the pleasures of old formal habits as options, not requirements, have shifted their character as they've been transformed into costumes. Men in dresses, skirts, and makeup, for example, have their own category very different from that of women in jackets, pants, and short hair. Meanwhile the high-level, famous-designer fashion machine has its own celebrity niche. It's still glamorous, expensive, and thrillingly fraught with risk, but no longer of general social importance and application—as the haute couture still was, when Dior cinched waists and lowered hems in 1947, and Avedon began his long trajectory on fashion's bat-winged back. Since 2000, however, fashion's own trajectory has needed restarting. If Avedon could begin again now, the fresh work of emerging designers (Ghesquière, Rodriguez) might well inspire him, since it already shows the exhilarating effect on women's self-image that Chanel and Dior once had.

During the fifties Avedon developed other ways of gaining ground in the portrait genre he had definitively enlarged as a fashion photographer. His fiercely unconventional picture of the Windsors, for example, together with those of Hitchcock, Chaplin, and many other stage and screen faces, showed his range then. He enlarged it further during the turbulent sixties, chiefly with unsparing views both of men in power and of men opposing them: Henry Kissinger, The Chicago Seven, Malcolm X, George Wallace. The sequence that registered his old father's decline in the early seventies, however, displayed a matchless filial attention and tenderness; and yet he matched it himself, with an equally attentive tenderness one might call fraternal, in portraits that showed mature women's faces. There he registered doubt, strain, or ruefulness as transparent veils that seemed to ratify the small lines and pouches, traces of bodily habits formed over time. It gave the women's images an acutely authentic look, with no element in them giving the lie to any other. He did this with great delicacy for June Leaf and Polly Mellen in the 70s, and much more recently for Patti Smith and Mitsuko Uchida. Avedon would get this kind of fleeting, complicated look by posing and preparing the subject as a painter might, building layers of attention and rapport instead of paint, to present

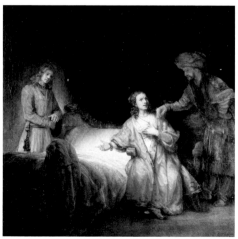

Rembrandt. Joseph Accused by Potiphar's Wife, 1655. National Gallery of Art, Washington

the person living through one instant that implies the next instant and the one before—the woman leading her life, not exercising her profession (pp. 167, 157, 195, and 233).

Centuries of painters have depicted women in their mythic, domestic, and erotic roles, often in portraits that emphasized the role and denatured the sitter. Avedon once said that an otherwise fine portrait could be ruined by falsity in the expression, something pasted on the face to fit an idea. The best painters seized the eye with the complex feelings of the woman at the present moment. Rembrandt, for example, embedded a portrait in a biblical scene, showing Potiphar's wife in the act of lying to her husband. Her look of intense persuasiveness combined with fear, anger, and frustration distills the whole story into one view of a woman's face, as she bears false witness to save her own credit and punish Joseph's rejection. The male faces have simple expressions; it's the two-faced woman that draws the eye.

But there is more to it. This painter senses women's large receptivity to being seen, especially being seen to perform; and he can show a woman's role as inseparable from her sense of herself. Avedon's photographic portraits further convey that role-playing for spectators is wholly natural female behavior, certainly in most of the subjects he chose for this book. The mother, the singer, the writer, the editor, the activist, the star, the artist, the socialite, the fashion model—each wants to be seen to perform expertly as herself, with all her present inward states and outward circumstances individually tempered to the performance, and its appropriate dress, whether that's clothes, a costume, or skin.

Velázquez showed this subtle combination in women's faces as Rembrandt did in the same epoch. Velázquez's great instance is the mirrored face of the Rokeby Venus, a woman he depicts as unwilling to reveal whether she

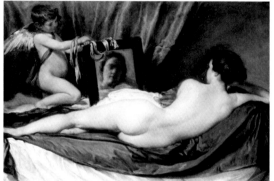

Diego Velázquez. Venus and Cupid (The Rokeby Venus), 1647–51. National Gallery, London

looks at us, or at her reflection, or inward, or all of these. Her delicate, turned-away nudity is similarly both receptive and reticent—but Cupid holds the mirror; this woman's face and body consciously invite our attention to their joint performance as The Goddess of Love.

Avedon could enfold similar devices into his photographs of women's faces by referring to the power of the film close-up, invented in the twentieth century as if to exploit the complex female look once rendered by great painters. Avedon's faces of Marilyn Monroe and Maria Callas (p. 83), among many others, share something with Scarlett's face as she brandishes the turnip, or Christina of Sweden's as she stands at the taffrail. The camera closes in on the woman's critical moment, and we see her inward look of feeling and awareness blended with her receptive look of being rightly seen. The look is related to her situation, but evoked only as she accepts the artist's gaze, and through his, the world's. Garbo said she was thinking of nothing; her complicated unconscious did it all.

From cool Dorian Leigh appreciating her frontal image in a bathroom mirror, to warm Lorraine Hunt Lieberson feeling her rich Botticelli hair come to life through his lens, Richard Avedon repeatedly showed that whenever he took the picture, the woman and the performer were one and the same; and that each was really Venus, in one of her infinite guises.

Subjects

ACKNOWLEDGMENTS

Norma Stevens, Bill Bachmann, Delia Cohen, Jennifer Congregane, James Martin, Dirk Kikstra, Daymion Mardel, Jamie Peachey, Cameron Sterling, Michael Wright, Chris Bishop, Regina Monfort, and Asya Palatova for the Avedon Studio

Andrew Wylie and Jeffrey Posternak for The Wylie Agency

Eric Himmel and Deborah Aaronson for Harry N. Abrams

Douglas Nickel and Trinity Parker for The Center for Creative Photography

Doon Arbus, John Avedon, Jeffrey Fraenkel, Adam Gopnik, Robert Hennessey, Anne Hollander, Martha Parker, Mary Shanahan, and Martin Stevens

Typographic design by Agnethe Glatved
Tritone and four-color separations by Robert Hennessey
Master Printer: John Delaney of Silverworks

For Harry N. Abrams, Inc.
Production Manager: Maria Pia Gramaglia

Library of Congress Cataloging-in-Publication Data

Avedon, Richard.
 Woman in the mirror / by Richard Avedon ; essay by Anne Hollander.
 p. cm.
 Includes bibliographical references and index.
 ISBN 0-8109-5962-3 (alk. paper)
 1. Photography of women. 2. Fashion photography. 3. Avedon,
Richard. I. Hollander, Anne. II. Title.

 TR681.W6A94 2005
 779'.24'092—dc22
 2005012645

Photograph credits
Page 239: Courtesy Museo del Prado, Madrid, and Art Resource, New York.
Page 243: Courtesy Frans Halsmuseum, Haarlem, and Art Resource,
New York. Page 245 (left): Courtesy National Gallery of Art, Washington,
D.C., Andrew W. Mellon Collection. Page 245 (right): National Gallery,
London, and Art Resource, New York.

Printed in Germany

10 9 8 7 6 5 4 3 2 1

Harry N. Abrams, Inc.
100 Fifth Avenue
New York, N.Y. 10011
www.abramsbooks.com

Abrams is a subsidiary of

LA MARTINIÈRE